# KAZIMIR MALEVICH
## The Climax of Disclosure

# KAZIMIR MALEVICH
## The Climax of Disclosure

Rainer Crone · David Moos

REAKTION BOOKS

To Mom and Dad

Published by Reaktion Books Ltd
1–5 Midford Place, Tottenham Court Road
London WIP 9HH, UK

First published 1991
Copyright © 1991 Rainer Crone and David Moos

Designed by Ron Costley
Photoset by Rowland Phototypesetting Ltd
Bury St Edmunds, Suffolk
Printed and bound in Great Britain by
Balding and Mansell plc, Wisbech, Cambs

British Library Cataloguing in Publication Data

Crone, Rainer, 1942–
    Kazimir Malevich: the climax of disclosure.
    I. Title II. Moos, David, 1965–
    709.2

ISBN 0 948 46221 3

Acknowledgements

Although Jean-Claude Marcadé remains for
me the most enduring and serious spiritual
force behind Malevich studies, it is to earlier
scholars that my initial debt must be paid. I
was fortunate enough to meet Roman
Jakobson in the late 1970s at Yale University,
but it is rather Victor Erlich and Edward Stan-
kiewicz that I am personally indebted to, for
they provided me with sustained and genuine
inspiration. For the time they gave me at
Yale when I first formulated my ideas, I am
most grateful.
    Joseph Leo Koerner of Harvard University
deserves particular thanks for instigating this
book. Without his admonishments it would
not have been written in the time that it was –
a vital moment of reawakened interest in
Malevich.
    To Lester Johnson for his superb accom-
modation, Alex Oronov for his prompt assist-
ance in reaching Russia, and Bill Orcutt for
his excellent photography, I am deeply grateful;
without such logistical help there would be no
book.
    For David Moos . . . who allowed me to
realize what I never thought lay within me.
                                                    R.C.

Photographic Acknowledgements
Ardis Publishers, Ann Arbor, Michigan: Nos.
63, 73 British Library, London: Nos. 50, 55,
60, 76, 79, 80, 107, 111 Giraudon, Paris: No.
29 Rheinisches Bildarchiv, Cologne: Nos.
119, 144 Sovfoto/Eastfoto, New York: No. 49

Endpapers from:
*Fabric Ornament No 15*, 1919,
watercolour and pencil (35.6 × 27.0 cm).
State Russian Museum, Leningrad.

# Contents

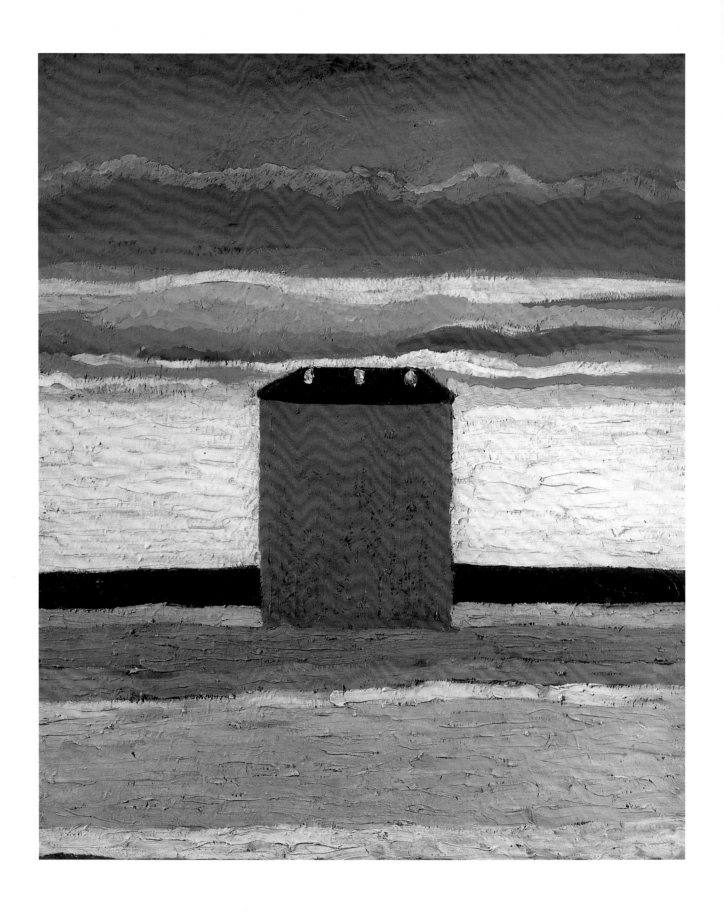

1 *Red House*, 1932, oil on canvas (63 x 55).
State Russian Museum, Leningrad.

# Prologue

We are dreaming of something else. It is something that we cannot quite remember, cannot exactly phrase in words that you will be able to read and understand. But, we ask each other, are dreams for other people to understand? Partial memories leading to improper questions . . . . Like all points of departure, when one, in this case two, sit down to write about the paintings of Kazimir Malevich, the beginning is a place where clarity is always close at hand. It is not, however, clear where the beginning will lead, how it will continue, or even if that initial clarity was actually there. The thereness of clarity . . . something like this dream envisioning fields, vast fields, and sky, more sky than you can imagine. The absence of places and the prominence of ideas drifting above the fields, held below the sky, just in reach of the probing, leaping and keeping gaze of minds that want to know only what pictures will permit.

If an anecdote about the complexity of the paintings of Kazimir Malevich could contain in condensed, enigmatic fashion the wealth of thinking they incite, then – if you believe in such stories – then indeed, it would be told. But no such anecdote is available to the authors at the present time. And because of this deficiency, we must take a longer path – an approach which is dense, involved, and at times leads into unknown territory.

When we mention the unknown, how is it possible that we even know what we are mentioning? A tautological quest . . . certainly not, one author informs the other, because if it were, why would we be here? Finding answers in the questions that have been asked in order to find the answers is an ungratifying, indeed mystifying, endeavour, and our intention in this book departs from the deadlock of closed circuits, and systems that find themselves through self-reflection. Although introspective scrutiny and magnified structural analysis inform a major portion of our thinking about Malevich, without cognitive interfacing the methodology would not yield the fruit we seek.

As one moves further along the path to unravel enlightenment, one begins to assume a position that denies sleep and discounts the possibility of thinking that stops at the end of the day. Night is only an illusory re-composed veil cast down on our seeing eyes, as Nature's vengeance. Circumventing this insinuating obstacle, the mind awakens at all hours, consumes itself with an order beyond doubt's vengeful suspicion. This night is itself polluted with so many images of day, so many figures of light, that the eyes of the mind could not see enough, not glimpse the enormity of brief, always brief, moments when something happened; a moment when the world rearranged itself into a configuration that confounded imagination. Could it be, we ask, standing in the carpeted rooms of this museum in Europe, in another museum in America, that images – no, not images, paintings, yes, paintings – that paintings have rearranged our reality, have made us wonder (on the

drive home in 1990, 1991, and so forth) in what time and through which places we are travelling.

And we like to travel. All of us love to travel. This urge is not connected to vacations or business trips, but rather concerns an atavistic quest to seek that which our predecessors have not experienced – to travel beyond the limits known through convention and order. If we are to embark, as did Kazimir Malevich with the aid of a mere paintbrush, then we must do so with conviction and confidence. We must let go of the familiar and embrace the unexplored, because this is an exploration, an expedition.

With a computer in one room (it seems that we are only ever in one room) we sit down to record dreams, to recode reality in words. Inspired by such previous efforts as those of the painter, with the task fully flowing, one's ideas turn away from the letter or screen and question . . . question the room itself. If anything, *The Climax of Disclosure* is a discussion about the climaxes that Malevich reached when he lived through what we are only beginning to learn about, beginning to look at, when we look at his paintings.

New York City, December 1990

2 *Composition with Four Grey Elements*, 1920, lithograph, printed in black (11.4 x 7.9).

# Introduction

Everything has vanished, only a mass of material has remained from which the new forms will be built...

Until now there was a realism of objects, but not of painted units of colour...

Each form is free and individual.

Each form is a world.

—Kazimir Malevich, Moscow, 1916

What is Nature? – an encyclopaedic, systematic index of our mind.... We know only in so far as we make.

—Novalis, 1795

3 Kazimir Malevich in Warsaw, March 1927.

# This Book . . . and the End of Experience

This book is about a painter who lived at the opening of our century, working in cities that still today seem remote. This book seeks to deliver insight into the creative process of a painter who terminated the tradition of five long centuries in Western painting, departing from the triumvirate of fundamental tenets that had secured creative man in his world: a ceaselessly illusionistic representation of observable experience; realism as a measure of truth; and requisite accuracy proclaimed through perspectival systems. In his search to find an essence in reason for the ways of the universe in which he lived, Kazimir Malevich sought to cast off conceptions linking humanity to a character in a conclusive narrative called life. And although the musings of man with destiny have a long-standing tradition in the arts, it is with this painter that a fundamental disruption occurs; a break not with the musings themselves, but in the form that they take. Indeed, even a cursory glance at the reproductions in this book confronts today's reader and viewer with visions that confound cognition and rule out easy assimilation into experience.

Surpassing artistic predecessors in the Western tradition of examining the natural world through pure craft and artifice, Malevich was an artist able to catapult his commentary away from foundations in Nature into the realm of technique and creation alone. Where minds in previous centuries were preoccupied and ordained by existence in Nature, their works established a likeness by examining how thinking generated and perpetuated itself through a suitably accessible form. While in poetry, for example, we can read in Novalis of the late eighteenth century the urge to know in Nature a divine essence, we can also observe in another language, in the early nineteenth century, Wordsworth's sonorous odes to time, to time emptying Nature of human confidence. Both poets exemplify the inadequacies of written language – even poetry – when posed against transcendent essences. Indeed, man's quest for reason, seen through the lens of his surroundings, follows a limitless excursion into the landscape of the world, phrased and rephrased in the languages of art.

We would run this historic course until the opening of the twentieth century, until we arrived in Russia and discovered the minds of three men among a group of avant-garde artists. And a poet, in particular, would draw our early attention. Velimir Khlebnikov, a visionary, a traveller and a humanist, established in language a 'nature' beyond the natural world, and guided the hand of the painter, Kazimir Malevich, into the structured cosmic sphere of Suprematism. It was this poet, counting numbers and compiling lists for the tables of destiny, who inspired a linguist and scholar, Roman Jakobson, to embark upon an adventure of explanation.

This unique concordance of three minds achieved an outlook that asserted and verified that there can no longer be, regardless of accuracy or delicacy, *any* representations of Nature. For what is Nature, they asked, if not a

collection of sentiment, an assemblage of observations amalgamating in our perceptions to transport us along our pastoral journey? Is Nature not that which is within the mind and soul of the artist? Their collaboration brought this insight from suspicion into realization. This book does not dwell on the particulars of their friendships, but rather plumbs the depths of the ideas that brought these three together.

Evolving at a rate contiguous with the rapid sequence of discovery in the natural sciences, the artists gleaned inspiration directly from concrete propositions set forth in the atomic atmosphere of unpredictability, of uncertainty, and of doubt strong enough to ask questions that may indeed be unanswerable. This book investigates the limits of experience felt by each artist. It explores how the very act of living seemed sometimes insufficient in the face of a creation that reached beyond any known boundaries of the day. When, in the December of 1915, a year that witnessed the obliteration of humanity in the trenches of the West, Malevich, at the occasion of the first public viewing of Suprematist paintings, wrote, 'I have transformed myself into the zero of form', he understood the transient and finite borders of existence. With insight into the vast and minute realms of theoretical physics, the task of locating humanity upon the surface of the earth became an inquiry into the limits of limitations themselves. To what degree, however extreme, could humanity seek a definition of itself that did not capitulate to destruction or succumb to reproduction of the past?

The questions asked in this book are questions that maintain a contemporary context. Our initial concerns were historical, while our overriding objective has been the elucidation of current understanding of extraordinarily complex artistic contributions. As with all scholarly quests, a great deal of methodological reflection has accompanied these objectives. It is our desire to make present the past, to make lucid the opaque, dense images of art. As historians we are only ever dealing with information, some shadowy, some more secure, although all is merely an interpretation, a point of view. As art historians, however, we maintain the extra opportunity of possessing at least one object. One irrefutable piece of evidence allows us to make assertions about circumstance, about deliberate intention, and ultimately about meaning.

Through detailed description and obsessive observation a viewer with firm historical knowledge is able with vision to motivate dormant insight. If paintings can bear through their virtual description the information of history as interpretation – ideas like metaphor, influence, allegory, etc. – then the description becomes as meaningful as the history within the painting. For when we describe what we see, we can only speak of what we are thinking in front of the painting itself. A fixed eye is a blind eye, like a frozen mind is a thoughtless mind. Ultimately, description can recognize itself as an autonomous yet affiliated category of epistemological inquiry. As a methodological tool, it can yield the most powerful insight into how thoughts are organized and applied through their objective instigating essences. All echelons of experience concluding in information connect with ways of looking – of looking through to understanding.

As historians, to appreciate the significance of description we must attune

4 *Untitled*, c. 1911, pencil on paper (14.6 x 10.3). Wilhelm-Hack-Museum, Ludwigshafen.

our minds to a particular type of methodological inquest – namely, the interconnectedness of cerebral chains. Unlike a conventional interdisciplinary approach, connections made between cerebral chains (main streams of thought) may appear to be tangential in terms of subject matter and content. This distance, however, is not circuitous, nor does it imply arcane assumptions. Often, antagonistic confrontation of disparate structures enables a mechanistic constitution of certain ideas to be approached from what was a previously undetected vantage point. It is, of course, only through different ways of looking that we can begin to think differently.

For example, our use of a contemporary paradigm in explaining how theories of information apply to culture and history however distant in the past) should serve to establish embracing currents of thought in the reader's imagination. A new and as yet incurable disease has helped us to isolate delicate issues about the transfer of information and the relationship of this process to the conservation of meaning. It allows us not only to inquire into the construction of our major critical networks of assessment, but also to posit the existence of a deficiency in the transfer of research for a general methodology. This urgent and all-pervasive case (one with devastating implications, as the modern disease intrudes upon everyone's consciousness) effects in the conscientious reader an intellectual open-mindedness suited to learning and discovery. The shock of existence versus its obstinate counterpart – in this case rampant consumption – must spark in any, even sequestered, mind a degree of reality that is inescapable. Indeed, this modern disease has become real to a populace forced to witness the statistical outcome of compounded information, that is both the potential and actual incidence of mortality. Despite the availability of data and the supposed accuracy of laboratory fact, information is mediated through networks of dissemination. And as this occurs, so interpretation adapts itself.

The circuit, from initial information through interpretation to acquired reality, is liable to become a linear operation that excludes independent readings. When, given this circuit, can pure information ever be treated at its fundamental level, beyond the constraints of obvious answerability? Taken as a substance, pure information offers opportunities of interpretation that make it potentially explosive, unmediated and difficult to procure. But inside the circuit, which is an actual working model of the process bridging information, dissemination, interpretation, and reality, we can depart equipped with this working paradigm to inquire into other fields of thought, other disciplines. And even beyond academic concerns this 'circuit' stretches into a tenuous and often nefarious zone of ideology, with implications for any political body seeking to constrain or mediate information for discursive ends.

The painting on page 184 of this book, dating from the early zenith of Stalin's power, represents the need of the human being to prevail amid even the strongest manipulations and perversions of basic identity. With the assertive and even descriptive resolution inherent in this painted image, the one and only imperative of all academic, experimental, cerebral, and poetic investigations is stated. The painting represents in iconic terms Malevich's definition of all worthwhile pursuits as those that originate from the assertive individual. Indeed, as this book meanders through various transformations

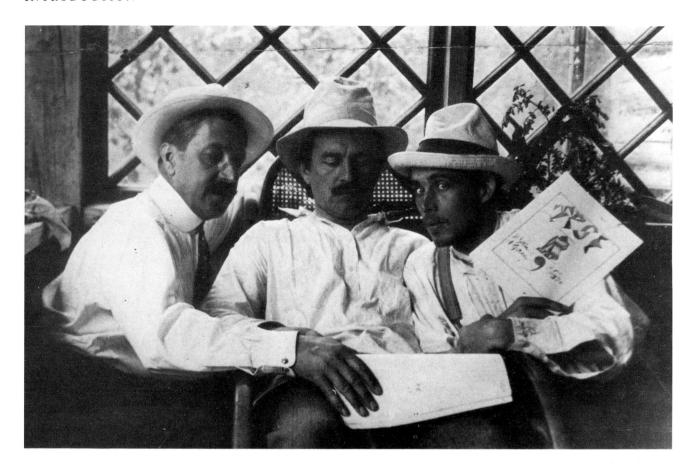

and invocations of dialogue, let the reader always keep in mind this one de facto image of all existence.

5 Mikhail Matiushin, Kazimir Malevich and Aleksei Kruchenykh during a holiday at Uusi-kirkko, Finland, 1913.

One must balance the descriptions of philosophical innovation with the memory of the people who actually initiated (and had to live with) the break-throughs. In the case of the Russian avant-garde, with its neat analogue to the evolution of theoretical physics governed by Planck and Einstein, the collaborative method of investigation resulted in composite fracturing reali-ties. Enveloping the experience of theoretical phenomena, the Russian inves-tigators sought to create, in their articles and their treatises, a form of expression that would subsume the content of everyday life into a higher phenomenon of reality.

This book aspires to integrate and then to deliver to the reader a meaning-ful approach to the general content of ideas set forth in an art that radically redistributed the values of a given culture. By connecting various related disciplines and extracting cornerstone after cornerstone, the epochal and soluble inventions proposed by Malevich will hopefully gain unequivocal meaning within the minds of the reader. In support of these thoughts, it was Roman Jakobson who reflected early in his career on the intricate workings of a culture in total transformation, stating in 1929 with reference to the art of the Russian avant-garde: 'For the most fundamental and specific sections of Russian science, especially the contemporary ones, the following is charac-teristic: the correlation between singular strands of thinking is not to be regarded in terms of causality – one strand is not to be deduced from another.

7

The basic screen with which science is operating is a system of correlative strands; it is an immanent structure, which is built upon an inner principle.'[1]

It is the triangle of cooperation and communication between Malevich, Khlebnikov and Jakobson which gives this book a dynamic that surpasses the convention of a monograph on one artist: the resulting impact is epitomized in interpretations of a select number of paintings by Malevich. Our disinterest in an overall assemblage of biographical data allows us to focus upon meaning. The radicality of each of these three personalities is complementary and mutually informative. But it was Roman Jakobson who humbly proclaimed on behalf of an entire generation, 'without Khlebnikov none of us would have been'.[2] The poet could be said to have single-handedly introduced to this generation of vanguard thinkers and creators the philosophical insights of the most recent and radical developments in the natural sciences. His vision greatly accelerated the endeavours of the avant-garde, and thus in this book we will occasionally digress to follow his particular philosophical development in detail.

As Khlebnikov opened up the parameters of tradition in poetry and creative thinking, one might correctly anticipate that a longer book on the work of Malevich would not submit to the conventional form of a monograph. The monographic book – the comprehensive chronological survey – is in itself a form of discourse on art history that finds its impetus and distant roots in a tradition reaching back to the Renaissance. It still denotes what most in the field of art history consider to be a satisfactory and viable way of locating the contributions of one artist within a historical framework. Thus, by invoking the form of the monograph the art historian invokes tradition. Inside tradition, however, there are always aberrations. Indeed, the history of art is a tradition premised on the belief in innovation and steeped in a tradition of defiance, contradiction, and dissent from convention. It is to the great innovators that our attention turns when we cast our gaze backwards in time, and not to the masses of the mainstream. Kazimir Malevich belongs to the class of innovators, standing out from convention and securing a place in histories of art regardless of how they are written.

However, the monograph presents itself as a problematic vehicle. It is an approach more suited to traditional outlooks than innovative disruptions. The monograph depends upon artistic vision and, like the history of art, it implicitly asserts hierarchy, priority, and an inevitable evolution. But art, and artists' lives, as Kazimir Malevich has informed us, do not necessarily submit to such predetermined schemes of logical interpretation. And when the concerns of art history overreach a mere coherent narrative, the path taken by the wandering mind and by the inquisitive creative vision often follow internally set models that do not equate with the historian's way of looking at the past.

Our main objective in the writing of this book was to attain an understanding of Malevich's work with reference to both his cultural time and our own – especially with regard to contemporary art. Although the impact of his work upon the viewer may have changed, we believe that the meanings carried within his painting are only now beginning to be adequately understood. Indeed, it is from our temporally secure vantage point in the present that many propositions of meaning can best be tested against the past.

6 *Untitled*, pencil on paper (11.5 x 9.4). Wilhelm-Hack-Museum, Ludwigshafen.

We used to perceive [pictures] as valuable artistic objects, and it did not enter our heads that we were not perceiving the essence of the pictures. We have always striven to perceive in an exclusively aesthetic way all that is artistic . . . In reality matters are quite different. Whilst examining all the different trends we did not notice that we failed to mention the artistic side of a given work. On the contrary, we always spoke of the sensations of the various aspects of a work, of its elements and of the painter's perception. We have discussed painting, colour and tone sensations, the contrasting interrelations of elements in each picture, dynamics, statics, and mystical and other sensations. Hence one might draw the conclusion that the man known as the artist is not always able to be . . . an artist, and does not always paint exclusively artistic works. He perceives the world in greater depth and breadth than we at first thought, particularly at a period of extremely developed activity in pictorial art.

—Kazimir Malevich, 'Aesthetics', 1929[1]

# The Question of Information

Sitting across from each other, just after 8:00 am on the TGV (*train à grande vitesse*) travelling from Paris to Geneva at 260 kilometres per hour, we were talking about an advertisement on television. Rainer was describing the images – a contrast to the verdant fields still damp with the morning fog lifting off as the sun began to rise in the sky. The landscape of France revealed itself in reverse because our seats faced backwards to the direction of travel. Looking out of the window yielded retrospective visions of an unfolding day. The conversation consisted of a certain advertisement . . .

An elegant young couple, man and woman, sit across from each other in a train, dramaturgically posed, speaking about friendship. The viewer becomes interested in these characters, captivated by their concerns. They speak about the complexity of their respect for each other, which is genuine, one infers, from the delicate manner of their expressions. The scripted episode appears to be a clip from a classic feature film. The night driving scene from *Un homme et une femme* (Claude Lelouche, 1966) comes to mind, because of the serious intent of each person and their desire to understand each other. In this television sequence the cameras alternate between tightly focused shots of each character's face; the scene is rich with romance, augmented by subtly delivered lines. The outside landscape, seen through the curve-cornered window, rushes by as the couple become comfortable in dialogue, and overcome their hesitancy within the awkwardly small train compartment. A relaxed smile animates her face. The two begin to enjoy their romantic journey together. All is made evident to the viewer in a brief twenty seconds. The scene is cut, and now the train itself is seen from outside in profile, blazing across the countryside. The camera advances upon the sleek locomotive, tracking its progress. The speed is tangible, experienced hurtling around a turn as the locomotive and first car suddenly enter a tunnel. At this entrance the camera stops, frozen on the visible cars; the locomotive and first cars have already disappeared inside the tunnel. A transparent luminous covering unfolds in the opposite direction of motion – as rapidly as the train's movement – over the visible cars, encircling them. An evident cinematic trick, replicating the covering of a condom! All action is arrested as the word 'AIDS' is imposed diagonally on the screen, boldly cancelling the image of the penetrating train.

This was an advertisement made in Sweden for television. Viewing it in Paris on a programme featuring international award-winning advertisements, one immediately became self-conscious of language and the greater concerns of culture. The narrative sequences of images were most effective when they connected with emotions, with episodes and desires close to one's own. Recognition and appreciation were dependent upon familiarity. Because

7 *Trees*, 1904–5, oil (31 x 19).
Collection of George Costakis, Athens.

many advertisements were in foreign, incomprehensible languages the dialectic between image and word became a central preoccupation, determining impact. Unlike the normally minimal demands placed upon the television viewer, this international sampling necessitated full attention. Sharing only the common interest of promoting a product, the advertisements revealed an enormous range of strategies for conveying information. Each country's contributions were characterized by a specific style, discernible through details in depiction and approaches to subject matter. All the elements related to what we call 'style' – hairdos, gestures, poses, voice intonations, and particular camera positions – became the substance of the overall style, and of the original interpretations.

The effectiveness of the advertisements could rarely be assessed, because most of the products were not available for purchase in Paris. The ones that were, such as 'foreign cars', seemed likely to alter in significance simply through their hypothetical acquisition in France; taken out of their prescribed context, their meaning would change. Advertisements construct a specific and actual context which can only rarely be transferred through products from one culture to another; those few products that do travel become leitmotifs of foreign countries, synonymous with that culture. It is not merely that certain exportable products reflect the established values of a nation, but that those supposed values are coded into the product – propagating the belief that the product will deliver to the purchaser greater knowledge of that foreign culture.

This festival of advertising revealed how the reception of information is constrained by cultural conditioning. Information itself becomes fluid when the connection between intention and interpretation is obscured through un-translatability, or, even more confounding, mis-translation. Accurate dissemination of information is no longer dependent upon technological capacity, but governed by a variety of issues that permit transmission but cannot dictate reception.

No longer characterized by fields, our TGV skirted the bank of a river. On one side the wide, slow flowing, flatness of the Ain, while out of our window flashed junctions and small towns, or a few cars and vans lined up at a crossing. The sun, full in the sky, flickered behind the shadows of trees lining the river. Fog, now entirely burned off.

Condom? A totally inadequate protection against AIDS! How could condoms prevent the spread of AIDS? The virus is so much smaller than the fabric weave of a condom; thousands fit on the head of a pin. Anyway, C. Everitt Koop recently announced, just prior to the end of his term as Surgeon General of the United States, that he had erroneously assessed and grossly overestimated the effectiveness of condoms in containing AIDS. And doesn't this reversal of position raise questions about the AIDS virus itself, what is known about it and what we believe of it? Why are condoms being advertised around the world?

The critical dependence of our conceptions upon accessible, refined information, means that we ought to be aware of how information becomes avail-

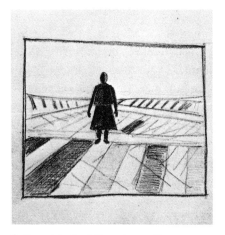

8 *Peasant in the fields*, n.d., pencil on paper (13 x 14.6).

able to us. Pure information, discovered and construed by experts, is mediated through a screen of interpreters who serve the dual function of forwarding data, while at the same time editing it for our consumption. Under the constraints of publicity, this system of mediation can only be as accurate as the information provided, but does not necessarily guarantee that the most significant aspects will be emphasized, or the less important omitted. And, given the overwhelming amount of data and information being reassessed and generated every day, one must ask by which criterion is the selection of those 'most significant aspects' made. There is a story to be told ...

Leaving the Ain below we began our ascent into the Jura, winding up worn valley systems, our speed noticeably diminishing with the incline. Trees, growing on the impossible sides of rocks, reached upward, pointing to the peaks of mountains in the far distance. Leaning close now, we started talking about a singular person; a pharmacologist, Dr Strecker, whose main interest lies in pathology, had taken the time to explain, in a seventy-five minute video, another version of a real story, of a story that is already history.

Concerning the case of AIDS, and all our thoughts and ideas surrounding the virus, what emerges as significant is not what we know or do not know about its origin and impact, but rather how we have formed our (partial?) understanding and interpretation of the phenomenon. AIDS should be treated, in this context, like any other problem confronting the scholar/researcher/scientist. The fundamental rules of intellectual inquiry must follow the same course as with any proposition (academic, historical or real), if we are to draw conclusions that yield insight greater than our point of departure.

The once widely publicized notion that AIDS originated from green monkeys in the Congo is difficult to accept, given the fact that when these monkeys were injected with AIDS, they did not contract the virus. The idea of AIDS as a jungle disease seems anomalous because pygmies (the last remaining jungle population in Africa) are known to have the lowest incidence of AIDS on that continent. Clearly AIDS, as we know it, is an urban disease. The main question is how it got there.

As early as 1966, in an article published in *The Lancet*, a highly respected British medical journal, Sir Macfarlane Burnet questioned the aims of experimental tampering with molecular biology through genetic engineering. This was at a time when this relatively new scientific discipline had advanced to the point where its fundamentals had been enumerated and provisionally understood, where it had become apparent that the theoretical implications were as far reaching as the discovery of subatomic structure at the beginning of this century. And yet this leading researcher felt obliged to caution us against the potential applications of genetics:

The human implication of what is going on in this sophisticated universe of tissue-cultured cells, bacteria, and the viruses which can be grown at the expense of one or other, is at best dubious, at worst frankly terrifying ... Theoretically, anything within the physical possibility of mutation can be obtained by current techniques from cell line, bacterium, or virus, and can be isolated in unlimited quantity. It is interesting to contemplate the possibilities for human good or evil in the mutations thus obtained.[2]

9 *Suprematism: Supremus No. 57*, c. 1916,
oil on canvas (80.2 x 80.3).
Tate Gallery, London.

10 *Suprematism*, 1918, oil on canvas
(97 x 70). Stedelijk Museum, Amsterdam.

Genetics, providing man with the capability of unlocking and replicating the essence of life, has multifarious applications in science and medicine. Today, for example, immunology is intimately related to, if not dependent upon, findings from experiments conducted in the field of genetics. The relevant discipline of virology is similarly dependent upon genetics. And it is, perhaps, because of this methodology that by the early 1970s researchers could envision a 'fictitious' scenario characterized by 'a contagious virus resulting in a pandemic of neo-plastic diseases occurring and rapidly proliferating before a vaccine could be developed.'[3]

In 1972 the World Health Organization recommended in a memorandum entitled 'Virus-associated Immunopathology', co-authored by twelve experts from five countries on three continents, that: 'An attempt should be made to ascertain whether viruses can in fact exert selective effects on immune function, e.g., by depressing 7S versus 19S antibody, or by effecting T cell function as opposed to B cell function. The possibility should be looked into that the immune response to the virus may itself be impaired if the infecting virus damages more or less selectively the cells responding to the viral antigens.'[4] This theoretical request for experimentation is intriguing because of its precision; it suggests an exact process with an explicit result, although no clear purpose, besides experimentation, is apparent. The detail of this outline bears striking similarity to viral syndromes associated with what we now refer to as AIDS.

Indeed, one particularly pernicious characteristic of the AIDS virus concerns the way in which it affects the human immune system. AIDS, unlike other degenerative ailments, does not directly impair the body's ability to produce antibodies. It rather affects, by selectively destroying, T4 cells. These cells play the vital role of identifying foreign agents inside the body, and then instruct B cell (antibody) production.

AIDS can be classified in virology as a bovine-vesna virus. This double classification derives from certain morphologically parallel viruses known to afflict cattle and cause brain degeneration in sheep. The cellular composition of the six or more currently identified retro-viruses related to and including AIDS are of a molecular composition which nearly replicates these animal diseases. That viruses occurring in humans could so closely resemble animal ones seems to be the direct result of genetic innovation, which by 1973 had the ability to pass an RNA retro-virus from species to species through tissue culture transmission.[5]

One theory regarding the transmission of viruses between species, perhaps partially accounting for the AIDS epidemic, concerns the production of vaccines in laboratories. In the late 1960s the World Health Organization undertook a massive innoculation programme aimed at eradicating smallpox from central Africa. Smallpox vaccine is manufactured by scarring the stomach of a cow until it bleeds. Scabs form and after a week of growth, with the cow in a stall unable to lick its wounds, the scabs are collected and taken to a laboratory where the vaccine is produced. Given the theoretical capabilities of genetics it is not inconceivable to imagine a situation where viruses could be intentionally or accidentally transferred between species.

The spread of AIDS, and its present distribution throughout the world,

coincides with the main targeted areas of the World Health Organization's immunization programme.[6] In 1987, in a report from *The Times* of London, 'Smallpox Vaccine "Triggered Aids Virus"', the connection was made frighteningly clear. Although the link between the smallpox vaccine *Vaccinia* and AIDS was not thought necessarily to have been caused by laboratory transfer, 'some experts fear, that in obliterating one disease, another disease was transformed from a minor endemic illness of the Third World into the current pandemic.'[7]

The quest for inventing a vaccine against AIDS – the main thrust of cancer research for the past forty years has been for a vaccine – seems enormous given the fact that AIDS mutates as it infects each person. The virus is such that it grafts onto the double helix of individual DNA and alters accordingly; this means that no two AIDS viruses can ever be identical. There is, one concludes, no single AIDS, but rather an inestimable multitude – as many different types as there are people.

The rapid dissemination of AIDS in international urban centres and our failure to comprehend both its origin and substance raise major questions about AIDS and our encounter with it. The possibility of such a virus being 'predicted and requested' (i.e. a genetically engineered virus) is a startling proposition. And common (mis)conceptions about the virus are apparently not founded on scientific evidence, but rather the product of another mechanism.

Beyond these disturbing details, which characterize a scientific age incapable of mastering or maintaining control over fundamental yet life-threatening processes, the phenomenon of AIDS functions in our context as a perfect paradigm for policies of research, information, interpretation, and reception. These four facets of knowledge, here extracted from science, can (and we believe should) be transposed into any modern study of contemporary culture.

The above example demonstrates how research – conducted progressively (in the form of experimentation) or retrospectively (in the form of scholarly review) – becomes the single determining factor upon which conceptions are built. And regardless of the accuracy of the research, which is inevitably variable, the result is only ever an interpretation. In the light of this theoretical position, we come into contact with the defining limits of epistemology. Knowledge, or what is believed and widely accepted to be the single concrete interpretation of proposed facts, merely becomes one order of interpretation. What is taken as knowledge at a given moment in history is strictly dependent upon the current ability to probe and understand what we do not know. And how we think about approaching the unknown will dictate how we think about what we do know – this paradox being balanced only through interpretation.

Out beyond each centre of information lie concentric systems of mediation and interpretation. Research in the natural sciences invokes a highly specific terminology, comprehensible only to select specialists conversant with details of the language. If language is regarded as imposing the first form of interpretation, then it is though transcription and translation (of findings coded in language) that this research information assumes another form

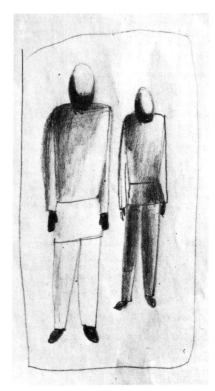

11 *Untitled*, 1928–32, pencil on paper (18.7 x 14.2).

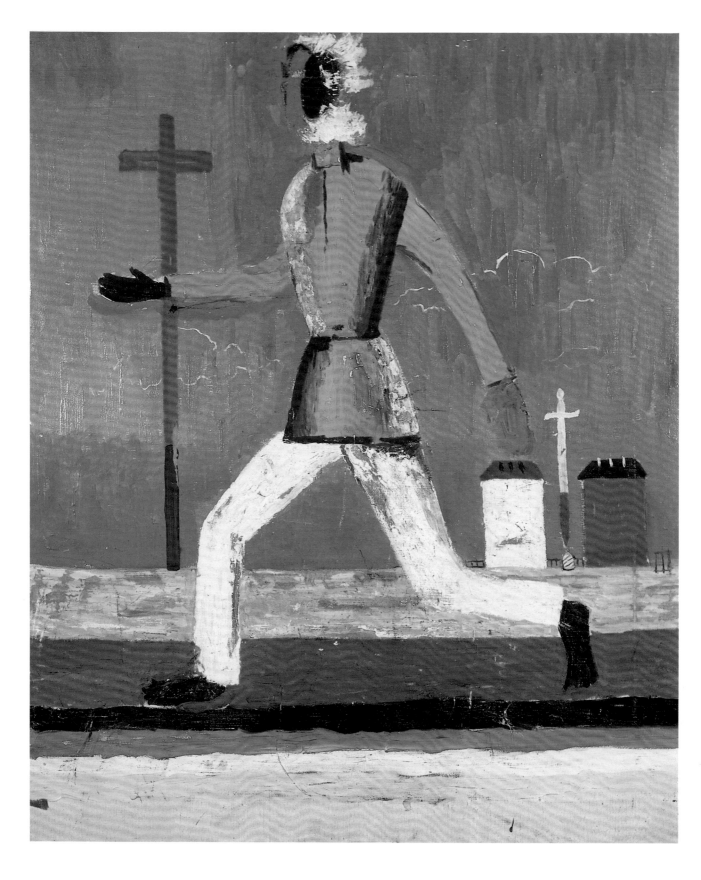

**12** *Running Man*, c. 1930, oil on canvas
(78.5 x 65). Musée National d'Art
Moderne, Paris.

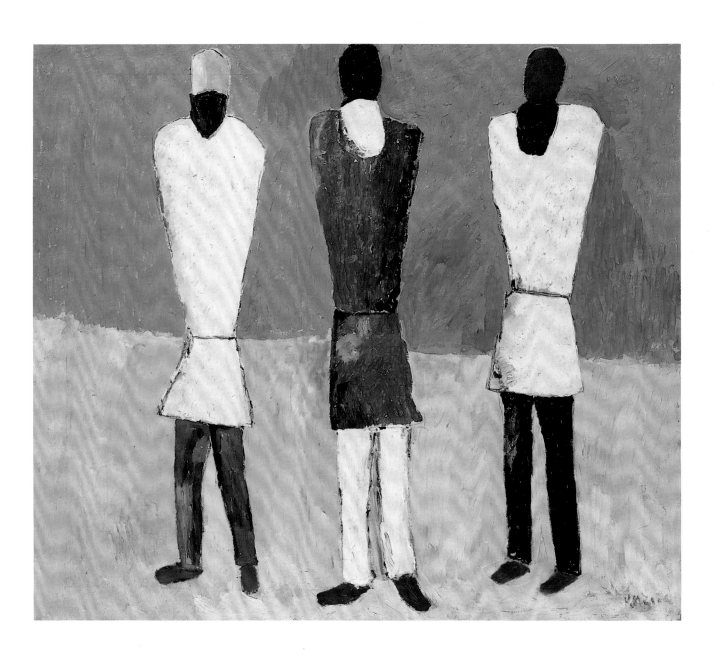

**13** *Peasants*, 1928–32, oil on canvas
(77.5 x 88). State Russian Museum,
Leningrad.

suitable for wider comprehension. Each forum of presentation is characterized by its own criterion which will impact in specific ways (for example, the language of medical journals is different from science sections in newspapers). Although the natural sciences are radically different to the human sciences, because their mandates and methodological apparatuses refer to separate types of problems, they converge at a crucial point through linguistics. Regardless of the nature of human inquiry into the perceived world, whether scientific or humanistic, all propositions and consequent findings must be transcribed through language into the broad realm of societal comprehension. The meaningful continuation of the sciences relies upon the acceptance of radical new findings in the broader domain of cultural simulation.

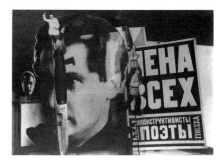

14 Alexander Rodchenko, *Spatial Photomontage-Collage*, 1924, mixed media, plexiglass, knife and photomontage.

In order to understand the state of knowledge at any given historical moment, it is not enough to trace the publication of data in various forms; past ways of disseminating information must also be examined. Once these methods are understood, it can be recognized where exactly information was conceived, received and subsequently interpreted. The communication of information often involves a 'circle of deception', either intentional or inadvertent, but accrued and integral to information itself. Hans-Georg Gadamer remarked upon methods of transmission, which are always dependent upon interpretation, in *Truth and Method*:

A reflection on what truth is in the human sciences must not seek to derive itself from the tradition, the validity of which it has recognised. Hence it must, for its own method of working, endeavor to acquire as much historical self-transparency as possible. In its concern to understand the universe of understanding better than seems possible under the modern scientific notion of cognition, it has to try to establish a new relation to the concepts which it uses. It must be aware of the fact that its own understanding and interpretation is not a construction out of principles, but the development of an event that goes back a long way.[8]

In the example of the AIDS phenomenon, which is a contemporary manifestation of scientific hermeneutics transposed into the public realm, we find that the comprehension of advanced theoretical information is governed directly by the theoretical models set forth. Vast social concerns necessarily impact upon the highest form of laboratory-derived fact. Information must always be conveyed and transferred – that is its necessity. And those receiving it experience it in a modified form, created out of reception itself.

The natural sciences, with their intimate and immediate relationship to Nature, are founded on a premise which seeks to establish 'truth(s)'. Thus:

Modern science is for Heidegger a work of man as subject in this sense. Modern man as scientist, through the prescribed procedures of experiment, inquires of nature to learn more and more about it ... For the scientist's 'nature' is in fact, Heidegger says, a human construction. Science strikingly manifests the way in which modern man as subject *represents* reality. The modern scientist does not let things presence as they are in themselves. He arrests them, objectifies them, sets them over against themselves, precisely by representing them to himself in a particular way. Modern theory, Heidegger says, is an 'entrapping and securing refining of the real'.[9]

Empiricism, by virtue of its directive, has ordered information and ideas in a certain way, seeking to construct intelligible models for those people who

initially confront the findings. In this context, empiricism is revealed as a hermeneutic system dictated by conventional perception.

What, then, are the applications of science when we consider them in broad terms, and how are we to derive significance from a discipline that interacts with and implicates all levels of culture? The answer to this question must concern itself with a definition of the terms employed in order to acquire accuracy. When we refer to culture, usually implying the artistic activities of man, we should not exclude those recognized as scientific. Conversely, Martin Heidegger points out in 'Science and Reflection' (1954), 'so long as we take science [purely and restrictively as science] in this cultural sense, we will never be able to gauge the scope of its essence.' Only through combination and interrelation can decisive insight into the complex reality confronting us be apprehended.[10]

15 Eisenstein editing his film *October*, 1927.

Exploration of the disciplines of art and science can no longer be constrained by methodological divisions. The developments from the beginning of this century concerning relativity and interrelationships parallel similar developments in the visual arts. New ideas, which were only fully understood by those who invented them, found resistance from others who were confronted with the applications. Perception, the product of expectation and familiarization, surfaces as paramount because it alone decides whether an idea or work will be accepted.

An example illustrating the dissemination of theory, discovery, and information can be closely observed within art history, concerning Paul Cézanne's methods of creating paintings for the express purpose of communicating complex and intimate visual insights to his viewers. Cézanne intuitively recognized a particular artistic dichotomy; he then built that dichotomy into his artistic working methods and made it integral to his relationship to the viewer. Discussing perception and the artist's way of adapting to circumstance, Merleau-Ponty wrote:

> . . . he [Cézanne] preferred to search for the true meaning of painting, which is continually to question tradition. Cézanne did not think he had to choose between feeling and thought, between order and chaos. He did not want to separate the stable things which we see and the shifting way in which they appear . . . He makes a basic distinction not between 'the senses' and 'the understanding', but rather between the spontaneous organization of the things we perceive and the human organization of ideas and sciences.[11]

Each aspect of human culture can only be understood through its interrelationship to neighbouring disciplines. When art is represented as one single sphere of the cultural enterprise, we experience nothing of its essence. In order to understand the significance of art produced in the past, historical moments must be evoked. A given artwork will have a particular meaning when it was made and first viewed, but over time that meaning may have altered.

Bursting out of the blackness of a ten-minute tunnel, the light stings your eyes. You see the first signs of a city from the train window. You feel the power of the machine restrain itself, and your weight press lightly against the back of the orange, upholstered, cushioned seat. When the train arrives, there will be Customs; after the cursory glance at your documents, the

echoing smooth tiles of the station. And people walk, dragging the weight of their luggage in lines, from the expanse of the underground terrace to the small portals, stairwells leading to tracks. You walk among them, coming close to some, others passing at a distance. Their features are remarkable, telling you everything imagined, but little for sure.

The African appears, in patterned cloths, tall and lean, wearing socks inside his sandals. He brings with him all the memories of some colony you haven't ventured to, but somewhere, you are sure, his memory connects with yours. He catches your gaze, holding it before letting go, to leave you wondering where exactly he has come from, what he did yesterday, an hour ago. You become concerned, for a moment, with his experience – whether he has more of it than you, if he has seen what you have only heard people speak about, tell stories to each other about, intent on making them end in an episode that delivers meaning. The plot lines of peoples' lives sometimes sound greater than your own, but in the end, the endings, you tell yourself, must not be as accomplished. You lose sight of him, and with his disappearance he vanishes out of your mind.

A station in central Europe, late morning in a city of business and banking. The station is periodically full of sound from the voice over the speaker system, announcing departures to stations in any other European city. Through the network of stations, the continent is bound to itself, revolving the people from place to place. Aside from the renovations, small fixings of the façade, the stations do not really change. They serve their assigned function, following the rhythm of man's waking hours. They have no memory, no sympathies, forgetting what once was only a passing thought. Like most thoughts, they are bound to recur, in the fictions that other people produce, others bring into life, explore, and make into their own. Soon, becoming a story, they grow into themselves, catching attention from listeners who make additions and mould them, pass them along until history finds space in its fast-moving memory.

Our interest with Malevich resides in the careful and refined formulation of the question: Why was a specific work of art produced at a given moment? With, for example, the *Red Square* (illus. 16), March 1915, in St Petersburg, we ask how the mind that created this was disposed to such a radical orientation, or how the hand holding the brush was inclined to such subtlety. This is our primary question, and if it is adequately addressed it will, by the nature of intellectual inquiry, resolve the secondary issues of intention, factual analyses, and historical direction. Our concern is not merely with the casual determination of painting, but ultimately regards meaning.

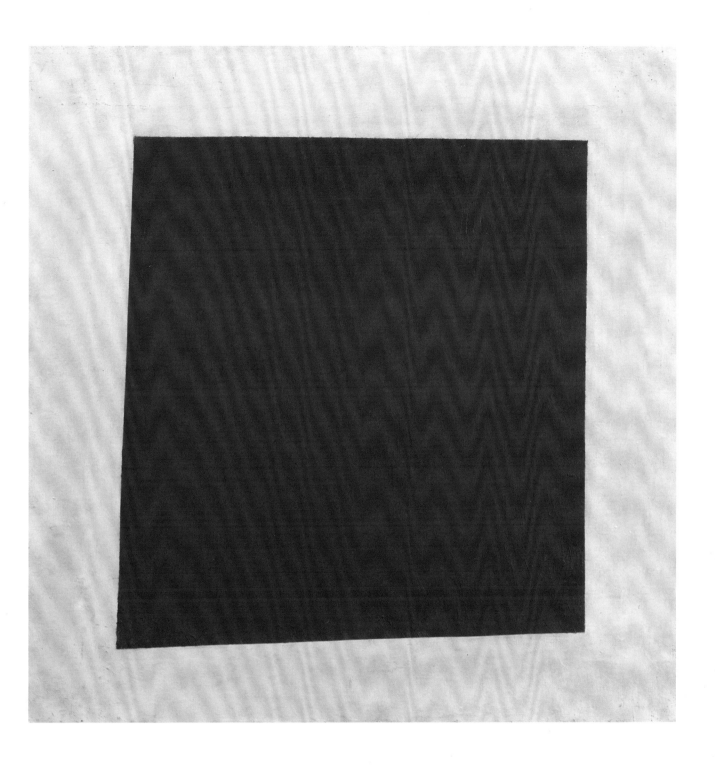

16 *Red Square: Painterly Realism of a Peasant
Woman in Two Dimensions*, 1915,
oil on canvas (53 x 53).
State Russian Museum, Leningrad.
Reproduced as exhibited in 1915.

Painting is not what it has been considered until now. There is more to it than a simple expression of nature or a composition of abstract forms or mere combinations of colours and ornamentations.

Colour is a means of creating form and structure . . . not composition for composition's own sake; it is something different – a language composed of special words. It is an aid with which one can talk about the universe or about the state of our inner animation, something one cannot express by means of words, sounds.

– Kazimir Malevich, 'In Nature There Exists . . .', 1916[12]

Characteristic signs which distinguish the new painting from representative painting . . . are reflected in painters' differing perceptual conceptions of the world and attitudes regarding it.

With such conceptions images have begun to disappear from new works of art, entailing the disappearance of the object as an illustrative reflection of everyday life; representation as such, of the manifestations of life has ceased. Art in general, and painting in particular, have become autonomous.

Thus, by their very essence, the new arts are no longer representative; rather the predisposition of separate categories is expressed in the respective pictorial movements.

– Kazimir Malevich, 'Towards a Definition of the Relation Between Colour and Form in Painting', 1930[13]

# Artistic Positions: A Critical Survey

In 1915 Kazimir Malevich, the grand innovator of the abstract, began to present paintings liberated from conventions of representation (illus. 18). With these works, he announced the beginnings of theoretical ideas that would take him years to explore. By the late 1920s, he had proposed images of an integrated sophistication which we believe must be interpreted both individually and in reference to his entire oeuvre. Paintings, dating from 1927 until his death in 1935 (illus. 19), are composed of astonishingly beautiful combinations of pure colour, articulated through an apparently intuitive and often tentative touch of the brush – almost entirely characterized by the human figure. In contrast to the non-object-oriented paintings of his Suprematist period (1914 – early 1920s), his late works strike the viewer as representational, but have inevitably retained formal criteria and primary conceptual positions germane to the advancement of his earlier abstraction. If upon first view they appear to be of a nature that contradicts abstraction, intimate reading suggests that these late works promote a further formulation of the artist's fundamental outlook.

*Peasant* (illus. 21) embodies and reveals all of these concerns. A single standing human figure, presumably male (implied through the clothing), faces the viewer frontally. Depicted in a specific and deliberate pose, the figure assumes an iconic quality because the spectator's viewpoint is set far below the blank face of the figure. The bearded face, minimally articulated with short rapid strokes of white paint, is topped with a curiously restricted arc of black hair that constitutes the focal point for any emerging hermeneutic scheme. Combined with the gesture of the out-stretched left arm, and offset by the equally demonstrative yet less assertive right arm, these crucial figural elements permit insight into Malevich's intimate reality. The peasant standing on land, below the limitless blue sky, demands communication between himself and the viewer, and on another level signifies a dialogue between the artist and his 'painting' – between both the act and the object. Painting is a communicative act, for the outcome of its endeavour is intensified by its object.

A succession of six variously coloured irregular horizontal bands, roughly painted with the unprimed canvas shining through, alludes to the earth. The uppermost green band curves downward as it approaches the sides of the painting, appearing to delimit the planetary shape of the Earth. Against this band a large field of blue strokes, the lower ones small and intense, indicate the far horizon. They fuse and dissipate into the larger, evenly distributed pattern of blue rising above, comprising a celestial dome that emerges into the boundless universe. If the viewer elects to read this composition as a landscape it must indeed be a solitary one, because there are no concomitant references enriching this approach.

Contrary to this representational reading, the viewer is tempted to initiate a dialogue dependent upon the autonomous interplay between colour, form,

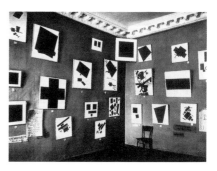

18 Installation photograph of *'0.10'*.
*Last Futurist Exhibition*,
Petrograd, 17 December 1915–17 January 1916.

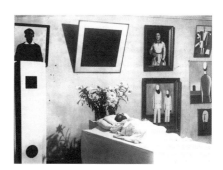

19 Kazimir Malevich lying in state in his Leningrad flat, 1935.

20 *Landscape with Five Houses*, 1928–32, oil on canvas (83 x 62). State Russian Museum, Leningrad.

21 *Peasant*, 1928–32, oil on canvas (131 x 100). State Russian Museum, Leningrad.

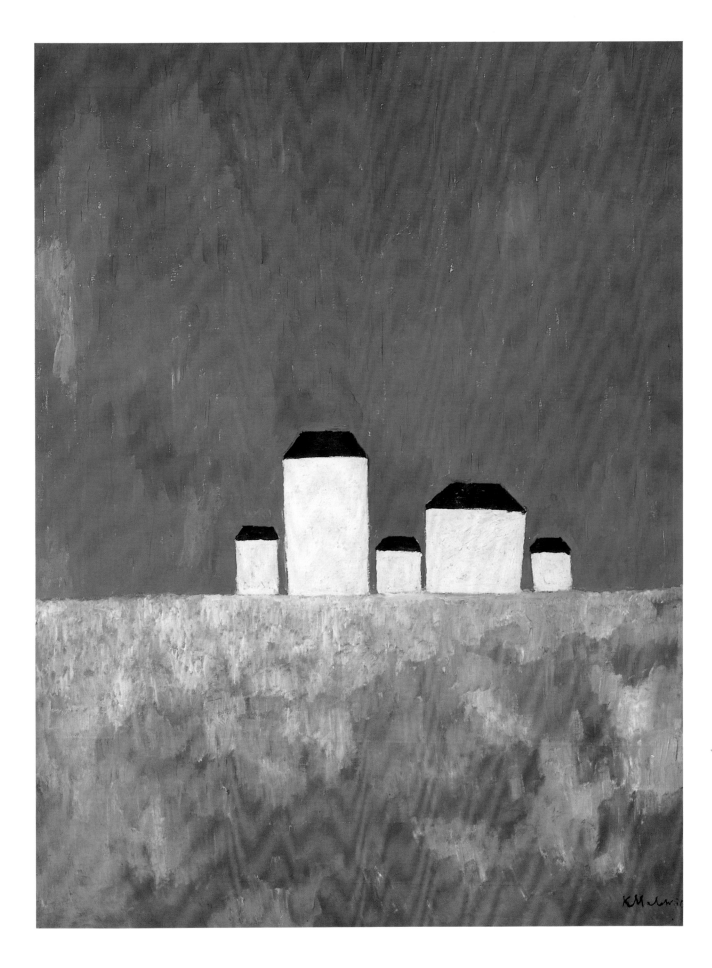

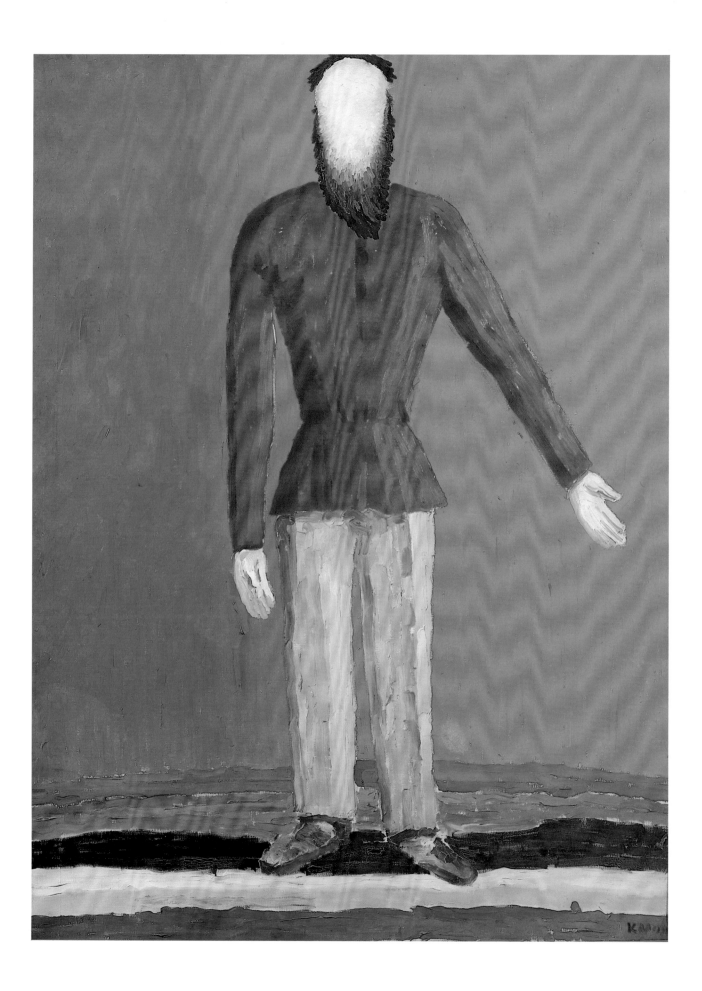

and texture articulated on the canvas surface through painting alone. The tall standing figure, the man, the peasant, is imposed upon this intricately constructed and regimented colour field uniting the upper and lower systems. His weathered face, wind-blown beard, and frank stance all express his existential commitment to interlocution. These human elements draw us continually into the unrivalled intimacy of a great, still undiscovered, Russian painter of the first half of this century. *Peasant* is the assertion of an alternative to the artistic positions occupied by Picasso, Matisse and Western European painting.

The painting is about a man who knows his place; a face without features, a gesture without direction, a figure without location. A peasant shows us, in all generosity, his open palms. A gesture to the earth, undirected and motivated by honesty, is matched by his face – a mirror and open field, requesting our participation. Whether resigned in solitude, in a state of desperation, or expressing aspirations, he is certainly assured of his self. The vital white of his hands and face signal direct communion with the cosmos:

> Wherefrom does the good in me wake
> can it be from you Nature, that I get
> my goodness, tenderness.
> Yet always from your innermost life
> evil, murder grow,
> the evergrowing murderer, and you know this
> for you create the protective colouring.
> Not all of you is perfection
> and this is obvious when I divide
> myself, sometimes.[14]

As Malevich himself was able to imply in words, his concern with painting transcended rigid expressions of the formal, and instead functioned as a primary constructive system of communication. Invoking man's multiple senses – sight, sound, touch – the artist attained his purpose through combined internal and exterior interaction.

As early as 1916, Malevich found that colour is a means with which one can talk about the universe or about the state of our inner animation, something one cannot express by means of words, or sound.[15] In *Peasant*, the figure's face unified with the beard is articulated in a tactile manner by various sizes and forms of brushstrokes, moving from black through brown and yellow to white. Associations connect not to possible exterior character traits, rather alluding to inner atavistic dimensions. It is a face of universal scope, caught at a transitory moment of flux where the black seems threatened with eclipse by the white. Primordial cosmic phases are related to those personal to the human figure. In a similar painting, *Head of a Peasant*, these aspects of the face are intensified and distilled into one composition (illus. 23). Here, what we read as constituting the head of a man functions as a sign because it allows us to read the forms in this painting in more than one dimension simultaneously.

Even superficial examination encourages the spectator to search beyond immediate portrait associations – beyond the simple representation of a bearded head with thin neck and truncated shoulders. All meaning must

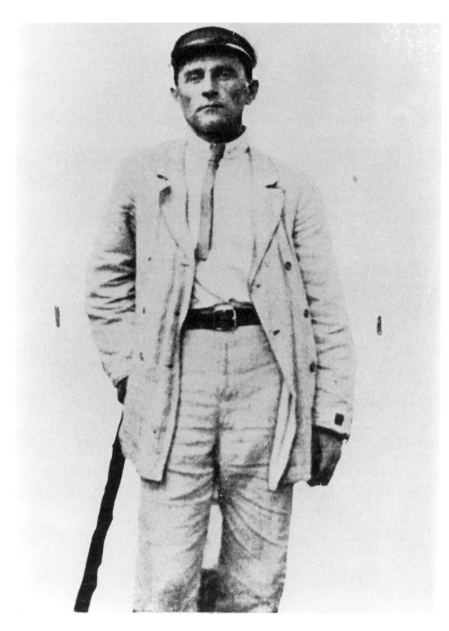

22 Kazimir Malevich in Vitebsk, c. 1920.

derive from the brushwork, because representational attachments are sub-
sumed by the painterly suppression of realistic feature articulation. The
process of signification, the intricate correlation between the signifier and
signified, is of such a density – what is the explicit representational reference
to the two related details of beard and hair? – that simultaneous reading of
representational features with compositional aspects of colour and texture
are impeded. Only this complex simultaneity of the visual sign (the brush,
the colour, the form) with its representational referent allows us to surpass
a conventional sensorial reading of pictures, uncovering deeper layers of
meaning beyond the narratives of everyday life – in this case portraiture; a
man without character traits. The implications of the signifier transcend their
own limits, producing allusions detached from the image itself. For example,
we can ascertain that the rugged shoulders refer directly to terrestrial terrain,
the outline of a landscape. But how could this landscape be molten red?
Perhaps it is not a landscape, not landscape at all.

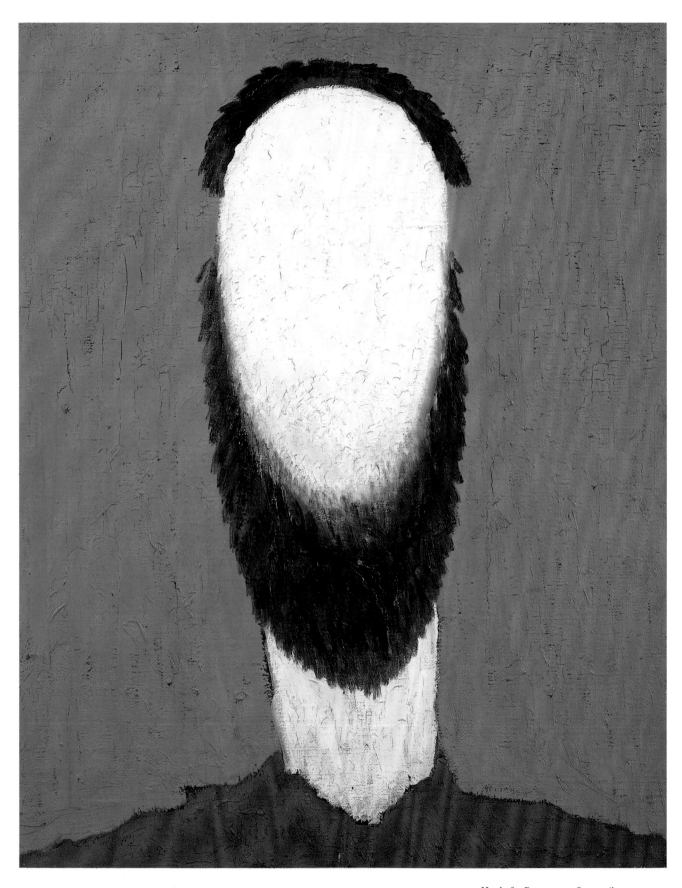

**23** *Head of a Peasant*, 1928–32, oil on canvas (55 x 45). State Russian Museum, Leningrad.

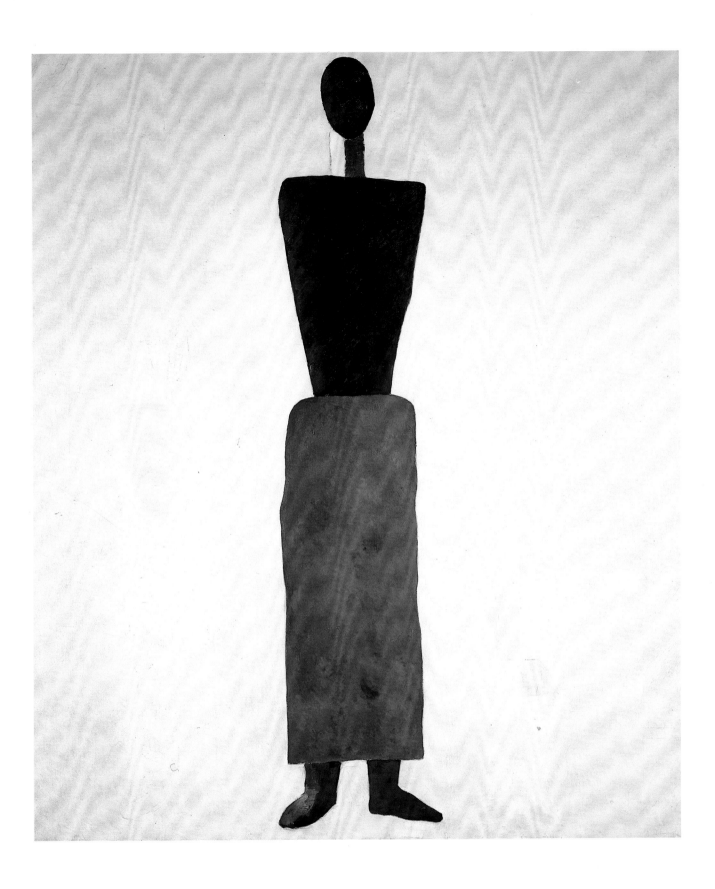

**24** *Suprematism: Female Figure*, 1928–32,
oil on canvas (126 x 106).
State Russian Museum, Leningrad.

Does this not raise the issue of how we perceive forms? How we process colour and integrate it into application in form? Under what circumstances does colour take precedence over form, or form dominate colour? With the oval of the face, it is the ovalness (form) and not the whiteness (colour) that resounds in our perception. The whiteness is understood here to implicate colour in a non-referential mode, permitting the ovalness to come into being and assume prominence over colour. The oval connotes salient features of a head, not the white. It is only after this process of colour detachment that aspects and attitudes of form are prominently conceived through the tactility of the rugged paint, applied with a successive, relentless brush. Texture (faktura of the paint itself) exposes the final assumption of meaning, focusing the urge to comprehensibility upon the individuation of facial regions. The lower part of the oval, masked by tightly broken strokes supplying definition, contrasts with smoother areas of patient longer strokes. One can read significance into the form through its dynamic constitution, the white colour acting as a medium for the form.

At the bottom of the painting in the form that could be read as a volcanic landscape, colour maintains the signifying function. The form produces multiple desultory meanings (a shirt, a vest, a peaked landscape, a supine base bearing weight, etc.), letting colour assume the dominant and dictating role. The more immediate recognition of red, as opposed to the rather unspecific articulation of forms, is accelerated by its placement within the painting; occupying the lowest part, the loose line of the form is uncharacteristically surprised by the rectilinear bottom edge of the frame. While the other forms in the composition are completed and wholly constituted within the format of the painting, the shoulder-form concludes abruptly at its linear limit. This rupture of consistency diminishes the strength of a self-contained form, thus giving over the region to colour.

But, indeed, what are the forms in this painting? A primary oval (face), a crescent (hair), a parabolic arc (beard), a cylinder (neck), and a loose type of oblique pyramid (shoulders). Here, Malevich, in controlled aesthetic terms, articulated what was later labelled as the 'transcendental signified'.[16] In this painting Malevich effects the subversion of the idealistic notion that a particular sign in written or spoken language maintains a fixed correlate in the exterior world (i.e. in the phenomenologically quantified world separate from language). When one concedes that the sign may posit its currency of meaning in a realm beyond immediate referentiality, the governing substructure of significance partakes of an abstract character that is known through its consequent manifestation. Although we cannot depict or systematically delineate the realm of meaning in its own terms, language can function as the residual and intimate approximation. And when this process is followed through to its inversion, where meaning has a repercussive effect on the arrangement of linguistic signs, that meaning is itself transformed away from translatability.

If we then re-examine the relationship between colour and form in *Head of a Peasant*, the mutual but never simultaneous definition of each element reflects the displacement process of how a language operates to attain meaning. The demonstrably executed painting of a subject clarifies – without

being literally denotative – this complex and intricate issue of the relationship between signifier/signified and the generation of meaning. It qualifies as a philosophical discourse on that very subject. For how else could we justify the ovalness of the supposed head as a signifier for a head if we were not to deny the verisimilitude of its form to its referent, and thus conclude that the form is based on its own motivating concept. This, then, only permits the viewer to return to the network of meaning in order to fulfill the purpose of the image itself. Consequently, it is not a painting of a head of a farmer, but rather, a painting of a painting as a head of a farmer.

The proposition of a floating, non-referential signifier addresses the issue of whether discrete forms/colours carry pre-existing meaning. In this case, could there be associations anterior to each of the forms/colours taken individually? When we confront, for example, the primary oval in the context of this painting, what type of immediate meanings do we ascribe to its form? The answer to these questions must not follow directly, because Malevich has not arranged the issues in a particular order. Subverting the discourse, *Head of a Peasant* reveals an ingenious inversion, because Malevich commences painting, unlike the tradition of Western European painting, not with a preconceived signified in mind, but rather with a pattern of intention that leaves open the signifier to unmediated proliferation.[17] Commenting upon modes of aesthetic and cultural consumption in Western painting, Malevich expresses in a passage of unrivalled clarity his desire to surpass representational thought with a new mode of creation:

It is essentially a movement in reverse, a decomposition and a dissipation of what was collected into its separate elements; it is the attempt to escape from the objective identity of the image to direct creation and to break away from idealization and pretense. I wish to create the new signs of my inner movement, for the way of the world is in me, and I neither want to imitate nor distort the movement of the subject or any other manifestation of Nature's forms.[18]

Another related work from the late 1920s, *Suprematism: Female Figure* (illus. 24), reveals these central concerns. Black, green, white and off-white are uncombined in this rigidly restricted colour scheme. The manipulation of brushwork goes beyond implication of texture, addressing the luminosity of the centrally posed figure, with the two attendant figures entirely reduced to alternating facets of white. The form of the female figure (femininity signified by the long skirt which curves around the hips at the thin waistline) is reduced to its essentials, a selection process more rigorous than in *Peasant*. What draws our attention to this figure and maintains our interest, given the absence of referential details, the suppression of representational colours, and the effacement of revealing brushwork?

A subtle dialectic between presence and absence occurs in the face, minimally enhanced by darkened green strokes on the left side, intimating a certain expression we are reluctant to define. The torso is characterized by similar tentative brushstrokes, not descriptive, but instead providing luminosity and suggesting autonomous creation with the brush. The absence of arms and the suppression of detail in general make the central figure a cryptic one.

A comparison of the compositional validity of individual components displays Malevich's quest to infuse all forms with significance, regardless of

35

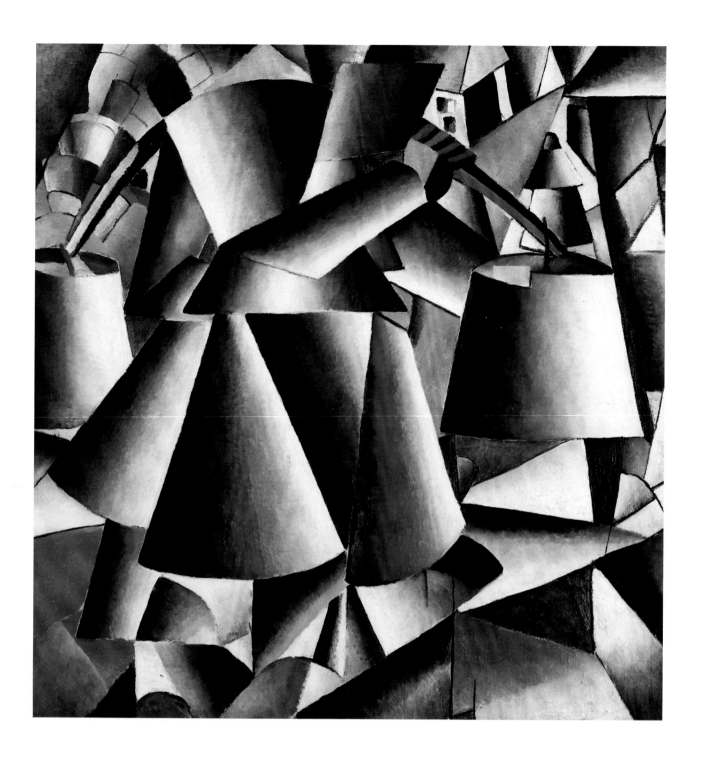

**25** *Peasant Woman with Buckets*, 1912,
oil on canvas (80.3 x 80.3).
Museum of Modern Art, New York.

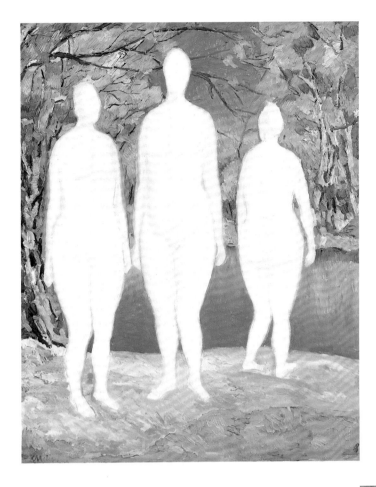

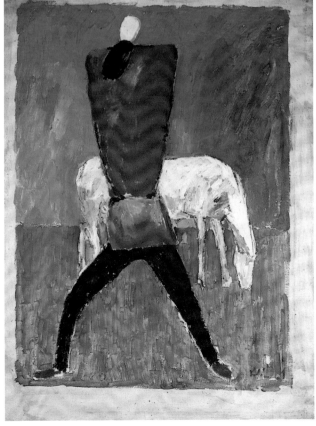

26 *Bathing Women*, 1908, oil on canvas
(59 x 48). State Russian Museum, Leningrad.

27 *Peasant and Horse*, 1928–32, oil on canvas,
(57 x 43). Musée National d'Art Moderne,
Paris.

their size in the painting, their relative scale, or the value of their colours. Each part of the figure (dual-toned neck, solid black foot, carefully shaded black-brown-grey foot, skirt, torso and head) can be viewed in any sequence as independent forms integral to the composition as a whole. This discourse on equivalence ensues when the central figure is compared to the medium and small white figures. Conventional order determined by scale is challenged by the progression from the large central figure through to the middle and small white figures. This leads to the discounting of colour, scale, and perspective as denotative and qualitative criteria: all components are essential and equal, though some are revealed before others.

The fact that Malevich, who began his career as an idiosyncratic figurative painter, produced an image like *Suprematism: Female Figure* in the late 1920s posits the issue of representation as applied in painting against its own radical conclusion. The subtle juxtaposition of boldly delineated forms against partially obscure ones demands revaluation and refinement of viewing techniques. In 'An Attempt to Determine the Relation Between Colour and Form in Painting', written in 1930, Malevich states:

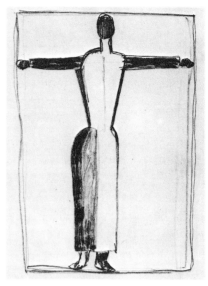

**28** *Figure with Arms Extended*, n.d., pencil (36 x 22.5). Private collection.

...the perception of the physical side of the world through subconscious sensation interpreted in the artist's imagination will not correspond to the verdicts of an optical laboratory. The optical perception serves as material for the artist's subconscious centre.

If for optical truth the form and colour 'as such' are important, for the artist they have no significance for he gives first place to *his impression of the phenomenon, not the phenomena 'as such' which he is supposed to present according to all the rules of visual perception of the model* . . .

Thus, the artist, in order to convey his Weltanschauung, does not create colour or form until light, as he senses it, arises in his imagination, since *the sensation determines the colour and form.*[19]

Malevich's adherence to sophisticated abstraction in painting, complemented by his clearly articulated and advanced conceptual stance, culminates in late works such as those discussed above. These works, usually interpreted as a return to representation, demonstrate precisely the converse of that supposed regression. Seemingly familiar forms have more impact upon the act of painting itself than upon illustration, both visually and cerebrally – necessitating combined applications of all our faculties of apprehension. For every representational attachment we assign to elements in a painting, different, opposing ones may be made.

The complexity and importance of the late work is fully recognized when Malevich's early endeavour with emerging abstraction and its evolution away from contemporary modes of Western European painting is examined. Its examination allows us to evidence a subtle, if not major, theoretical inversion permeating Malevich's work. Certain conceptual traits distinguish his painting from the Western tradition out of which he established himself. The first and immediately obvious factor refers to that fundamental tenet of logic concerning the historical and sequentially linear assignment of progress – as applied to the early or late dating of specific works within his oeuvre. In his particular and idiosyncratically dense fashion, Malevich implements the inevitable and subtle erosion of Western culture's paramount principle of validation – namely, logocentrism.

Throughout his career as a painter there is a conceptual consistency to Malevich's thinking, and in certain cases there exist striking formal similiarities between works presumed to be completed at different stages in his development, spanning many years. Distinctions between early and late works have been complicated and, indeed, obfuscated by Malevich himself (see note 20). In *Bathing Women* (illus. 26), one of the most conspicuous examples subverting straightforward temporal placement, Malevich has enriched his pictorial programme by freely interweaving what seem to be temporally disjunct stylistic components. This evident phase must be regarded as a carefully conceived artistic principle, and thus demands integration into an overall hermeneutic understanding of his work. The overriding concern of art historical inquiry to determine exact, absolute dates for paintings can too often lead into positivistic conundrums that deny any radical potential – for example, ideas such as Malevich's discarding of the classical time continuum. To overcome the constraints of historicity and fact, and to open up these supposedly closed systems to productive reading, one must focus the discussion and analysis of art objects upon the artist and his techniques, the maker and his mind, and ultimately the painting and its contextual position in the world. Thus, if for the moment the dating problem is set aside, one may examine the inherent values of a given work unprejudiced by its chronological implications. And, with certain paintings, the most productive way of understanding their mysteries is by examining each work as it is for itself, irrespective of formulaic sequential assumptions. In view of the overall conceptual character of Malevich's project this intentional ambiguity permeating his work opens up a set of ideas that can best be comprehended following a sustained review of the hermetic traits characterizing his oeuvre. Once equipped with insight drawn from his mature work of post-1913, we will be suitably confident to put forward a comprehensive explanation of his major undertakings as an artist. But first we must pursue our in-depth analysis by carefully looking at his paintings.

In *Bathing Women*, a variously scaled triad of figures is reminiscent of the white schematic figures in *Suprematism: Female Figure*.[20] The three corpulent female bathers are rendered in white, with the addition of one bluish off-white. These three bathers, two of which have whited-out faces, are set into a landscape with compositional elements typical of Cézanne: the shallow yet clearly defined foreground space; passage of foliage off to one side functioning as a repoussoir element; interceding body of water complicating the relationship between foreground and background; and the protective arching trees fusing with the sky. This affinity is augmented by the awkward poses of the bathers, which agitate a potentially straightforward calm landscape scene.

Cézanne's paintings of bathers clearly reveal this pictorial strategy. For example in *The Bathers* (1881–82; illus. 29), a pastoral scene with rising trees, branches reaching together at the top of the composition against a blue sky frame a classically composed landscape. The viewer regards this scene from an apparently fixed vantage point, and if it were not for the imposition of the three monumental nude bathers, the viewer's eye would find repose within the idyllic landscape scene. Indeed, aesthetic pleasure would result from admiring the care taken with the parts of the landscape painted in detail,

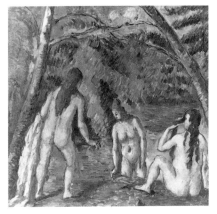

29 Cézanne, *The Bathers*, c. 1881–82, oil on canvas (50 × 50). Musée du Petit Palais, Paris.

39

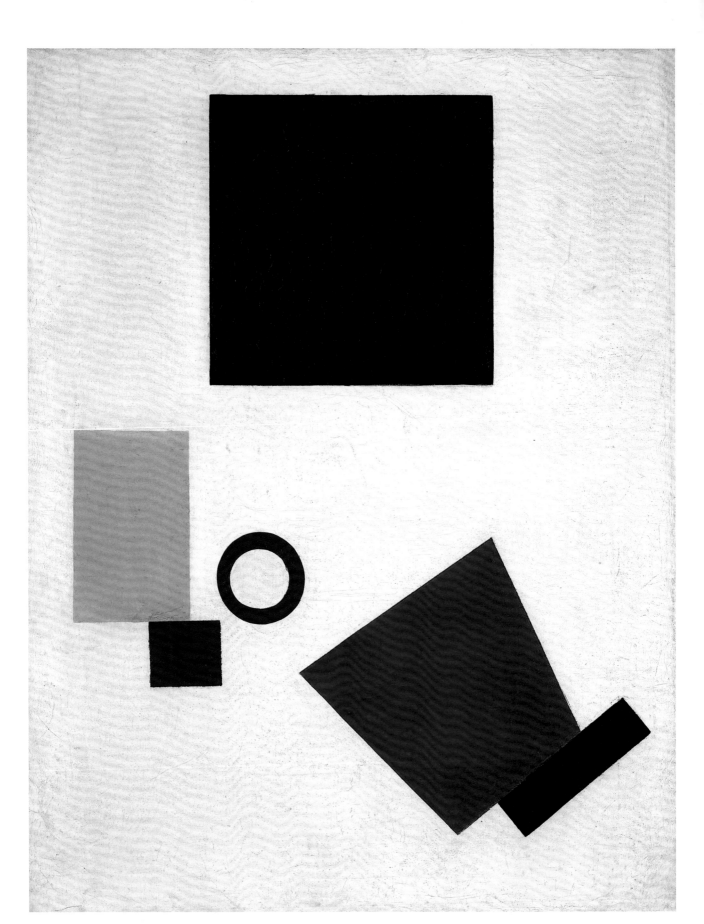

**40** *Flower Girl*, 1903, oil on canvas
(80 x 100). State Russian Museum, Leningrad.

**41** *Unemployed Girl*, 1904, oil on canvas
(80 x 66). State Russian Museum,
Leningrad.

42 *Chiropodist at the Baths*, 1911–12, charcoal and gouache on paper (77.7 x 103). Stedelijk Museum, Amsterdam.

Coming under the influence of such local artist groups as the Symbolist 'Blue Rose', the impressionable Malevich acclimatized to his multifaceted surroundings. In 1908 he participated in the Moscow Association of Artists exhibitions, submitting works like *Relaxing: High Society in Top Hats* (illus. 45). And by 1911, after the first 'Knave of Diamonds' exhibition, Malevich presented three distinct series of work at the First Moscow Salon. In the same year he and the circle of Moscow artists including David Burliuk, Natalya Goncharova, Mikhail Larionov, and Vladimir Tatlin participated in the exhibition of the St Petersburg group 'Union of Youth', which was formed in the beginning of 1910. By 1912 Malevich had met Mikhail Matiushin – on a visit to Moscow from St Petersburg – laying the foundation of what would prove to be a life-long friendship.

During these crucial years Malevich advanced his technical abilities, working through formal problems posed by each successive movement. His explorations of the role of form in painting stemmed from a desire to depart from direct representation by developing a new, more complex iconography based on metaphors and associations. This aspiration is manifest in 'the Symbolist *Bathing of the Red Horse* by Kuzma Petrov-Vodkin, *Eastern Poems* by Pavel Kuznetsov, and the metaphorical still lifes by Petr Konchalovsky', from

which, as Zhadova points out, 'Malevich stood apart by his interest in reflecting the life of the common people, an interest which had become traditional in Russian painting since the "Wanderers".'[37]

*Relaxing: High Society in Top Hats* is an idiosyncratic, lyrical work, characterized by curious disregard for conventional perspective. Through inversion it thematically reflects upon his project to portray the working class. Formally related to Symbolist inspired works like *Shroud of Christ, Relaxing* exudes none of the sonorous seriousness of these meditative and mysterious works. Against the pervasive green lawn punctuated by cartoon-like flowers, Malevich has randomly arrayed a somewhat intoxicated bunch of aristocrats. A commentary on luxury and indolence, *Relaxing* is a witty glimpse of decadence, complete with a urinating gentleman at the top of the composition.

This extensive and rapid phase of familiarization culminated, about 1911, with Malevich combining a series of styles to forge an independent unity. *Chiropodist at the Baths* (illus. 42) is compositionally indebted to Cézanne, but in painterly terms relates to Fauvism, with the addition of bold, dark, form–delineating lines.[38] This spatially condensed work is difficult to affiliate to previous examples, signalling that Malevich had matured and was preparing to integrate the theoretical advances of Cubism. The completion of this early period is clearly marked by a new conceptual approach to painting that Malevich inflicts upon his canvases, destroying the conventions he had systematically digested.

His work over the next decade, perhaps the most influential in Russia and the most radical anywhere, must be understood as rigorous transcendence over existing modes of painting – a prevailing of innovation so striking that if it were not for the early work mentioned above, it could not have been conceived, still less recognized and received within the realm of painting.

**43** *Church*, c. 1905, oil on cardboard (60.3 x 44). George Costakis Collection, Athens.

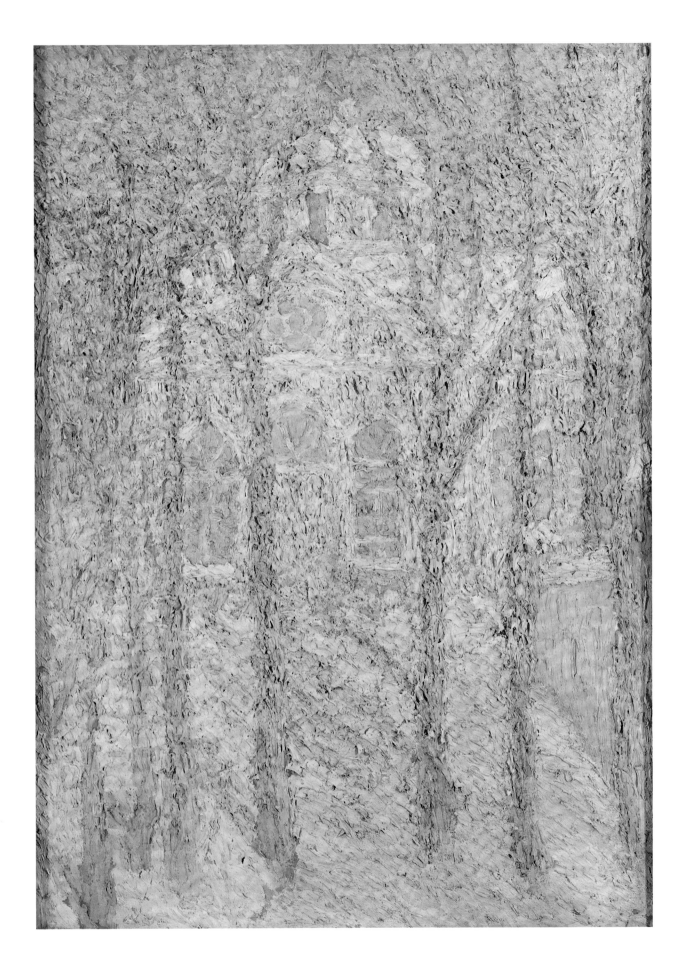

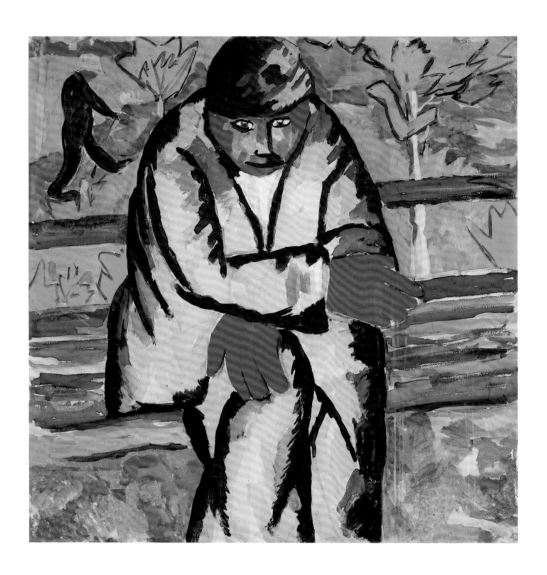

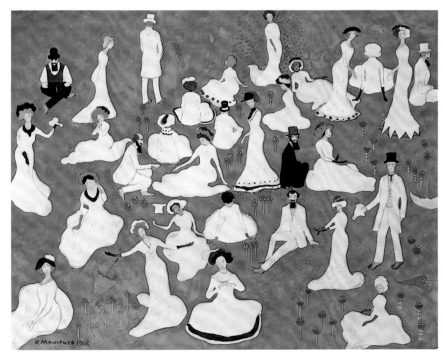

44 *On the Boulevard*, 1911, gouache on paper
(72 x 71). Stedelijk Museum, Amsterdam.

45 *Relaxing: High Society in Top Hats*, 1908,
watercolour, gouache, indian ink and egg
white on cardboard (23.8 x 30.2). State
Russian Museum, Leningrad.

**46** *Medieval Figure*, n.d., pencil on paper (18.5 x 16).

Stimulus is a cosmic flame that lives in
what is non-objective: only in the skull of
thought does it become cool in real con-
cepts of its immeasurableness; and
thought, as a certain degree in the action
of stimulus, white-hot from its flame,
moves deeper and deeper into the infi-
nite, creating in its path worlds of the
universe.

– Kazimir Malevich, 'God Is Not Cast
Down', 1920 [39]

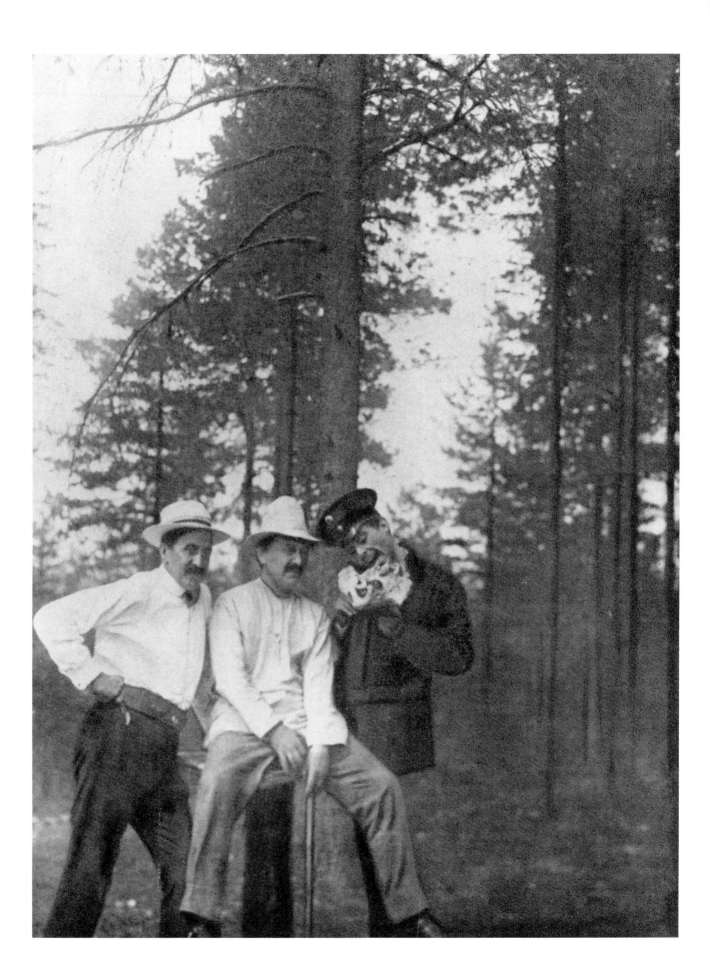

# Cubo-Futurism: Interchanges

'I am coming,' wrote Velimir Khlebnikov, the central figure among the Russian Futurists, to his friend and collaborator Mikhail Matiushin, 'wait for me and send me 18 to 20 rubels, those earthly wings, to fly from Astrakhan to you.'[40] Having, rather curiously, lost the received money, Khlebnikov (who Mayakovsky referred to as the 'Columbus of new poetic continents') did not join 'The First All-Russian Congress of Poets of the Future (The Poet-Futurists)' at Matiushin's dacha in Uusikirkko, Finland, in July 1913. The event proved to be the culmination of the artistic discourse of the Russian Futurists, and occasion for the formulation of advanced artistic activities. Comprising three prominent figures of the Russian Futurist movement (Matiushin, the composer; Aleksei Kruchenykh, the tempestuous poet; and Malevich, the artist), the grandiose title of this meeting signals the magnitude of their conception.

48 Velimir Khlebnikov, 1908–9.

This meeting occurred at a crucial moment in the tumultuous evolution of what is now regarded as an epic sequence of innovation, for both art and poetry, in the twentieth century. Following Khlebnikov's initial poetic breakthroughs in 1908, which concerned man's existential situation while addressing the predicament of expression in view of conceptually oriented achievements, the Russian artists assumed a unique and radical position in modern art. Khlebnikov supplied both the conceptual framework and theoretical direction to the avant-garde, fusing linguistic inquiry with the exploration of modern sciences. By 1910, Khlebnikov's experiments with language, aimed at creating new syntactical systems independent and separate from existing language, had progressed to the stage where poetry no longer required its formal conventions to deliver meaning. Relying upon sound as the primary element of communication, sequential linguistic bonds between the subject/object of speech and meaning were no longer required; the corollaries of signification disintegrated into discrete elements of autonomous value. 'Incantation by Laughter' (probably written in 1908, published in 1910) reveals these radical innovations:

Incantation by Laughter

Hlahla! Uthlofan, lauflings!
Hlahla! Ufhlofan, lauflings!
Who lawghen with lafe, who hlaehen lewchly,
Hlahla! Ufhlofan hlouly!
Hlahla! Hloufish lauflings lafe uf beloght lauchalorum!
Hlahla! Loufenish lauflings lafe, hlohan utlaufly!
Lawfen, lawfen,
Hloh, hlouh, hlou! luifekin, luifekin,
Hlofeningum, hlofeningum.
Hlahla! Uthlofan, lauflings!
Hlahla! Ufhlofan, lauflings![41]

47 Kazimir Malevich (centre) with M. Matiushin (left) and A. Kruchenykh (right) in Uusikirkko, Finland, 1913.

And if one closely examines a transliteration from the original Russian, the high degree of innovation becomes evident:

Zaklyatie Smekhom

O, rassmeites', smekhachi!
O, zasmeites', smekhachi
Chto smeyutsya smekhami, chto smeyanstvuyut smeyal'no.
O, zasmeites' usmeyal'no!
O, rassmeshishch nadsmeyal'nykh – smekh usmeinykh smekhachei!
O, issmeisya rassmeyal'no, smekh nadsmeinykh smeyachei!
Smeievo, smeievo,
Usmei, osmei, smeshiki, smeshiki,
Smeyunchiki, smeyunchiki,
O, rassmeites', smekhachi!
O, zasmeites', smekhachi![42]

Beyond the constraints of local dialects or national languages, the poem asserts itself as universal utterance. Demanding the engagement of the reader/listener, interpretation is subservient to participation. The opening couplet, forming a fragmentary basis throughout, is repeated at the close. What commences as a tentative proposition, concludes with the triumphant pronouncement of laughter; the incantation is an undeniable invitation.

'Incantation by Laughter' offers an experience with the actual material of language. Units of sound, composed of letters, are arranged fundamentally, demonstrating construction as a method of meaning. The technique of separating and juxtaposing word roots and sounds distils the poetic endeavour into pure form: ' . . . it reveals, without any distractions of meaning or reference, certain essentials of poetic device: repetend, assonance, rich alliteration, a variety of rhythmic intonations.'[43] This combinatory device in poetry is neologistic; a neologism activates pure elements of language, reducing communicative functions of everyday language to a minimum and disclosing the basic structures and devices of language itself.

49 Vladimir Mayakovsky, 1912.

Roman Jakobson, an intimate of both Khlebnikov and Malevich, was a then young theoretician and scholar of linguistics who articulated concerns of the Russian avant-garde in a prolific body of essays. He asserted in 'Newest Russian Poetry' (1919), a seminal article for early twentieth century poetics and linguistics, that poetic language 'emerges as the directed utterance, an expression organized according to immanent laws; the communicative function, which is constitutive for practical and emotional language, has been reduced in poetic language to a minimum . . . Poetics is language in its aesthetic function.'[44]

Having made distinctions between three types of language, poetry assumes primacy as the form which relates directly to the essence of language as a means of expression. Khlebnikov was clearly attuned to this distinction, as his employment of neologisms implies. Extracting the roots of words and then adding to them various suffixes and prefixes, he attempted to expand language, multiplying its syntax to synthesize methods of word generation. Jakobson, further assessing neologisms, observed that the meaning of a word in practical language is at every given moment more or less static, yet the meaning of neologisms has been determined to a large degree through con-

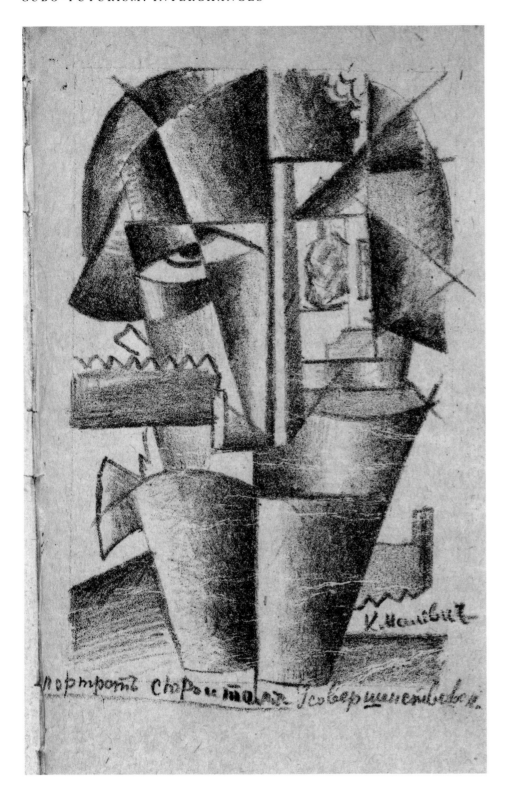

50 *Portrait of a Builder Completed*, 1913, lithograph (17.5 x 11.2). Tipped between pp. 12–13 of the book *Piglets*, 1913; text by Kruchenykh.

text. Stimulating in the reader etymological thinking, a tenet of poetic construction, neologisms create small semantic units which are labile and indeterminate, and therefore subvert employment for logical operations.

An example of how this functions was provided by Vladimir Mayakovsky, a fellow poet and writer, when he eulogized Khlebnikov in a memorial tribute in the year of Khlebnikov's death, 1922:

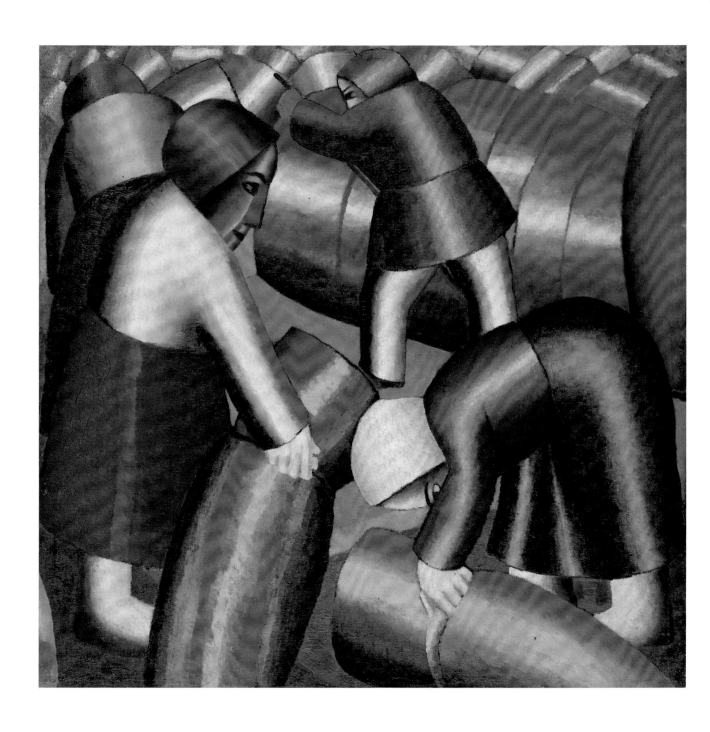

**51** *Taking in the Rye*, 1912, oil on canvas
(72 x 74.5). Stedelijk Museum, Amsterdam.

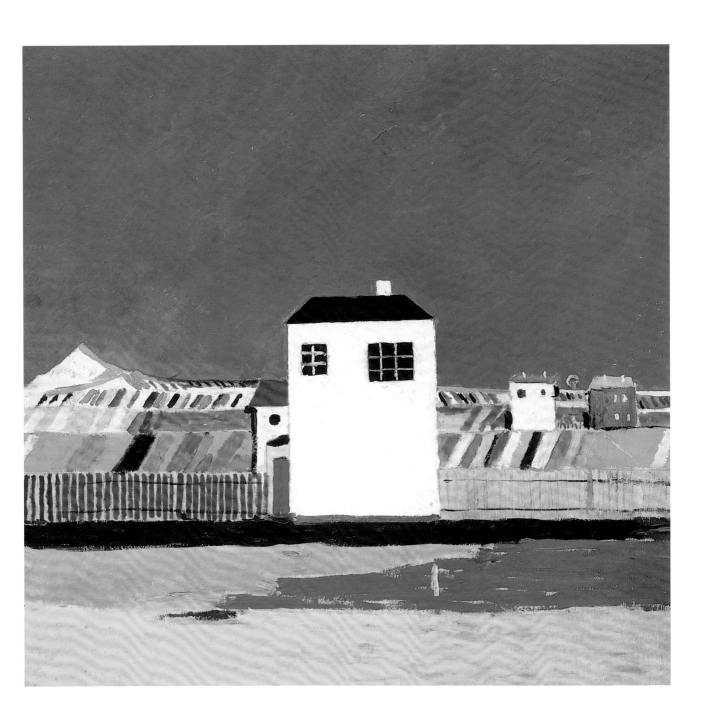

**52** *Landscape with a White House*, c. 1930, oil on canvas (59 x 59.6). State Russian Museum, Leningrad.

Taking the word in its undeveloped, unfamiliar forms, comparing these with the developed word, Khlebnikov demonstrated the necessity and the inevitability of the emergence of new words . . . If the existing word *plyas* (dance) has a derivative *plyasunya* (dancer), then the growth of aviation, of flying (*let*) ought by analogy to yield the form *letunya* (flier). And if the day of christening is *krestiny*, then the day of flying is, of course, *letiny* . . . Khlebnikov is simply revealing the process of word formation.[45]

Khlebnikov's ingenious and at times witty manipulation of language stands at the core of Russian Futurism, defining characteristics of the movement while at the same time differentiating it from the related exploits of the Italian Futurists.

Futurism, often perceived to be an indigenous Italian movement, had its first critical origins in Russia, partly as a consequence of the 'Congress' between the three artists, and partly due to Khlebnikov's independent achievements (which were known to the Italians). Indeed, the conflict of origins came to prominence in 1914 when Marinetti, the prominent member of the vocal and widely publicized Italian Futurist movement, visited Russia.[46] Differences between Italian and Russian Futurism are apparent in the aspirations of the artists and in the motivating impetus guiding their desire for change. While the Italians avidly embraced technology and its mechanically oriented innovation, regarding speed as a mechanism for social advance, the Russians sought profound, convention-shattering change. Because of the particular social repression discussed in the preceding chapter the Russian Futurists addressed themselves to the entire structure of society, implicating the foundations of human interaction and questioning the validity of national purpose.

**53** Giacomo Balla, *The Hand of a Violinist*, 1912, oil on canvas (52 x 75). Collection of Mr and Mrs Eric Estorick.

Futurism was to provide a model for a new world, one to be built from absolutely new methods of communication, beginning with the structure of language. Unlike the Italians' emphasis on reporting physical and psychological facts about the modern designed urban industrial environment, the Russians, commencing with basic analysis of how we apprehend what occurs, aimed not merely to invoke man's technically proficient abilities, but his most advanced conceptual faculties. This endeavour necessitated a new conception of the world itself. Differences between positions assumed by the Russians and Italians are revealed through their distinct artistic approaches to language: while the Italians reformed the means of reporting by utilizing an emotional system of language, the Russians concerned themselves with structural changes in poetic systems of language.[47]

Despite Khlebnikov's physical absence from 'The First All-Russian Futurist Congress', the convening of the three artists was characteristic of the development of Russian Futurism. It manifested beautifully the intricate and intense collaboration among the arts: poetry, music, theatre and painting. It would prove to be a landmark for the history of painting because it was here that theories developed in poetry began to find a lucid application, even direct transposition, into painting and the visual arts.

Collaborative efforts in Russia are discernible as early as 1906, when artists began to reveal their work in a sequence of Moscow and St Petersburg exhibitions with titles such as 'Stephanos', 'Golden Fleece', 'Triangle' and

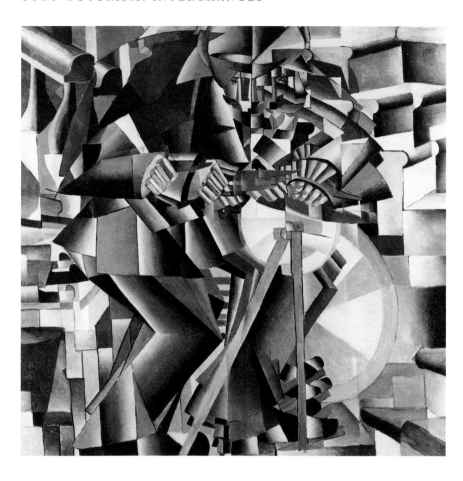

**54** *Knife Grinder*, 1912–13, oil on canvas (79.7 x 79.7). Yale University Art Gallery, gift of Société Anonyme.

the 'Moscow Artists Association'. The two most influential and prevailing groups to emerge out of this rapid proliferation of artists' organizations were the Jack of Diamonds (Moscow) and the Union of Youth (St Petersburg). These groups in particular were catalysts for an accelerating discourse which developed between leading figures. Certain of the central artistic concerns undertaken by artists within these groups delineated an aesthetic and conceptual programme that permeated creative enterprises for many years.

In the work of both groups the phenomenon of what is commonly referred to as 'Russian Primitivism' (Markov) emerged so strongly that one can surely detect a broad movement – a common tendency to seek a connection to culture that was both endemic and universal. The third 'Golden Fleece' exhibition at the end of 1909 articulated the possibility of the primitive, displaying works characterized by 'fauvist line and the abstract use of colour, [as well as] specimens of folk art, such as lace, popular lithographs (*lubok*), icons, and even ornamental cookies.'[48] The three remarkable protagonists of primitivism in the visual arts were David Burliuk, Natalya Goncharova, and Mikhail Larionov, embodying the quest for a fundamental method of communication that would circumvent the particulars of a given visual syntax, and activate a primordial essence. In music, Igor Stravinsky's 'Rite of Spring' is an outstanding parallel manifestation of this desire.

In painting, the primitive revealed itself through certain immediately recognizable traits (finding impetus from, but eventually influencing future waves

of, German Expressionism): raw block-like line; emphasis on immediacy of technique; simplicity of subject matter; and a directness of presentation that excluded peripheral decoration. These features aimed to eliminate tendencies that had ensnared the artist's ability to directly transcribe thought and emotion into an image. Inspiration was gleaned from Slavic mythology and from folkloric traditions (both native and foreign) in an attempt to effect a primal relationship with the artwork.

Nikolai Kulbin extended the boundaries, publishing in the 1910 issue of *Impressionists' Studio* an article examining the art of children, infantilism, and prehistoric man, and conceiving of these as sources of pure forms that spontaneously colluded with the intrinsic beauty of Nature. The concern with accessing hidden facets of consciousness is reflected in the urge among Futurists to explore the terrain of the mind in its unknown depths. Jack of Diamonds' members like the poet Elena Guro, for example, became enthralled and fascinated with observing children in creative states. She sought to activate or anticipate the way in which the child arranges concepts, and to equate this with the primitive.

The intertwining of Primitivism with Futurism attained its most comprehensive, experimental and sophisticated format in various publications. The 1912 *Worldbackwards*, for example, displays the combined primitivist skills of Kruchenykh and Khlebnikov. Their writings radically overpower the semi-abstract illustrations by Larionov, Goncharova, Tatlin and I. Rogovin. Kruchenykh's contributions demonstrated the full range between convention and invention. The 'solemn introductory poem written in traditional iambic pentameter'[49] functioned as a foil, a mere reference point for departure. Some texts were reproduced in handwritten form, while others were crudely printed using rubber stamps of various sizes for individual letters. 'Lapses and errors reign supreme in this book, with wrong word transfers, incorrect spelling, spaces of varying length between words, capital letters inside words, and repetition of . . . texts (sometimes printed upside down).'[50] Kruchenykh amplified these formal breaks, adumbrating them through his process-oriented twenty pages of 'A Voyage Across the Whole World', which was an exercise in automatic writing, implying that process can function as a vehicle to overcome distance and space. At this level of implication, however, Khlebnikov – in his typically detached, casual manner – emerges as the master of subversion and conversion, initiating links between disciplines.

His contributions to *Worldbackwards* included random excerpts from some of his longer works and impromptu selections of shorter poems, presented on the pages in a fashion that recalled previous experiments where he consciously imitated such specific painting devices as *'protekayushchaya raskraska'* (colour extending beyond the outline).[51] In one poem the letters are printed in mirror-image form, indicating the reversability of language and dual direction of world history – both forwards and backwards. The mirror device implies both reflection and deflection, a redirection of ideas and materials into a conglomerate realm. Khlebnikov's manipulation of ancient folkloric traditions, illiterate transcription, and distortion of literature, and his invention of whole imaginary eras in both history and the future, carry the current primitivist ideals into a remade forum where the aspiration to articulate the

55 Cover for the book *The Word as Such*, 1913, with texts by Kruchenykh and Khlebnikov and illustrations by Malevich and Rozanova.

56 *Portrait of a Young Man*, 1933, oil on canvas (52 x 39.5). State Russian Museum, Leningrad.

**57** *Head of a Peasant*, 1911, gouache on card-board (46 x 46). Stedelijk Museum, Amsterdam.

naive primal voice gains a resolution worthy of contemporary concep-tualization.

Although many of the Futurists' books functioned as pure platforms for their poetic and artistic pursuits, other publications were content-oriented and served to lucidly disseminate information of general artistic concern, often delivering vital observations and theoretical insights. Kandinsky's 'Con-tent and Form' (1910) in the catalogue of the 'Second Salon Exhibition' in Odessa; Markov's 'The Principles of the New Art' (1912) in the first and second issues of *Union of Youth*; and David Burliuk's 'Cubism (Surface-Plane)' (1912) in *A Slap in the Face of Public Taste*, may be cited as significant examples.[52] The exchange of opinion, examination of newest trends from Western Europe, and the lively dialogue displayed in publications created an atmosphere of evolving maturity. However, the groups did not always satisfy the artists' desire for security within the artistic community and society at large, despite eager and assiduous efforts at collaboration intended to bring together the discourses of various disciplines. Many of the early instances, appearing to demonstrate genuine cooperation among artists, were charac-terized by a tempestuousness and ephemerality. There was often heated debate and controversy, but the discussions were ultimately broad in scope and fragmentary in nature.[53]

73

Perhaps the most dramatic and politicized fracturing within an artistic group occurred in the Knave of Diamonds. Larionov and his wife Goncharova, initial catalysts for the formation of the Knave of Diamonds, quickly grew critical of the group's proximity to Western European trends of Post-Impressionism. In March 1911 they broke away to form Donkey's Tail. The name was taken from a newspaper story, recounting how some French artists tied a paintbrush to a donkey's tail, and submitted to an exhibition canvases displaying random colour traces made by the incensed beast.

None of these developments, however, managed to prefigure the intimacy and density of the interchange between Matiushin, Kruchenykh, Malevich and Khlebnikov. These four minds, including their immediate confidants, created the complex fusion of ideas and ideals that produced, in retrospect, some of the most articulate and advanced abstract breakthroughs in the twentieth century. One succinct example can be observed in the 1913 theatrical event *Victory over the Sun* – a triumph for the Union of Youth – which was initially conceived at the Congress meeting at Matiushin's dacha in Finland. Demonstrating an ability to accomplish ambitious projects, and deliver their societal and artistic critique of convention to a mass audience, *Victory Over the Sun* stands as perhaps the most successful and pure accomplishment of any group, not least because of the number of people involved in the production of the opera (inexperienced university students were boldly presented as vital actors on stage). Malevich designed the stage sets, the costumes and the cover of the brochure. This version of his set design, when compared to the primitivist drawing by David Burliuk for the back cover of the brochure, evidences how quickly Malevich assimilated, and grasped the potential meaning of, ideas that had really only been tentatively proposed by 1913.

Malevich, who showed no consistent allegiance to any single style taken over from the West, maintained a cooperative yet distant attitude towards the various local artist groups. For example, he was included in the first Donkey's Tail exhibition of early 1912, yet also continued to show with the Knave of Diamonds, submitting five stylistically different works to their February 1914 exhibition. His acquiescent yet nominal subscription to the artistic demands made by various groups reveals that by 1912 Malevich had gained a clear conception of his creative project; he was now focusing on issues that he valued personally, and was reluctant to be consumed by communal yearnings.

The ferment among the artists of Moscow and St Petersburg between 1910 and 1913 was enhanced by certain major exhibitions of Western European painting. Perhaps the most important of these foreign exhibitions was 'The Centennial of French Painting 1812–1912' in St Petersburg in January 1912.[54] In addition to works by French modernists that Malevich was already familiar with, this exhibition provided an occasion to view works by nineteenth-century Realists like J. F. Millet and Gustave Courbet. Paintings of oppressed French peasants and working class labourers must have impacted upon Malevich, who was already engaged by similar subject matter. As well as this potential thematic affirmation, the exhibition allowed him to

**58** *Woman's Head in Profile*, 1910–11, pencil on paper (18.6 x 14.2). State Russian Museum, Leningrad.

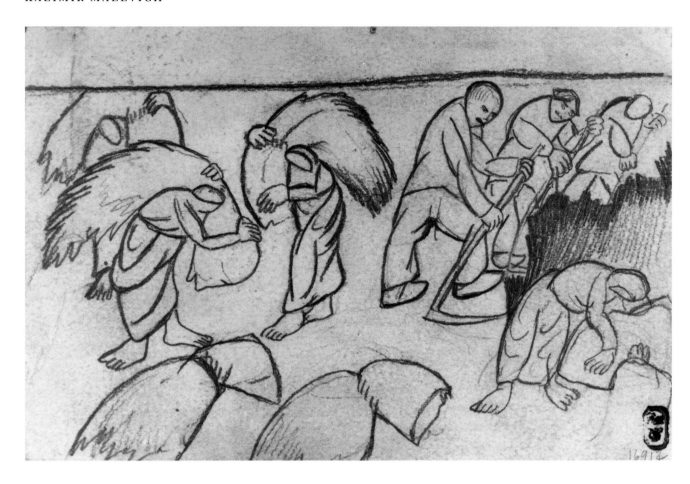

59 *Harvest*, 1910–11, pen on paper
(9.2 x 14). State Russian Museum, Leningrad.

assess his abilities against those of his illustrious foreign predecessors, providing a moment of recognition that helped to define his individual style. The yearning for autonomy in his brush was now traversing the terrain of history, emptying it of relevant information, and yielding what could only be a solid point of departure for further invention.

A central catalyst responsible for initiating international discourse was David Burliuk, an independently wealthy painter who had studied in Munich and Paris before returning to Moscow in 1907. Conversant with European trends, Burliuk was an early proponent of radical propositions necessitating detachment from conventions, both those of the West and transcribed ones inside Russia. In January 1912, for the second Knave of Diamonds exhibition in Moscow, Burliuk used his connections with Kandinsky and the Blue Rider group in Munich to supplement the Russian section with vanguard European painting. Coinciding with the French Centennial exhibition in St Petersburg, this international Knave exhibition was comprised of paintings from Munich, work from the German Expressionist group Die Brücke, and works from Paris by Picasso, Matisse, Léger, and Sonia Delaunay.

The exhibition sparked serious debate concerning the fundamental objectives of painting, and its relationship to poetry. On February 12, in a crowded Moscow auditorium, Burliuk shocked the audience with a lecture on Cubism, declaring that the content of painting was inconsequential and 'that Raphael and Velázquez were philistines and photographers'.[55] The evening ended in

an uproar when Goncharova usurped control, dealing out an unscheduled attack on the Knave of Diamonds and launching a piercing prelude of the ideology that would motivate the Donkey's Tail. Two weeks later, without any intrusions, Burliuk delivered his speech entitled 'Evolution of Beauty and Art', insisting that art should not be a copy, but rather a distortion, of life. Proposing three basic principles integral to this approach, he articulated the devices of disharmony, dissymmetry and deconstruction as applied to painting.

Parallel activities were taking place in St Petersburg with the Union of Youth, the group Khlebnikov maintained a vital interest in. Their publication of the same title, first appearing in April 1912, contained art criticism as well as translations of Chinese poetry; this mixture signalled a cross-cultural aesthetic awareness crucial for the advancement of theoretical positions in contemporary art and poetry. In the second issue, two Italian Futurist manifestoes were published, and from these it is evident that the Italians were of a less radical conceptual nature than the Russians. Concerning subject matter in painting, which Burliuk had dismissed months previously in his Moscow lecture as irrelevant, the Italians (specifically Umberto Boccioni, Carlo Carrà and Giacomo Balla) felt that observed modern phenomena were indispensable for the generation of 'modern sensations', which then formed the basis of painting. An excerpt from the second manifesto, 'The Exhibitors to the Public' (February 1912), reprinted in the June issue of *Union of Youth*, reveals this concern:

Is it not, indeed, a return to the academy to declare that the subject in painting is of perfectly insignificant value?

We declare, on the contrary, that there can be no modern painting without the starting point of an absolutely modern sensation, and none can contradict us when we state that *painting* and *sensation* are two inseparable words.[56]

The differences between Italian and Russian Futurism, noticeable in painting, are unmistakably defined through poetry and its conveyance of advanced linguistic notions. Indeed, the radical Russian bent for conceptualism on fundamental issues is nowhere more clearly observed. A small, profoundly progressive, group of Russian poets, known as Hylaea, were able to voice their concerns in the third issue of *Union of Youth*, published in March 1913. Evolving out of the intimate interchange and concordance between artists and poets in general – the union of competing experimenters – this publication is an early complete manifestation of the sophisticated nature underlying poetic invention in Russia. Organized by Burliuk, who conducted preliminary meetings as early as December 1911, Hylaea came together for summers at a mansion on the Black Sea. Khlebnikov, Kruchenykh, Livshits, Mayakovsky and the Burliuks, the group's most perceptive and essential poets, were the nucleus of Hylaea. The title Hylaea, taken from the ancient Greek name for this Black Sea region, reflected a sensitivity for the idyllic landscape.

The 1913 *Union of Youth* publication was the seminal joint product of the Union of Youth (painters) and Hylaea (poets) groups, which for the first time coherently and succinctly discussed the application of major theoretical issues to the core of creativity. Markov observes the following about their cooperative effort:

**60** David Burliuk, linocut, from the booklet *A Trap for Judges 2*, 1913.

61 David Burliuk, Nicolai Burliuk, Vladimir Mayakovsky and others, 1913.

There was an enumeration of rather vague points uniting the two organizations:
1. the definition of the philosophically beautiful;
2. the establishment of a difference between the creator and the cospectator;
3. the fight against automatism and temporality.
These first three points were followed by three points 'which unite as well as separate':
1. the extension of the evaluation of the beautiful beyond the limits of consciousness (the principle of relativity);
2. the acceptance of the theory of knowledge as a criterion;
3. the unity of the so-called material.[57]

The magazine was divided into two parts; the first contained essays on the arts, the second contained poems by Hylaeans. Besides Olga Rozanova's essay 'The Foundations of the New Art', the most important text was Matiushin's synopsis of 'Du Cubisme' by Gleizes and Metzinger, intermingled with lengthy quotations from Peter Ouspensky's *Tertium Organum* (1911).

Khlebnikov contributed two texts to the *Union*, in addition to his poetry: 'Teacher and Pupil' and another dialogue 'A Conversation Between Two Personages', criticizing the idealistic philosophy of Kant while demonstrating the affinity between words and numbers as communicative means. Anticipating concerns evidenced in the second part of the magazine, Khlebnikov relies upon prose form to discuss and elucidate what must have appeared to be among the most radical formal innovations. 'The War, The Death', his only contribution to the second part, is, as Markov says, 'a magnificent tour de force'; it is his only long poem built of neologisms. Similarly notable poems include Kruchenykh's 'Horses Are Pulled', a typographical poem with most letters being upper case. Relying upon the expressive manipulation of typesetting, certain devices foreshadow e. e. cummings' jestings, as, for example, the printing of the word *zazhatyi* ('clamped') as *zAZHAtyi*.

This publication, when set into the context of the wide-ranging activities (interchange, exhibitions, publications, lectures, etc.) within the Russian

avant-garde of 1912–13, demonstrates an increasing awareness of, and dedi-
cation to, theoretical approaches. Reviewing the cultural ferment of Moscow
and St Petersburg, the discourse focuses upon rigorously analytic, at times
clashing, conceptual aspirations, which were regarded as necessary if artistic
communication was to redirect the course of society and history. Even Bur-
liuk's early attempt to isolate Cubism's fundamental elements reflects upon
the general urge to go beyond formalism. In 'Cubism (Surface-Plane)' of
1912 Burliuk gives a somewhat convoluted account of painting's recent evol-
ution. Despite his belief that the 'New Art' is intimately related to previous
movements in painting, he states that; 'Nowadays not to be a theoretician of
painting means to reject an understanding of it . . . Art's centre of gravity
has been transferred. Formerly the spectator used to be the idle witness . . .
but now he presses close to the lenses of a Superior Visual Analysis of the
Visible Essence . . .'[58]

Matiushin, continuing in this conceptual direction, produced an impress-
ively complex article that integrated Gleizes and Metzinger's 'Du Cubisme'
into a sequence of excerpts extracted from Ouspensky's *Tertium Organum*.
The weaving together of these texts was enhanced by Matiushin's own
intercut comments:

[from 'Du Cubisme'] To establish pictorial space [in painting], we must have recourse to
the sensation of movement and of touch and to all our faculties. It is our whole personality
which, contracting and expanding, modifies the picture . . .

[Matiushin's commentary] The American scholar Hinton, whose thoughts on the
fourth dimension are so full of significance and surprisingly coincide with the most
extreme ideas of the innovators of painting, speaks as follows:

[from *Tertium Organum*] We see objects distorted, but we know them as they are. And
we can free ourselves from the habit of visualizing objects as we see them, and we can
learn to visualize them as we know they really are. Hinton's idea is precisely that before
thinking of developing the capacity in the fourth dimension, we must learn to visualize
objects as they would be seen from the fourth dimension, i.e., first of all not in perspective,
but from all sides at once, as they are known to our consciousness.[59]

Regardless of the validity and relevance of Ouspensky's theosophically
derived dictums, mediated through Matiushin's dense doubly-accommo-
dating commentary, the article stands out as a manifestation of an advanced
conceptual integration of multiform ideas. The separate spheres of Cubism
and theosophy are tenuously, and not necessarily correctly, linked, as being
mutually informative ways of attaining profound insight. In certain cases
Matiushin warps the original 'Du Cubisme' text to sustain his argument. In
the example noted below, which is the conclusion of Matiushin's article, the
lapse in meaning cannot be attributed to sloppy translation (as other almost
perfectly translated parts attest to his exactness). It is rather a symptom of
his over zealous desire to integrate Ouspensky into the predominantly French
and Western oriented discourse on Cubism – understandably, a strategy
aimed at decreasing any aspects that may have alienated the Russian Cubo-
Futurists.[60] Gleizes and Metzinger's lengthy treatise 'Du Cubisme', which
appeared in its entirety in two different Russian translations published in
Moscow and St Petersburg (both in March 1913), concludes:

That the ultimate end of painting is to reach the masses, we have agreed; it is, however,
not in the language of the masses that painting should address the masses, but in its own,

in order to move, to dominate, to direct, and not in order to be understood. It is the same with religions and philosophies. The artist who abstains from any concessions, who does not explain himself and who tells nothing, builds up an internal strength whose radiance shines all around.[61]

Their manifesto is centred on the artist's need to communicate to the masses without bowing to historical convention or utilizing religion; aspects of this essay emerge as similar to the fundamental concerns confronting the Russian avant-garde in their endeavour to secure change. Clearly the 'Du Cubisme' argument denies mysticism or religious philosophy (as popularly comprehended) any place inside artistic discourse. Consequently, Matiushin's transformation of the conclusion to their text reveals an ulterior motive:

If, from feebleness or lack of mental development, the painter remains enslaved to the forms in common use, his work captivates the crowd.

If the artist makes no concession to accepted canons, his work will inevitably be incomprehensible to one who cannot, with a single stroke of his wings, lift himself up to unknown dimensions.[62]

Matiushin's final summary must have surprised those who scrutinized the article in the March translations. Employing the original syntax, Matiushin has altered the meaning almost completely – reversing what is stated in 'Du Cubisme'.

Emphasis upon religious inclinations, as expressed by Matiushin in this example, merits our brief attention because some Russian artists at this time flirted with mystical notions of transcendence, multi-dimensional geometry, and other arcane approaches to art.[63] Considerable research has been done concerning the impact of such diverse sources of inspiration as Ouspensky, Rudolf Steiner, Madame Blavatsky, Schoenmaekers, and the Kabala, to cite the most widely discussed in scholarship. This obscure approach has been given disproportionate emphasis, and has led to an underestimation of the conceptual acuity of the group's leading figures – Matiushin among them.

The crucial significance of the heated discourse and consequent achievements of the avant-garde in the second decade of this century, their capacity to assimilate, comprehend, and ultimately surpass Western precedent, lies precisely in their sustained articulation of a theoretical position(s). Forming a nucleus for emergent structuralism, formalism, linguistics (semiotics) and a non-Newtonian/non-objective *weltanschauung*, their contribution lies in the products of their creative endeavour. To explain away the innovations of this short-lived but essential episode in Western art by seeking recourse to mysticism is to misapprehend the profundity of the Russian contribution to conceptualism. Malevich and Khlebnikov are giants of painting and poetry, and have altered our conception of the arts permanently by transforming idealism into tangible theory.

62 *Portrait of the Composer Matiushin*, 1913, pencil on paper (13 x 12.2). Private collection.

And what about us? The militant vanguard of the inventor/explorers? ...

That is why the inventor/explorers, in full consciousness of their particular nature, their different way of life and their special mission, separate themselves from the investor/exploiters in order to form an independent government of time (no longer dependent on space), and put a line of iron bars between ourselves and them. The future will decide who winds up in the zoo, inventor/explorers or investor/exploiters, who winds up chomping at the iron bars.

– Velimir Khlebnikov, 'The Trumpet of the Martians', 1916

There are ways of looking at a new form of creativity, the art of number blocks, where a number artist can freely draw the inspired head of the universe as he sees it turned toward him ... Proclaiming a free triangle with three points – the world, the artist, and the number – he draws the ear or the mouth of the universe with the broad brush numbers. He executes his strokes freely in scientific space and he knows that number serves the human mind in the same way that charcoal serves the artist's hand ... Working with number as his charcoal he unites all previous human knowledge in his art.

– Velimir Khlebnikov, 'The Head of the Universe: Time in Space', 1919

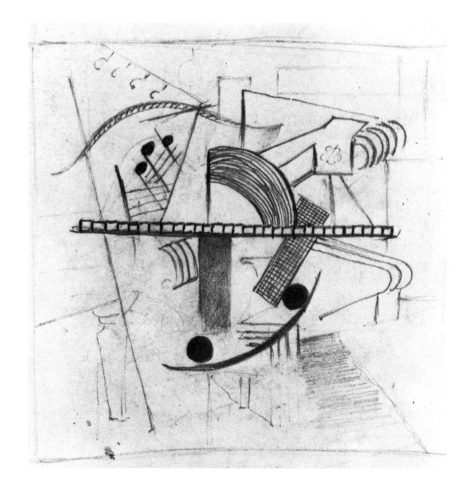

# Passages Through Poetry

By 1913 a refined theoretical discourse was being conducted by Khlebnikov, who had already emerged as an outstanding poet destined to become the most innovative and influential artist of the Russian avant-garde. Through invented poetic devices such as neologisms and *zaum* (trans-sense) language, he evolved theoretical concepts that were lucidly expressed in treatises published in various Futurist booklets, beginning in 1912. In 'Teacher and Pupil' (1912)[64] the basic tenets of his theoretical foundation are laid out. A masterful blend of dialogue, fused with a complex sequence of statistical/mathematical charts and diagrams, demonstrates Khlebnikov's use of hybrid linguistic method to imply meaning; the treatise is a reflection upon language from the beginning of its formulation as a system of representation. Sentence construction (the verbal way of arranging information in successive lines) is supplemented with charts and tables (the mathematical format of arraying information). Posing words against the artificial system of numbers, Khlebnikov expands syntax through a combination of established modes of conveying information – enabling the written sentence to assume a significance beyond its form.

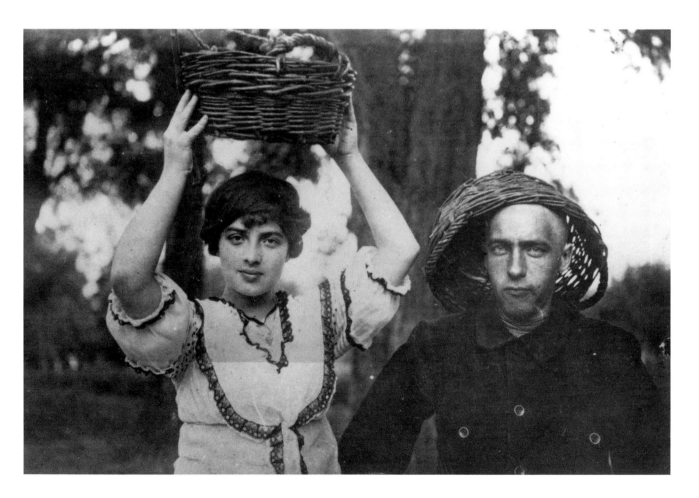

'Words are especially potent when they have two meanings; when they are living eyes for concealment and when they veil common sense, generating a secondary meaning that shines through.'[65] Khlebnikov, referring to canonized literature, regarded convention as having imposed upon words one single intractable meaning, which denied them their innate potential for generating disinterested meaning. Mayakovsky was similarly critical of literary tradition that limited word meaning by neglecting 'the structure, resistance and fabrication of words'.

Literature has determined the life of words by narrowly defining their relationship to the objects they supposedly indicate. Beyond this referential semantic concern, Khlebnikov's poetic vocabulary takes into account more fundamental issues. His analysis is composed of five parts:

1. The word as primary unit (i.e. the word as self-valuing).
2. The syllable as the primary element for the extension of language through new and newly formed words.
3. The letter as the smallest building component of the word (which also forms the foundation of Khlebnikov's 'language of stars').
4. The number as adequate possibility, able to indicate and express ideas more precisely and concisely then verbal language.
5. The pure sound, the sound combinations of *zaum* language.[66]

Khlebnikov cautions, weary of distancing the reader/observer from the artwork, that 'a piece written of exclusively new words will not touch the consciousness.'[67] Accordingly, his poetic system consists of combinations of *zaum* and everyday language, of numbers and speech/literature, etc. An admixture of the five characteristic components listed above is required for the creation of meaningful texts:

> A greeny goblin grabbles in the forest –
> A wood-willy, slurping his mouth organ –
> Where a clump of aspens quivers
> And benifolent spruces cascade.[68]

In Khlebnikov's analysis of the word four different perspectives must be distinguished: the word as a semantic unity; as a phonetic/acoustic unity; as a graphic audio/visual unity; and the word in its syntactical combination as an element of construction in the sentence and in the verse. The genius of his theorizing is that it was attuned to the significance of the letter, and not merely of the spoken and written word. He was able to see beyond conventional meaning, into the realm of autonomous and singular significance, in a way that surpasses formal analysis of the whole. Reducing the most elaborate structure of interpretation man has imposed in his world (language) beyond its various separate elements, distilling it down to the essence of the internal or articulated utterance of thought, Khlebnikov was able to assign value to the actual formation of the process, and not simply focus on its minimal products.

This critical insight has a refined conceptual proposition as its starting point, and is only validated – and can only be continued – not through further conceptualization, but, as he succeeded in accomplishing, through theoretically governed practices of art. The creative mind in its most advanced form reduces theory to essence by integrating it into a new system,

64 Velimir Khlebnikov, drawing of a frog, c. 1900.

based on new structures that have not previously existed. Khlebnikov's poems and Malevich's paintings occur as concrete manifestations, mirroring theory articulated by vanguard critics such as Jakobson, Shklovsky, Tynjanov, and Eichenbaum, yet they are constructed by means those critics did not envision.

The dialogue of 'Teacher and Pupil', besides using combinatory forms, contains lucid prose passages:

Pupil: Have you already heard of the inner conjugation of words? Of inflection within the word? If the genitive answers on the question *from where*, and the accusative and dative on the question *to where* and *where*, then the conjugation according to the inflection must give to the newly created words a meaning opposite to its essence. Thus, words of the same lineage must have disparate meanings. And this can be reasoned. The words *bobr* (beaver) and *babr* (jaguar) designate a harmless gnawing creature and a terrible predator, inclined by the accusative and the genitive of the mutual root *bo*; to chase the beaver as prey ('*bobra . . .*'), yet however, be afraid of the jaguar ('*babra . . .*'), since in this case man himself can become the object of the predator. Here, the simplest word-body changes the meaning of word formation, through the change of grammatical tense. In one word ('*bobra . . .*') it is prescribed that fight-action is directed towards the animal (the accusative – to where?), while another word ('*babra . . .*') implies that the action of fight originates from the animal (genitive – from where?).[69]

To isolate the formal elements of this passage, to focus on the twisting of etymological aspects in language and understand this as a device aimed at aesthetic pleasure, would be to misconstrue Khlebnikov's objectives. Taken on this superficial level the 'Teacher and Pupil' dialogue does shock the reader into an awareness of language's atavistic characteristics as well as conversely signifying that our everyday use of language does not usually entail thinking about the internal meanings of the words we employ to express thoughts. There may, as the pupil observes, be hidden significance underlying our syntax that casually or critically reflects upon what we intend to say (convey) and what is understood.

Khlebnikov's writing operates on a more sophisticated level than the fracturing aesthetic of Futurist poetics. One must be reminded of the full characteristic definition of what comprises an aesthetic entity, able to generate an experience external to, in this case, literary poetics – meaning external to appearances. It is, thus, not literary poetics but philosophical aesthetics that ultimately result from the authentic play of constituent elements, by which the internal referential structure alters as various parts are considered, through juxtaposition, comparison, and definition within the entirety they form.

Khlebnikov's theoretical formulations in 'poetry' (if ever that nineteenth-century word could embrace the design of his ideas) appear crystalline and extensive when compared to early Russian linguistic precedents. Aleksandr Potebnja (1835–1891) pioneered analysis of poetic language as a mode of apprehending the world and acquiring knowledge. By freeing the word from the process of denoting and describing ideas, positing that 'the word is art, more exactly, poetry',[70] it was possible to regard the word as an agent for creation. Such ideas arose through the juxtaposition of everyday language with poetic language, implying that they are not equal, but related. Therefore, poetic language might also be used functionally to communicate images in a more complex way. This position, however, did not challenge the veiled mystery of language and words because it still operated on a level of imagistic

65 Velimir Khlebnikov, wordplay, n.d., page from notebook.

85

representation. Potebnja inspired certain disciples, who expanded his discourse in preparation for the Futurist poets and the Formalist critics. Concepts concerning everyday language's (and literature's) debasing effect upon original word-meaning gained currency late in the nineteenth century. The proposition of words being 'tropes', reduced 'emblems' whose figurative core had faded under evolutionary social pressures, was an essential theoretical foundation. The line of thought descending from Potebnja was, however, still bound to the images of what poetry expressed.

This conquest of content over form was appropriated by the group of Russian Symbolists active after 1900, and became their primary justification for abstruse readings of representations. Andrej Belyj, in his book *Symbolism* (Moscow, 1910), pointed out that it is important to research poetry as art, yet he denied the importance of any material inquiry into the word 'art'.[71] Russian Symbolism 'could not be, and did not want to be, merely art.' It aspired, as noted by Victor Erlich, 'to become an integrated world view, a philosophy, more exactly a metaphysics. While Verlaine, Laforgue, and Mallarmé were primarily concerned with evolving a new form of poetic expression, their Russian counterparts grappled with "ultimate" questions in a forthright attempt to find a way out of the fin-de-siècle spiritual impasse.'[72] It was, however, only by dismissing the image from language (which Khlebnikov began to do in 1908), that the emphasis of poetic practice could shift its focus towards the aesthetic exploration of material and technique. As theory detached from the prescribed parameters of representational art, necessary alterations brought about correspondingly radical new forms and techniques, reflecting the question of 'material' in the poetic word. In Khlebnikov, for the first time in modern poetics, we find a theoretician who is able to illustrate his ideas in the actual art form that his theory derives from.

One primary facet of poetry that Khlebnikov relied upon is the capability of the neologism to generate not merely new phonetic significance, but also meaning separate from conventional syntax's employment within logical structures, and necessarily separate from direct references to implicated objects. When emphasis is placed upon the phonetic construction of words, an intrinsic correlation between euphonics and semantics is made prominent. In practical language the freeing of words from their assigned meanings is inconceivable given the stipulation that the arrangement of their letters is determined by the convention of order. For example, the word 'ebullient' exists as the sequential arrangement of nine letters into three syllables, none of which can be extracted or rearranged without obliterating meaning ('ebient', 'ebul', etc.). It is thus evident how sound patterns are intimately tied to ordered letter formations. There is no 'construction' involved when using the word 'ebullient'.

Neologisms create shocking euphonic patterns where old words phonetically crumble. Euphonic construction entails the releasing of the discrete and independent substance of the word. Everyday speech only partially recognizes phonetics, because habitual use reduces awareness of intrinsic components. And everyday word usage generates meaning inside the structure of language by having an assigned idea/object to which it refers. However, the breaking of words into parts as small as the letter (or number, punctuation element,

etc.) provides a new basis from which to secure fluctuating meaning; a meaning still inside the conventional appearance of language, yet denying, without excluding, previously accumulated meaning. Khlebnikov realized that no matter how disorienting his word constructions appeared, they were either intimately or distantly dependent upon the tradition of placing words onto the page for the purpose of expressing and elucidating thought. It is not the convention of word usage inside language as a construct for communication that Khlebnikov aims to reinvent and reorient, but rather the process by which meaning is generated through this basic system of expression. Isolating the significance of word parts as self-valuing unities that convey meaning outside of practical language's logical combinatory rules, raises the fundamental issue of how meaning is produced.

The aims of Khlebnikov's practice of word creation are best understood through close analysis of one neologism. The word 'benefolent', cited above, has various modes of meaning signification. The first concerns correlation within convention (benevolent, beneficent, etc.) because the reader recognizes distant predecessor words, inferring that meaning should derive from this initial process of orientation. Comparison between 'benefolent' and benevolent, however, does not necessarily imply any direct semantic relationship. As the reader thinks of other words which could inform 'benefolent', by dismantling it into roots and parts that resemble those of, say, benevolent, it becomes evident that this process can only partially inform that of meaning generation because it is ineluctably tied to the finite reserves of logical words existing in language. This process is inadequate for providing a cogent meaning of 'benefolent' because the dominating linear structure of language can only suggest a sequence of meaning that is limited in its ability to deviate and to invent. It should, however, not be dismissed entirely, as it retains referential significance (for summoning up and enhancing the texture – sound – of 'benefolent'). For 'benefolent' to acquire meaning we must reiterate its complete phonetic construction, first syllabically, then by each successive letter – and neither of these progressions can be altered (unlike painting). Although this is not unlike conventional semantic enunciation, 'benefolent' acquires an independent meaning as an autonomous, euphonically constructed and altered word.

One important aspect of the poetic neologism is its non-objectivity. Despite the fact that the law of poetic etymology functions so that the inner and exterior form of the word is experienced, 'benefolent' ultimately lacks objective reference to any words or concepts that conventional poetic language could generate. Thus, the neologism gains significance in relation to the line 'And benefolent spruces cascade', signalling that 'benefolent' can only be used in this exclusively defined context, which is conversely the reason for its creation. 'Benefolent' is a word that can never be repeated elsewhere in any language without its meaning being transformed. It is a unique creation, providing information about its companion words and their intrinsic value. Thus regarded, 'benefolent' internally comments upon conventional language's operating method, and externally reflects upon that method's ability to express meaning.

This redirection of meaning signification is further elucidated in the same

Портрет В. Хлебникова

66 Vladimir Mayakovsky, ink drawing of Khlebnikov, 1913.

four lines (which we can loosely refer to as an untitled poem) by the sequence of words: 'greeny goblin grabbles'. This reflection upon basic poetic devices, such as alliteration and onomatopoeia, assumes an entirely new significance when understood inside the whole line: 'A greeny goblin grabbles in the forest . . .' In this line the actual linguistic function of the words is thrown into doubt, because we are forced to question whether we should regard, for example, the word 'grabbles' as a verb or an adjective, or the word 'greeny' as an adjective or an adverb. That 'grabbles' is characterized by the same meaning process as 'benefolent' announces the possibility that an even more advanced reflection upon conventional language is in operation. By calling into question the definition of 'grabbles' as a functional word in a supposed sentence, in this case a line, the convention of linguistic order is challenged; the multiple value of 'grabbles' as a possible verb, adverb, or adjective means that all preceding and subsequent words must come under similar scrutiny. Hence, readers are free to stipulate that the word 'forest' might not necessarily be a noun, but could fall entirely out of place in an arrangement of words that now only distantly alludes to the conventional logic of sentence construction. Because of the floating option of multiple verbal definitions we must ask ourselves how to combine the words not only with each other, but among each other into a line. And this process is expanded due to the disregard of, and in some cases total absence of, punctuation. Hence the possibility of 'in the' being extracted for independent semantic consideration – a proposition that could not have existed before.

Unlike conventional language and poetry, Khlebnikov's writing is bound by no apparent rules. While conventional poetry demands that certain words mutually inform each other and possess designated functions (observable in any Pushkin poem), Khlebnikov allows any and all words to inform each other in an infinity of ways, only mediated and restricted through cumulative euphonic structure. In our example, this multidirectional informing process is noted by the forward reference of 'wood-willy' into the context of its following words 'slurping his mouth organ', and the backward reference of 'wood-willy' to 'forest'. This is the most obvious example of multidirectional meaning generation, which, of course, applies to each and every word.

In summary, construction and application of neologisms in literary texts provoke substantially different, unexpected formations of meaning. Internally, their construction can only be understood through the phonetic and syntactic arrangement of essential unchangeable parts; externally, they produce significance through a singular, unique, and necessary context. Both methods of meaning generation relate to convention in the limited sense that they retain apparent methodological similarities. Thus, this relationship is strictly formal, and does not determine the actual meaning itself. It is not possible to assign any significance through this procedure, because application merely serves to emphasize the limitations of language as a vestigal and outmoded system.

Khlebnikov attains the fundamental revaluing of the verbal utterance (initially appearing to the inattentive mind as superficial gibberish) without destroying syntactic and semantic unity. As a profound investigation into logic and knowledge, 'Incantation by Laughter' demonstrates his inventive

lucid thinking. Arranging letters into syllables and building components into what appear to be words, the poem authentically grapples with the outward appearance of thought, emotion, action, and our way of ordering. Does this not question the very definition of what our universe consists of, and how that substance is presented intelligibly?

These essential and epistemological questions were, it seems, of equal importance to Malevich, who saw in painting (unlike any other members of the Cubo-Futurists) a way of radically articulating formal and philosophical issues. His paintings, for example the *Portrait of the Composer Matiushin* (illus. 71), detach themselves from modes set by Russian or French Cubist precedents. And in other works from this time, artistic conventions normally assumed to be required for interpreting the observable world are no longer manifest. Like Khlebnikov, who was able to succeed in dismantling the material of poetics to reformulate that system into an autonomous self-generating one, Malevich began a reordering of formal properties to attain a new conception of what painting should fulfill.

For Malevich, 1913 was a year of startling discovery and swift progression. From late 1912 to the end of 1913 he proceeded to re-organize the components of painting in such a way that they no longer obeyed any tradition of describing the observed world. His March 1913 address to the Union of Youth declared as his objective the formulation of a universal criterion for painting. And his attendance at the Moscow 'First Evening of the Creators of Language in Russia' (October 13), which included Khlebnikov, Mayakovsky, Kruchenykh, the Burliuk brothers and Livshits (the *zaum*-Futurists), was an even more significant episode in his rapid development. The tight affiliation and conceptual collaboration between the poets and this one painter is entirely revealing.

The *Portrait of the Composer Matiushin* initially seems to rely upon Cubist techniques, but it is (as we will see) only remotely related to the French movement, which can be considered as the final qualification of Renaissance precepts. Picasso adhered to all the primary conditions of painting in the Renaissance tradition, never threatening observed subject matter with the possibility of its dissolution. With both analytic and synthetic Cubism, the viewer is always able to discover, with the aid of titles and representational cues, objects of observed reality. The way in which Cubism translated vision permitted for the first time in art a subjective perspective that could rival, or exclude, other empirical stipulations. Objective and traditional modes of construing the world could now be questioned. The Cubist's aesthetic, necessitating observance of objects from multiple vantage points, implies that the Renaissance concept of a single, fixed, anthropocentric viewpoint was not essential for a rational comprehension of reality. A trialectic developed between the manifest shifting world, Cubist assumptions, and Malevich's urge to go beyond commentary and to make an actual contribution suited to the conceptual task he had set himself.

The degree to which Malevich understood these fundamental ideas of Cubism is revealed by comparing the *Portrait of the Composer Matiushin* to Picasso's *Portrait of Ambroise Vollard* (1910; illus. 67). In Picasso's painting we

observe a well-dressed man of considerable social stature, his eyes downcast reading the newspaper. Behind him on the left is a bottle, and on the right a book standing on a shelf. Vollard's primary facial features are clearly displayed and described. The bulbous nose, downturned corners of the mouth, high receding forehead and light beard instantaneously and unequivocally signify the personality of the man. The focal point of the face, central to the composition, receives the most carefully articulated attention, while the detail loses resolution as the faceted passages disappear into the greyish nondescript edges of the painting. However, though one can detect multiple viewpoints of certain details of the subject, there is no profound innovation in the general approach. Multiplicity is cognized as small fracturings of one larger and consistent view; it does not necessarily apply to Picasso's interpretation of the subject matter. It becomes quite obvious that a unified coherence is preserved. Even the fact that the white handkerchief in Vollard's breast pocket is visible through the newspaper is part of the consistency of the artist's gaze. The innovative fracturing and faceting technique of description continues to operate in the service of realistic comprehension. The revealed handkerchief does not demonstrate a radical multiple viewpoint or (a conceptual) theory that departs from apodictic assertions about reality; it is clearly a product of Picasso's desire to have all the means of artistic freedom at his disposal – his urge for freedom within conventional systems of perception. In Malevich's *Portrait of the Composer Matiushin* the main reference to tradition lies in the fact that this composition is a portrait of a man. Picasso's probing exploration of the appearance of objects is surpassed by Malevich's questioning of what secures objects in our observed world.

And indeed – if we reflect upon the correlation between phenomenology and epistemology – do not the provocative questions set by Picasso and Malevich (as interpreted here) eventually lead us, following intuition, to consider our assumptions about the constitution of the observed world itself? The apparent differences of approach taken by these two major artists of the early twentieth century isolates the quest to determine what exactly the qualifying characteristics of the observed world are defined by.

In order to determine what inspired the formal innovations proposed by Picasso and Malevich, one must probe beyond their pictorial projects and address the consequences of painterly creation within the broader realms of culture and society. Picasso's need to exert and display his free will within the given system of painting determined by society is countered by Malevich's clear ambition to transcend systems – to cross into uncharted realms, to discover neglected boundaries. And it is at this juncture, where systems and reality intersect to support each other, that Malevich inserts the possibility of breaking the limits of interconnection, inaugurating the possibility of a reality beyond system. This idea – which is an 'idea' only in so far as it seeks a formal equivalent – concerns a tangible, but not attainable, resolution, and this is precisely because it doubts and dismisses the notion of the resolution as a defining criterion for thought. While systems require process and progress-oriented development towards statements and resolutions, reality – in itself – can, as Malevich ponders, exist in a sphere where resolutions are neither fixed nor transient; where they merely *are*.

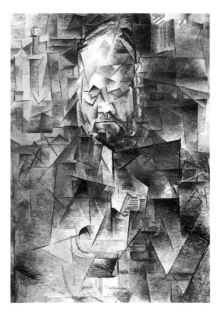

**67** Pablo Picasso, *Portrait of Ambroise Vollard*, 1910, oil on canvas (92 x 65) State Pushkin Museum of Fine Art, Moscow.

**68** Detail of *Portrait of the Composer Matiushin*, illus. 71.

A piece of a forehead with neatly combed hair is accompanied by an out-of-scale violet-blue neck tie, under the small edge of a collar – aspects that characterize Matiushin so well. Or are these details just fragments from an open wooden drawer? A measuring stick with no calibration is imposed over the conglomeration of coloured forms, functioning as the last vestige of inadequate empiricism. In contrast to Picasso's composition, the references to subject matter are suppressed, yet transformed. They serve to signal the distance from convention, instead of (as in Picasso's case) functioning as connections to the past, clues for remembrance.

Malevich's progress can be charted in the two previous portraits of Ivan Kliun. The now lost *Portrait of I. V. Kliun* (1912) [not reproduced], which was first shown in the fifth Union of Youth exhibition of December 1912, is compositionally related to *Peasant Woman with Buckets* of the same year. A frontally posed bearded head is stylized to fuse with the geometricized background. The unequal sloping shoulders, neither fully attached to the head nor describing a particular aspect of the surrounding background, mediate between disparate planes of painterly space. Of the facial features, the eyes are the most riveting, directly confronting the viewer and representing the one classical portrait element in this painting. A curiously elongated nose descends the length of the face, as does the tricoloured nose in *Portrait of Kliun Completed* (Autumn 1913; illus. 69).

Unlike the square format of the previous portrait, this comparatively large composition is vertical and consumed by the face which leaves little room for articulation of a background. The gleaming metallic surfaces comprising the armature of the face obfuscate any character traits (except the pursed lips), while scattered references to Malevich's pictorial world subvert the norms of existing and anticipated convention.

That one eye is split into two implies that one might be two. Indeed, as the left eye holds the viewer in its gaze, the place for the right eye offers a glimpse into another vision. The complex structure of the left eye describes the richness of sight, while the construction revealed on the right side is a suitably dense, faceted revelation of form: part of a log cabin, roof borrowed from the facial façade, a massive chimney with billowing smoke, and an amorphous constructed arrangement of nondescript allusive planes. This dialectic between vision and observed phenomena is the first step in Malevich's conquest of conceptual reality, bypassing observed reality. Accordingly, Malevich first exhibited this painting in a group that he titled '*zaum* realism', or 'trans-sense realism'. Despite the differences in the eyes of Kliun, it is clear that both eyes belong to the same head – and see into the same mind. With one mind, how must man reconcile more than one vision?

Jakobson supplies insight into the meaning of *zaum* when he writes of Khlebnikov's poetic contribution that 'the word loses its objective reference to reality [becoming non-objective], losing its inner and finally even its outward form.'[73] This syntactical analysis applies to Malevich. The opposing sections of a saw, the left part inverted and overlaid on top of Kliun's cheek, while the right part (its handle with a grip) goes behind the head, form an image which loses 'its objective reference to reality'. The quest to logically unite these two parts makes little sense. Even the existence of such an object,

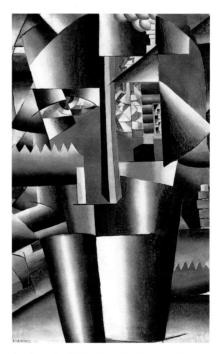

**69** *Portrait of Kliun Completed*, 1913, oil on canvas (112 x 70). State Russian Museum, Leningrad.

totally unrelated to descriptive portraiture, is an example of how Malevich supersedes even the most striking features of Cubism. Besides this fortuitous juxtaposition of thematically disjunct elements (the divided saw, chimney, roof, etc.), the issue of scale is utterly subverted. The viewer must rely solely upon formal articulation of implied objects in order to recognize elements such as the saw, log cabin, etc. If it was not for the overwhelming desire to identify with a representational conception of the world, there would be little reason to describe form in words. It is in this context, of free painterly passages characterizing the hair, lower part of the face, and background that Malevich begins to assert the primacy of painting as an autonomous language.

The *Portrait of the Composer Matiushin* is one further progression in the development of this artistic project.[74] This painting, as we shall see, constitutes an experience of reality which asserts itself in opposition to the conventions of representational depiction, as these conventions had evolved since the Renaissance. Amongst the conglomeration of forms in this portrait, one can descry bits of objects that are manifest like fragments of nouns in a Khlebnikov poem. In contrast to any painting by Pablo Picasso from analytic or synthetic Cubism, we are confronted here with an elaborate compositional scheme which proposes a syntax of painting that eludes understanding through any familiar approach: there is no consistent perspectival system, no direct correlation between colour and form, no pre-established relationships dictating scale, and no unified logical sequence of formal comprehension. On a precisely measured square canvas Malevich has composed in ascending vertical orientation a tightly interlocking and overlapping arrangement of painted forms. One strikingly illusionistic fragment, forming the centre of the canvas, immediately attracts our attention. The quarter-portion of Matiushin's head is conspicuously truncated by the transversive imposition of a measuring stick without numbers. The units that best apply to this yardstick will be those supplied by the forms within the painting. Having left out any clue to calibration, Malevich thus hints that this painted yardstick will allow us to gauge aspects of the artist's work; assess the size and scale of various forms; measure the intensity of different colours; and, perhaps most remarkable, quantitatively assign appropriate levels to the variety of painted textures. This awakening of consciousness to texture is directly linked to the Russian Formalists emphatic articulation of the poetic device called 'faktura'. This insistence upon surface characteristics as qualifying properties of sound allowed the material of poetics – actual words – to retain an intrinsic significance beyond common definition and functional use. This square canvas has been grounded with a base application of white, one of the two non-descriptive colours. Applied in a painterly fashion, the white sometimes permits bare canvas to show through – revealing the actual fabric of painting. This composite fused surface of white paint and raw canvas carries autonomous painterly value, and constitutes the material base onto which the further forms are arrayed in particular combinations. On top of the grounding, Malevich has superimposed a conglomeration of geometrized forms. The outside boundaries of this composite complex of forms and colours is clearly delineated on the left side by ruler defined black lines. The right side reminisces over this exactitude, but partakes of no obvious linearity.

Entering the conglomeration one wonders about pure colours, such as the primary red, yellow and blue, and others like the green, brown and ochre. The contrast between the depictive fragment of Matiushin's head, signalling clear characteristics of his creative mind, and other painted forms, raises the prospect of random generation, in the face of conventional perception. The curvature of red covered over by sharp trapezoids of black and white, and the carefully shaded potential cylinder of green which continues through its transformation above into white and blue – as clearly instructed by the left black line passing under the yardstick and through a median phase of local colour – assert a precision in design and conception. By carefully looking throughout the variegated assortment of colours, surface textures, lines and forms, the question of irregularity and incident becomes a potential issue. Indeed, the painting is so rich in its manipulations of diversity that one asks whether any logical or intuitive system could govern its overwhelming intricacies. In this world of detached reference, what kind of scheme, beyond the purely inventive, could determine visual articulation and resolve explosive decision making?

Malevich's employment of specific artistic principles in the working of this painting becomes evident in the equally seminal, yet rarely discussed, *The Accounting Lectern and Room (Portrait of a Landowner)* (illus. 70), which allows us to understand how radically he reduced formulas of tradition to conceptually lucid appearances in paint. We are confronted with an elaborate compositional scheme which proposes a syntax that denies access through any familiar mode of approach; there is no consistent perspectival system, no direct correlation between colour and form, no pre-established relationships dictating scale, and no unified logical sequence of formal comprehension. On this equally square canvas Malevich proposes for the first time in strictly defined language, omitting any direct referential clues to the outside world, the pure power of relationships between distinct geometric forms. For example, observe the two white trapezoids, adjacent to a red rectangle, each participating in an immediate relationship with the underlying yellow/ochre trapezoidal wedge. The maturity of Malevich's visual thinking is exemplified in the agitated, yet consistent, paint application characterizing the yellow wedge from top to bottom, and also by the contrasting veil-like translucent overlying quadrants of milky-grey. These two ephemeral forms, one nearly central, the other placed peripherally at the right, re-define translucence as an idea that not only admits light, but is also affected by texture – which here, like light, breaks through.

This startling recognition about the character of transition is augmented in crystalline syntax in *Portrait of the Composer Matiushin*. Imagining this large canvas installed, let us move our eyes horizontally rightward from the reality of the wall. As we approach the framed or unframed painting, crossing-in to enter it, we first read the whiteness of . . . of painted space. Only after traversing this white ground, do we gain access to the conglomeration of painted forms in the composition. Indeed, with this painting Malevich implies that were there to be no white underground, there would be no firm foundation for painting. Mediating the gap between richly illuminated form and the starkness of something as regular as a wall, the white ground functions to

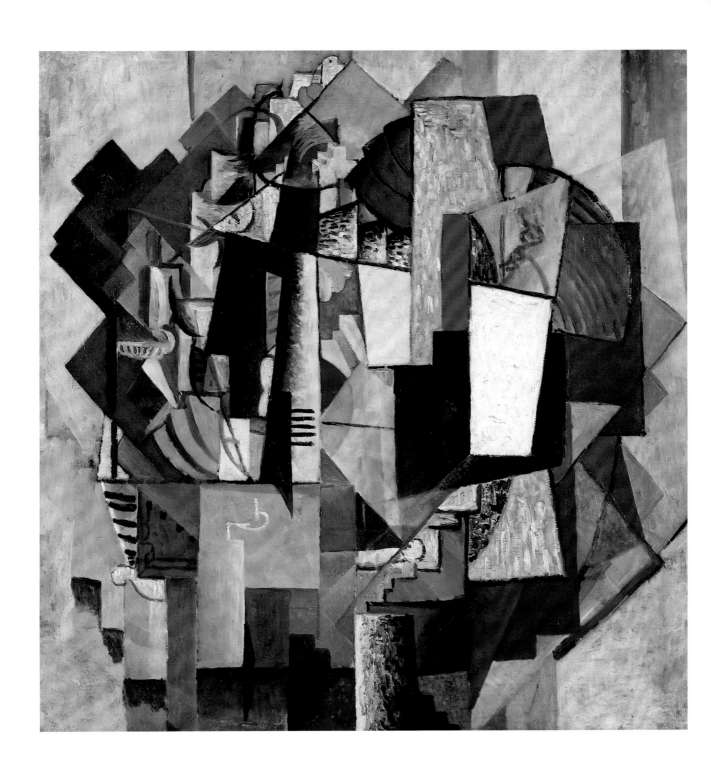

**70** *The Accounting Lectern and Room (Portrait of a Landowner)*, 1913, oil on canvas (79.5 x 79.5). Stedelijk Museum, Amsterdam.

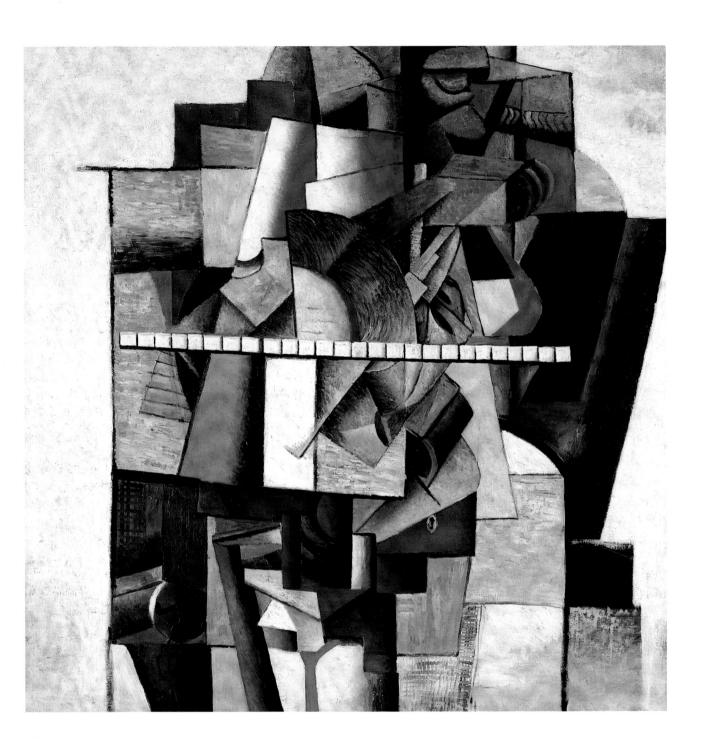

**71** *Portrait of the Composer Matiushin*, 1913,
oil on canvas (106.5 x 106.7). State
Tretiakov Gallery, Moscow.

support its own proposition – that it be a new arena for conceptual painting. Malevich thus proposes that the picture be characterized by two or more independent self-sufficient systems – a deliberate painted construction which is not a representation of any tangible or intangible aspects of perception. The white internal framing device removes the language of painting from the language of reality.

To assign these works to the category of synthetic Cubism, as defined by French contemporaries, serves to elucidate fundamental differences. Despite supposed formal similarities there are profound artistic and philosophical distinctions. Cursory reference to a work by Picasso unequivocally demonstrates Malevich's conceptual undertaking – an undertaking that crucially anticipates Suprematism. The laws of perception persist throughout Picasso's Cubism, pervading even such liberal compositions as *Man with a Guitar* (Spring 1913; illus. 72). A system of geometricized planes, of variously coloured rectangles, act to retain an observance of setting in Picasso's work. The centrally posed costumed entertainer is integrated into a patterned arrangement of shapes, providing both a painterly setting and a mood-oriented description of the surroundings. These planes of colour (black, white, ochre, green, red, brown and pink) are loosely composed, and, like the interior parts of the painting, they reflect upon and define the character of the figure. The outward shapes seem necessary simply to fill up the unaddressed surrounding space. This 'patterning out' of faceted passages ultimately results in the innocuous dissolution of form for decorative ends.

72 Pablo Picasso, *Man with a Guitar*, 1913, oil on canvas (130.2 x 88.9). Museum of Modern Art, New York, André Meyer bequest.

Another analytic approach encouraged by the *Portrait of the Composer Matiushin* concerns the 'linguistic' structure of the composition. Keeping Jakobson's reading of Khlebnikov in mind, parts of Malevich's painting could be equated with certain elements of verbal construction. If the representation of forms in conventional painting are considered akin to referential words in the conventions of sentence structure, then, one presumes, it should be possible to assign each element a place within a narrative sequence.

Counter to this linear proposition, the *Portrait of the Composer Matiushin* functions in a similarly subversive yet ultimately constructive mode to Khlebnikov's neologistic poetry. Parts of words and elements of speech appear recognizable only through discrete reference. The randomness of Malevich's forms are reminiscent of a familiar language, but do not depend upon that language's structure to generate value. Jakobson conducts a semiotic analysis of abstract painting, noting that 'the "responses" between the various chromatic and geometric categories which, it goes without saying, play a non-prescriptive role in representational painting, become the only semiotic value in abstract painting.'[75]

In Malevich's painting the 'chromatic and geometric' forms, characterized by a multiplicity of textural surfaces, which culminate upwards and diagonally, subvert the creation of illusionistic space. In certain regions, as in the lower right corner, there are at least five different painted surfaces juxtaposed to reveal actual and visual spatial differentiation, which does not qualify as volumetric illusionism. Carefully executed brushwork, producing smooth underplanes, contrasts with rough, tentative, hatched passages. In the case

of the apparently receding, large, black-faceted form, spatial definition is subtly attained by the fluid white reflective 'shadow', separating the upper from the lower part. The application of paint and its local artificial articulation supplies all the vital information within this critically conceptual framework. Our detailed analysis of this painting is designed to display its complexity, but also to imply that its appearance is the consequence of a thoughtfully predisposed attitude towards painting as a language of expression in the world.

In his several lectures for the Moscow group Knave of Diamonds, and in his article 'Cubism (Surface-Plane)', published in the Hylaean manifesto *A Slap in the Face of Public Taste* (December 1912), David Burliuk, the head of the Hylaeans, speaks of painting as 'having become an end itself', enumerating 'the essential nature of painting' as composed of:

I.    line
II.   surface
III.  colour
IV.   texture (the character of surface)

while referring to Khlebnikov as the apologist of *vers libre*.[76]

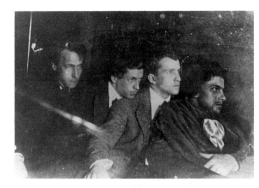

73 From left to right, Velimir Khlebnikov, G. Kuzmin, S. Dolinsky and Vladimir Mayakovsky.

In the *Portrait of the Composer Matiushin* a dialectical implosion, of protruding three-dimensional elements set against receding ones, has been created by opposing the brown drawer to the translucent trapezoid connecting the top of the head to the geometricized volumetric backdrop. The arrangement of all forms is based on an arbitrary scheme. According to structuralist linguistic analysis, of which Jakobson[77] was an early formulator (following Baudouin de Courtenay, Kruszewski, Saussure, et al.),[78] the relationship between any material signifier (in this case the geometric forms) and its signified (pertaining to spatial, volumetric, and 'realistic' connotations) is arbitrary and only ever determined by context. The unifying element supporting this painterly proposition, evident in *Portrait of the Composer Matiushin*, is the prevalent, tactile articulation of all parts. Subtle variations in the painted texture encourage layers of insight, premised on the recognition that surface is intrinsic to the Formalist approach, which is thus distancing itself from Renaissance painting. The prospect of subversion is exchanged for a composition of meanings not previously possible.

As a final assessment of the advanced nature of Malevich's theoretically oriented thinking, *Portrait of the Composer Matiushin* is revealing when submitted to strict linguistic analysis. The composition acts as a statement about the status of painting, and fulfils the formal criterion of the most significant discourse among the avant-garde. Internally, its structure reacts against conventional representational systems (as discussed above), enacting a critique of semantic valence. The carefully painted piece of the human head (commenting on the power and fallacy of illusionism) describing combed and parted hair, casts shadow onto a wrinkled forehead. The 'chunk' of head is bounded at the lower edge by a measuring stick, and at the left edge abruptly cut off. These pseudo-representational forms are clearly articulated with black lines that set them off from the 'ground' of other forms. The distinct elements, head and ruler, combined with the other forms, permit the viewer easy access to Matiushin's dense world of ideas.

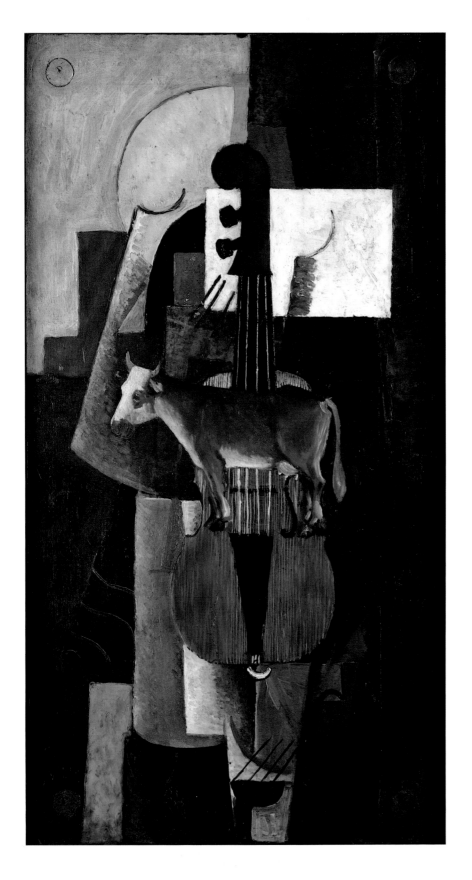

74 *Cow and Violin*, 1913, oil on wood
(48.8 x 25.8). State Russian Museum,
Leningrad.

75 *An Englishman in Moscow*, 1914, oil on
canvas (88 x 57). Stedelijk Museum,
Amsterdam.

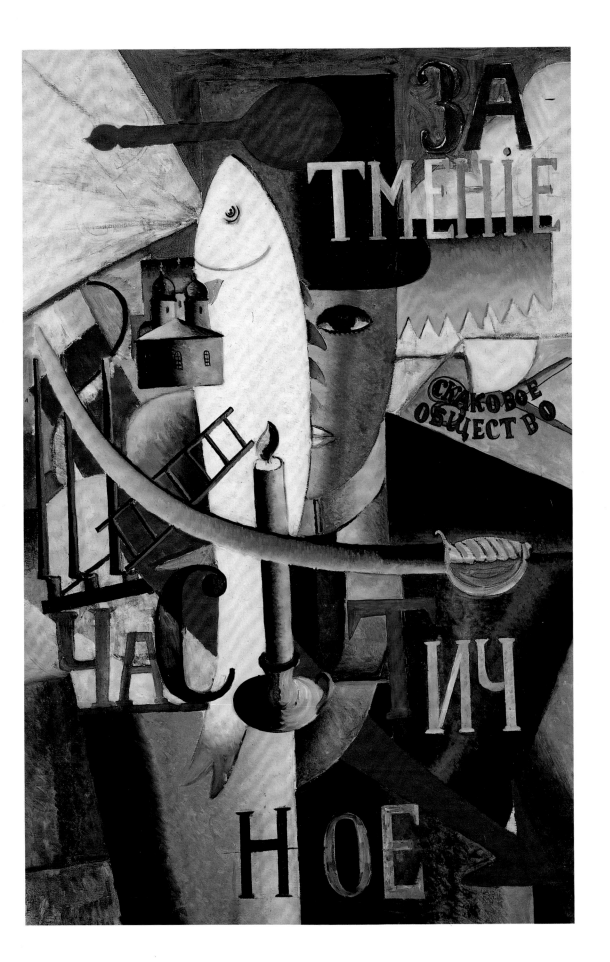

The disjunct nature of these elements functions like the roots or recognizable parts of Khlebnikov's neologisms. Inside this poetic language, which can now be seen to have a direct correlate in painting, every new word (when compared to practical and familiar ones) possesses a degree of phonetic and semantic deformation. Parts of Malevich's pictorial language have also developed their own form, giving rise to complementary semantic insights. This is unlike any of the manipulative aspects of Cubism or Futurism, because Malevich used a syntax so reduced that coherent fragments cannot be linked together into intelligible chains resembling representational modes.

In contrast to the carefully constructed formal narrative, there are sparsely painted areas which incorporate the unprimed canvas into their form. The regions at the lower left and right, and upper right of the canvas, speak lucidly of how visual utterances are created and gain definition. They represent the base denominator of form (comparable to phonemes in verbal language). Thus they possess a positive communicative function within and on top of their own potential absence; the regions are positives of paint within the negative field. Furthermore, the fluid succession of applied paint, which melds onto the canvas surface, creates meaning where there was none. The nothing of substance is incorporated into the new something of structure. And the deliberateness of this technique prompts the viewer to halt for a moment, to question the structural function of an unpainted passage in an otherwise ordered and painted arena; is that function to place emphasis on unadorned texture and surface, in contrast to the painted surface and its texture? Is it, indeed, a refined and subtle statement of what was later to motivate the Russian Formalists' position in poetry? Beyond doubt, it is conceptually and theoretically distant from those beautiful canvases of Cézanne in which unpainted passages and areas of canvas simply demonstrate an individual method, an artistic choice. Here, *Portrait of the Composer Matiushin* reveals its numerous allusive theoretical positions about painting in a representational mode. It is a concise and prescient statement, pointing in the direction Malevich chose to take in the years to come – to the zero of form, the tangible void of paint.

The discourse pertaining to what exactly constitutes a semantic system rapidly evolves in Malevich's painting throughout 1913 and 1914. In *Cow and Violin* (illus. 74) representation has been subverted, as illusionistic space and its concomitant notion of scale has been dispensed with to create a more radical and overt critique of convention than *Portrait of the Composer Matiushin*. Malevich does not hesitate to deploy obvious symbols with pre-assigned connotations in order to piece together the finite cycle of interpretation. The illusionistically painted cow doubles as a symbol of nature (so often invoked by Malevich to hint nostalgically at rural Russia), both appealing to the old 'common sense' view of the world, and also serving as an anecdotal *sujet* for naturalistic perspectival form. The cow is combined in an apparently collage-like fashion with a two-dimensional representation of a violin – a refined product of Western civilization since the Renaissance. These culturally diverse emblems locate the social dichotomy felt in Russia between the

76 *Cow and Violin*, 1919, lithograph, printed in black (13.2 x 8). Published in *On New Systems in Art*, Vitebsk, December 1919. The following caption appeared below the image, handwritten by Malevich:

The above drawing represents a moment of struggle through the confrontation of two forms: that of the cow and that of the violin in a cubist construction. Logic has always placed a barrier against new subconscious movements. The 'Alogical' movement has been created to free it from preconceptions.

peasant classes, the intelligentsia, and the aristocracy, and the international dichotomy between Russia and Western Europe.

On the reverse of the wood panel Malevich has inscribed 'a logical juxtaposition of the two forms, "violin and cow" [note Malevich's quotation marks], as an aspect of the struggle against logic, natural order, and bourgeois meaning and prejudice. K. Malevich.'[79] Not only are the cow and violin iconographically disoriented as symbols, their individual significance is also broken down. An alogical contrast between notions (or images) destroys or at least disturbs associations with the original meaning that each element previously possessed. In *Cow and Violin* the violin, its body signified by a textured 'trompe l'œil' build-up of painting, is positioned centrally in the picture plane, without a defined scale. In fact, the superimposition of a proportionally unrelated object, the cow, both implies and destroys a representational attachment oriented to the scale of objects in space – a major aspiration of painting since the Renaissance. Internal spatial effects no longer function between the cow and violin and their context of painted forms. The creation of a new context, a self-sufficient one of painting, free from the constraints of spatial depiction and logical and empirical scale, presumes a broad range of optional significance. The four indented circles placed in the corners function independently as formal devices.

Following this reading, the geometricized arrangement of forms emerge as anticipating Malevich's evolution to Suprematism. The bold juxtaposition of two rectangular shapes in the most intense non-colours of the composition, black and white, reveals an uneasy painterly transition, brought through an intermediate phase of various brushstrokes of grey. At this crucial phase of his painterly conception, Malevich converts the meaning of painted symbols into the deeper implicatory realm of linguistically oriented signs. The referents of the symbol have been converted into informants of the sign, allowing the signifieds to multiply, loosening from their associated forms.

With the painting *Cow and Violin* Malevich's artistic development displays a mature conceptual understanding of the referentiality of painting, permitting no alternative except detachment from the conventions dictating the relationship between image and meaning. This painting, for the first time, throws into question naive commonsense perceptions of the image itself. It marks the beginning of a subversion of the correlation between image and meaning, between convention and what was not yet known. Beyond all linguistic and artistic implications, *Cow and Violin* asserts that the most fundamental laws of communication – established through a rigid linear correspondence of representation and object, connected through name[80] – cannot be taken for granted. This picture is less about the practice of art than about the philosophical foundation underlying the history of what constitutes an image.

Finally, it confronts us with the question of the real. Is the image we observe, combined with its conventionally assigned meaning, what constitutes the real, or is reality composed of independent meaning generated from imaginative associations that partially derive from what we recall to be the real? It declares a crisis about the image, while also implying similar

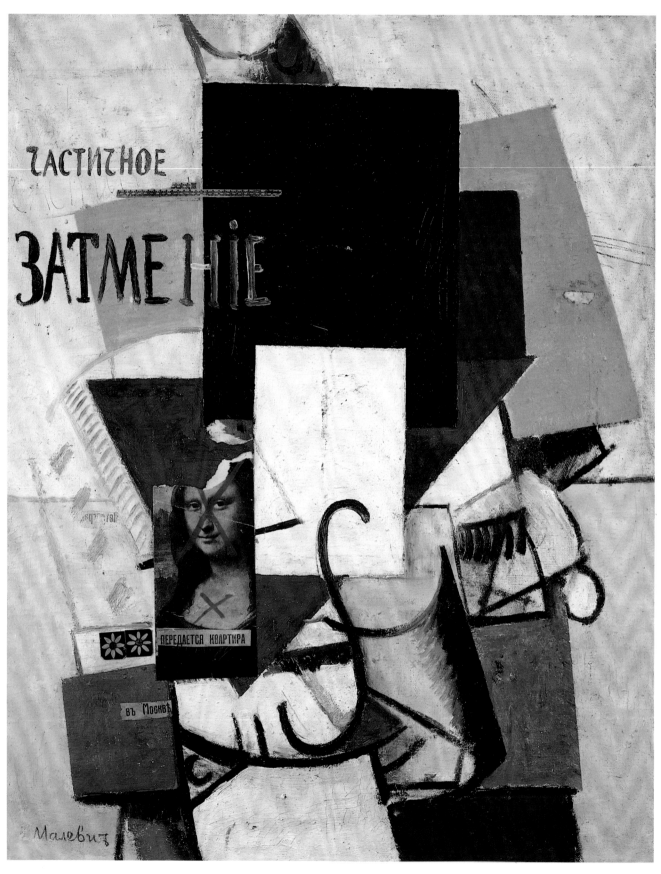

**77** *Composition with Mona Lisa*, 1914, oil, collage and graphite on canvas (62 x 49.5). Private collection, Leningrad.

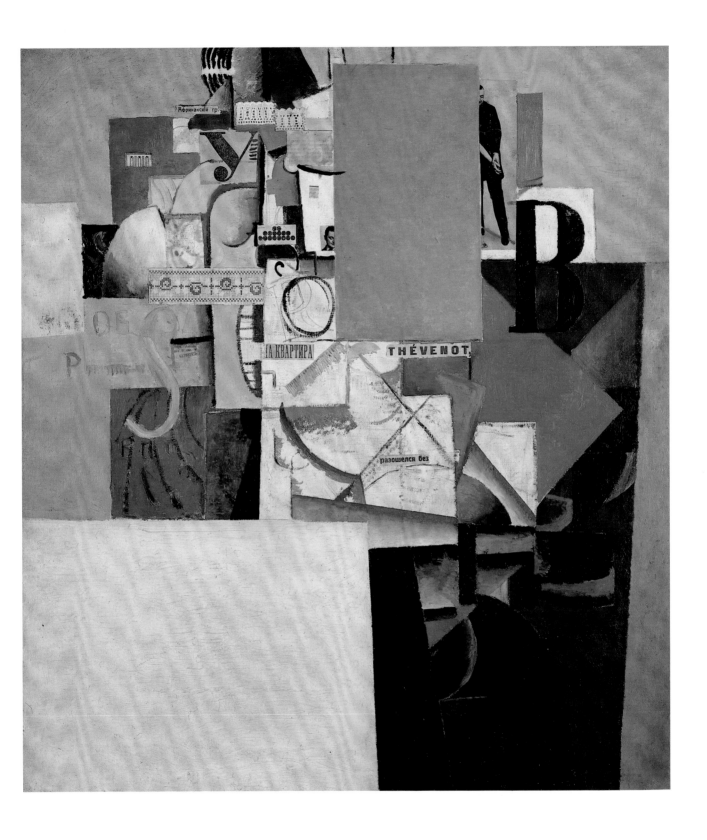

**78** *Lady at the Poster Column*, 1914, oil and collage on canvas (71 x 64). Stedelijk Museum, Amsterdam.

deficiencies concerning the word, re-addressing the epochal dichotomy in Western humanism between image and word.

If the semantic 'truth' of images challenges the linguistic foundations on which meaning is based, then how can significance be secured; if the relationship is broken how can meaning be reconstructed? These are the questions Malevich singularly addressed in that miraculous year, 1913.

In this context, one can coherently analyse the much discussed opera *Victory Over The Sun*, a collaborative achievement between Matiushin who composed the music, Khlebnikov who wrote the linguistically sophisticated prologue,[81] Kruchenykh who produced the libretto, and Malevich who designed the backdrop and costumes. The opera, fulfilling the function of a social and artistic tirade, ultimately reflects how intensely everyday perception and conventional logic were questioned. *Cow and Violin*, combined with contemporary poetic practices, reflected the main theoretical issues that *Victory* exemplified. And conversely, following the controversial yet popular success of the opera, Malevich produced *An Englishman in Moscow* (1914; illus. 75), which both elucidates and amplifies this emergent criterion for opening unexplored venues of communication.

If the *Victory Over the Sun* represents the direct result of the conceptual issues manifest in *Cow and Violin* and in other poetic devices from 1913, then the pictorial structure of *An Englishman in Moscow*, soon to follow in early 1914, ultimately assumes a destructive position towards the correlation of image and meaning. Supplicating, it asks how can syntactical relationships between words and images, between words and painting, be conserved?

**79** Cover of libretto for *Victory over the Sun* (1913).

ВСТУПЛЕНІЕ.

**80** Mikhail Matiushin, Prelude to *Victory over the Sun*, 1913, from the booklet *Three*, 1913; texts by Khlebnikov and Khruchenykh, illustrations by Malevich.

The central figure of a well-dressed man wearing a tophat emerges from behind a clutter of objects, each depicted to a different scale, each maintaining a different spatial position. Merely because of the pictorial juxtaposition, of man amongst objects, the viewer's overriding tendency is to forge associative bonds, despite initial bewilderment over the strange array. A lit candle dangling before the solitary eye illuminates the white flank of a fish; a ladder leads back into space, up to the church. Below the secret red spoon the conflation abounds with aggressive emblems: bayonettes crossed, cut

through, by the prominent curve of the sword, scissors open to cut, and the silver saw blade – a motif from the previous year. The diagonal swoop of the travelling arrow implies one connection among all this diversity; perhaps the images represent a foreigner's disorientation in an unfamiliar culture, fleeting remembrances and premonitions amalgamating. The painterly stage of this picture appears to be set with enough props to act out scenarios *ad infinitum*, to fulfil internally the fantastic wondering of an imagining mind.

These representational associations, however, are inhabited, inhibited and challenged by the mysterious presence of painted words, reading *za/tmenie* (eclipse) – broken into parts, not by syllable – and *chas/tich/noe* (partial) – broken into parts by syllable. Besides these similarly sized letters appears a separate grouping, uniformly red, and reading *skakovoe obshchestvo* (racing society). Unlike this immediately recognizable, somewhat ornamental, inscription the other more iconic words, broken into parts, are less easily discernible because the spacing and colours do not necessarily follow conventional syllabic divisions.

The correlation between image and word must be analysed on more than one level, especially if the notions *zatmenie* and *chastichnoe*, which recur in *Composition with Mona Lisa* (illus. 77) of the same year, are compared in their pictorial and syntactical context. In both paintings the same words appear, painted in a different script, indeed, a different style, which radically alters their impact upon the viewer. Because their aesthetic values so evidently shift, the two paintings demonstrate how formal manipulation of perception can determine different meaning.

The first and most obvious function of words within *An Englishman in Moscow* is to destroy habitual perceptions of syntax in the objective world, because there is no obvious correlation between word and image. Even if the viewer follows conventional tendencies of association, connecting objects to thematic currents suggested by the words, the overall arrangement generates numerous possibilities but isolates no single option as definitive, or prominent. One can follow this system of construction linking, for example, 'racing society' with the elegant Englishman and the ceremonial sabre. 'Racing society' also implies contemporary technological inventions enabling man to move faster, to accelerate himself through his world. Such words, however, when understood in a non-literary mode, assume higher significance, altering our conception of painting as a comprehension of reality. Attuned to Khlebnikov's poetic experimentation, here Malevich deploys words to encourage the viewer to discard old meanings of words, to form new ones, free of deadening associations with the complacent bourgeois world, free from the Symbolists' methods of programming meaning into images.

'Racing society', because of the way it is painted and its position within the composition (being threatened from behind by menacing scissors), supplies connotations that are not necessarily substantiated through other elements in the painting. An evolving system of alogicism occurs, where meanings become multiply coded. *Chastichnoe*, which means 'partial', is also more colloquially understood as black-out or mental derangement. Blackout evidently refers to the notion of eclipse, connecting to the *Victory Over The Sun* theme, and by implication to any process of alogical perception. *Zaum* poetry

81 David Burliuk, c. 1913.

interpretation techniques can be applied to both *za/tmenie* and *chas/tich/noe*. Stable units of sound material can be uncovered beneath the seemingly disorganized surface variety of language. Following Khlebnikov's quest to formulate abstract meanings for letters and sounds, parts of words may be interpreted. 'Z' (painted in red), because of its shape, refers to reflection, the impact of a ray on a solid surface. Combined with the 'a', *Za* gains the literal meaning of 'behind', or 'in the back of'. These two letters also form the beginning of the word *zaum* – the condensed notion containing all central Futurist aspirations. *Chas* pertains to time, meaning 'hour' or 'o'clock'. The Cyrillic 'S', which is painted larger than the other letters, assumes broad associations. Words like *solntse* (sun) and *siiat* (to shine) begin with s.

82 *Fish and Ace of Clubs*, c. 1914–15, pencil on graph paper (11.2 x 16.3). Private collection.

The suggestiveness of the elements (both visual and verbal) of *An Englishman in Moscow* reveals the informed nature of Malevich's thinking at this time. In the specific cultural context of Russia, interpretations must be attuned to other academic disciplines. Our reading resembles, for example, similar methods beginning to be employed in geometry and mathematics. Before intuition and imagination are applied, one should investigate the 'internal' conditions of a given complex (whether it be a coordinate system or a painting), and subsequently relate that complex to external conditions, still containing intuition.[82]

83 *Boat and Shovel*, 1914–15, pencil on graph paper (16.5 x 11.1). Private collection.

With *An Englishman in Moscow* all of the possible associations result from our conditioning, which dictates that paintings should be unravelled, interpreted in representational ways. And if the representation is not coherent or immediately apparent, then we search through for clues and cues, yearning to attach conventional meaning to parts we hope to recognize. Interpretation revolves around possible vestigial attachments linked to representations, with both image (fragments) and words (letters). Indeed, all of Malevich's work preceding Suprematism falls into this category, playing on convention to highlight its deficiencies. It is, however, only with the absolute breakthrough of Suprematism that Malevich was able to distance himself from convention with such a decisiveness that he would surmount all previous systems. To comprehend this leap, we must first consider a key transitional work, dating from 1914.

*Lady at the Poster Column* (illus. 78) is the last reference to representation before the inception of Malevich's totalizing abstraction, as manifest in Suprematist painting. *Lady at the Poster Column* is a seminal work of art with such an impregnable plethora of possibilities and propositions that its interpretative recalcitrance has prevailed over its meaning until today. It is our ambition to decode its intimate yearning toward a new sublime reality, toward a manifest utopian level of information and communication that is comparable to Picasso's *Les Demoiselles d'Avignon* of 1907 and Barnett Newman's *Onement I* from 1948.

With the painting's bold emphasis upon written 'words' Malevich acknowledges his debt to Khlebnikovian innovation, which comes into clear resolution when compared to *An Englishman in Moscow*. In this previous painting all of the Cyrillic vowels and consonants are legibly depicted and arranged into decipherable words or fragments of words. Despite the colouristic variations

(red, green, black, etc.), script size, and type style, there is little phonetic manipulation and almost no semantic deformation. The reference to *zaum* poetry is novel insofar as Malevich has drawn from a conventional 'alphabet of forms' with pre-assigned meaning (the Cyrillic alphabet) to propose that such forms may have independent visual and painterly significance and an inherent potential beauty. Malevich's understanding of *zaum* language, following Khlebnikov and Kruchenykh, was lucidly expressed in the spring of 1913, when he wrote in a letter to Matiushin:

> We have come to reject reason, but we have rejected reason because a different kind of reason has arisen within us, one which might be called transrational [*zaum*] if compared with the one which we have rejected; it also has its own law, construction and meaning, and only when we have cognized it will our works be founded on the truly new law of transrationalism.[83]

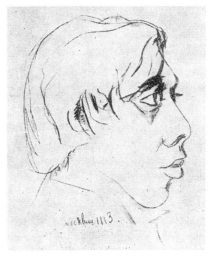

**84** Velimir Khlebnikov, *Drawing of Aleksei Khruchenykh*, 1913.

The *zaum* method is crystallized by Malevich into a method employed for purely creative ends.

As a painter, Malevich was able to realize the broader linguistic implications of transrationalism more fully than his poet colleagues, because he was able to exploit the material advantages, intrinsic to the medium of paint, while the poets were by definition limited to the printed page. Malevich's transrationalism encompasses the additional aspect of visual and aesthetic formation and construction of the letter itself.

*Lady at the Poster Column* is a sensorial bombardment of pictorial and 'verbal' information that confronts the viewer in a similar fashion to a passerby absorbing advertisements and announcements. The hectic nature of fragmented 'fact' within the composition dwells upon the interactive cognitive capabilities of human perception, and reflects upon the systems of ordering information that the mind is receptive to. Unlike *An Englishman in Moscow*, here Malevich has expanded the painterly surface to include another dimension – that of collage. Newspaper elements from Russian and French journals are integrated, bringing written languages into the primary realm of the visual. Through a brief but intense visual blast pieces of excerpted 'words' from newspapers are absorbed. The masculine adverb 'African' Африканскій гр is coupled with 'gr', and from the mysterious fragment are stirred a combinatory subclass of words, images and ideas like 'city' or 'citizen', or 'hail', or . . . one's mind wanders. These associations are, of course, impacted upon, manipulated, and contextualized by the preceding 'African'. Other verbal flashes include the name 'Aviva', and below, the temporally oriented line 'day 9 in/to 14', and further below, 'Thursday' (seemingly a favourite day of Malevich's). Fixing the centre of the painting is the newspaper shard 'to part from without', which reads in one uncut line.

Inside this newly fused system fragments from the printed page, of a single bold letter (like 'Y') or a design of 'pyramidal' dots, qualify as expressive. No distinction is made between printed parts of a page and blank parts, as the paper rectangle between the 'Y' and painted pink rectangle asserts. The printed page of paper becomes an explosive signifier; full of meaning as material in itself, material with verbal components, or material with descriptive images. Part of a dancing man, his head dominated and divided by the

painted pink rectangle, clearly poses the page against itself – the visual and verbal interlocking within painting. The collage is further developed by the addition of a pattern for a design of lace, which may be interpreted as a reference to femininity mediating the gap between visual and verbal, because the lace pattern acts as an instant analogue concerning the assimilation and formation of various observed data.

All questions concerning information rely upon the systematizing and ordering of that information; and the way in which information translates itself and permutates. Malevich gives lucid definition to this process. Two collaged haptic pieces of real lace, one still linen white, the other aged and ivory, stand as the actual textile results of the coded patterns below, which are previous incarnations and plans for their form. Two related systems of information organization are displayed on cut pieces of paper; the progressive layering of black circles (the pyramidal dots, which now suggest the binary codes of computer systems), and the grid-based formalized pattern for lace, or an embroidery design for the edges of fabric. Both these rigid and auto-mated methods of ordering and presenting information (similar to small linguistic entities) allow only marginal freedom when compared with the explosive ramifications of the linguistic system in its full range, which is displayed as demonstrative, expressive, and subtle. It is as if a transformation has occurred. The original design proposed by the repetitious paper pattern has been processed through the mechanic referent of the pyramid dots, a process that has yielded an altered material product. Or, is the actual lace the precise result of the original pattern, not a deviation but merely the translation, proving that information assumes various visual formats depending on its intention and use? Perhaps the pattern is coded in such a way that the machine of dots reads it according to its internal mechanisms, mechanisms designed to respond to signifiers that appear differently to our eyes than to mechanical receptors.

This process of form formation underlies the densely layered elements of *Lady at the Poster Column*. A poster column is itself a pastiche of the additive, an ever-evolving conduit of current information; it is a constantly revolving communal collage that invites and entices interpretation and reading. In view of its potentially random and disjunct nature, it awaits processes of presentation and organization that it will never receive precisely because its composition is transient, elusive, and dependent upon the inspiration of application. On the poster column information fights for primacy, where the amalgam of words and images compete for recognition, fortuitously cancel-ling or contributing to meaning. And because of its unconfined and indeter-minate position – there are no rules, only statement-governed objectives of display – the poster column is a place that manages to function effectively without being regulated. As a proposition, its communal and cumulative making signify the possibility of cohesion where there should be none, logic overruled by impulse and necessity. It is determined by one need and defined through one purpose, the intelligible presentation and dissemination of infor-mation.

Malevich addressed these issues with complete sophistication, carrying his project through various nuances of transformation. Only after such a highly

reflected and involved discourse was he able to dispense with the governing parameters of information, which had hitherto reduced communication to a clear but linear mode. After the advent of Suprematism the basic qualifying definitions of information and communication, and even their classical mutual relationship, were permanently altered as systems. Instead of forging linear connections the systems became whole and independent networks, able to blossom within themselves as referential pools of pure cognizing media.

Above the mauve-pink-grey 'S'-shaped form which struggles for self-formation and significance, occurs the strip of patterned paper for the lace design, receiving the arabic letter 'S'. And above this element appears a smooth rectangle of fabric, material of such smoothness that it is hardly distinguished from surrounding patterned areas of paint. This subdued ochre-brown-blueish-grey material pattern (a surface like silk with colours that have faded with time, though the cloth maintains its original sheen) possesses the curvacious echo of the 'S'-form, which is obscured as it undergoes transformation. It is different in character, design and shape because of a shift in material away from paint into woven fabric. And the significance of the fabric is reasserted in the most heavily painted section of the whole composition, the blue-brown-pink impasto horizontally to the left of the fabric. With an accent of green swirled in, this is a proto-expressionist demonstration of painting using thick, wet, blended paint – in form and sensibility it mirrors and mimics the bleeding pattern of the fabric. The evolution of the 'S'-form, from a nascent state through the screen of the paper lace pattern into the transformation of fabric, and finally arriving at the fully formed but totally unattached accumulation of bold brushwork, displays Malevich's transcriptive and reflective progression from the verbal into the pronouncement of the painterly. This small but intense region is the most liberal and bold admixture of free colour and liquid anywhere in his oeuvre until this time. Paint, paint alone, emerges as the result of each and all transformative states.

Thus idea evolves into pattern, is given form through material, and concludes in paint. The idea is revealed in a four-fold discourse about the inception, procedure and realization of human thought in creation as validated in a demonstrated reality. This mind-shattering, head-splitting process can barely be sustained within the composition; it seems to require an outlet from vibrating chaos, from a disintegrated reintegrating representational world seeking a resolution that can only come in the form of pure darkness, and that would entail total destruction if it were not to attain resolve in a serene and classic calm. And this calm would have to involve a manifest ideal; it could only be premised on an untold and untellable state – Suprematism. The absolute reconciliation of this generative proposition would have to be supreme.

Malevich moved beyond expansive poetic techniques concerning word construction, questioning not merely what constitutes a word, but also performing the atavistic incarnation of the letter itself. Unlike the poets revelation of the letter's autonomy, with Malevich the letter is revealed as it

is destroyed before our eyes. His letters surface tentatively, and then degenerate into the oblivion of paint. In the purple/grey and dark-blue/grey rectangles letters are born and letters are repressed. With an uncontrolled and unpredictable logic, a faint 'O' and 'E', a stronger 'P', and an oversized dual-toned 'S' arise from a mercurial painterly region which also breeds a line of small, dark-grey, vertical brushstrokes. In the centre of the composition the outline of a black circle can be regarded as the more secure proposition of an 'O'. On the right side is a bold black 'B', backed by clearly defined white, brown, and blue planes of colour. The hesitant method of painterly letter formation on the left side has yielded more concrete results on the materially constructed and tactile right side Cyrillic 'B' – a pronouncement of painting's ability to generate entirely new semantic significance.

The form observed to be an 'S' in this linguistic series of signifiers, may also be regarded as a purely visual entity, that is, one sound hole in the face of a violin or other string instrument. Malevich had employed this device previously in *Cow and Violin*, where the single evident sound hole on the right side appears as a written 'S' and not the actual form of the sound hole, which is a backwards 'S'. Comparison to any of Picasso's and Braque's Cubist paintings that utilize the violin reveals that they never transformed any of the actual and observed components, always rigidly adhering to observed reality. Malevich's intentionally conceptual transformation of the sound hole in the violin becomes a linguistic correlate to a visual form. In *Lady at the Poster Column* the 'S', which primarily functions linguistically, is a clear reference to the auditory significance of the letter. With this multiple implication Malevich transforms the letter into a sign, relying upon the fluctuating context of the painting to expand meaning. The appearance of the form, when considered as a letter, finds direct correlation in a brief manifesto by Khlebnikov and Kruchenykh entitled 'The Letter as Such' (September 1913). Discussing the expressive power of articulated handwritten letters in text, they note: 'Our handwriting, distinctively altered by our mood, conveys that mood to the reader independently of the words. We must therefore consider the question of written signs – visible, or simply palpable, that a blind man could touch.'[84] Malevich's 'letters' in *Lady at the Poster Column* reflect upon these ideas, yet also necessarily subsume them, because through painting he is able to incorporate the 'handwritten utterance' into a formal, tactile visual scheme that transforms any 'letter' into sign.

The sequence of letter formation from the left to right side transcends the *zaum* critique of convention, integrating phonetic and implied semantics (both *zaum* and conventional, as well as the painterly precedent of Cubism)[85] into the dominant spatial system of painting. It is within this restrained two-dimensional format that Malevich obliterates observed reality with great assertions of colour, the triumphant touch of his brush able to confront, mitigate and integrate any aspect of any language that allows man to imagine and interpret his universe.

**85** *Suprematist Drawing*, 1917, pencil on paper (35.3 x 51.5). Museum of Modern Art, New York.

Man has invented something of interest: the conditional and the relative. And in particular, relativity proves that nothing constructed and nothing ordered exists; and also that nothing chaotic exists. Hence, one can deduce that life's totality relies upon defined [i.e. not natural] rules and laws which are nothing but empty stipulations (the conditional) governed by relativity.

– Kazimir Malevich, 'Suprematism as Pure Cognition', 1922

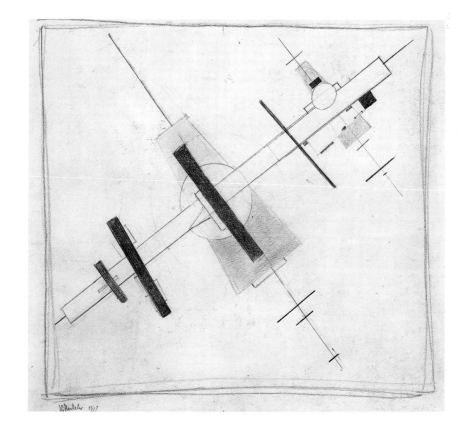

# The Edge of Innovation

What, then, are the triumphant touches of Malevich's brush, and what languages can man employ to imagine and interpret his universe, a universe which has never been more encompassing, fraught with contradiction, or characterized by complexity and trans-sensorality. The 'world' Max Planck and Albert Einstein invented, a sub-universe of our physically knowable surroundings, constituted its own 'reality', separate and significant – a self-contained sub-atomic nature which divides the twentieth century from all others.

The aura of change, necessitating a complete reassessment of convention, that Malevich and Khlebnikov were immersed in, finds a parallel in the sphere of scientific inquiry in Russia at the turn of the century. Among Russian physicists a major intellectual shift gave rise to 'idealistic physics.' On philosophical grounds the 'idealists' turned against classical tradition, attacking Newtonian physics as over-simplified. Like Malevich and Khlebnikov, who realized that convention could only be altered through radical reorientation, the new physicists reacted against old inadequate models by creating different, at times hypothetical, ones. As A. I. Bachinskii, the Russian translator and the chief defender of Henri Poincaré's ideas, asserted, all scientific generalizations and concepts are 'symbols' or 'models' and not mechanistic reflections of the outside world. While sensory data generated an ephemeral picture of the external world, 'symbols' and 'models', constructions of man's logical mind, revealed the 'essential' and 'real' aspects of the universe.[86] The phrasing of phenomena must not exclude or contradict our physically apparent foundations in the world we 'know' and inhabit. The concept states that the macrocosmos is intimately dependent upon a new sub-atomic foundation, which is governed by different criteria but does not invalidate what man has invested into organizing familiar phenomena.

Ernst Cassirer, one of the most challenging philosophers from the 1920s, who traced the evolution of the major ideas man employs to secure his world (the neo-Kantian critique of intellectual formation), reveals his thinking in two main texts: *Zur Einsteinschen Relativitätstheorie* (1921) and *The Philosophy of Symbolic Forms* (1923). Around this time, when Malevich wrote his significant philosophical text, 'On the Subjective and Objective in Art or On Art in General' (1922), Cassirer addressed issues of relevance to the discourse conducted among the Russian Futurists, both before and after the Revolution. In his three-volume inquiry into symbolic forms, Cassirer focuses on the problem of objective meaning in the sign through an analysis of the 'universal function of the sign' and 'the problem of "representation" and the structure of consciousness'. In reference to the physicist Heinrich Hertz, who explained phenomena in the natural sciences through a statement governed by their necessary connection, Cassirer writes that the physicist:

...must not only leave behind him the immediate world of sensory impressions, but must seemingly turn away from them entirely. The concepts with which he operates, the

concepts of space and time, of mass and force, of material point and energy, of the atom or the ether, are free 'fictions'. Cognition devises them in order to dominate the world of sensory experience and survey it as a world ordered by law, but nothing in the sensory data themselves immediately corresponds to them, yet although there is no such corre-spondence – and perhaps precisely *because* there is none – the conceptual world of physics is entirely self-contained. Each particular concept, each special fiction and sign, is like the articulated *word* of a *language* meaningful in itself and ordered according to fixed rules.[87]

As in the world of painting, physics develops its essence through the positing of abstract conceptions against sensations gleaned from the externally observed world. And whether their relationship is intimately linked or dis-tantly felt, the conjunction and necessary confluence between thought and articulation of conceptions in language is at once incidental and habitual.

The inception of a conceptually valid sphere of interpretation relevant to poetry and painting can be likened to the revelation of the subatomic world in physics. Just as subatomic expressions affect our macrocosmic world, so too must the conceptual be expressed in art. The dependency of each upon the other is a crucial realization; each must accommodate and not negate the other. Separation of the conceptual from the physical would reduce it to unintelligibility.

Thus, the conceptual breakthroughs initiated by Khlebnikov and Malevich must be located within a wider arena of progressive thinking that had brought forth an epistemology capable of embracing innovation. The interpretation of the discourse among the most radical members of the Russian avant-garde gains its full historical significance only within this extra-artistic context. Separating art from the rest of culture or discussing movements only in relation to others (making analogies and comparisons between Russian Cubo-Futurism and French Cubism), treats conceptual innovation in a for-mal and simplistic fashion and sequesters it within a category of random inception.

By 1914 Malevich's painting had emerged as a distinct series of aesthetic-ally articulated issues with correlates in other intellectual fields. As Malevich himself admonished, in poetic language: 'Only with the disappearance of a habit of mind which sees in pictures little corners of Nature, madonnas and shameless Venuses, shall we witness a work of pure, living art.'[88] Painting is not the linear transcription of theory from other seemingly unrelated endeav-ours, like atomic physics, but rather the complex manifestation of a historical moment composed of various stratified and ever-present attempts at a reformulated cognition of knowledge and existence. And inside each appar-ently discrete system, like painting, individual parts may necessitate specifi-cally designed definitions of their characteristic purposes. Thus, the discussion of *Lady at the Poster Column* may differ from *Suprematism: Self-Portrait in Two Dimensions* in analytic and formal terms, however, the embrac-ing and underlying theoretical constructs may yield a synthesis grounded in the cohesion of a time of change that is as unified as any other time.

Concerning the topic of time, it was Velimir Khlebnikov, among all members of the Russian avant-garde, who conducted the most profound investigation of its significance as the fundamental tool of comprehension enabling man

86 Velimir Khlebnikov, 1913.

to relate to the expanse of his universe. Khlebnikov's quest to gain insight into the workings of time had specific historical applications. In 1904, when he was a student of Lobachevsky in mathematics and of Baudouin de Courtenay in linguistics at Kazan University, news of the decimation of the Russian fleet at Tsushima prompted him to seek a mathematical understanding of historical events. Attuned to the tumultuous history of humanity, he believed that it could be understood through the use of numerically structured networks. The breadth of his poetic endeavour demanded the inclusion of any applicable hermeneutic systems, like mathematics, because Khlebnikov aspired to a logic of the 'real'; he recognized, from the outset, that this project would confront the pure essence of his mind.

Participating in history itself, Khlebnikov spent one month in jail at the age of 18 as a consequence of his involvement in an anti-government demonstration. In a letter to his parents from jail he writes, 'I am studying physics these days, and have read more than 100 pages . . . One of us is a mathematician and has written to Vasiljev[89] about the coming exams, and Vasiljev has answered that the last ones are on December 18, so we still have enough time to prepare . . .'.[90] Although his first academic focus was upon physics and mathematics, which he pursued for six complete years,[91] Khlebnikov was interested in diverse disciplines. In 1905 he made a five-month expedition into the Urals with his brother to study birds, and the following year he delivered a paper ('Ornithological Observations . . .') to the Kazan University Naturalist Society, of which he was a member.[92] In 1908 – the year 'Incantation by Laughter' was written – Khlebnikov transferred to St Petersburg University, at first continuing his studies in mathematics and natural sciences, but later changing to major in biology, then Sanskrit, and finally Slavic linguistic studies. In St Petersburg Khlebnikov quickly became associated with the leading literary circles.

His ability to synthesize information gained from various sources and to

87 Velimir Khlebnikov, sheet of drawings, dated 21 June 1900.

impose his will upon knowledge is reflected in 'K' (written March 7–23, 1915), a nine-part prose piece describing the escapades of a soul travelling throughout the world, forwards and backwards in time. 'K' is replete with references to the numerous academic disciplines that Khlebnikov had explored as a student and reflected upon as an artist:

And K introduced me to a scientist from the year 2222 ... 'Number of eyes, two,' he read. 'Number of hands, two; number of feet, two; fingers, ten; toes, ten. Fingers and toes combined, twenty...'

... We discussed the advantages and disadvantages of that particular number. 'These figures,' he said, with a piercing look from his large intelligent eyes, 'do they ever change?'

'Those are the maximum figures,' I answered. 'Of course people do turn up from time to time with only one arm and one leg. And there will be a significant increase in such people every 317 years.'

'And yet,' he answered, 'this gives us enough information to calculate the equation of their death.' 'Language,' remarked the scientist from the year 2222, 'is the everlasting source of knowledge. What is the relationship between gravity and time? ... The very soul of your language shows us that weight and time are different absorptions of the same force.'

He thought the whole thing over. 'Yes,' he said, 'language contains more truths than we know.'

All this happened back in the days when people made the first flights over the capital city of the north. I lived high then and thought about the seven measured feet of time. Egypt, then Rome, Russia alone, England; I drifted from the dust of Copernicus to the dust of Mendeelev, constantly aware of the noise of a Sikorsky airplane. I was preoccupied by the wavelengths of good and evil, I dreamed of the convexo-convex lenses of good and evil, because I knew that black burning rays coincided with knowledge of evil, and cold bright rays with knowledge of good. I thought about bits of time melting into the universe, and about death.[93]

The fluid voyages K initiates and the appointments he arranges explore facets of knowledge that give reason to existence. Khlebnikov introduces mythological characters, like the goddess who uses a dead butterfly impaled on a porcupine quill for a fan: 'In her hand was a willow twig with silvery buds, the hand of the Venus of the Apes.'[94] Invented or known legends comprise a repertoire of images that are treated as independent and significant – not interpreted in personal or symbolic terms. Each adventure is externalized and accessible to the reader who is included, and thus capable of generating related and personally valid interpretations.

At the time 'K' was written, the new interpretative discipline of psychology was prevalent in the West, and was making a heavy impact upon the Russian Symbolist movement. Unlike the Symbolist techniques, which equated images with emotional memory, Khlebnikov's diverse imagery relates to mythology, regarded as history devised by man. This method exceeded the established intransigent Symbolist catalogue of images, allowing Khlebnikov to write an autonomous text that comprehends the world conceptually through the rationale of modern science. Within Russian literary circles, Khlebnikov emerged as the proponent of a position that denies naive egocentric perceptions of man and the belief in Nature as finite and knowable. The Symbolists, Impressionists, Acmeists, Ego-Futurists, and sundry Theosophists all adhered to the convention that man's relationship to the object in

88 *A Purse was Snatched on the Tram,* c. 1913–14, pencil (17.7 x 8.3).

Nature was linear and unbroken – negotiable through marginal fluctuations in perception. Khlebnikov understood the double alienation (of both man and the object) which, through reflecting upon the unsettling stipulations of modern science, resulted in Nature being as vast as any conceptual investments man is able to make. Nature as such can only ever be theoretical fiction. Opposed to the conviction that man is an arrangement of construed sensory data, Khlebnikov relegated measured and recorded data to the primary echelon of information upon which theoretical constructs are formulated. Hence, the insouciant pair, K and the narrator, embark on a discourse which is neither metaphysical nor utopian, but based upon a new epistemology aimed at collecting insight about the nature of the universe.

89 Velimir Khlebnikov, *Self-Portrait*.

Khlebnikov's singular endeavour is governed by the primacy of time over any other cognitive measure for man in Nature, meaning, for example, that time dominates as the dictating notion that shapes space. The concept of an ever-expanding, flexible time, indebted to contemporary definitions in science, represents the cornerstone of his thoughts about man's new situation in the physical universe. Khlebnikov's philosophical reflections were ingenious responses linked to certain scientific articulations: Chebychev's probability theory, Minkowski's interpretation of Einsteinian relativity, and above all the intricate workings of the atomic model as elaborated by Planck and Bohr. All their ideas were readily available to Khlebnikov through the writings of his former Kazan University teacher, Vasiljev.

Life, as Khlebnikov understood it, was affected by systems, and thus could best be interpreted through the investigation of systemic structure. His devotion to knowledge, world travel, personal experimentation and experience reveal his encompassing desire to conduct an intense physical and cerebral life. In 1911, at the age of 26 and with an advanced formal education behind him, Khlebnikov wrote a letter to his brother that anticipates 'The Tables of Destiny' (1922, unfinished), his most comprehensive exploration of how human history functions in time. In his letter of 1911 referring to the final project which was to be his masterpiece, Khlebnikov prophetically states 'I am making a diligent study of numbers . . . I intend to keep going and work it all out completely, until I get some answers as to why it all behaves this way.'[95]

Life, as he understood it, was affected by systems.

Purple, red, green, orange, black, brown, all posed against white. Powerful black, red flying, orange asserting, quiet purple, small green, and other black pieces evading – all posed against white. Rectangles, trapezoids, squares and bars in any order all posed against a white surface. Above and below; two categories of space, two groups of forms, divided and bound by a long diagonal and a short diagonal running in the same direction. From top to bottom or bottom to top, sideways from the left or sideways from the right . . . in this way, the forms of *Suprematism* are to be seen, felt and thought of (illus. 93). A paradigm for the pure invention of man, the arbitrarily arrayed forms do not resemble conventional compositions. Composed of rising random sensations, characterized by discontinuity or only an uneasy local unity, the forms function beyond any external reference. Scale becomes a relative

117

notion that the viewer may or may not elect to apply to an interpretation of the forms. The painting's validity, as a concept, depends only on what the viewer/interpreter is able to generate in terms of a cogent and meaningful reading.

All of the 'classical' terminology that painting acquired over the centuries comes under question in Malevich's Suprematism. The depiction of an illusory space has been supplanted by an unspoken rhythm operating between the forms in the actual space of the canvas, with its tactile articulation of 'depth' accentuated through the overlaying of shapes. Malevich's space is more real than any Renaissance perspectival illusionistic space.

Through such descriptions of paintings like *Suprematism*, fundamental issues of how syntax functions within language to construct conceptions and semantics are brought to the fore of any discourse on art. There are two possible approaches: either to discard all insufficient terminology, or, perhaps more informative, to reorient deficient terminology in order to carry on the description and discussion of new creation. Such analysis can only serve to bring out the complexities of both the painting and artistic discourse itself.

Suprematism did not exist until 17 December 1915, the date of its public debut at the '0.10. Last Futurist Exhibition' (illus. 114) in St Petersburg, where Malevich chose to present his new art in a body of 39 precisely installed paintings. As a single extant photograph reveals, *Suprematism* was among these first works, hung in a corner closer to the ceiling than to the floor, or farther from the floor than to the ceiling. Relying upon the wall as a surface for creation in itself, Malevich arranged his paintings so that the space they occupied by covering the wall became as significant as the interceding space between them.

That certain paintings were hung in deliberate proximity tells of the intended relationship between them, assuming lateral, vertical and diagonal orientations. It was through couplings and comparisons that aspects of individual paintings were accentuated, if never fully explained. For example, when the viewer compared *Suprematist Painting: Aeroplane Flying*, to the paintings immediately above and to the left side, the viewer would have tended to engage various elements of each painting in a dialectical assessment and counter-assessment. Of course, nothing limited comparison between *Aeroplane Flying* (illus. 102) and a painting as far away as *Painterly Realism: Boy with Knapsack – Colour Masses of the Fourth Dimension* (illus. 103), in the upper-left corner. If this is accepted then Malevich's installation differs from any others, of either representational or non-representational paintings, because the autonomy of each painting was simultaneously asserted and destroyed.[96] Each painting became equally involved with every other, proposing a sort of alphabet that was densely layered and labyrinthine in its combinations. The most prominent painting was the *Black Square*, hanging at the top of the corner at 45 degrees from each wall as if to suggest that the paintings on both walls should be treated as a composed entirety. Beneath its elevated position, all the other paintings operated in a democratic fashion.[97]

The wide range of compositional structures inherent in Suprematism from its inception reveals a curious eschewal of conventional criterion regarding

how the viewer is to determine style and painterly consistency. From the titles alone diversity is revealed as essential to the Suprematist undertaking. Some paintings like *Red Square: Painterly Realism of a Peasant Woman in Two Dimensions* maintain through the precise title an allusive relationship to an apparently observable phenomenon. This red square on a white ground is derived from the image of a peasant woman as conceived by Malevich. The painting, however, does not resemble ordinary vision, because it is painterly realism – as emphasized by the artist – and human beings do not exist in two dimensions, except as now transformed in Malevich's painting. This external reference in the title questions the limits of our perception of phenomena per se, also reflecting upon the mediating power of paint, which functions between perception and cognition.

*Suprematism: Eight Red Rectangles* (illus. 104) asserts itself by enumerating its basic parts, by calling attention to the constructed painted geometric forms referred to as rectangles, and not by deriving meaning from externally observed phenomena or ideas. Indeed, the rectangle can only ever be a concept because it is one component of the artificially constructed language of mathematics – Euclidean geometry. Malevich inquires into the arbitrary nature of such languages by giving each rectangle its own orientation upon the painterly plain, denying the imposition of any predetermined scheme. There are no set axes governing the placement of these shapes. In the '0.10' exhibition, as revealed by the photograph, *Suprematism: Eight Red Rectangles* maintained a special position, being the lowest (at knee-level, close to the floor) of any painting in the exhibition. Characterized by an inherent aesthetic beauty, it retains, unlike most other Suprematist paintings, a vestigial relationship to traditional standards. It is this allusive painting that defines an actual limit, simultaneously implying that there need be no rule dictating the positions where paintings may hang.

One of the most complex compositions, *Suprematism* (illus. 92), can be characterized as self-sufficient painterly realism governed by its own internal rules of creation: rectangles, trapezoids, triangles for the first time, circles, and rotated chevrons combine with forms that conventional language has no name for. Indeed, does this not make the viewer wonder whether forms are characterized by the assigned labels of verbal and mathematical language, or whether forms are beyond linguistic description, more complex than syntactical combinations from existing language can describe? This incompatibility between language and observable forms directly implicates the definition of realism, as that notion developed in the nineteenth century.

This concern with understanding 'realism' through language lay at the core of progressive discourses emerging in early twentieth century Russia. In the natural sciences, especially in the domain of rapidly advancing physics, new methodological principles accompanied the major re-evaluations and refutations of certain fundamental tenets of classical thought. The scientific community in Russia at the turn of the century was adept at adapting the latest discoveries occurring in the West. Publications like *Scientific Word*, dedicated to the popularization of the newest scientific trends and achievements, enabled astute readers to glean crucial facts necessary for the

formulation of epistemological and philosophical viewpoints. An example of the rapid, yet sophisticated, Russian response to recent discoveries in modern physics is evidenced in N. A. Umov's 'The Evolution of the Atom' (1905), where he:

... described the gradual development of an unorthodox orientation in science. Such discoveries as electric waves, X-rays and radioactivity cannot be explained either in terms of classical physics or by crude empiricism. At the end of the century we thought that science had already penetrated the innermost depths of Nature; but now we know that it had only worked on the thin surface of the physical universe. The world unveiled by the physics and the chemistry of atoms had opened new paths to the comprehension of a single *reality lying far beyond our senses* [our italics].[98]

This definition of the new physics can be likened to what Khlebnikov intended to perform with the poetic word – namely to intimate a 'reality far beyond our senses', the *zaum* reality. His artistic exploration aspired not to confront and dismantle conventional modes of apprehension, but rather challenged awareness of, and adherence to, classical logic itself. Khlebnikov aimed to transcend the five physical senses. Does not Malevich's painterly proposition of *zaum*-realism question whether the boundaries of each of these senses should be entirely eradicated, thus permitting the theoretical inception of senses not previously conceived of?

Malevich, who aspired to create a unity from new elements, included all spheres of intellectual and artistic activity in his new conception of reality, reacting against tradition, as the following characterization reveals:

Art, like science, strives to break down reality into its component parts in order to grasp it in thought. But for poets, as for scientists, again and again, only an object emerges from their notion of reality. Consequently, it is not so much reality that is grasped, as rather *a mere notion of reality* [our italics]. Art which has arrived at Suprematism, at non-objectivity as the universal reality, reveals the significance of all that is objective for the ascent to this border.[99]

What Malevich regards as the flaw in those nineteenth-century and traditional ideas which dictated man's relationship to Nature (exhaustively articulated throughout Western philosophy, science and art) is the overriding self-imposed necessity to invest all cognition into tangible objects. Of course, there can only be as many cognitive principles as there are objects to reflect them. Malevich's proposition, that theoretical realities result from the absorbed information of conceptual 'senses', is unrivalled among visual artists, especially when we again recall that he formulated his theories in Russia before World War I. Reality could no longer be defined as one secure empirically experienced world of objects. Reality was now a matter of a notion, an assertion by man and his logic.[100]

Malevich's theoretical position was developed in painting as the result of a sustained consideration of Khlebnikov's elaborate mathematical and scientific schemes, which demand universality. Distinct spheres of culture, as Malevich advocated, must be regarded as interlocking parts of a new theoretical unity. The Suprematist 'ascent to this border' entailed the crossing of all man-made boundaries which separated creation from intellect, and the erasure of the arbitrary distinctions between cultural pursuits. As Malevich and Khlebnikov drew from diverse worldly fields, so too did scientists, engineers,

architects and other 'artists' (Malevich refers to all these professionals). Indeed, even the arcane mystical writings of Ouspensky rely upon an awareness of the latest advances in atomic or 'theoretical' physics to formulate a new criterion for human engagement. Matiushin's inspired interpretation of Cubism, infused with Ouspensky, is an example of intimate intellectual communication; and of a methodology that relies upon an expanded range of referential information to supply insight into isolated areas of once-specific disciplines.

Khlebnikov, attuned to the enormous discoveries that refuted science's classical foundations, was engaged in a discourse that sought to re-evaluate the way man could explain the workings of the universe. He was well aware of such ideas as Poincaré's contention that scientific knowledge could not be reduced to, or derived from, experience alone – that even the 'self-evident' postulates of Euclidean geometry were mere conventions invented by the human mind;[101] or, as Malevich believed, notions of categorizing reality.

The difference between scientific/mathematical and artistic/verbal-visual language systems is that each element in scientific syntax has an assigned and unequivocal meaning, while verbal syntax has a multiplicity of constantly changing meanings dependent on context. It is the combination, and not segregation, of linguistic systems that permits deep insight into man's (physical and cerebral) environment. Without interaction, conceptions intelligible and promising in one domain would be of no consequence to those not conversant with that particular and explicit syntax. As early as 1927, Werner Heisenberg focused upon the impossibility of applying conventional language to the understanding of the atom or to phenomena observed in specialized experiments in twentieth-century physics.[102] The limitations of language for such uses had become undeniable with the advent of quantum theory, which did not so much describe the new ideas as supply the syntax necessary to permit their articulation. It was Niels Bohr who stated that the various possible languages required to articulate a single system are complementary, rather than interchangeable: 'The wealth of reality ... extends beyond all possible languages, beyond all logical structures. Each language [mathematics, physics, painting, poetry etc.] can only express part of reality.'[103] Concerning the interdependence of languages, and the rapid advance of scientific inquiry from 1890 through the second decade of the twentieth century, an anthropologist who centred his research upon the correlation between linguistics and the natural sciences, Benjamin Lee Whorf, noted the essential conceptual shift in how data were interpreted. Not only were 'new ways of thinking about facts' required, but 'a more nearly accurate statement would say new ways of talking about facts. It is the use of language upon data that is central to scientific progress ... "Talk" ought to be a more noble and dignified word than "think". We must face the fact that science begins and ends in talk ...'.[104] This shift in outlook concerning the methodology of scientific inquiry is reflected in a profoundly altered conceptual approach to natural phenomena.

Malevich's Suprematist paintings can be regarded as directly reflecting upon the dialectic between language and thought. His exploration of language has

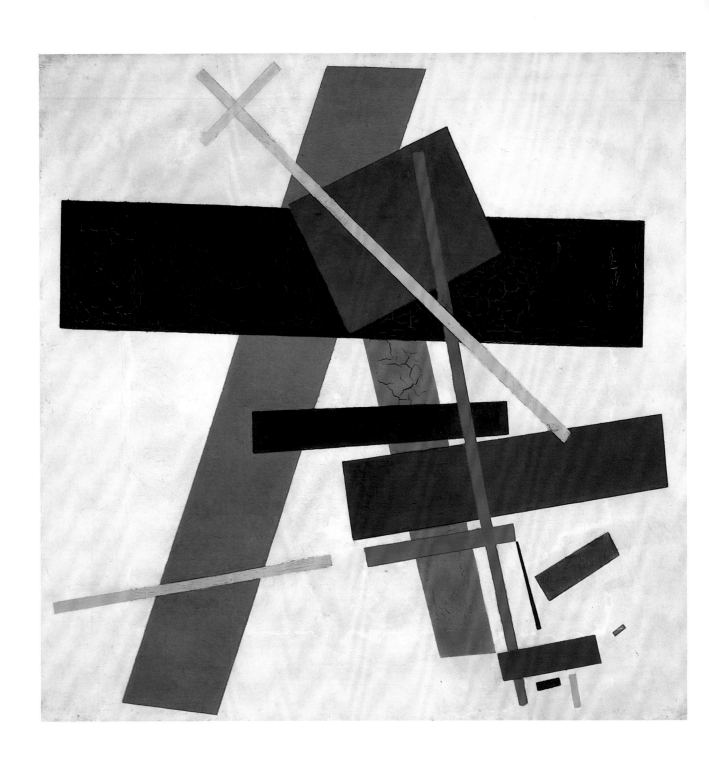

**90** *Suprematism*, 1915, oil on canvas
(87.5 x 72). State Russian Museum, Leningrad.

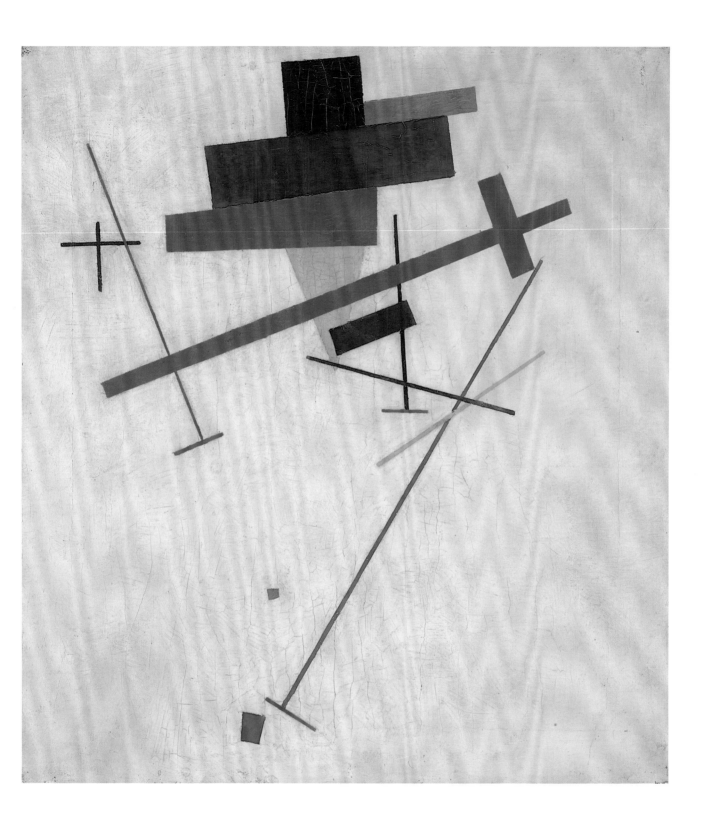

**91** *Suprematist Painting*, 1915–16, oil on canvas (49 x 44.5). Wilhelm-Hack-Museum, Ludwigshafen.

less to do with the dissection of discrete signs than (in keeping with Khlebnikov's approach) with the discovery of *how* language is created. Close hermeneutic analysis of Suprematist paintings proves that this question lies at the foundation of Malevich's endeavour as a painter.

Upon seeing *Painterly Realism: Boy with Knapsack – Colour Masses of the Fourth Dimension* (illus. 103), the viewer feels impelled by a black form which resembles a square, but is rather composed of sides of various length. Floating against a white ground, the diagonal black sides react against the rectilinear canvas corners. The red form below, with equal sides, assumes an uncertain position within the white, vertically-defined plain of the canvas, unsettled by the black form above. The eye circulates inside the white rectangle, assessing the created forms, measuring distances to corners and sides, vertically and horizontally, deciding upon two forms or three. Indeed, a dialectic ensues between existing forms (that of the canvas) and created forms (those of painting), declaring that the picture is composed of itself as much as its elements. The similarities of the three forms in terms of shape and linear definition intensifies the interrelationships, which further engage the viewer because each form is characterized by a distinctly different treatment of paint. Applied paint formulates an individuality of surface texture that succeeds colour as a distinguishing factor. The frenetic brushiness of the black plain, alluding to transparency, is in profound contrast to the opaque, assertive red. The white surface embraces these polarities, allowing the separate elements of texture and form to intermingle, producing hybrid effects and meanings. For example, the black and red forms appear to float, adrift fortuitously upon the white ground – and this is achieved through the various activating textures.

The marginal difference between the tactile, dynamic elucidation of surface in the white ground and the partially translucent black rectangle, emphasizes the dichotomy between the white ground and the tightly constituted red square. This correspondence between the painterly dynamism of a dense surface and its formal outcome had specific meaning for Malevich, who noted:

... in one and the same picture I create the same forms, but colour them with different colours ... in order to underline that in my pictures I draw a strict distinction between colour and form ... I colour the form with this or that colour, not because red or blue corresponds to this or that form, but because I paint in colours according to the scale that has arisen in my creative centre ...

In addition, I would also state that in such cases two principles always begin to clash. Both claim supremacy – the principle of knowledge, the centre of consciousness, and, on the other hand, the centre of subconsciousness, or sensation ...

The creative process begins beyond the realm of knowledge ...[105]

Through his paint application, Malevich seeks to overcome the viewer's obvious impulse to regard the painting merely as an arrangement of basic forms. In *Painterly Realism: Boy with Knapsack – Colour Masses of the Fourth Dimension* the specific characteristics of shape are subsumed by the painterly articulation of the canvas surface, achieved with two tones (white and black) and one colour (red). Attention to the formation of forms themselves reflects Malevich's desire to resist interpreting his painterly language for the viewer.

By leaving the forms in variously defined states, creation endures as a self-validating process, constantly revealing possibilities.

The tactile quality of the canvas came to be known as 'faktura', an issue Malevich devoted entire paintings to the exploration of. Although certain Cubist paintings show a heightened sense of surface, it is in Suprematist works that the articulated paint surface becomes a 'foregrounded' concern, motivating inquiry into the phenomenon of impulse, method, and outcome. By reducing colour and suppressing form, paint application assumes a primary role, counteracting any implications of illusionism or representation. In *Suprematism* (illus. 98), and the related 'white on white' series begun in 1916, the painting becomes an object – more precisely a surface – created by the movement of a paint brush loaded with paint. Creation is distilled down to its essence, and painting becomes the immediate response to thought. There need be no external references explaining illusionism or relating to the formal contingencies of representation. With faktura, the haptic aspect of the creative mind is tangibly articulated; the painter is at one with his discipline. The autonomous aesthetic state of art is fully fused with its object. And the viewer may revel in the infinite aspects of surface the guided brush has treated in a random or deliberate way, with infinite detail and with broad generalities. Suprematism, the contained order of an autonomous aesthetic state, is this conquest over limits and divisions. Faktura posits a dialectic between the imagined implications of painting and its evident qualities. In *Suprematism* the placement of the overlapping rectangles (forming a 'cross') and the tonal differentiation between ground and form are fused in the haptic plane – consumed by the surface itself.

Victor Shklovsky, a prominent Formalist critic, regarded faktura as a cornerstone element of defamiliarization – the radicalizing of preconceptions into an 'un-re-cognized' scheme. Emphasis on faktura, in a text or any artwork, removes attention from constructed aspects, focusing the observer's energy upon the artwork per se. The artistic product is a creation that can only be defined by the meaning it generates. Meaning becomes the sole validating criterion for the artwork. In Shklovsky's words, 'faktura generates a new haptical world, placing the viewer in a permanent creative perceptual state.'[106]

We have come to know at least one painting in which painterly and conceptual manifestations achieve a unity that may well serve today as a paradigm for an ultimate state of painting. The conducted act, refined into smaller actions, of the hand-governed brush, organizes structure and arranges texture so deliberately and wilfully that meaning fuses with its image of paint. Malevich's resolved treatment of geometrical issues in Suprematist works led him in 1917–18 to a reduced and essential approach to painting which concentrated on the slow formation of image in paint, rather than the composed placement of shapes and forms onto the painted plane. Malevich accentuates the potential for perceptual experience by amplifying the precision of his painting process. The incessant all-over brushstroke that is nearly uniform threatens itself; it risks discrepancies and differences of form within the small workings of the self. And it is through recognition of the self that the

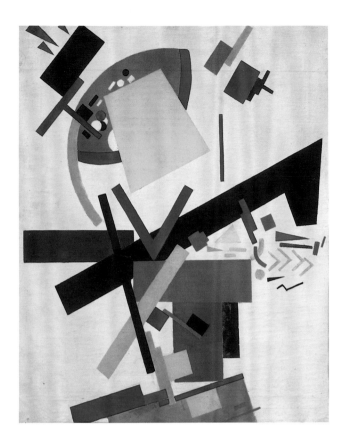

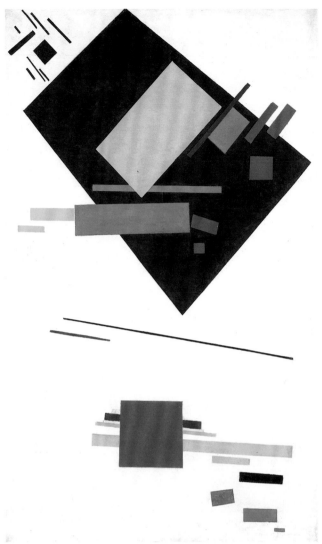

92 *Suprematism*, 1915, oil on canvas
(81.5 x 81). State Russian Museum, Leningrad.

93 *Suprematism*, 1915, oil on canvas
(101.5 x 62). Stedelijk Museum,
Amsterdam.

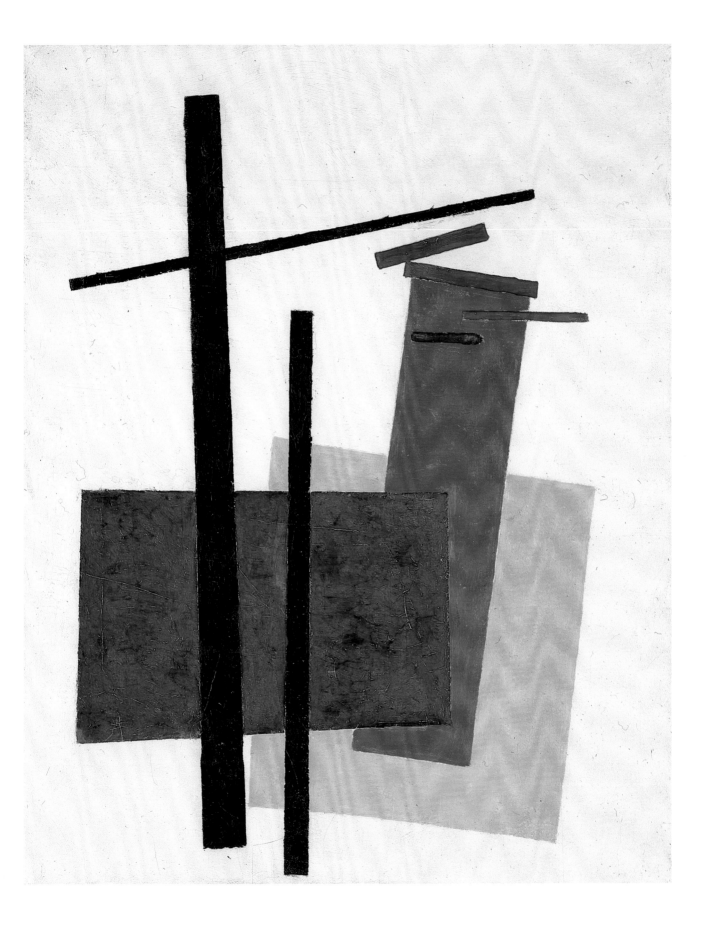

individual brushstroke – which appears in this gesture of painting to be infused with accurate, interlocking, similitude – asserts itself with a modesty governed by complexity. Each stroke, regardless of function or definition, plays a role inside the consistent patterning of surface. The surface is the plane of existence for each stroke. Multidirectional, short, curved movements, arcs of ridged paint in the a-harmonic interplay of the movement, spontaneously organize structure. The style allows for no bare canvas edges, no deviations from the overall painted surface, though the underlying canvas continues to shine through, lending substance to the frail intimacy of one, only one, movement that is alone within. The concept of pattern leads into the core of individuality. The pattern becomes a place of transaction where individuals conspire.

In *Suprematist Painting* (illus. 96) the easy flow among all strokes is interrupted by the hard edge-asserting form. The true hard edge emerges as necessary for the organization and breaking of the brush strokes. Technically, it is achieved by laying, perhaps, a piece of paper (or any flat, foreign surface) over the painted surface of the canvas along the whole defining line. In the case of the left hard edge of the diagonal rectangular bar, form-contrasting short, choppy strokes lead from the 'ground' (i.e. the paper) into the white, literally onto the white. What goes into and what goes onto is the defining line of transmutation, and is also the intersection of two patterns, two surfaces. The process of the flow and of the intersection of two dimensions in paint assumes a continuous character at the top of each crescent shape, where shape-defining line is smoothed over at the painted top parts of the crescent (where the long left line of the rectangle blends away into the calm of white that allows the crescents to survive). The essential contrast occurs with the *sfumato* transitional phase at the lower parts of the crescents, which glide like vapour out of white into the 'ground' (illus. 99). Here distinctions are brought into resolution through colour alone, because the brushstrokes are perceived as equal – despite the 'fact' that they are not. The aspect of transition, which is both striking and unnoticeable, makes the concept of boundary and division almost meaningless. Distinctions become unfamiliar amid this texture. To what design should preconceived ideas conform, if perception undermines consolidation? Indeed, where an entire transitional zone (the fundamental zone of intersection between the lowest tight arc of the crescents and the diagonal rectangular bar's soft sliding side) is characterized by nearly invisible delicate brushstrokes of thinly applied paint, one is left with only the idea of distinction but not the vision. Malevich's brush re-determines difference by assigning the stroke an independent significance, designating individuality amidst uniformity. Like any harvest of clouds, there will only be rain if moisture is present, and humidity may be content – a content never known, its outcome always felt in rain . . . if rain then arrives.

Suprematism, as explored above, emerges as a pure product of the creative mind. Notions of transcendence, often attached to the Suprematist achievement, have no place within this realm of absolute human confidence. Suprematism is not perfection, nor is it the aspiration of attaining a higher individuality. Malevich regarded painting as a way of reflecting upon a world characterized by new concepts, a changing world, an active thinking world

94 *Suprematism*, 1915, oil on canvas (44.5 x 35.5). Stedelijk Museum, Amsterdam. Reproduced as exhibited in Moscow 1919 and in Berlin 1927.

that through its achievements communicated with the greater external universe. In this context, of eternally transitional reality, it is informative to compare Malevich's theoretical strategy to a related one, created by a group of contemporary thinkers whose stated aim was to unravel the workings, not merely of the world, but of the universe.

Any comparison to early twentieth-century physics, that evolved in a similar conceptual fashion, will not necessarily yield an answer to the question: 'how did Malevich develop Suprematism?', or 'where did Suprematism come from?' An attempt at answering this basic art historical question could only lead to an assortment of positivistically derived 'facts' which would, at best, be convincing, but never conclusive. If we shift our focus away from uncovering historically oriented data into the broader realm of conceptual assessment, then Suprematism becomes a powerful statement – an attempt at understanding structure and mechanics, rather than an attempt to answer formal problems about the place of art in society.

If the universe is made up of systems and events that cannot be observed as experience, yet can be known through hypothetical postulates (probability, determination and experimental outcome), then the creation of scientific models as concrete conceptual constructs shows how modern physics replaced its classical roots with a different methodology, exchanging the physical with the conceptual. The existence of a reality, as defined by rules and laws, is only dependent upon how 'the model' is proposed and articulated in language. In the new physics, to be unable to physically experience an experimental event in 'nature', signifies that the experience must be mental and theoretical. Max Planck, a young German physicist whose research formed the foundation for quantum theory, was instrumental in illustrating this conceptual approach to physical phenomena. He addressed the unresolved problem of heat conversion into light by beginning with the assumption that most mathematically complex problems are solved only when the correct answer has been guessed. Accordingly, he set out to find a formula that would fit an experimental curve through a process of trial and error. Having a solution predetermined, the process of inquiry became paramount. Planck, who rapidly discovered an empirical formula, realized, despite the fact that the formula mathematically confirmed the data, that it was not based on a physical picture of the process being described. In this context, mathematics becomes a closed self-referential language, only able to discuss and describe the domain that created it – a process of interpretation that continues irrespective of the actual physical world, yet which is still indebted to that world for its beginnings. Planck's finding of the formula $E=hv$ demonstrated that the conversion of heat into light could not occur in any amount but was transferred in segmented units. The formula states that the smallest of these units must be a whole number multiple of this amount.

Planck's constant ($h$) ranks with $c$ (the speed of light) as one of the two basic constants of nature. Because $E$, at any given moment in the process of conversion, can only ever be a whole number, the formula is characterized as being an arbitrarily imposed rule which restricts energy to granularly composed 'quanta', as Planck called them. The idea of quantum, being an

95 *Suprematist Painting*, 1917, oil on canvas (96.5 x 65.4). Museum of Modern Art, New York.

96 *Suprematist Painting*, 1918, oil on canvas (97 x 70). Stedelijk Museum, Amsterdam.

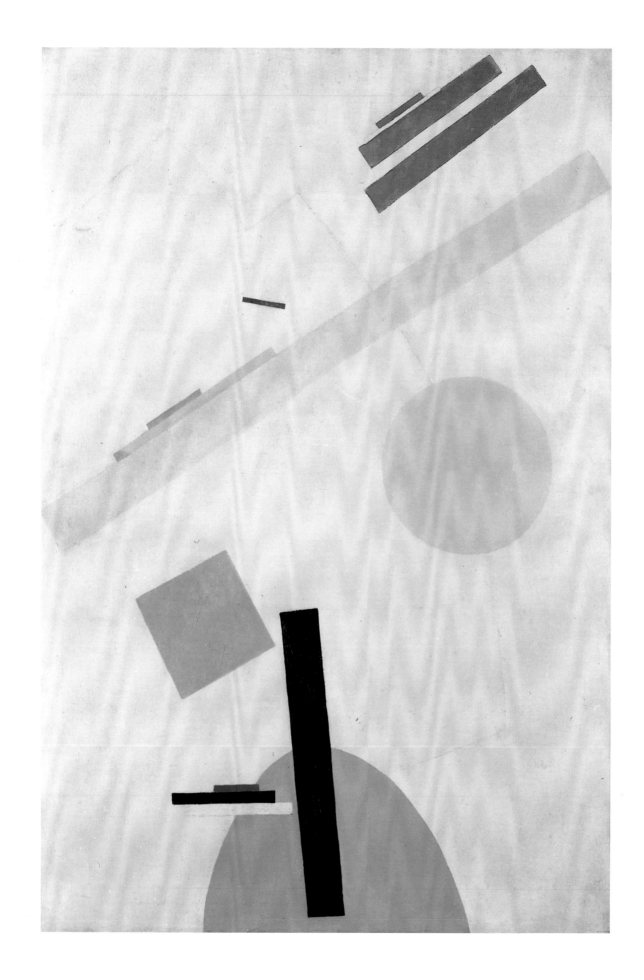

invented condition, stands out in physics as an irrefutable mathematical entirety. Being defined only in whole numbers, never in fractional or decimal amounts, the quantum embodies one of mathematics' most basic assertions, namely, that phenomena can be understood and precisely described through an artificial systematic syntax. Planck's constant inserts unmanipulated numbers into a formula that actually describes the mechanics of a natural process. It denies divisibility and diversity, which are inherent in the mathematical pursuit of explaining complexity. By the late nineteenth century, elaborate mathematical systems had removed thinking from its roots in 'reality'. The numerical precision of Planck's equation illustrates that the whole number represents itself; the formula is not an expressive reflection of a phenomenon, but rather a manifestation of the intrinsic workings of that phenomenon. It is neither creation nor stipulation, but merely a statement which sustains uninterpreted reality.

A paradoxical imperative results from Planck's method and formula. It concerns arbitrariness and its necessity in achieving concordance between syntax and concept. This idea was not confined to physics alone. 'Suprematism', Malevich tells us, 'originated neither from Cubism nor from Futurism, neither from the West nor from the East. For, non-objectivity could not originate from something else; the single significant question is whether something is *cognized* or not. Possibly everything can be reduced to the proof of unity, of general homogeneity – can be reduced to point zero, to the proof that the rejection of diversities can be recognized in everything. Everything observable stands outside of the differentiations.'[107] In *White on White* (illus. 97) Malevich reveals that there can be no discrepancy between theory and painting, in other words, between an arbitrarily generated concept and its painterly expression. From this point of departure, the proposition that denies language's evolutionary representational inadequacy, a conceptual unity is inherent – stating that painting represents itself, painting means painting. The verb and the noun 'painting' is exemplified by the 'white on white' Suprematist works which describe their process as much as their result. The 'painting' represents itself, and only once we have reached this conceptual as well as artistic threshold are we able as artists, or as audience, to generate a multiplicity of meanings which ultimately stand beyond the single represented image. The viewer may effect an unmediated dialogue with concepts in painting, creatively generating implicit ideas. Unlike representational painting, which has a specific, inherent, and internalized cultural context, Suprematism resists any explicit cultural references that the viewer may feel inclined to impose – precisely because Suprematism is non-objective.

The viewer can visually describe, in Malevich's words 'cognize', the painting, and this is significant because Suprematism emerges as a succinct self-defining system – just as Planck's whole number quantum formula can only ever describe its own process. Meaning follows afterwards, separate from the event and reception of painting. Hermeneutics, for theoretical physics and painting, supplies all insight, and should never be assumed to be predeterminate.

Planck's startling innovations at the beginning of this century altered the notion of experience dramatically. What Planck and all other physicists thought disturbing about the derivation of his formula, was that it found no

**97** *White on White*, 1918, oil on canvas (78.7 x 78.7). Museum of Modern Art, New York. Reproduced as exhibited in Moscow 1919.

coherent impetus in the logical realm of scientific inquiry. His assertion of random intuition precedes the radicality of implication, because it was precisely such an expanded conception of science that transformed man's capability of universal apperception. The final outcome of arbitrary creation integrated into empirically relevant models is, as one might imagine, that anything conceived of *is* anything experienced.

The postulate that any existing foundations or systems known to a creator can be available for deployment, or dismissed as inadequate, is a proposition that has no simple manifestation. An example of this new dialectic between pre-existing structures and individually formulated ones occurs with the notion of 'illusionistic space' in Suprematism. Malevich asserted that, 'represented spaces, planes and lines exist only on the picture surface and not in reality. The painter believes that he has caught time, space and spatial relationships in his picture. The painter has no choice but to express his essential being through juxtapositions of differences.'[108]

One of Malevich's most complex compositions, *Suprematism: Supremus No. 58 with Yellow and Black* (illus. 100) will suffice to elucidate the theoretical ideas discussed above. A vertical painting measuring 79.5 x 70.5 cm is suffused with shades of beige. The dominant element is a grey half-crescent supporting an accumulation of geometrical shapes – rectangles, trapezoids, and squares. The viewer's first tendency when approaching this work is to regard the arrangement of forms as objects in space, and to attempt to unravel

**98** *Suprematism*, before 1927, oil on canvas
(88 x 68.5). Stedelijk Museum, Amsterdam.

**99** Detail of *Suprematist Painting*, illus. 96.

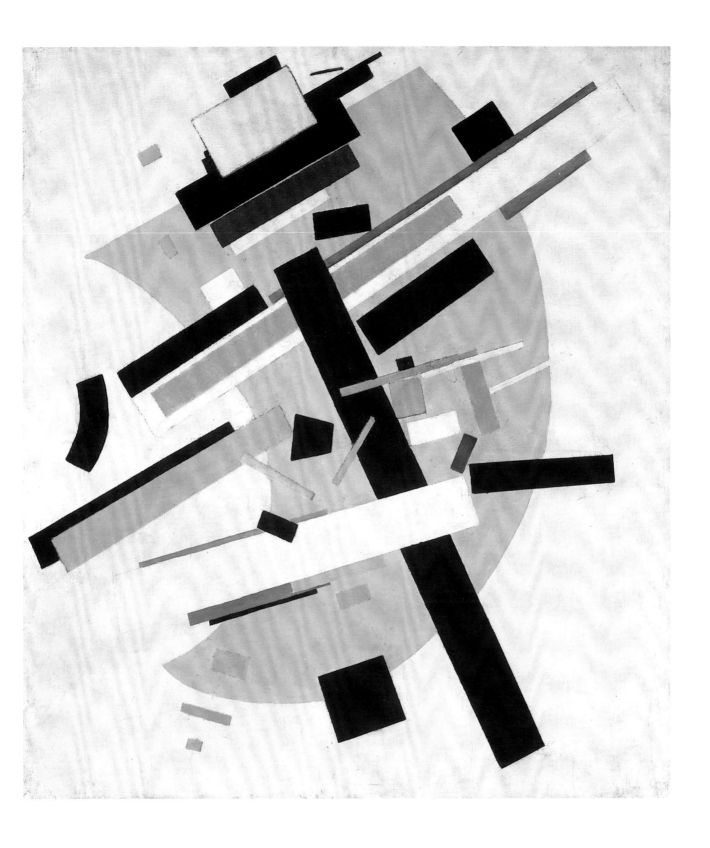

**100** *Suprematism: Supremus No. 58 with Yellow and Black*, 1916, oil on canvas (79.5 x 70.5). State Russian Museum, Leningrad.

their positions in relation to each other. Malevich, however, as we now know, intended an alternative interpretation.

The grey form can be regarded as a non-Euclidean structure, supporting and intersecting with various shapes derived from Euclidean geometry. This proposed reversal of the primacy between classical shapes (here to be equated with Newtonian mechanics) and non-classical shapes (associated with Quantum mechanics and theoretical physics) illustrates a newly recognized concept, that of the dependency of classical upon non-classical geometry. This juxtaposition demonstrates that non-Euclidean geometry is as much of a conceptualization by human beings confronted with the infinitely expanding universe as Euclidean laws were idealistically proposed stipulations (inventions) by ancient Greek geometricians. The Euclidean forms are manipulated so as to constitute the basis for a new vocabulary of visual signs. And this suggests the importance of Malevich's endeavour, not only for painting but also for the articulation and comprehension of knowledge in general. Khlebnikov, in his essay 'To the Painters of the Universe' (1919), demands that conventionally derived forms provide the basis for a universal language: 'The mute geometric signs will make peace with the multitude of all different languages . . . To create geometric signs as the fundamental unit of knowledge is the task of the artist of colour.'[109] And it is the artist of colour who controls polarizing signs. In *Suprematism: Supremus No. 58* . . . the two major cream-coloured rectangles, diagonal bars, are sensuously composed of a rich horizontally directed brushstroke (parallel to the horizontal line of the canvas). In these areas the strokes gain mastery over technique into form. The black rectangular bars appear in sharp juxtaposition, descending absences of quality. The black exists, it appears to the eye, without support from any brushstroke. The black which passes gently through the cream carries a deadness of depth that is absolute in its opposition. And the meeting of two solutions is where different languages communicate.

Perhaps the most radical aspect of this and other Suprematist compositions is the uncompliant articulation of various dimensions, as well as the concept of space itself.[110] An interpretation that approaches this issue by relating to three-dimensional illusionistic space should be excluded; the work exists in two dimensions, and all meaning derives from the tactile picture-surface and the interconnecting two-dimensional forms. Space is only implied in the ground that separates and intercedes between these forms. Malevich formulated this explicitly in a well-known statement: 'I have transformed myself into the zero of form.'

Form rather than space emerges as the single carrier of meaning. Form – the structural shaping and colouristic delineation of space – proposes open-ended questions. In *Suprematism: Supremus No. 58* . . . the grey crescent is a demonstration of the concept of infinity. Its shape is determined by the outlines of two acute exponential curves, arbitrarily broken at the top, both a beginning and an end. The radius of each curve progressively and rapidly diminishes, the interior curve compressing acutely. The point of their intersection signifies maximum compression, delineating the infinite. This reading suggests the meaning of a dialectical response that Malevich's paintings seek: neither subjective nor objective can exist without the other.

101 *Suprematist Composition (Feeling of a Mystical 'Wave' in the Cosmos)*, 1917, pencil (26.5 x 20.5). Kunstsammlung Basel.

To find the magic stone for transforming all Slavic words, the magic that transforms one into another without breaking the circle of verbal roots, and so to fuse Slavic words freely: this is my first approach to the word. The self-sufficient word stands outside historical fact and beyond ordinary life. And having seen that the roots are merely an apparition behind which stand the strings of the alphabet, my second approach to language is to find the unity of all the world's languages constructed from units of the alphabet. A path to a universal *zaum* (trans-sense) language.

—Velimir Khlebnikov, 'My Own', 1919

**102** *Suprematist Painting: Aeroplane Flying*, 1915, oil on canvas (57.3 x 48.3). Museum of Modern Art, New York. Reproduced as exhibited in 1915.

# Subjectivity in Temporality

Thus wrote Khlebnikov in 1919, reflecting upon his own poetic project. Two intimately related concepts, the subjective and the objective, which pertain equally to man and his community, emerge as underlying concerns. Questions about language and intelligibility can only be resolved if a subjective utterance is comprehended within an objective context. Meaning may or may not be affected by the transfer from one sphere to another, for indeed, how does one know whether meaning has been conserved for each and every participant in a language?

In an essay considered among his most philosophical 'On the Subjective and Objective in Art or On Art in General' (1922), Malevich discusses the notions of subjectivity and objectivity, noting their close mutually defining relationship. Concerns that Khlebnikov addressed are explicitly dealt with by Malevich, revealing his paramount desire to be understood through painting. Throughout the 1920s Malevich devoted attention to this vital question, turning to writing as an alternative way of expressing his most profound beliefs in Suprematism. The fear of being misunderstood, as can be observed with so many other articulate and ground-breaking theoreticians, surfaced only after the initial reception of his work. Although Malevich's work was widely acknowledged within artistic circles, he was, as can be inferred from his writings, uncertain of the level of comprehension sustained by his audience. And in Bolshevik Russia, following 1917, the receptive audience for radical art became one that was often politically and ideologically motivated. As he understood, his endeavours demanded profound comprehension:

103 *Painterly Realism: Boy with Knapsack - Colour Masses of the Fourth Dimension*, 1915, oil on canvas (71.1 x 44.4). Museum of Modern Art, New York.

Anyone can maintain that he is unconcerned whether his work will be understood or not. But no one should demand that it be understood. Other researchers, other critics will make this demand. At one time this point of view was operative and perhaps it even exists now among some members of the artistic community. My own standpoint has changed and it rejects the outside researcher or critic. I now develop my subjective perception of effect into an objective existence . . .

So the modern artist is a scientist . . . The artist-scientist develops his activity quite consciously and he orients his artistic effect in accordance with a definite plan; he reveals the innermost motives of a phenomenon and for its reflex action; he endeavours to move from one phenomenon to another consciously and according to plan; his system is an objective and legitimate course of his effective force.[111]

The question of objective or subjective, and how object is defined in opposition to and concordance with subject, raises in turn the question of understanding – the comprehension of phenomena. Both conditions depend on perception.

The primary concern of this inquiry is meaning, but a contextual foundation first needs to be established, and a brief review of terminology is required. Malevich continually acknowledges the shortcomings of everyday language, and swiftly instructs the reader about his endeavour to explain complex ideas: 'Indeed, what I call consciousness and cognition are simply

104 *Suprematism: Eight Red Rectangles*, 1915, oil on canvas (57.5 x 48.5). Stedelijk Museum, Amsterdam.

conditions, an assumptive agreement. We take anything to be a unit, and this unit becomes objective for everyone.'[112] The suspicion that basic under-standing can be arduous is noted in reference to sensory experience: 'at the moment when we thought we were recognizing phenomena they were, in fact, dead ... So if we glance at the whole history of man's consciousness, I think we won't find a single realized fact.'[113] The rift between transmission and reception occupies Malevich's thoughts, and throughout 'On the Subjec-tive and Objective ...' he formulates a dialectic which revolves around the art object, as the mediating component in the relationship between artist and audience.

Again, the first and most relevant phenomenological inquiry that set out to define subject and object occurred in theoretical physics. By 1905 Albert Einstein was able to set forth 'The Special Theory of Relativity' as a conse-quence of Planck's research of quantum mechanics, and H. A. Lorentz's discoveries concerning the propagation of light – discoveries followed by others that permanently and immediately altered man's conception of himself and his position in the universe.[114]

And here, as stated earlier, methodologies of interpretation among various disciplines converge. For what is a painting that breaches the boundaries of conceptualism (as does Malevich's Suprematism), if not the intuitive organiz-ation of ideas, of innovative propositions? Our purposes concern the investi-gation of ideas rather than the exploration of technique and medium. The tracing of ideas must follow the origin, initiation, and deep probing of thought underlying those ideas. As the essence of mind addresses itself to theoretical thinking as envisioning, it is equally important to examine the mental pro-cesses at work as well as their residual outcome. Though our hermeneutic quest leads us through the veil of painting that Malevich erected as a human geometry of propositions, we are able to comprehend the workings of the mind more clearly through the analogous pursuits of Albert Einstein. In the detailed analysis of a mind articulating itself in physics and mathematics, we may hope to be exact. Einstein's physics, the beginning of the new world, function as a concrete platform from which we can depart into the exhilarat-ing and often intuitive domain of Suprematist creation. The voyage into the artistic supreme, even more inscrutable than the journey into the sublime of physical phenomena, is one that may take us to places we have never gone before. Like characters in Khlebnikov's 'K', we might imagine ourselves standing in a railway station, deciding upon trains to destinations unknown, to places with no names. And if Malevich paints these places, we might modify our imagination and metaphorically presume that the physics of Planck and Einstein function as the trains to take us there.

The Theory of Special Relativity is often discussed and explained, by Einstein and other physicists, with related theories of gravitation. Thus, from the outset, Einstein's discoveries by 1905 – which included 'Inertia of Energy', 'Theory of Brownian Movement and the Quantum', and 'Law of Emission and Absorption of Light' – had universal ramifications. Conceptions of time acquired new meaning, as explained in Einstein's treatise of 1916, *Relativity: The Special and General Theory*. In a chapter entitled 'On the Idea of Time

in Physics', Einstein contended that the classical notion of simultaneity is not only inadequate but simply, in truth, can never exist. That the velocity of light is a constant is neither a supposition nor a hypothesis, nor an empirically affirmed fact about the physical nature of light. It is rather a stipulation, a subjective assertion, which, as Einstein stated: 'I can make of my own free will in order to arrive at a definition of simultaneity . . . With this, one also reaches a definition of time in physics.'[115] In the structure of reality concepts, and even possible occurrences, of the simultaneous preoccupied basic thinking about certitude, perception, and cognition. By imposing this constraint – the stipulation that the speed of light is absolute – Einstein demonstrated how subjectivity is the determining factor in defining reality. It is from the mathematically complex text, *The Meaning of Relativity*, that the following passage is excerpted:

Upon giving up the hypothesis of the absolute time, particularly that of simultaneity, the four-dimensionality of the time-space concept was immediately recognized. *It is neither the point in space nor the instant in time, at which something happens that has physical reality, but only the event itself* [our italics]. There is no absolute (independent of the space of reference) relation in space, and no absolute relation in time between two events, but there is *an absolute* (independent of the space of reference) *relation in space and time . . .* [our italics]. The circumstance that there is no objective rational division of the four-dimensional continuum into a three-dimensional space, and a one-dimensional time continuum indicates that the laws of nature will assume a form which is logically most satisfactory . . .[116]

Reality could no longer be defined as objects simply existing in the closed and separate aspects of space and time. The recognition that neither concepts (space or time) adequately addressed the actual workings of events in reality – events like the impact of two bodies – necessitated a new criterion for understanding precisely what was happening. Definitions of objects in space needed clarification concerning their relative positions in space-time. Ideas like intersection, collision, departure, and movement were all reinterpreted through a view of reality which sought to comprehensively account for events under specific, yet always applicable, dictates.

Einstein, who disposed of the notion of time as constant, replaced that essential with $c$ (the speed of light) in order to formulate the properties of moving particles through space over distance in time. Assisted by Minkowski's progress with the problem of space and time, and Lorentz's research of the propagation of light, Einstein was able to develop a theory that applied to multiple coordinate systems. This allowed phenomena occurring in higher dimensions to be apprehended. And the significance was reciprocal; with the advent of the 'imaginary' in higher dimensions, conceptions of events happening in three dimensions were radically altered. The classical notion of simultaneity, a term central to Newtonian mechanics, was transformed and completely undermined.

No longer could the nineteenth-century methodological approach of empirical physics suffice in explaining the entirety of perceptible events. Information gleaned from the realm of the senses was incomplete within the context of theoretical physics, which now wielded the laws of a universal substructure to nature (as conceived of in the nineteenth century). For previously 'nature' had been defined solely through man's faculties of

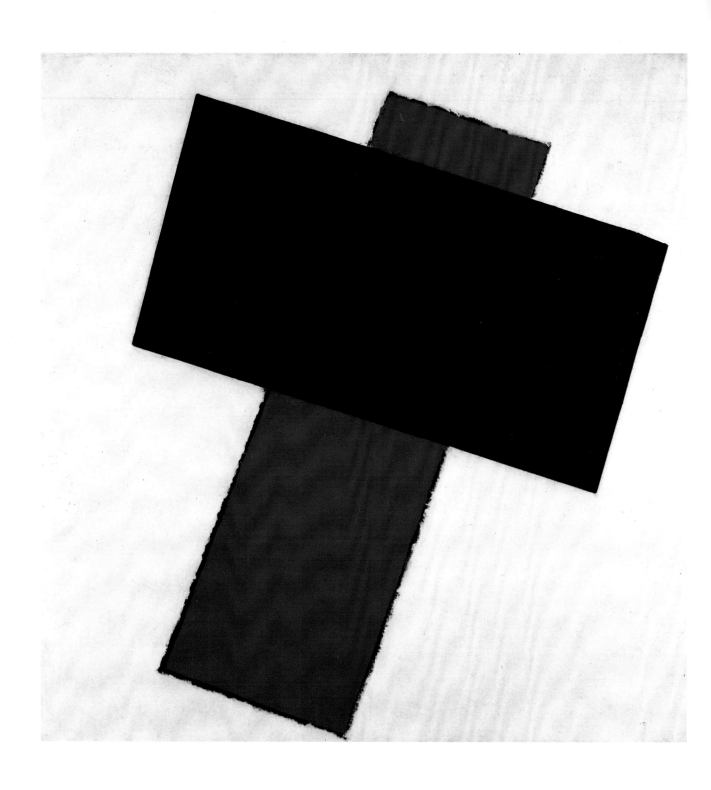

**105** *Suprematist Composition*, c. 1923–25, oil on canvas (80.3 x 80.3). Museum of Modern Art, New York.

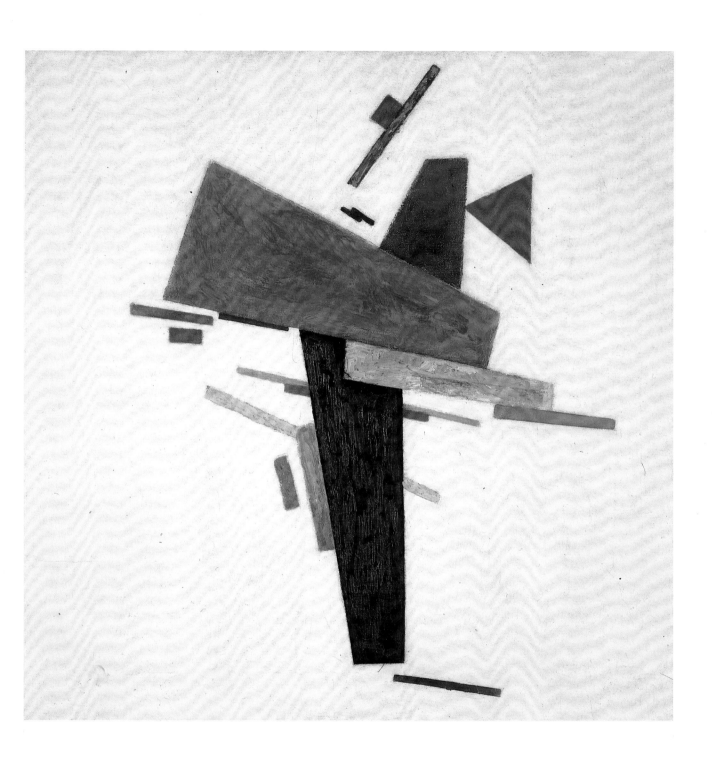

**106** *Suprematist Construction*, 1915–16, oil on canvas (53 x 53). Peggy Guggenheim Collection/The Solomon R. Guggenheim Foundation, Venice.

observation and apprehension guided by mechanisms of recording phenomena that merely affirmed the design of 'nature' set out by daily experience. An epochal shift in thought, entailing the transformation of experience into the terms of the universe, occurred with the acceptance of the theoretical as the real. As Lincoln Barnett, under the aegis of Einstein himself, put into popular words in 1948:

Einstein thus surmounts the barrier reared by man's impulse to define reality solely as he perceives it through the screen of his senses. Just as the Quantum Theory demonstrated that elementary particles of matter do not behave like the larger particles we discern in the coarse-grained world of our perceptions, so Relativity shows that we cannot foretell the phenomena accompanying great velocities from the sluggish behaviour of objects visible to man's indolent eye. Nor may we assume that the laws of Relativity deal with exceptional occurrences; on the contrary they provide a comprehensive picture of an incredibly complex universe in which the simple mechanical events of our earthly experience are the exceptions. The present-day scientist, coping with the tremendous velocities that prevail in the fast universe of the atom, or with the immensities of sidereal space and time, finds the old Newtonian laws inadequate. But Relativity provides him in every instance with a complete and accurate description of Nature.[117]

In addition to exposing the classical notion of simultaneity as fictitious, Einstein's related breakthroughs regarding temporality involved the discovery that when clocks are set in various spheres of motion they record time at variant rates. As acceleration approaches the speed of light, the rate at which time progresses enormously decreases in comparison to the time in which we live. With the outcome of his findings[118] the conception of time as flexible reverberated throughout Newtonian mechanics. Interrelationships were not empirical, but subject to and dependent upon circumstances; subjectivity became the essential dictating issue.

The conceptual formulations Einstein produced (concerning not only simultaneity but also the structure of matter and the universe) relied upon his ability to conceive of quantities of energy, distances and values of both intensely minute and vast proportions. With this expansion in the realm of mathematical-physical thought, man's conception of the universe was hugely extended:

The development of non-Euclidean geometry led to the recognition of the fact that we can cast doubt on the 'infiniteness' of our space without coming into conflict with laws of thought or with experience (Riemann, Helmholtz) . . . As a result of this discussion, a most interesting question arises for astronomers and physicists and that is whether the universe in which we live is infinite, or whether it is finite in the manner of the spherical universe. Our experience is far from being sufficient to enable us to answer this question. But the general theory of relativity permits of our answering it with a moderate degree of certainty . . .[119]

These fundamental re-evaluations and recognitions of universal structure, perhaps appearing abstruse to the layman, both then and today, were integral to the development of modern society in general, and inevitably had an enormous impact on the new *Weltanschauung* of the intellectual and artistic elite. 'Those of us', Roman Jakobson reflected, 'who were concerned with language learned to apply the principle of relativity in linguistic operations; we were consistently drawn in this direction by the spectacular development of modern physics and by the pictorial theory and practice of Cubism . . .'[120]

The various spheres of human inquiry each utilize a different language and different syntax to express issues central to that inquiry. In the case of theoretical physics, addressing itself to an understanding of the objective world with its seemingly infinite complexity of detail, revelation of the intimate structure of nature is the focus. The inquiry not only questions the objective world, but also its own linguistic systems of articulation (in this case primarily mathematics) and the inherent limitations of that system. Recalling Khlebnikov's desire to obtain a unity between knowledge and language, we begin to understand that previously segregated undertakings may, in fact, be connected. Indeed, in the work of Malevich one can observe a conceptual convergence among disciplines.

His Suprematist artistic project may be regarded as the striving for coherence, the assertion of one expressive language that would embody both the deficiencies and strengths of aspects from wide-ranging epistemological areas of inquiry. His work is a brilliant solution to the inadequacy of avant-garde pictorial language when applied to the sophisticated concepts exploding in Western culture (especially theoretical physics), from the end of the nineteenth century.

The history of art knows rare instances where a visual artist is able to reflect upon and interpret advanced ideas from separate disciplines, and articulate aspects of those ideas which reach beyond the inherent dictates of that discipline. If such a process is to be valid it must not be simply a transcriptive device, or mere conceptual mimesis. In the lithograph with the surprising

**107** *Death of a Man Simultaneously in an Aeroplane and on a Railway*, 1913, lithograph/watercolour, from the book *Explodity*, 1913.

**108** *Suprematism: Painterly Realism of a Football-Player. Colour Masses of the Fourth Dimension*, 1915, oil on canvas (70 x 44). Stedelijk Museum, Amsterdam.

**109** *Suprematism: Supremus No. 50*, 1915, oil on canvas (97 x 66). Stedelijk Museum, Amsterdam.

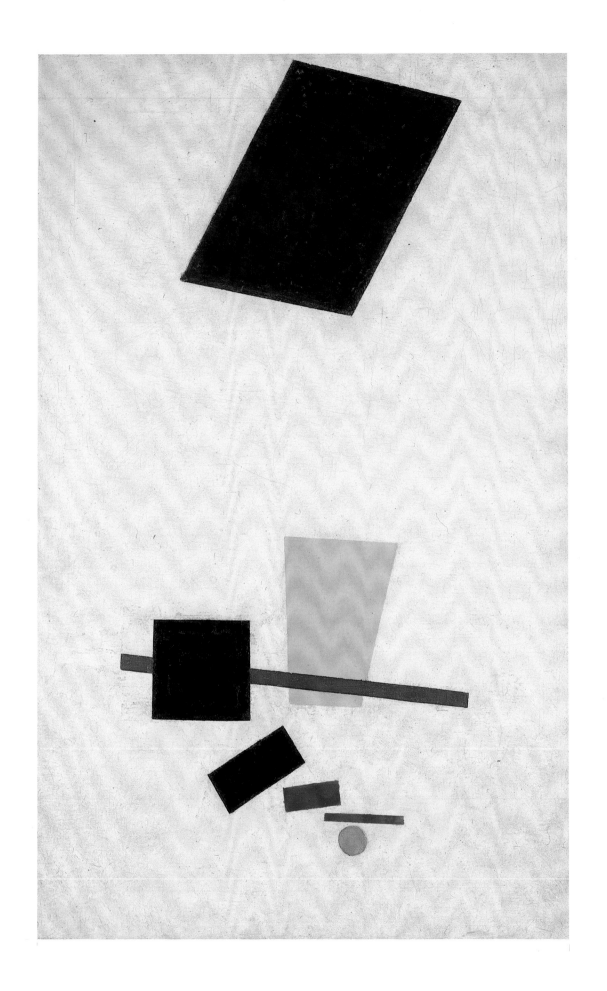

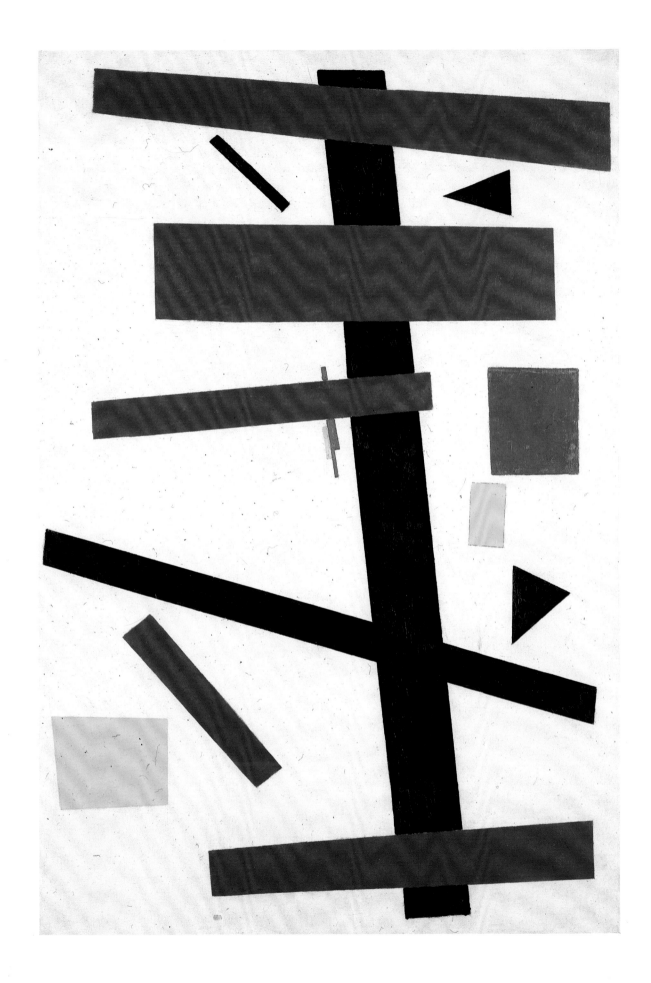

and curious title, *Death of a Man Simultaneously in an Aeroplane and on a Railway* (1913; illus. 107), Malevich displays wilful and specific intent. By writing this particular title into the image at the bottom right-hand corner of the composition, he overtly refers to a recently established cornerstone of theoretical physics – namely, the relativity of simultaneity. The circumstances under which this lithograph was produced demonstrate a conscious intentionality, isolating both an aesthetic and scientific exactitude that supports, without impinging upon, artistic autonomy. Although the composition appears to be stylistically related to Rayonism in Italian Futurism, one discerns how Malevich realized the limitations of that syntax for expressing concepts beyond the mechanically oriented genesis of the Italian movement. Through combining the Rayonistic linear components with a verbal inscription, Malevich announces the necessity of formulating new syntactic approaches that fulfil and adequately respond to thought structures advancing elsewhere in culture.

Detailed description of *Death of a Man Simultaneously . . .* reveals a conceptual acumen that would become essential to the evolution of Suprematism. This lithograph, one among many produced between 1913 and 1916, displays traces of the artist's mindset that permit visual analysis to explore the process of creation itself. From among the tonally differentiated charcoal-drawn lines and shapes emerge objects in motion. Entering the composition at the top left, the front of an aeroplane with recognizable wheels, wing-structure, and the whirling arcs of a propeller, descends into a vortex of geometric elements. Convergent with this direction of motion, run a sequence of three telephone poles, carrying wires into the vortex. Next to the poles, what one presumes to be the front of a locomotive, with cylindrical tank and iron front (coincidentally suggesting the head and shoulders of a human figure), moves forward, coming out from the centre of the composition. Slightly below this centre, near the bottom where the inscription begins, appears a similar form; it seems to be the same locomotive interpreted at another position, another point in time. Consistent with this double representation, the wheels of the aeroplane appear again, gliding across the top right corner of the composition, over four distinctly straight lines resembling telegraph wires. From the wires alone, one immediately recognizes that two separate and distinct viewpoints operate inside this composition: on the left side, from an oblique vantage point, and on the right side, from below. Events that occur simultaneously, embodying independent coordinate systems of movement, time and space, have specific points of view.

On both the left and right side of the lithograph the same three primary elements are depicted: train racing on the tracks, aeroplane flying and telephone poles carrying wires. Unlike the Cubist technique of revealing facets of objects through rotation, Malevich provides a more complex view of objects in fluid space – objects moving through space. This distinction can only be explained through analysis of Einstein's Special Theory of Relativity. Evidence of Malevich's sophistication is revealed in this lithograph, proving a clear conceptual departure that supersedes the casual affiliations of Picasso, Braque, or any of the Paris Cubists to certain 'scientific discourses' – with the possible exception of Marcel Duchamp.[121]

The centre of the composition shows a convergence and conglomeration of geometrical shapes, variously shaded and directionally oriented. Among these shapes are smaller details, perhaps denoting parts of machines, parts of an urban landscape, or merely the smaller components of motion. Explicit meaning is given to this arrangement by the title, stating that an event occurs; and in view of the inscription it can only be read as pertaining to the death of a man in an airplane and of another on a railway simultaneously (either standing on the railway embankment or riding in the railway train). The fact that this lithograph depicts death isolates the instantaneous moment as paramount for the observer. For an observer, death assumes significance as an instantaneous occurrence, a locatable incident perceptible at one point in time in one spatial plane. The theme of this image focuses the possibilities of perception with regard to the supposedly singular event of death.

With the Special Theory of Relativity, Einstein's main breakthrough was to recognize the inadequacies in the classical notion of simultaneity. Perception and recognition of events resided completely in the viewpoint of the observer – a subjective assertion of individual presence, at once transitory and absolute. Malevich's formulation of simultaneity descends directly from Einstein's theory, which reads: 'Events which are simultaneous with reference to the railroad embankment are not simultaneous with respect to the train and vice versa (relativity of simultaneity). Every reference body has its own particular time; unless we are told the reference body to which the statement of time refers, there is *no meaning* [our italics] in a statement of the time of an event.'[122]

Einstein described the relativity of simultaneity with a famous illustrative analogy. To one observer stationed at a fixed position on the embankment two bolts of lightning strike the earth at what appears to be the same exact instant; that is, they strike the earth simultaneously. However, to another observer travelling in a moving train the same two lightning bolts striking the earth at the same locations will not appear simultaneous. One bolt in the direction of the train's movement will appear to strike the earth first. Thus, in fact, these same two lightning bolts do not strike the earth simultaneously for the observer travelling in the train. This simple concept, when applied to distances of galactic proportions, revalues and profoundly affects our understanding of what distance and time actually represent. With the assertion of the relativity of simultaneity Einstein showed that man could not assume that his subjective sense of 'now' equally and uniformly applies to all places at various times, fixed or fluctuating.[123]

It is to this simple illustrative analogy that Malevich's lithograph is indebted for its pictorial articulation. How else could the simultaneity of a man's death be understood in this context? Malevich poetically extrapolated from Einstein's straightforward analogy. Including an aeroplane, a machine for the acceleration of man in space – in the pure space of air – allows the parameters of speed to be expanded, and the coordinates of space to be compressed. And it is within this expanded representational realm that Malevich investigates representation itself. By choosing to 'depict' the death of a man, the essential epistemological ramifications of theoretical physics are immediately recognized in profound terms. The lithograph focuses upon the implications of

110 Vasilii Kamenskii in his aeroplane in Warsaw, 1911.

111 Vasilii Kamenskii, *Ferro-concrete poem* (dedicated to David Burliuk), *First Journal of Russian Futurists* 1–2, 1914, p. 25.

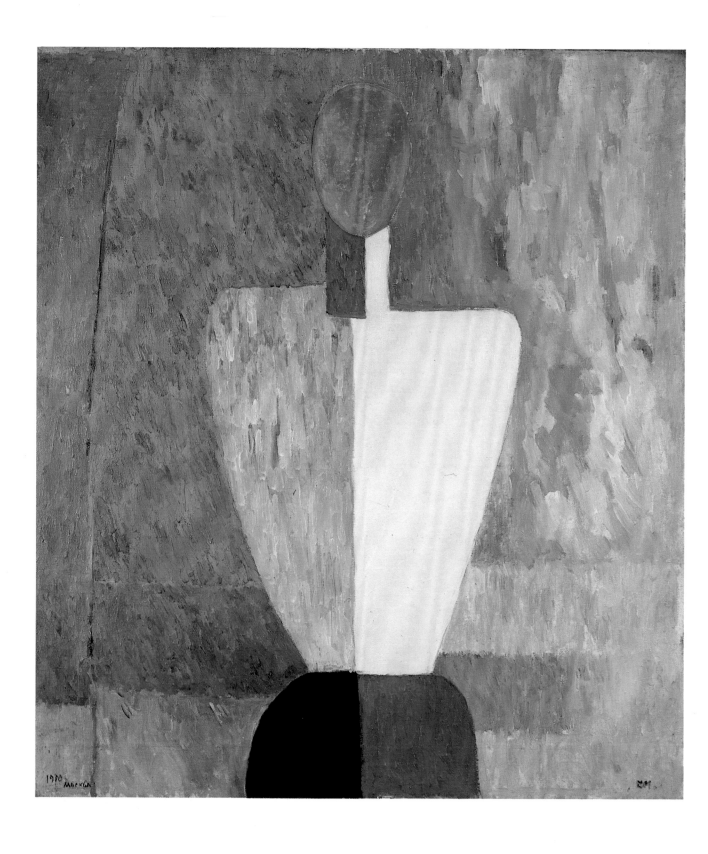

112 *Torso: Half-Figure with a Pink Face*,
1928–32, oil on canvas (72 x 65). State
Russian Museum, Leningrad.

113 *Complex Presentiment: Half-Figure in a
Yellow Shirt*, 1928–32, oil on canvas (99 x 79).
State Russian Museum, Leningrad.

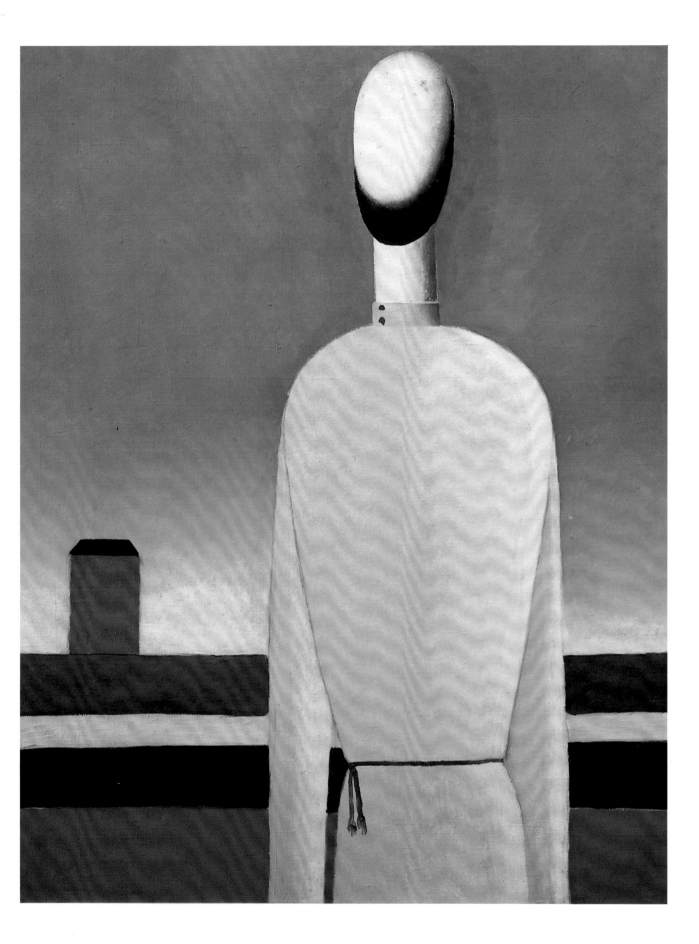

subjectivity in temporality – upon the instantaneous, the successive, and momentary comprehension of events. Indeed, what are events if they can be adequately observed only from certain vantage points but not from others? That a death is secured here as subject, questions the essence of dying as an event or concept in itself. By invoking Einsteinian temporality, it is uncertain when the man/men has/have died, or, indeed, if he/they has/have died. Jean-Claude Marcadé supplies insight into the subtlety of Malevich's depiction when he states that the artist's 'non-objectivity is the radical destruction of the bridge by which metaphysics and traditional art spanned this "great abyss" [the abyss of being] separating the world accessible to reason or intuition from a world which is not.'[124]

With the new subjectivity of temporality acquired through simultaneity, Einstein not only revoked aspects of convention in physics, but also cast aspersions on the humanistic disciplines occupied with understanding events through their placement in history. By dismissing the concept of 'the now' (a secure conceptual syntax by which we are able to retrace our steps in time), both the notion of history and the ability to remember the past become illusions, with no greater strength than any other stipulations of the free will. Departing from the vicinity of classical concepts of time, our latitude for self-discovery becomes discontinuous and inventive. For if history is governed in its make-up by a theory of time that dispossesses events of the apparent moment when they happen, then the significance of 'when' becomes simply the question of 'how' and 'if'. It was, of course, Planck's quanta and Einstein's relativity of simultaneity that demolished the two main pillars of the classical world, causality and determinism.

Formally, the composition of *Death of a Man Simultaneously*... revolves around one dark triangular shape, roughly dominating the centre of the composition. This form, inflicted onto the geometric vortex, can be read symbolically within a simplistic representational scheme; it could denote a moment of impact, the maximum compression of force. Applying such 'literary' connotations to the composition, however, does not describe its full complexity – a complexity which concerns the foundation of the Suprematist pictorial dialect. Even upon cursory examination, this lithograph possesses sharply defined shapes which anticipate the carefully constructed primary shapes of Suprematism in 1915.

The central triangle is a pictorial sign. Its referents and exterior signifieds surround it both visually and conceptually in the composition. It expresses everything that all of the other elements cannot express – either literarily in the theme of the inscription, or pictorially in the narrative of the composition. The triangle, assuming the form of a stretched chevron, in this instance transforms itself into an absolute form – the first such occurrence in Malevich's oeuvre – representing nothing other than itself, but simultaneously embodying the contextual array of possible stylistically divergent readings. In this unassuming lithograph, Malevich articulated a concept of universal importance: the recognition of subjectivity in an object-oriented world. He later stated, in 1922: 'The question of objective or subjective raises the issue of understanding and perception ... of phenomena.'[125] As the major philosopher-scientists of the early twentieth century recognized, it was

through the dialectical correlation of the two epistemological vantage points – the subjective and the objective – that phenomena, regardless of their observable or theoretical actuality, were both *created* and *perceived* for understanding. Ultimately, the specifics of various experiments are of marginal consequence, given the evolution of primary concepts that provided the basis for a new philosophy concerning existence.

Theoretical physics informs questions of individual, subjective perception. As Werner Heisenberg so eloquently phrased in his 1941 lecture 'The Teachings of Goethe and Newton on Color in the Light of Modern Physics':

We must remember that every word of our language can refer to different aspects of reality. The real meaning of words often emerges only in their context or is determined by tradition and habit.

Modern sciences soon made a division of reality into objective and subjective. While the latter is not necessarily common to different people, objective reality is forced on us from the outside world always in the same way, and for that reason early science made it the subject of its investigations. In a way, science represents the attempt to describe the world to the extent that it is independent of our thought and action. Our senses rank only as more or less imperfect aids enabling us to acquire knowledge about the objective world.[126]

Without the inscription, an essential, prominent, and immediately recognizable aspect of the composition, we viewers would not be able to ascribe to the work under analysis the explicit theme of 'simultaneous death'. Thematically a connection is made, but in actuality – anticipating the expectations of representational painting – the inscription supplies superficial exactitude while also isolating a communicative disfunction between written words and visual imagery. Here, the two most powerful expressive and linguistic apparatus (drawing and writing) are brought into question, challenged by another concealed motivating system – the mathematical language of theoretical physics. *Death of a Man Simultaneously . . .* demonstrates the convergence of linguistic structures, implying their collapse under the theoretical weight of one major conception. Human expression of thought, of the single final existential issue confronting humanity (death), becomes Malevich's primary artistic inquiry.

*Death of a Man Simultaneously . . .* signifies a turning point in Malevich's development as a major artist. Although its imagery appears to be rooted in the supposed subject matter of representation, the treatment of the forms and the dynamic articulation indicates a conceptual operation. Indeed, it was in the beginning of the *annus mirabilis* 1913, with paintings like *Cow and Violin* (illus. 74) and *Portrait of the Composer Matiushin* (illus. 71), that Malevich's regard for representation according to Western convention begins to transform under the emerging network of conceptual thinking that redefined what representation could be. Clearly, with reality no longer defined by existing objects alone, if representation was to denote reality, then this pursuit, to the advanced mind, would become an irreconcilable conundrum.

The foundations of such a position come directly from the sphere of physics, where Planck's formulations almost immediately relegated representation to an alien era – an era of merely one obvious construction of 'reality'. For Planck, who first recognized that orbiting electrons and particles of

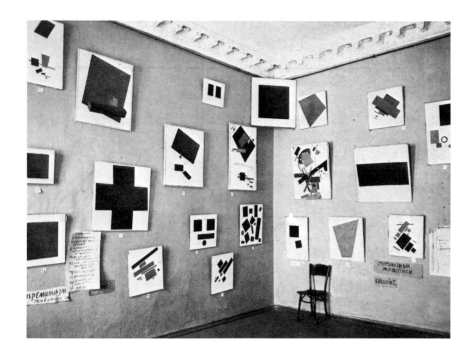

**114** Installation photograph of *'o.10'. Last Futurist Exhibition*, Petrograd, 17 December 1915–17 January 1916.

matter (whether defined as particles or waves) could never be observed or actually ascertained, the very notion of representation was precluded. Thus, adequate subject matter no longer existed for Planck, if reality was to be manifest in thinking. With one fundamental statement the entire grounds of representation are forever cast away: representation can only describe *how* a subject may be, but can never describe *what* the subject itself is. In atomic physics, a set of propositions describing how bodies function and what forces dictate their constitution was found to be adequate not merely for the understanding of reality, but in effect *as* a reality – concrete, precise, and all-encompassing. Descriptions of how the things were, but not how they 'look like', *were* the things in themselves. The preposterousness of representational schemes predicated on the imitation of the observable world became too obvious, as the world itself became unobservable, let alone describable in words.

Malevich addressed his lithograph to this central concept. Soon he would realize the limits of the expressive systems he employed, and unveil the triumphant new possibilities of Suprematism; he would carry his art virtually and beautifully into the realm of conceptual thinking. To gain mastery over the world of visions, to surpass looking and seeing, the arts as Malevich conceived of them had to pierce through intuition and cognition, to go behind even the frail veil of questions proliferating in uncertain minds, and attach creation itself – the act of painting – to an essence that, if we rely on words, could be called sublime.

Suprematism, sequentially bound by the inceptive lithograph described above (visualization of thinking) and the reflective essays (verbalization of painted realities), articulating subjectivity in objective terms, can be regarded as an integrated discourse on the relativity of cognition in specific situations. If we pause to recall our phrase that in Suprematism 'anything conceived of *is*

anything experienced', then this seemingly eternal mandate for creation seeks mediation only through the autonomous stipulation of objective comprehension. In the expansive realm of Suprematism, which denied previous referents in art and asserted Malevich's ascent to a 'pure' art – 'transformed into the zero of form' – the question of a correct or incorrect cognition ceases to be valid. Philosophies of art dependent upon disoriented and faint links to history are exposed as uninformative. The nineteenth-century conviction about truth and its assumed 'reality', recognizable from Delacroix and Courbet through Impressionism and Cézanne to Cubism, is revealed as deficient, as are the representational dictates of distant conventions in traditional art.

Besides the formal and semantic characteristics of Suprematism, as discussed above, another of its major aspects displays Malevich's theoretical disposition. Malevich literally turned convention upside down by altering the orientation of certain Suprematist paintings. Comparisons between installation photographs from exhibitions of 1915, 1919, and 1927 reveal what may be referred to as the indeterminacy of pictorial orientation. In the 1915–1916 '0.10' Petrograd exhibition (illus. 147) the paintings are arranged in a deliberate, ordered but not programmed way, spread over the walls and spaced so that they correspond to and communicate among each other. This installation photograph should not be viewed merely as a carrier of documentary information – too frequently art history uses such evidence as an excuse for simple archival pursuits. The photograph beautifully reveals the intricate philosophy of an artist who had arrived at the forefront of innovation.

In an American monographic retrospective of Malevich's work this image was magnified to the scale of life. The original photograph was taken with the camera positioned at a high level, thus emphasizing two details about the existing world apart from the paintings themselves. The crenellation of the ceiling, rhythmically and repetitively carved, and the presence of a chair in the corner, protruded into our consciousness as we 'walked through' the enlarged image at the retrospective. With the dimensions restored to life-size, we as viewers were able to experience the original impact of the paintings, arranged the way they were first presented – creations entering the world. The image, like the room itself, managed to sustain the notion of simultaneity in time because the conventional interior (the carved ceiling and functional chair) was confronted with the new and transforming hanging of the paintings. The old aestheticism manifest in the architecture was brought into concordance with radical Suprematist spatial organization, which purveyed principles that dissolved all previous ideas of order applied to material and substance.

At '0.10', individual paintings did not relate to each other in any obvious system. The compositional structure and the lack of a signature on the front of each canvas mean that the top and the bottom of each picture are not necessarily differentiated. The way Malevich hung the work probably best accorded with his aesthetic sensibility. The photographs of Malevich's major exhibitions by no means supply us with a comprehensive picture of each installation (with the exception of Berlin), but the extant material enables us to make irrefutable observations about numerous significant paintings.

  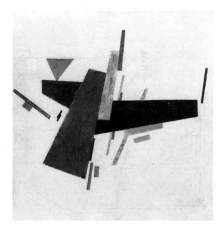

If the '0.10' 1915 installation is compared to the State Exhibition of 1919 in Moscow (illus. 148), it becomes clear that two paintings are upside down compared to their initial orientation. And these two paintings appear to be among the most complex compositions, with visually dense syntactic schemes. Their descriptive titles, only employed by Malevich at the '0.10' exhibition, *Suprematism: Painterly Realism of a Football Player: Colour Masses of the Fourth Dimension* and *Suprematist Painting: Aeroplane Flying*,[127] impact directly upon conventional painting. Even if one could discover in these non-referential paintings any visual reminder of the external world, like a football or an aeroplane, then how would a shift in their orientation affect that reading; could the images remain valid and recognizable once turned upside down?

This same operation occurred with *Suprematism: Self-Portrait in Two Dimensions*, which was exhibited in Berlin (May – September, 1927; illus. 30) upside down from its position in the '0.10' exhibition. In the immediately preceding Warsaw exhibition of March 1927 (illus. 151), the *Football Player* was hung upside down when compared to the '0.10' exhibition, while *Aeroplane Flying*, after its Moscow 1919 inversion, was returned to its initial '0.10' orientation. The indeterminacy of pictorial orientation in Suprematism is most deliberate and obvious when examining the near-contemporary exhibitions of Warsaw in March 1927 and Berlin in May–September 1927. From photographs of both installations mounted by Malevich himself we are able to see that of 11 Suprematist works clearly visible in the Warsaw installation, nearly half have been rotated for their showing in Berlin.

With one painting this device achieves an extreme versatility. As *Suprematist Construction* (illus. 106) was transported from one exhibition location to another over a twelve year time span, Malevich installed it in three different exhibitions with a different orientation each time: in Moscow 1919 (illus. 115) the triangle is positioned on the upper-right side, in the Warsaw 1927 exhibition (illus. 116) the triangle is on the lower-left side, and several weeks later in Berlin the same painting was exhibited with the triangle at the upper-left side (illus. 117).

In the painting *Suprematist Construction* we find a centralized accumulation of rectilinear forms, contained through tight complementary interaction. The black, green, blue and grey-brown trapezoids interlock around a focal point and seem to gently rotate, implying a spiral. These four primary trapezoids

115–117 *Suprematist Construction*, 1915–16 (see ill. 106), as installed in separate exhibitions:
115 Sixteenth State Exhibition. 'K. S. Malevich: His Way from Impressionism to Suprematism', Moscow, 1919–20.
116 'Kazimir Malevich', solo exhibition, Hotel Polonia, Warsaw, 8 March – 28 March 1927.
117 'Kasimir Malewitsch' in 'Grosse Berliner Kunstausstellung', Lehrter Bahnhof, Berlin, 7 May – 30 September 1927.

forge a facile harmony, displaying a balance produced by all of the basic elements of a painting's construction: form, colour, mass, substance, surface, and faktura. This harmony results from the pairing of the blue trapezoid with its attendant red triangle and the brown-grey trapezoid possessing a subordinate black bar. The two smallest of the four trapezoids are supported by secondary forms, permitting an irregular yet harmonious balance which accommodates both dominant and suppressed colour. Malevich has compensated the subdued brown-grey trapezoid by investing the most faktural attention there.

Balance is at once differentiated from, and intimately related to, harmony because all of the primary and secondary forms are essential to maintain a unified structure within the potentially discordant combination. The only parallel and perpendicular axes are those given by the convention of the picture frame, which is the sole received tradition Malevich adheres to. All of the forms in *Suprematist Construction* are governed by a new logic that has broken free from the rigid constraint of the rectilinear (horizontal/vertical) dictates of the frame.

Balance and harmony are major aspirations of this composition, because these characteristics are essential if a picture is to be hung in several different ways. Only through sustained consideration of these seemingly 'classical' elements in painting was Malevich able to break with a habit that centuries of repetition had turned into an unquestionable norm: the painting as a direct metaphor of a framed window, opening onto the external and referential world. This conception presumed a necessary – and often hierarchical – orientation toward a designated top versus bottom, and a left side versus a right side. In Malevich's work, for the first time in the history of Western art, the elements that constitute a picture are dealt with autonomously and individually within the same painting.

*Suprematist Construction* is a canvas that is precisely square. This simplicity of format, when considered in relation to the centralized and compressed

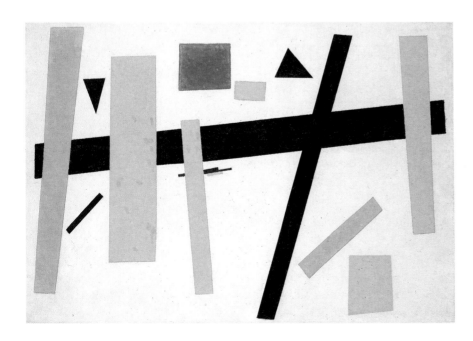

118 *Suprematism: Supremus No. 50*, 1915, oil on canvas (97 x 66). Stedelijk Museum, Amsterdam. Reproduced as exhibited in Warsaw 1927.

157

painted forms, allows a versatility of presentation. The square is a shape that has no implicit orientation. The deliberateness and conceptual bent of Malevich's thinking becomes clear, however, in one other painting. The larger *Suprematism: Supremus No. 50* (illus. 118) is a rectangular painting with the longer sides measuring one third greater than the short sides. In Warsaw the painting was installed with a horizontal orientation and in Berlin, consistent with its Moscow 1919 placement, it returned to its vertical orientation. The red bars stretch like vectors of force running to the limits of the frame, making space within which attendant coloured shapes are permitted to float and rest. The 90-degree shift in the orientation of *Suprematism: Supremus No. 50*, from vertical to horizontal, denotes a perpendicular assault upon the single fundamental baseline that had been consistently used in Western painting since its Early Renaissance inception.

The concept of the picture frame grew out of the swirling, boundless, and architecturally continuous images of Medieval man, which drifted through the celestial spires of an intangible and haunting imagination. Apostles, saints, prophets, and players tell of devotion in a sphere of elevated being beyond the constraints of particular events – a gold-glimmering eternity under which meagre man ceaselessly rotated. With the coming of the Renaissance and its infusion of logic into existence, and the nascent emphasis upon individuality, images were transformed under the dictates of subject matter. The themes of Christendom had to acquire terrestrial connotations, had to be personified and reified into a format of (re)semblance, if Renaissance man was to cope with his destiny of personal responsibility. With the advent of the picture frame, ideas could be contained within a biomorphic format; they could be formalized into an approachable 'altarpiece' containing one story, describing one idea in images of human form. And as man began to associate himself with his abstract ideas, so did his images communicate directly as an attainable, even tangible, essence. The picture frame presented man as an image included within the sphere of experience, and with this the picture acquired an earthly orientation.

The introduction of the picture frame accords with man's traditional conception of the earth as flat, as ending at the distant planar horizon. And consistent with its initial use, the picture frame, since the Early Renaissance, has carried with it an undeniable belief in the line of the horizon. Codified systems of perspectival representation confirmed the intractable essence of a fixed horizon. Because painting in the Western tradition sought to surmise and surround the observable world, it was within the boundaries of terrestrial representation that it achieved this aspiration. In this context we can begin to understand the importance of Malevich's *Suprematism: Supremus No. 50*. By rotating the painting through 90 degrees, turning it onto a side and not upside down, the notion of the horizon is dispelled. The pictorial composition is devoid of any structure that could even distantly relate to a horizontal understanding of placement, both internal and external. In this picture the world is looked upon as never before in painting.

Announcing his decisive divorce from previous misconceptions, Malevich wrote in 'Suprematism as Pure Cognition' (1922): 'Represented spaces, planes and lines exist only on the pictorial surface, but not in reality.'[128] And

if spaces, planes and lines are aspects we employ to secure our existence in the world, then perhaps we should refer ourselves to more than one rigid reality. Our position on the earth need not be artificially defined by the rules of horizontal and vertical axes of a grid, but should submit to its true nature, which possesses no (straight) lines. Similarly the canvas must be liberated from the constraints of the grid, and our descriptive terminology should thus resist the assigning of objects into either a vertical or horizontal orientation. *Suprematism: Supremus No. 50* isolates this distinction and deficiency as such. Its rotation speaks so obviously about the conventional format of thought; and almost rhetorically, in the impoverished language of representation, it asks how long is the horizon, and is the horizon longer on the earth or higher in the sky?

Clearly the concept of Malevich's painting depended upon a compositional structure no longer affiliated to conventional aesthetics. His new creative stance pertains to continents of creative thought, entire galaxies. Shifts in the orientation of certain carefully selected paintings are based upon and dictated by Malevich's methods of creation, themselves governed by a principle of meaning which coincides with compositional structure and painterly quality. Indeterminacy of pictorial orientation does not apply to each painting and is not a random choice merely intuited by the artist. Suprematism is a precisely worked way of ordering and re-ordering pictorial sensations. And Malevich never hesitated to adjust or revise a painted form, or dispense with it completely by painting it away until it diminished into a faint visual memory. This total precision in the working method means that all of the crises central to formalist readings about meaning in Suprematism fall away as ill-considered and unscrutinous, because formalism does not demand such an intricate and painstaking correspondence between form and meaning. Even in the field of linguistics ultimate issues of form must always be resolved under the auspices of content, which designate meaning, regardless of how vague. Verbal language, from the written letter to the spoken sentence, always grants communication and function privileges above pure form.

Painting, however, allows for a degree of communication that is transcendent of function. It can admit the unintended as valid without compromising itself by the random; there can be no chances. If there is a suitable analogy to be found in the culture of man, it springs from ideas developed in non-Euclidean geometry (first published by Lobachevsky). For the non-Euclidean proposition defines the historical instant where descriptive visions from Newtonian tradition come into conflict with intuitive thinking. From Lobachevsky's famous treatise *New Principles of Geometry* (1835) one reads words that speak a telling truth: 'Surfaces, lines, points as geometry defines them, exist only in our imagination.'[129] It is in this frame of reference that the pure creative abilities of mind defeat the random logic of tradition, offering a viable alternative to the dominant mode of logocentrism. And at this conjunction of the imaginary and the everyday, we emerge as cognizing individuals who continually confront ourselves in existence, as existence happens. We are introspectively forced into re-evaluative reconciliations between suspicion as real knowledge and living as meaningful beings – conserving yet purveying essence. Bridging the schism between how we function in this world and

how we come to know our universe, how we become familiar with the ideas of possibilities, becomes the one major objective of creative man.

With the Suprematist method Malevich enables us as observers to become participants in realizing the subtleties of signification in the everyday world. With the breakdown and substitution of representational thought and narrative, we are free.

119 *Head*, c. 1930, pencil on paper (16.3 x 11.7). Museum Ludwig, Cologne.

If one compares the movement of thought with the movement of sunlight or comets in the cosmos and if one attempts to penetrate the power of appearances with thought, then new forms of ideas will be generated; faster than the igniting flash and instant extinguishing of ephemeral appearances, faster than the turning to dust and renewed agglomeration of worlds which only ever remain a concept, an opinion. There is nothing to be felt, nothing to be cognized, neither through the body nor the eyes. Nevertheless, in the mind, worlds whirl like in the depths of the universe, like notions created in thought.

The human skull represents the infinity of movements for concepts; commensurate to the infinite cosmos; and like the cosmos possesses no ceiling, no ground, only offering space for projections which allow the appearance of gleaming points, stars in space. In the human skull everything originates and perishes exactly as in the universe: comets, epochs, everything originates and perishes in man's conceptions.

– K. S. Malevich, 'Suprematism as Non-Objectivity', 18 February 1922[130]

# Late Sensations and the New Reality

Confronted with Kazimir Malevich in the *Self-Portrait* of 1933 (illus. 123), his arm raised in a mediating gesture, and his stern sidelong gaze fixing reality outside the frame of painting, we recall his thoughts from ten years earlier, voiced so concisely above. Given the galactic nature of thinking, of being in the world – a world among many, among an infinitude in the universe – the gesture of the artist, his offering in paint, assumes cosmic proportion. Self-portraiture, that distinct genre of painting unique to a class of humanity called artists, creators, attains meaning outside of tradition, beyond its lineage descending from the Renaissance.

The self-portrait articulates a conceptual position in the arts that raises the theoretical prospect of an 'autonomous likeness' in painting, where subject would retain an unmediated affinity with the painted object. The implications for the image in art, and for painting per se, subvert the pedanticism of transcription because the subject matter eludes secure observation; the self-portrait can only ever be an internal invention, or a record of the observing process as it observes itself processing. With the inception of self-portraiture in the Renaissance, we witness the birth of the creator's self-awareness – as a creator of art, and not of an image. It was the beginning of an attitude in painting that demystified the distance separating the subject of a painting from its external references, expanding the consciousness of painting as it admitted the autonomous and enigmatic presence of the maker.

The self-portrait places the artist, as conceived of by the artist, within the seemingly exposing realm of portraiture; however, it is also the only instance where sitter controls maker – confirming the validity of the artist's free will to create. Conversely, the self-portrait uniquely generates the possibilities of the autonomous self, reciprocally fulfilling painting's dual ends: the necessity of revelation, and the urge to conceal, are held inside the same image. With the arrival of self-portraiture all the conceptual implications and technical possibilities of the act of painting were displayed:

The self-portrait is suited to express, exemplarily, the fiction of the 'autonomous' likeness, such as was being theorized for painting during the Renaissance. In his treatise *De Sculptura* from 1504, for example, the Paduan humanist Pomponius Gauricus wrote that a portrait must depict its subject 'ex se', out of itself. Portraiture must renounce a referentiality which would turn the sitter into a mere representation of something other or more general than itself. This fiction of autonomy would be heightened in a painting in which the represented person is the work's creator. For in the self-portrait, the *uomo singulare* has himself given rise to his own likeness *ex se*. Displayed in both his appearance and his works, the artist stands self-contained and complete, freed of any functions or references beyond self-denomination.[131]

The intervention of theory, either by imposition or reflection upon artists' achievements, finds its early function at the moment in the history of painting where the image was transformed, superseding illustrative ends to acquire meaning beyond didactic necessity. Indeed, as painting's position to the

external world successively altered, so too can shifts be detected in related human disciplines. The concordance is often striking as, for example, with the German Romantic painter Caspar David Friedrich (illus. 122), who refined and fulfilled the philosophical qualifications outlined by F. W. J. Schelling: 'in landscape painting only subjective representation is possible, since landscape has only a reality in the eyes of the beholder.' Coincident with this statement is Friedrich's lapidary assertion that: 'The painter should not merely paint what he sees in front of him, but also what he sees within himself. If he sees nothing within, he should not paint what he sees before him . . .'.[132]

The theoretical discourse among the Romantics attained a clarity of interchange that is virtually unrivalled in the history of art. Similarly, in the case of Malevich and the inception of Suprematism, the discourse between the Russian Futurists (especially Khlebnikov) and the Formalist writers (Jakobson, Shklovsky, Tynjanov), prepared a fertile milieu for conceptual innovation.

The *Self-Portrait*, however, poses a challenge to this apparently uniform and linear understanding of radicality. Looking at it, we are at a loss for referents; and locating the picture within a relevant discourse becomes a difficult affair, one of deficiency rather than information. The image of the artist overtakes our expectations because it alludes to many traditions, but subscribes to none. It evokes the decorative lyricism of Piero della Francesca, antithetically fused with an atmosphere recalling Andrea Mantegna's programmed perspectival schemes. Fragments from the past, recognized through costume or comportment, evoke incomplete memories, and are randomly recombined against a twentieth-century backdrop – white light, white space, defined on either side by vertical bands. On this ground exists an arrangement of forms we can organize into the components of a formally dressed figure. The centre of the composition is occupied by the pierced, dipping, red, parabolic arc, chest ornament imposed on the smoothly painted black shoulder covering. Below the white collar, our attention focuses on the intersection of shapes, scrutinizing how certain regions are painted, detecting their beginnings and ends. Through describing what we see in the painting, our understanding of the history of painting is aided by the picture's malleability – a malleability that juxtaposes sequence and era against autonomous recombination.

Breaking into the text of this painting (all histories must eventually be written), breaching its format and information to achieve an understanding of its origins and historical context, is complicated by Malevich's inclusion of the self-referential system. Inside the syntactically signified history of painting – which is a general history – operates the Suprematist system (a personal history). The subject of self-portraiture, which is by definition a dualistic undertaking of observing and re-creating oneself at the same time, offers Malevich the opportunity to mingle systems, to simultaneously record and recode history.

On the reverse of the canvas Malevich inscribed the words, 'The Artist and a Black Square', displacing straightforward comprehension of this image as a self-portrait. Striking a rigidly formal, almost iconic, pose Malevich

120 Photo of Malevich painting, taken by Nikolai Suetin on 3 April 1933.

conceives of himself at a distance, discussing his personally directed observations in the third person by becoming the narrator of an event that occurs in an instant. He thus counters the definition of narrative as a mode of description: it is an allegory of an artist, not an autobiography of the painter. Set against a uniformly luminous cream background, Malevich resides in the depths of paint that photographically articulates his facial features, challenged from below by the furor of his brush bending under the strain of likeness. It is precisely this duality in paint, between free application (brown sleeves) and precision (his countenance), that Malevich describes with the posture of his hand – both through gesture and in a painterly sense with the consciously 'painted' hand, the hand that guides the brush. In an uncharacteristic shift away from the abstract, Malevich reveals himself and his craft: the infinite possibilities of the self, the possibilities of the brush.

A photograph from 3 April 1933 taken by N. M. Suetin reveals Malevich at work. He sits facing the easel in a state of concentration, calmly painting the collar of *Girl with a Red Pole* (not reproduced). The brush resting inside the crevice formed by thumb and forefinger focuses energy, articulating thought structures about to be phrased in the language of painting. The active right hand is separated from the canvas surface by a long length of brush handle; there is a critical distance, a critical lapse, between the touch

of his fingers articulating the tool and the touch of the brush on a canvas surface. This painting hand is steadied with the support of a wooden pole, which facilitates a precise manipulation of the distance of the hand from the canvas. The left hand, bracing the bar against the easel edge at the bottom of the photograph, guides the pole as the painting hand demands. Steadied by this pole the bodily scaffolding controls lateral and vertical movement, and forms a mediating system that provides both precision and freedom. Using this technique to reduce the randomness of gesture, Malevich plies the space between his command and his tool, formulating the distance of interceding space – or the refined motion – into the act of creation. The photograph is a document of process delivering one instant out of the continuum, synecdochically disclosing a whole through implication.

*Suprematism: Self-Portrait in Two-Dimensions* (1915), when compared to the late *Self-Portrait* of 1933, presents a different vision of the same painting style. Although the underlying compositional structures are radically different it appears that, besides thematic coherence, the methodology of paint application is consistent. Against the activated Suprematist white ground, an array of contrasting geometric shapes appear – smooth brush-effacing regions of colour. Our understanding of Malevich's use of paint density, of impasto opposed to thinness, gains resolution when considered in view of the late photograph we have just discussed. The forms are not mathematically ruled and are not produced by hard edge or compass; instead they found an organic genesis within the motile mechanisms the artist deployed.

Referring to Malevich's carefully formulated and introspective commentary about creation, we recognize the depth of his artistic meditation. Concerning the demands that were placed on the artist, the following passage from April–May 1927, perhaps written while staying in Germany for his Berlin exhibition, merits our close observation:

Suprematism is a new, non-objective system of relations between elements, by means of which sensations are expressed. The Suprematist square is the first element out of which the Suprematist method is built.

The square framed with white was the first form of non-objective sensation, the white field is not a field framing the black square, but only the sensation of the desert, of non-existence, in which the square form appears as the first non-objective element of sensation. It is not the end of art, as people suppose even now, but the beginning of true essence.

Society does not recognize this essence, just as it does not recognize an actor in the theatre playing the part of different characters, for the true face of the actor is hidden by that of the character.

This example also points to another side of the matter, namely why an actor puts on a different face – that of his part – for art has no face; in fact every actor feels in his part not a face, but only his sensation of the represented face.

Suprematism is that end and beginning where sensations are uncovered, where art emerges 'as such', faceless.[133]

Considering the 1915 and 1933 self-portraits in juxtaposition, the meaning of Suprematism emerges as a philosophy beyond form, giving conceptual insights about man and his receptive workings understood throughout a spectrum of appearances. The Shakespearean spectre of man thrust onto the limelit stage, the existential enormity of a project that aspires to fulfil itself

by always risking failure, motivates Malevich's dialogue with his painting. The radical pictorial span, documented first through his written expression and then with his late work, tests the limits of his vision. Suprematism transgresses its own boundaries. Malevich's late work expounds theory in its most complicated and threatening manifestation, going even beyond the works of the artist himself. The late *Self-Portrait* sets the new tradition of Suprematism, first understood in rigorously abstract forms, against its once-menacing nemesis, referentiality. This portrait is a true act of appropriation, because it not only reconstitutes the past (Malevich's own personal painterly history), but it reifies the theory of Suprematism, incarnating that history in its future format. By pre-empting possible dissolution, Malevich subsumes the earlier *Self-Portrait in Two-Dimensions*, literalizing his own theories against the challenge posed by observing himself, sensing his history. For how else are we to understand his phrase: 'Suprematism is that end and beginning where sensations are uncovered, where art emerges "as such", faceless.'

Only in comparison to Max Beckmann's famous *Self-Portrait in Tuxedo* of 1927 (illus. 121) does the sophisticated status of Malevich's psychological, philosophical and painterly depth become clear. By this late moment in Malevich's career, his understanding of European painting had become masterful and transgressive; after surmounting the centuries of representation, he reinserted himself into the tradition through inversion. His awareness of contemporary trends, in this case German Expressionism, is shown by the manipulation that occurs under the dictates of his own beliefs in painting. Unlike Beckmann, who sardonically relies upon his *Self-Portrait in Tuxedo* to convey disillusionment with society,[134] Malevich's late *Self-Portrait* has a grandeur that exceeds personal commentary.

In the Expressionist vein of pointed social criticism, following the reactionary tirades of George Grosz, Otto Dix and other members of the Neue Sachlichkeit, Beckmann proposes hyperbolized ennui, a laconic lament about decadence. The tuxedoed artist gazes opaquely at the viewer, his painting hands displaced and cynically occupied by social affectation instead of creative gesture. Malevich, who experienced throughout the 1920s considerable dislocation (he was occupied from 1920 through into 1927 by the writing, teaching and transcribing of Suprematist theories into architectural conceptions) does not capitulate to circumstance. His *Self-Portrait* overrides the forlorn, concentrating on the sovereignty of the artist, and the dignity of man after a long journey through life. In this context, the formal differences between the two portraits gain meaning. Beckmann renders himself in anatomically accurate terms, standing in a dimly lit parlour, his face and hands cast into deep shadow. Marginally cropped by the frame edge, we feel the full weight of the entire brooding figure. Malevich dispenses with exactitude, posing himself in non-referential space and maintaining an expression and gesture that results from paint rather than the transcriptive dictates of narrative. Malevich proposes the coincidence of sign (bodily features) and signified (supposed description of state), allowing gesture as the absolute concept. This late self-portrait is a revelation of the self in terms that transcend introspection, the vicissitudes of scrutiny, and the marvel of painting itself.

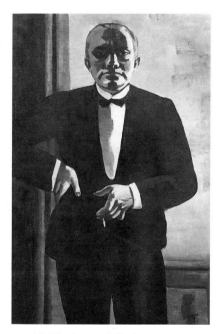

121 Max Beckmann, *Self-Portrait in Tuxedo*, 1927, oil on canvas (139.5 x 95.5). Busch-Reisinger Museum, Harvard University.

167

A statement in 1807 by F. W. J. Schelling who, as previously noted, exemplified the redirected philosophical propositions that would form the conceptual core of Northern Romanticism, gives insight into the artworks of that era:

We hope, by looking at plastic art in relation to its true model and fountainhead, nature, to be able to contribute something as yet unknown to its theory, to provide some more precise definitions or elucidations of concepts; but above all, to make the inter-relationship of the whole structure of art manifest in the light of higher necessity.[135]

At the opening of this chapter we surmised the mutual intertextuality of theory and painting, reiterating the essential bonds between Malevich and his circle. The notion of linkage, tracing developments across various disciplines, serves the primary scholarly ends of understanding intercourse and comprehending origin. The methodology, however, has a deeper significance, pertaining to the 'theory of history' that Malevich aspired to fulfil.

When we isolate certain advents or awakenings in thought, theory, the sciences, or related art forms, we undertake analysis of the inner workings motivating those events; we contextualize necessary correlative sequences around specific details. In painting we see a binary explication, and may conclude that the artwork must reflect external impetus/the greater context of culture, and that the true artwork then surmounts that discourse with additions. Caspar David Friedrich, for example, carries out in painting the actual materialization of Romantic theory (Novalis, Fichte, Schelling, the Schlegel brothers, and others). Friedrich's greatest paintings do not merely reflect advanced theoretics, but conversely encode those thought structures into painting. The mechanism is not transcriptive, but additive and irreproducible; it determines its own ultimate character, because what is produced in the painting represents that painting's essence – an essence which can be approximated in words, but not replicated.

122 Caspar David Friedrich, *The Large Enclosure*, c. 1832, oil on canvas (73.5 x 102.5). Gemäldegalerie, Dresden.

The painting becomes both a conduit and container of the given historical discourse. It possesses within its making the personally mediated cultural history of the artist, whose particular style rides on top of the painting itself. If paintings, then, carry in them the encoded kernels of history, it would be these kernels that signify tradition – thematically consistent but stylistically progressive. Innovation can thus be recognized against this flow, by the artist's ability to tap into the dormant essences of past paintings, and extract from them not stylistic traits but the encoded element of historical essence. Malevich's assimilation of French Cubism perfectly serves this understanding of history in painting. Works like the *Lady at the Poster Column* or *Private of the First Division* (not reproduced) are not mimetic homages to Picasso and Braque, but rather extrapolate from their theoretical core.

In his late work, Malevich's desire to surmount tradition finds a more refined position, a confrontational one opposed to the Suprematist phase (which simply effaced traces of the past). After 1927, Malevich deals only in the broadest categories of painting: portraiture and landscape. Confined to these enormous histories, the options for invention seem minimal. It is, however, as a consummate painter that Malevich returns to the question of painting's original function, its relationship not to the observed world, but to

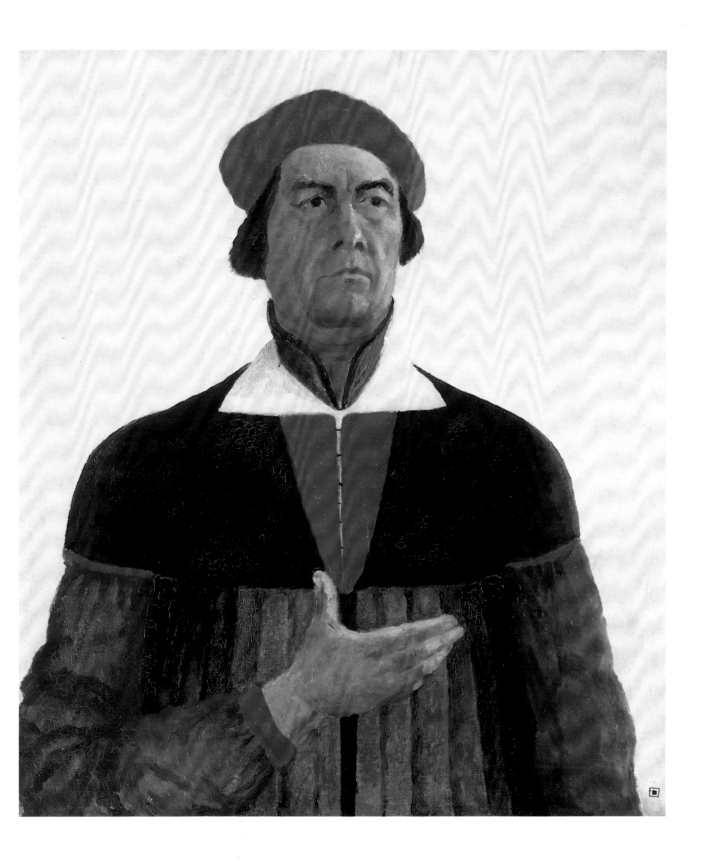

123 *Self-Portrait*, 1933, oil on canvas
(73 x 66). State Russian Museum,
Leningrad.

the world as human beings first inhabited it. Malevich is able to bypass successive trends (Fauvism, Futurism, Cubism, etc.), fixated as they were on reaction to the movement immediately preceeding them.

The view of time as discontinuous, of history as a spiral and not a line, opens up formal possibilities referentially aligned with meaning instead of appearance. From Antiquity forward, painting's role as a form of expression and a means of decoration altered little. Its position in the world, the way it was viewed, may have undergone radical shifts, but its root function defining its prime objective has remained within a fixed range. For Malevich to concentrate only on portraiture and landscape invokes this existential criterion; it helps us focus on the genesis of painting as an addendum to the world.

Malevich, being a painter of painting, demonstrated with Suprematism that end which denotes itself, the realm of 'pure painting'. In the late work, with his original instinctual necessity integrated into a refined cerebral gesture, incarnation is attained. In *Landscape with Five Houses* (illus. 20), humanity's terrestrial constructions (shelters painted loosely in diagonal strokes) appear on the high horizon, at the point where land and sky intersect. Reach-

124 *Ploughman*, 1910–11, pencil on paper (19.2 x 21.9). State Russian Museum, Leningrad.

125 *Face of a Peasant*, c. 1929 (?), pencil on paper (35.3 x 28.5). State Tretiakov Gallery, Moscow.

ing upward, they aspire to the celestial blue, yet are firmly grounded in the pink/white/red earth. Reflecting upon the irretrievably lost information of how to organize a community, the houses cluster close, attempting communication. The interchange is tentative and none of the structures connect; touch is inconceivable. Painting, offering the only potential liaison, cannot overcome the obstacles of separation. In this uncertain situation, Malevich defines at least one parameter. The dividing line, between the blue and red field, maintains aspects of geography while including the cosmic in its definition – atmosphere and surface, geometry and plane.

Although our attention is drawn to the houses, the consuming element of this composition is the vast, upper, blue region, which we associate with sky only because of its apparently denotative colour. Every other aspect of its painterly character speaks against the sky, both as we know it from life and through representations in past painting. Note the sheer *vertical* energy of the multi-toned strokes, disrupted by shards of white, unloose convention succumbing to the brush as it revels in use. We disappear inside our wildest dreams, travel to the depths of infinite regions of blue, more blue perhaps

171

126 *Three Figures*, 1928, oil on canvas
(37 x 27). Collection of V. A. Dudakov.

127 *Head of a Peasant*, c. 1930, oil on
plywood (69 x 55). State Russian Museum,
Leningrad.

than we indeed dreamed of, invoking an unfamiliar violet. Are we inside memory or beside the past? Are we lying supine staring upwards, or are our eyes closed as we meditate within? The major question, however, is left unanswered: are we alone in this experience or accompanied by a companion?

The subversive drive toward a painterly attitude, nascent in Suprematism, is here unleashed, exposed in full-blown freedom. If this painting is to be honoured in its totality, and its real importance understood, we must take a step back and view it against its prelude in Suprematism. This landscape painting, coming after Suprematism, after the writings and theorizing, after the architektons and planits of the 1920s, and indeed, after the consuming white of abstraction, is vital. Recalling that every Suprematist painting was based on a white or beige ground, it is in this late work that Malevich dislodges the constraints of his abstract format. Here, the deviant division of the painterly ground into two parts forms the bi-coloured foundation onto which the former ground is imposed; the one white square and four white rectangles are paintings within a painting that is volumetric only by implication.

With the loosening of the dogmatic principles of Suprematism, we find a parallel loosening of the painting style. Although Suprematism often restrained faktura to a systematic principle governed by strict geometric forms, here the brushstroke is prominently displayed. Individual strokes strive for autonomy, and in so doing aspire to meaning. This venture is controlled by a unifying verticality. The brushstrokes, discretely complete yet part of the field of colour, exemplify individual free will, and reveal the intelligence of the man who wielded the brush. This work leads us back to Malevich's comment in a 1913 letter to Matiushin 'that one cannot draw a single line without rational and thoughtful control.'[136]

In the dialectic between the free will of the brushstroke and pure rational thoughtfulness, manifest in the 'figurative-looking' painting of Malevich's late period, we find an achievement that subsumes the rigidity of Suprematism. Tracing the deep curve of history, one begins to see in this treatment of surface – these thoughtfully conducted brushstrokes – the first lights on a horizon that would ignite twenty years later with the two great American painters of Russian descent, Barnett Newman and Mark Rothko.

With this in mind, another work entitled *Three Figures* (illus. 126) declares its painterly quality. The fields of colour are more radically articulated than before. The neglect apparent in the brushstrokes in the upper region leads us to an awareness of the unknown freedom of painting itself; the bare canvas breaking through here and there demonstrates an application of paint unrivalled in the international scene around 1930. Nevertheless, these uneven, counter-systemic brushstrokes form a monochromatic upper part when compared to the roughly painted horizontal bands. The liberty taken in the nearly experimental combination of colour (reading like an abstruse code) and in the almost accidental and casual (causal [sic!]) play of the brush, as it ploughs evenness into the furrowed peaks of impasto (especially in the upper green register), shows a trust in gesture and an affirmation of the correctness of improvisation. But this painting, as with the other late works,

is not improvisational; it is the laborious result of a technique that took years to develop.

The improvisational character of these paintings is a potent sign of contemporary politics and culture, because beauty can be discovered not only in the aesthetic of the brushstroke itself but in the achievement of meaning as a consequence of rebellion. Post-revolutionary life in Russia was controlled and mapped out by the imposition of programmes that professed comradeship, but which ultimately dehumanized the concept of community. The greatest example of the organic process of life itself being circumscribed and obstructed by arbitrary rules is surely provided by the first five-year economic plan, launched in 1928. This plan was part of Stalin's quest to marginalize human deviation from a set standard. Malevich's quiet, humbling observance of the brush-touch asserts the finality that only the human presence and persistence in life can produce, generating not merely meaning, but substance. The late paintings condense doubt, questioning the new order in a classical language of painting; they are unproblematized by emblems of modernity, and are in no way characterized by elusive transcendent realms or governed by the straight edges of geometry.

In comparison to Piet Mondrian, who progressively embraced modernity by distilling painting down to three colours, two non-colours, and two directions, Malevich questions whether progress should be construed as reduction, simplification, and programatization. In works such as *Three Figures* and *Torso: Half-Figure with a Pink Face* (illus. 112) the arrival of the human form, initially striking us as regressive, must be, as living history so tellingly reveals, a premonition of what would come to haunt modern man. Sixty years after these paintings, humanity as a whole has finally begun to distrust the miracle of technology. Even in the optimistic afterglow of the great social revolution, an achievement not yet tarnished by failure, Malevich inserts his comment about the necessity of human cooperation and exchange. *Three Figures* elucidates this concern, while *Torso* raises the obverse, presenting the colouristically schematized figure of man, truncated and thrust forward. The prospect of disillusionment arises because the figures bear no specific character traits. As people they are completely de-individualized, functioning as single volunteers for the greater masses. Their relationship to us is through painting alone, but through Malevich's belief in the power of his medium we are assured that circumstance has not yet overwhelmed the individual.

Crudely applied to the bare canvas, the personages in *Three Figures* seem confronted by the abyss. It is unclear whether they are seen from behind or are facing us; or whether they are standing (frozen on the surface) or striding slowly across the plain. *Torso* maintains a more complex relationship with its painterly setting, and struggles to retain its form against the fully charged strokes of a 'background' that encroaches furiously upon the figure. Colour is the single defining trait; the texture and brushwork disobey the subject matter by attending to all areas of the canvas with equal conviction.

As with most of the late works, there is an embracing consistency (especially in the coherent paint application), offset by numerous compositional contradictions (usually resulting from a manipulation of the traits of classical painting). In *Three Figures* our desire for representational art appears

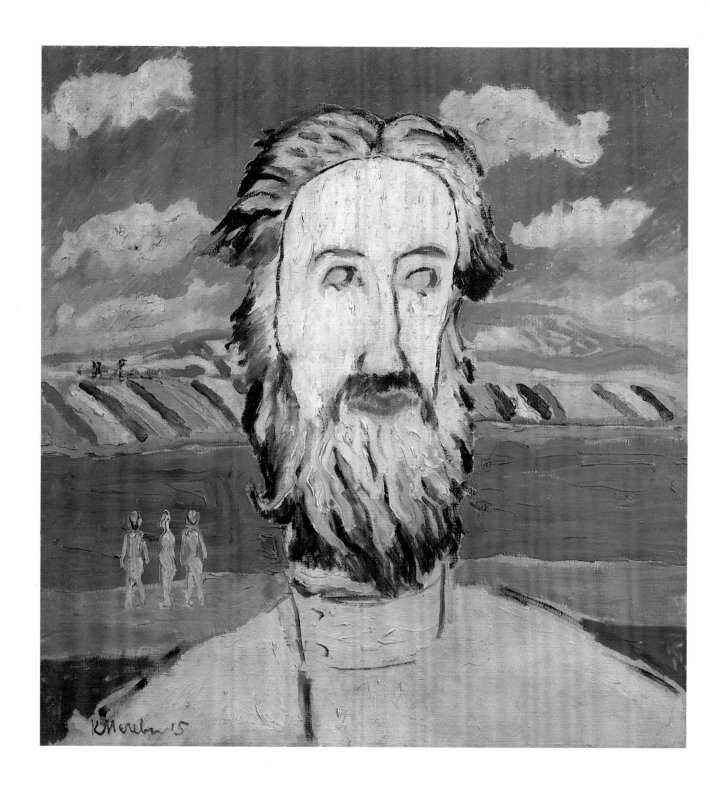

128 *Head of a Peasant*, 1928–32, oil on
canvas (63.5 x 51). State Russian Museum,
Leningrad.

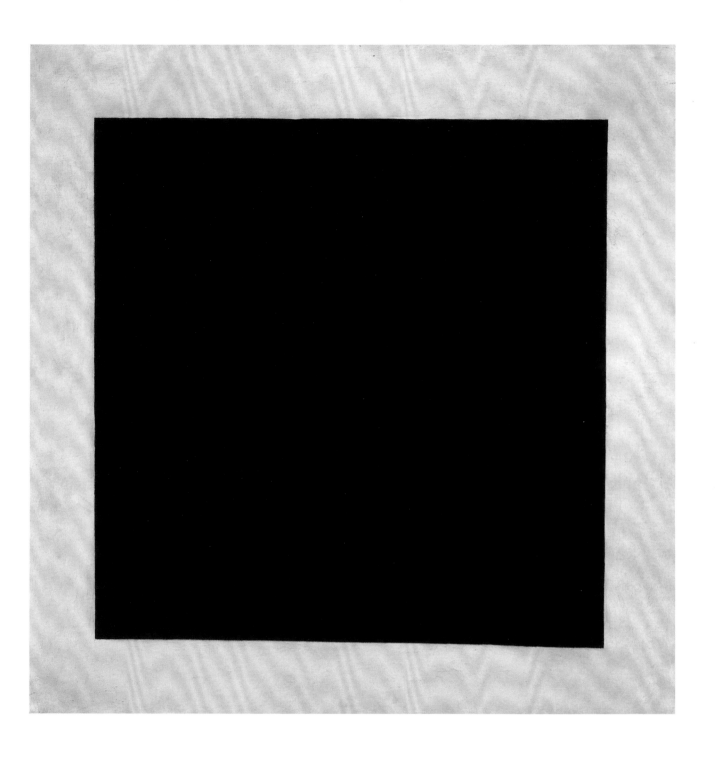

**129** *Black Square*, late 1920s, oil on canvas (106 x 106). State Russian Museum, Leningrad.

to be fulfilled, enabling us to connect the title to 'three figures, probably female, standing or walking in the field'. As soon as we scrutinize the picture, analyse specific elements in it, and search for refinement, this reading disintegrates, confronted by a lack of information – an inversion of 'fact' that is quite deliberate. The stratified soil, if it describes anything, probably refers to . . . pink, grey, black, white . . . the green may signify fertility, or plants perhaps – no! No amount of representational gymnastics can explain this colour sequence as descriptive. Malevich's conceptual acuity goes to the heart of painting and its function(s), dissecting the way art creates meaning in an experiential exegesis. Even while we strive to place the figures in space, presuming that the smallest must be in the background (as perspectival law insists), our need for interpretational security is undermined because the figure's legs dip deeply into the green band. And this contradiction was unmistakably asserted by Malevich from the beginning, because the gap in the green reveals bare unpainted canvas. With this one detail, we are assured of the artist's power. Malevich's absolute awareness of his craft culminates in this oft-dismissed late oeuvre, refuting simplistic critiques that accuse the artist of reversion. Here his work attains an intensity that rivals Suprematism.

130 *Man With a Beard*, c. 1930, pencil on paper (57 x 40.5). Private collection.

The references to earlier work are often striking. *Complex Presentiment: Half-Figure in a Yellow Shirt* (illus. 113) preserves the classic Suprematist attitude – the face is entirely eclipsed by the polarizing extremes of pure black and white, and crescents of an oval. The lustrous sheen of paint allows an illusionistic reading of the form of the figure, which seems to be positioned within a receding landscape. This scheme, however, is unravelled through a blatant contradiction: red occupies both the low immediate foreground horizontal and the high vertical band forming a house on the far horizon. It is exactly the same red in both instances. The seamlessness of paint application is consistent throughout the black, yellow, and blue intervals separating the red band from the red rectangle, and this creates an anti-illusionistic flat area.

Offset against this, the return to the techniques of classical Suprematism allow the suggestion of volume in the figure's torso, arms and head. Despite the impossible play of light, which shines from the right on the limbs and torso but from the left on the head and neck, our instincts urge us to see curvature and volume; thus the work almost exactly replicates the contradictions observed twenty years previously in Malevich's interpretation of Léger's cylindricism. Although scholars have frequently (though rarely specifically) noted the formal similitude between early works, such as *Peasant Woman with Buckets* (1912), and late works, such as *Complex Presentiment* (1928–32), the underlying drive of Malevich's final oeuvre differs sharply in its understanding of how painting operates to signify meaning.

Malevich's approach to his familiar themes of peasant life and the Russian landscape, rephrased from earlier work, subverts the notion of *narrative* that bound the early work to conventions of Western European and Russian nineteenth-century painting. *Complex Presentiment*, which immediately declares its subject matter, does not, however, describe narrative intention, as does the *Peasant Woman with Buckets* (illus. 25). In the 1912 painting we are made aware of the subject matter through the title, and from this starting

131 *Two Figures in a Landscape*, c. 1930, oil on canvas (47 x 58). Stedelijk Museum, Amsterdam.

point we begin to search the painting for movement, for progress along the plot line. Admonished through the discovery of articulated elements in the background, elaborated through clear geographical and seasonal character-istics, we piece together (unify) a story that gives reason to the image. The figure is activated through our ability to move it through time and space, across the surface of the canvas, and this sequential result builds narrative.

*Complex Presentiment*, a title that instantly imposes distance between a figurative reading and the image, discards the concept of narrative, replacing it by the more classic and complex idea of the *epic*. Unlike the literary novel, a narrative which is a shorter description of events at various paces, the epic addresses major issues, dwelling on their progress over sustained time. The epic is characterized by a steady flow, a self-perpetuating description that is its own subject and theme, where revelation is attained only after duration. Relying upon this trait, the epic distinguishes itself from narrative by possessing the depth and breadth to initiate allegory. If allegory is regarded as the metaphorical presentation of ideas in such a way that the metaphor both embodies and exceeds the initial meaning of those ideas, then indeed,

179

**132** *Composition*, 1928–32, oil (40 x 56).
State Russian Museum, Leningrad.

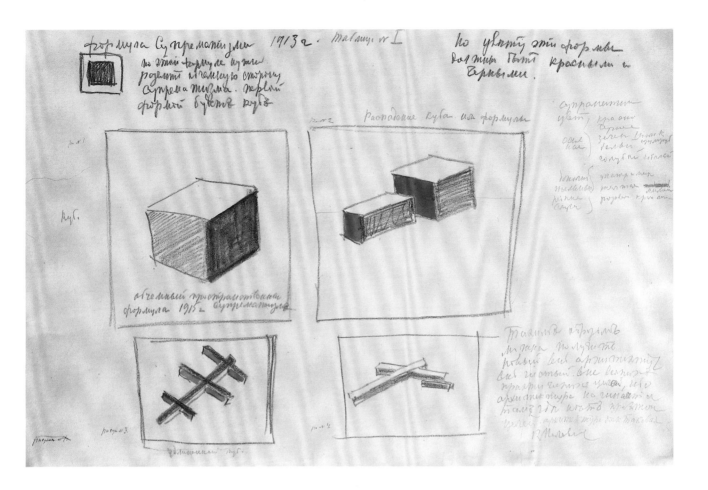

the epic alone accomplishes this task of telling. The epic retains the freedom to mingle the categories of description with the actual process of uncovering. By relying upon the always-on-going, the epic subsumes narrative, deploys description, speaking in terms of allegorical significance about the flow of life.[137]

*Complex Presentiment* proposes a paradoxical rupture in the narrative of painting, confronting the viewer with parts of a narrative that do not fit together. Using the highly refined painterly techniques of Suprematism, Malevich places a figure against a ground (earth with one house and the sky), cutting off description after depiction. The deadening solid colours, despite the fusion of blue and white and yellow and white, do not permit internal dialogue; we can state their presence but not describe their intricate workings. The brush has become diffident and is uneasily exercised in two points: the tassel of the belt and the dots on the collar. These details of belt and collar buttons isolate the dysfunction of narrative, floating against the yellow, suspended in the vacuum of colour, unrelated. Malevich's suppression of sensually more compelling enriched brushwork shows his advanced understanding of painterly technique and its intimate correlation to meaning. Here, the unarticulated brushstroke has been denied, imperceptibly conjoined with image. These features of non-narrative, however, do not guarantee the presence of an epic, which is a project entailing a much broader conceptual operation.

The epic quality conveyed by *Complex Presentiment*, and paintings like *Peasant* (1928–32; illus. 21), is initiated through the conjunction of image with statement, which instigates a circular retrieval of all readings that propose a linear progression from one starting point to one end. The image can be looked on as allegorical, and not symbolic, because its denotative power is not constrained to one level of significance. The human figure does not symbolize one state, does not depict a certain status. It takes on an allegorical identity as meaning through its presence in painting which provides a context or situation that supports its logic, without explicitly supplying information about the workings of the figure. It tells us about itself in the terms that have made it, and what we as viewers understand surpasses this apparent information. Here, the role of the image recedes, withholding the major function of painting as an image of narrative – circumventing singular propositions, encircling each departure point with a rival one, compressing the notion of departure into that of process without progress – an epic that continues and continues telling itself.

134 *Three Heads*, after 1930, pencil on paper (22 x 35.2). Private collection.

The world stands before man as an invariable fact of Reality, as unshakeable Reality (as people say); two people, however, cannot enter this unshakeable Reality, this actuality, in order to draw from it one single sum; they cannot measure it identically. However many people enter this Reality, each will bring a different Reality, and some will bring nothing, for they will see nothing Real; each will bring his judgement on the thing that he went to see and precisely their judgement will be the Reality, proving that the object under discussion does not exist, for even the judgements themselves, in mutual exchange, create very many shades of contradiction. Therefore what we call Reality is infinity without weight, measure, time or space, absolute or relative, never traced to become a form. It can be neither represented nor comprehended.

– Kazimir Malevich, 'God is Not Cast Down', Vitebsk, 1922

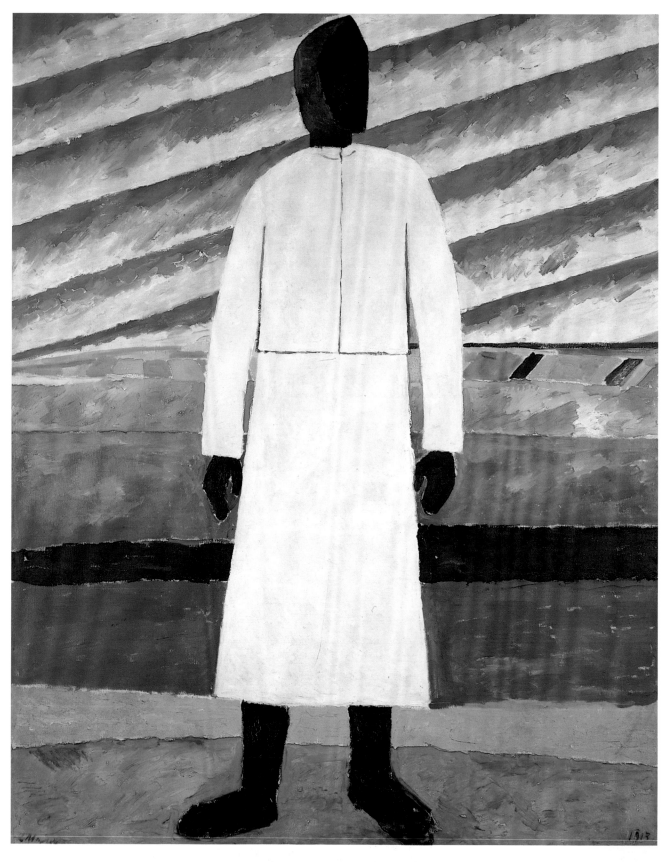

135 *Peasant Woman*, c. 1930, oil on canvas
(98.5 x 80). State Russian Museum,
Leningrad.

# The Free Imaginary Variation

By 1923 Malevich's thinking about Suprematism and non-objectivity had led him into the realm of architectural creation, allowing him to generate ideas in alternative dimensions, and in a medium other than the colour of paint. Ceasing his theoretically oriented activities at the Vitebsk art school in 1922, Malevich assumed directorship of St Petersburg's Museum for Artistic Culture (MKhK). There he undertook extensive investigations of invented architectural structures, testing the scope and scale of Suprematist propositions. His Architektons, initially built of cardboard in 1919 and fully developed in plaster in the early 1920s, show how ideas may be implemented into formal constructions that have no specific application; they denote a reality that does not necessarily coincide with the everyday.

In our approach to the Architekton *Alpha* (1920) we recognize direction that maintains its own internal orientation (illus. 137, 138). The thrust of the main frames of force follow our ascribed inclinations, our vision in motion from the air above. There is no scale to this part of a world, to this composite building block. In fact, the conglomerate form of *Alpha* is compiled from various discrete, elemental, cast blocks of plaster. This encourages us to view it as a vision which may extend beyond the constraints of 'a priori' or established physicality. Height and width and depth and length are dislodged into a spherical realm, and thus all relativized by tangents that can be drawn in the imagination from various corners and edges in order to define and circumscribe the parameters of the construction. Circular viewing and perception is the only way to comprehend the entirety. The Architektons distinguish themselves by that ultimate criterion of sculpture, the necessity of being viewed from all sides and all sights. Finely tuned and carefully planned proportions replace and displace notions of scale, so that the composite mass

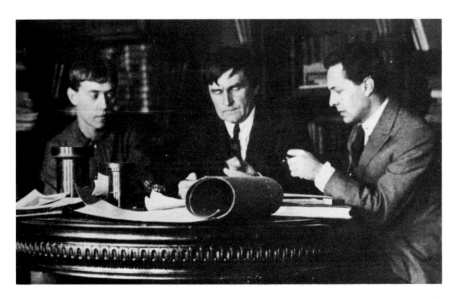

136 Kazimir Malevich (centre) with his pupils Nikolai Suetin (left) and Ilya Chashnik (right), Petrograd, 1924.

# KAZIMIR MALEVICH

**137, 138** *Alpha*, 1920, plaster (33 x 37 x 84.5). State Russian Museum, Leningrad.
**139** *Suprematist Architekton*, c. 1929, plaster.

186

140 *Architekton*, plaster.

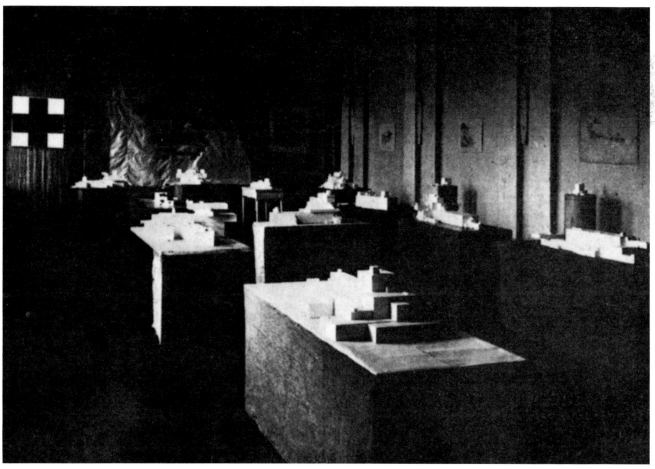

141 Exhibition photograph of the 'representative exhibition of the GINKhUK', Leningrad, June 1926.

maintains no fixed relationship to any of its isolatable parts. *Alpha*, as Malevich asserted, need have no functional meaning in the external world. There is no formal declension among any of its parts. Every aspect must be considered as an essential detail, a necessary keystone; that is, there emerges no hierarchy determining significance or asserting importance because each aspect is irremovable given the absence of scale. This generosity, admitting the possibility of additions and subtractions, dissolves the blunt seigniority of the façade as a fixed carrier of significance; and in this, *Alpha* remains superior to any example in architecture to date.

By dissolving the façade's primacy in this way, Malevich demonstrated that there need be no discrepancy between external (surface) and internal (structural) characteristics. His ability to recognize an architectural innovation that was consistent within and throughout allows the distinct parts of a whole construction to be consistent to that construction while refuting any repetitive degree of resemblance or similarity. The apparent diminution of difference actually becomes a refinement of exactly that dialectic – a dialectic in which decreased initial difference collapses to amplify the criterion of how distinctions are made. With this idea firmly in place one can begin to expand readings of Malevich's late painting, after 1927, which has so often been commented upon by scholars merely on the basis of initial impressions, or under the auspices of simplistic narrative. Just as the Architektons maintain a laconic reluctance to distinguish part and surface from whole and internal structure, so Malevich's late painting is comprised of imagery that purports to reveal aspects of a life while refusing to indulge any particulars of personification.

In accordance with theories of mutation in the Architektons, one instantly understands the potential for the total dissolution of defining edges in any spatial or architectural terms. Under the flexible coordinates of Suprematist construction, especially in this three-dimensional realm, the emphasis upon balance becomes paramount; and this explores the validity of such simple notions as symmetry versus discrepancy. The weight and solidity of main masses within the *Alpha* construction are contradicted and alleviated through the use of piercing planes, attached like peripheral wings reminding us of lightness (and suggesting such things as satellites). On certain sides apparently extraneous, curious elements jut out, impossibly suspended as if to imply that there can be no easy internal mechanism dictating the order of construction, and opposing any logic pertaining to functionality.

As a means of creation, how do the movements of the paint brush compare to the act of organizing cast blocks of plaster? With the impassive and nearly uniform faces of the Architektons, we can observe in Malevich the emptying out of small gesture from his creative framework, and an emphasis upon idea as opposed to delicate conversion into image. The Architekton, with reference to painting, denotes an absence of personality, a consummate striving after a universal language. It is a venue of proposition that bypasses the unitary and specific in favour of swift, effacing solutions. By moving creation beyond any boundary lines of convention (constraints which painting could never escape), the Architekton afforded an opportunity to reformulate the

142 *Future 'Planity' (Houses) for Earth Dwellers (People)*, 1923–24, pencil on paper (44 x 30.8). State Russian Museum, Leningrad.

basic postulate of accepted reality – namely, the conviction that the human mind can encircle the possibilities of existence. Man's conceptual and imaginary functions, beyond any experiential evidence founded in consciousness, triumph under the tests and hypotheses of pure invention, simplified. And even though reality was changing format quickly in the early twentieth century (in the natural sciences, physics in particular, and psychology) and the ways of addressing reality were leaping to adapt (linguistics, mathematics, and the arts), there remained certain recalcitrant issues needing redefinition and elucidation. Whether we articulate ideas about reality in philosophical terms, or if we resort to other demonstrative tactics, the essence of reality demands reflection. And when the painter Kazimir Malevich is elevated to this transcendent stage of a hermeneutic discourse, the parameters and polarities of potential reality become as eristic, caustic, contentious, and challenging as those created by any individual operating in the fragmented, incessantly actuating culture of the 1920s.

Malevich became increasingly aware of the disparity between the presence of phenomena and their necessary meaning. When, in 1922, he reflects upon the incalculable variety of possibility offered to man by his world, he neither attempts to extract an intrinsic logic from circumstance, nor to secure man an essential position at the discursive centre of existence. '*Man is preparing to comprehend and learn "everything"* [our italics], but is this "everything" before him? Can he put this "everything" on a table in front of him, investigate it and describe it . . .'[138] Can knowledge and comprehension be gained through reflective observation alone? Can man comprehend meaning and purpose using analytical approaches to the supposed substance of what is presented to his senses?

Malevich engages these epistemological issues with a double objective in mind. He aspires to dispel the validity of any supposed theory of knowledge that would relieve man of responsibility to ontological obligations, and in so doing he proposes a total reorganization of critical methodology. Within this second project, the task of Being confronts itself by becoming constrained through distillation: 'It seems to me that in order to investigate, study and learn, I must be able to take out a unit that has no connection with its environment and is free from all influences and dependents: if I can do this, I shall comprehend it; if not, I shall comprehend nothing, despite the mass of extracts and conclusions obtained.'[139] Phenomena, circumstance, and their appearances are discounted, figuring only as infinite sources of mental and sensory preoccupation and deception. Endeavours to observe and describe are fruitless without comprehension. What Malevich seeks is the realm of pure cognition – a reality of comprehension. And this directive affords the artist the freedom to make alterations and adjustments to apparent reality. Prospects that refute the logical assumptions of one world may demonstrate the reality of an alternative, perhaps elevated, method of Being.

Under the auspices of this seemingly speculative, but actually productive, approach, we can begin to question our own methodology. We might reconsider to what ends information is governed and reconstructed through interpretation, and question whether the object of any search through pure

**143** Alexander Rodchenko, *The Wheel*, 1940, photograph.

'factual' information should be conclusions. Do the kernels of certainty yielded by knowledge provide us with truly meaningful insight, or are they merely the superficially cogent outcome of the limited questions we decided to resolve?

For the beginning of an answer, we might return to the example from our first chapter – the contemporary model of medical research as self-reflexively manifest in the case of AIDS. In our discussion, the proposition that AIDS might not have been a fortuitous, socially specific disease became clear through analysis of certain events transpiring in genetic laboratories and other medical institutions responsible for manufacturing massive amounts of vaccine. And following a hypothesis concerning the accidental or intentional alteration of vaccine, it became apparent that AIDS is characterized by a retrovirus, which depletes the human body of antibody cells. The plausible, and now widely accepted, explanation of AIDS as an effect of this virus allows not only for public assumptions about the nature of the AIDS predicament to be made, but has also, on a more profound level, dictated the course of medical thinking. In fact, the viral explanation has defined all the research and development that is being applied to finding a solution.

The retrovirus assertion has come to limit all viable options of explanation, and has consequently curtailed the domain of new information. As research is conducted, it is thus designed specifically to address the retrovirus, and to overcome and resolve the threats that it poses. Our analysis of information and interpretation in the first chapter followed a line of argument and belief that can now be reviewed.

There is another approach to the AIDS model which contrasts dramatically with previous assertions, and surprisingly this alternative viewpoint was first suggested by a retrovirologist, who observed that:

... the [HIV] virus is clearly not sufficient to cause the disease, and on the basis of its low level of infiltration – that is, infecting so few cells and its extremely low level of infiltration in AIDS patients – ... it appears not to be necessary for it [AIDS]. Not even

to be necessary means not even to function as a co-factor ... the CDC [Centers for Disease Control] have redefined the guidelines for the diagnosis of AIDS ... They have stated that an AIDS patient can be diagnosed, and will appear now in statistics as an AIDS patient, without any laboratory evidence whatsoever.[140]

Not only has the institutional definition of the disease been redefined, but important aspects of laboratory research have now been completely undermined. The fundamental thrust of all research conducted in vitro, it appears, has almost no relation to what happens within the human body. All experimental propositions about the virus, about suppressing it, about new drugs designed to reverse damage caused by it, are revealed as relevant only in the realm of closed-circuit experimentation. This experimentation has no applied value because the virus does not significantly exist, survive, or even function in, human beings.

Medicine appears to have lost sight of its objectives; it has become obsessed with constructed models, and while it claims real-life applications it has not been able to deliver substantial practical results. The analysis of information can give rise to misplaced priority. What is credible in one domain of inquiry (the laboratory), maintains almost no value in a seemingly related sphere (human life). The suppositions of medicine, providing a correlative bridge of Being between circumstances, are defeated under the devastating recognition that facts – irrefutable 'truths' – performed, replicated and tested within one domain of inquiry, prove totally meaningless when applied to a related sphere.

It is precisely this dysfunction within human methodological inquiry that prevails throughout Malevich's discourses of the 1920s. His sophisticated ability to reflect upon modes of creation within his range – painting, sculpture (architektons, planits), and writing – led him to ask fundamental questions about how meaning can be conserved across the various media. Malevich sought not to replicate versions of information found in one media, to transfer insight and intuition between disciplines, but was rather concerned with achieving a comprehensive frame of investigation, which when adequately applied, could yield ideal meanings.

Through his mode of thinking he sought to activate in various necessary structures an essentially pure passage to cognitive comprehension. His creative pursuits were consumed by the objective of attaining one manifold method of existence; he sought a path through inquiry and intuition that would validate itself in application. His investigations were not some simplistic search for a key with which to unlock life, but instead attempted to uncover through reflective actions a passage through to meaning within a unifying existence. As early as 1920, in a brief but remarkably crystalline essay, he prefigures the programme of philosophical endeavours that permeated his later thinking and art:

I am only free when my will, on a *critical* and *philosophical* basis [our italics], can bring from what already exists the basis for new phenomena.

I have torn through the blue lampshade of colour limitations, and come out into the white, after me, comrade aviators sail into the chasms – I have set up semaphores of Suprematism ... The white, free chasm, infinity is before us.[141]

Among Malevich's late work after 1927 we find one seemingly unique paint-ing, characterized by the absence of an immediately recognizable subject matter. *Composition* (1928–32; illlus. 132) is unlike any Suprematist work dating from the '0.10' exhibition, or any produced during the mature Supre-matist phase which concluded in the early 1920s. Displaying certain marked aspects of order and consistency, *Composition* is entirely characterized by horizontal bands which become, as such, forays into the repetitious and methodical accumulation of paint. The individual brushstroke has been trans-mogrified into the brush-stream. In the blue and black bands the brush-trace extends in one virtually unbroken stretch across the entire width of the canvas. No longer does the texture, agitated faktura, maintain focal priority in the observer's eye, but rather more sustained surfaces of paint appear as either blended into, or attached to, the surface of the canvas. This is a display *of* paint, as opposed to previous hand-crafted displays *in* paint, and of how surface passes over surface; it reveals how the smooth and gentle impasto of applied paint can assert a significance wholly detached from the weave of canvas, which still has a sporadic tendency to demonstrate its material pres-ence. Although precise linearity has yielded to the fluid and irregular applica-tion of paint, one might imagine that a rigid geometric system underlies the intervals determining the width of the belts. Direction of the brush move-ments is uniformly horizontal, with the exception of several prominent vertical touches at the right end of the central green band. This deviant gesture emphasizes the autonomous (and obviously self-conscious) will of the artist to recognize the limits of consistency. The uppermost and lowest registers are occupied by the thin application of off-white beige, which in some small parts incorporate accents of blue undertones. Black recurs prominently in three bands, rhythmically challenging the two red applications.

Presumably *Composition* should be construed as a landscape, because the technique of horizontally layered bands of colour characterizes numerous paintings from this period (such as *Red House, Red Cavalry* [not reproduced], and *Peasant*), all of which employ this technique to denote patterns of the earth. *Composition* remains an enigma, however, because of its exclusion of any narrative elements that would enable secure assumptions about the 'landscape' to be made. No farmers, peasants, warriors, houses or foliage populate the image; only paint, horizontally consistent paint. And although our tendency is to avoid reductivist formal readings, it is clear that figurative assumptions (if they can be made) must be made using an inter-pictorial approach that would address *Composition* within the sequence of surrounding works. But even given this, how could we know exactly which figurative elements to apply in *Composition*? Would there be human figures, or only architectural edifices, as in *Landscape with Five Houses*? The immense variety of objects available to the painter provide an exhaustive encyclopaedia of possibility.

Instead of exploiting the craft of painting, Malevich undertakes an objective reduction in pictorial material that surpasses any trivial and specific insights. *Composition* represents, if indeed it represents anything at all, the totalizing and absolute reduction of all possible and potential objects, all possible and potential referents within the domain of painting. It is an attempt to refurbish

the acts of painting so that they accurately reflect the purified essence of painting. In the 1928 essay, 'Painting and the Problem of Architecture', Malevich delivers an encapsulated statement on this position: 'In the "non-objective" stages one is not dealing with the representation of phenomena "as such", but with the communication of definite sensations which exist in the phenomenal world.'[142]

Another philosophical fragment states, 'The world appears as a phenomenon of the world.'[143] And it continues: 'The task of phenomenology is not to describe a singular phenomenon but to uncover in it the universally valid and scientifically fruitful essence, or *eidos*. The eidetic insight, however, is not a procedure of abstraction, but a special kind of direct experience of universals, which reveal themselves to us with irresistible self-evidence. We do not presuppose any separate, autonomous kingdom of ideas, and we remain within transcendental consciousness.'[144] On this purged plane of pure transcendent thinking, existence can be dispensed with and placed within the suspending interconnecting brackets of *noesis* and *noema*; it can be omitted from the category of essential concern, where it now transpires only in acts of intellection. These concepts are pursued in Malevich's 1928 essay on painting and architecture: 'But in reality "non-objective" arts cannot be abstract, as they are the most concrete of all, both by their very nature and in their expression of a particular *Weltempfang* (universal reception).'[145]

Malevich's notion of abstraction in the 'non-objective arts' bears such a striking resemblance to central ideas discussed in the phenomenology of Edmund Husserl, in *Logical Investigations* (1900–1901) and *Ideas* (1913), that comparative analysis of certain passages serves to elucidate these intricate, elusive and extremely complex positions – propositions which, we are certain, cannot be represented or even depicted in all their challenging, indeed at times mystifying, complexity. Keeping in mind the tangible and unequivocal testaments forged in architectural constructions and late paintings such as *Composition*, it is informative to rely upon Malevich's writing to gain explicit direction. And as is common in the hermeneutic quest for essential meaning – the search for meaning that travels even beneath the strata of structural analysis – we seek points of origin that allow us to follow the highest tangents away from one secure point of departure. With Husserl, the concordance of interlocking ideas is extremely striking. Husserl, starting from his early *Logical Investigations*[146] and continuing in a consistent stream of thinking until his death in 1938, wrote what can here be read as complementary explanatory texts about the ultimate phenomenological significance of Malevich's work. Leszek Kolakowski provides concise insight into Husserl's project. Of Husserl's insistent urge to overcome the specific, subjective and always inconclusive products of consciousness in man and the empirical sciences, he writes under the heading 'The desire for immediacy versus the desire for being scientific':

Thus is the sense of [Husserl's] slogan 'back to things themselves' revealed. It means 'back to universals', but to universals that are not produced arbitrarily ... and do not make up a separate realm of being; it means, 'back to universals' as direct objects of intellectual intuition.[147]

144 *Untitled*, c. 1930, pencil on paper
(35.5 x 22). Museum Ludwig, Cologne.

Which parameters and determining factors should we allow to govern the
networks of information that enable us to interpret the world and give mean-
ing to any purpose that we may design for ourselves? There need be nothing
obvious in the existence of the world, according to Husserl, and we need not
doubt that the world transcends mere appearance. In pure phenomenology
no thinking subject is required for the absolute transcendental reduction of
consciousness: 'Certainly an incorporeal, and paradoxical as it may sound,
even an inanimate (*seelenloses*) and non-personal consciousness is
conceivable.'[148] In order to attain an echelon of phenomenological thinking
that transpires in a universal realm, Husserl uses his methodology to trans-
form the surrounding world of objects and the interior world of consciousness
into the absolute 'zero of form' – to substitute Malevich's phrase.

Philosophy finds itself through language, and language alone (spoken or written), and so we may turn to the writings of Roman Jakobson to clarify certain fundamentals. Knowing the close relationship that Jakobson shared with Malevich and Khlebnikov during the crucial years of 1914 through 1919, we can begin to substantiate our claim that these men were engaged in a phenomenological drive across various artistic and scholarly disciplines. Already by 1915 Jakobson had extensively studied and reflected upon the autonomous doctrine of forms in linguistics – 'the universal grammatology' proposed by Husserl in his *Investigations* – and concluded that semantics must operate above all other features of the linguistic structure if intrinsic values are to be grasped beyond endemic utterance. From Husserl, Jakobson also learned of the triple breakdown of signification held within verbal expressions; namely, that of meaning (semantic), of objective reference (universal), and expressive function (of what Jakobson later termed the 'emotive function'). And only two years later Jakobson was confronted with the first explicit and conclusive theory of language, Saussure's *Cours de linguistique générale*, which he was able to comprehensively integrate within his Husserlian-based framework of phenomenological structuralism. In fact, Husserl's ideas run so deeply in Jakobson that, 'there is hardly a single fundamental theoretical or methodological notion concerning structural linguistics and literary criticism that does not appear in Jakobson's work as explicitly or implicitly indebted to the phenomenological determination and reflection ... In Jakobson's work the influence of Husserl is everywhere evident.'[149]

With the phenomenological foundation in place, Jakobson overcame any of the lingering traces of realism, naturalism, and verisimilitude that poetic language was still subjected to. Thus, in this sense, phenomenology represents the historical and objective condition for the conception of structuralism, as Jakobson retrospectively noted in 1936:

When naturalistic problems finally yielded to the scientific system of phenomenology, this development was answered in linguistics through the vivid interest in questions regarding systems of language, the inner structure of language, and the correlation between distinct linguistic schemes. The main issue, then, was that the theoretically oriented doctrine of forms gained prominence; the pressing question of the relationship between form and function became urgent, and even in the doctrine of sounds the naturalistic conception capitulated step by step to the analysis of linguistic function. And also in the historical study of language questions about the inner laws of linguistic alterations assumed an increasingly dominant role.[150]

Where the crossroads of existence open reality to its maximal points of reference, certain fundamental decisions and exclusions are required to enable humanity to progress beyond mere doubt and questioning. And at such times, whole fields of discourse claiming diagnostic certainty must either prevail or perish under the eclipsing strain of activating viable constructs of interpretation, modes of functioning that connect to prevalent but necessarily refurbished schemes grounded in the tradition of Being. In the demanding field of epistemology pursued by Malevich, themes which concerned the repositing of cognizant existence within the realm of pure creations, adjusted as the course of this book has unfolded to a new frequency of thought

articulation (as in the reductive Suprematism of 1917 and 1918) that few explanatory venues can accommodate. An early and analogous integrative approach to cerebral possibility, reflecting upon both the mechanisms and substantial outcome of mental processing, can be discerned in Husserl's phenomenology. It was Husserl who ignited the pattern of pure potential that provides the basis for our present philosophical concern. Furthermore, Husserl greatly influenced those Slavic scholars who transformed our understanding of language, thus facilitating epistemological and creative discoveries unrivalled in the history of humanity.

A glimpse into the possibilities offered by Husserl obviates the magnitude of his vision, and provides us with precise correlations to Malevich. In an ultimate and conclusive blast against the psychologically governed, and in his view gravely misguided, European sciences of the late nineteenth century, Husserl refutes any speculative paths to transcendence; he dismisses paths that might follow metaphysics, spirituality, or virtually any domain of humanistic inquiry that are not entirely predicated on authentic and absolute acts of intellectuation (*noema*) independent of social, personal, physical, or scientific pursuits of essence. By stating that: 'Phenomenology's purely intuitive, concrete, and also apodictic mode of demonstration excludes all "metaphysical adventure", all speculative excesses',[151] Husserl elevated the phenomenological pursuit to a realm of absolute, always concrete, cohesiveness. Regardless of the sources, of impacting factors, and predicate modes of gathering impetus, pure phenomenology allows for major functional modes of Being to be constructed within the rigidly defined, compound essence of man's consciousness.

The connection between phenomenology and Being is made through an emphasis upon pure consciousness, upon the necessity of gathering essential cognition within the creative centre of man. The transcendental reduction,[152] perhaps the most notable and radically distilled of Husserlian resolutions, permits for 'free imaginary variations of consciousness' (Husserl) to be transposed from the intuitive resources of conscious thought onto a plane of pure cognition. Structuralism supplies us (as informed visitors to this sophisticated field of inquiry) with a means of unravelling the conceptual implications of such an all-pervasively cleansing assertion. Kazimir Malevich presents a unique case in the history of painting, because it was with him – with him alone – that the pictorial vocabulary of painting was reduced beyond its recognizable semantic. No comparable artist of his generation, including Piet Mondrian, Paul Klee, and Vasilii Kandinsky, was able to achieve such reversals of the visual criterion of painting, or to subvert inherent repetitions of the artistic quest by reifying its displaced opposites. The late figurative work of Malevich connects with Suprematism by replacing the concealed omissions incurred within highly reduced abstraction – that is, the apparent loss of subject matter, elimination of representation, and suppression of narrative concerns. Meaning is exponentially amplified when Suprematism is retrieved through the thematic urges prevalent in the late work. With *Complex Presentiment* Malevich, in a sweep of short phrases, characterized the connection between painting and living when he inscribed on the reverse of the canvas:

**145** Handwritten text in notebook, 1924.
Archives of the Stedelijk Museum, Amsterdam.

'The composition is founded on the conjunction of elements, of the sensation of the void, of solitude, and of the despair in life in 1913 in Kuntsevo.' The place and time of experiencing life is unique, as it resounds internally in the painted memory of an artist who interchanges the past for the future, affirming a present in paint.

In the brief manifesto, 'The Suprematist Mirror', written in 1923 (the median year dividing the mature Suprematist phase from the late phase), Malevich's thoughts about how to reconcile the identity of the universe with his chosen format of discourse are delivered in enigmatic phrases. The first sentence reads: 'Amongst all the changing phenomena the essence of Nature is invariable.'[153] Continuing in this fashion, the manifesto makes eight main statements, three of which are:

5. If science has comprehended Nature, it has comprehended nothing.
6. If art has comprehended harmony, rhythm, and beauty, it has comprehended nothing.
7. If anyone has comprehended the absolute, he has comprehended nothing.[154]

'The Suprematist Mirror' concludes with two ... not sentences, but not mere phrases either ... two thoughts:

The essence of distinctions.
The world as non-objectivity.

Written at the time when he was arranging modalities of thought into architectural configurations, Malevich affords us a rare occasion of total insight. His quest as an artist is revealed as an extensive and comprehensive undertaking, rivalling in scope the various tasks performed by philosophers. It is through the seemingly paradoxical, but deliberate, written words of the artist that we gain an almost bitterly clear idea of what he had in mind for his paintings. It was to the 'essence of distinctions' that he addressed his brush; in a pensive, reflective, and occasionally lyric mode he created that 'nothing'

197

for the human consciousness to luxuriate in. The senses are allowed to loose themselves from that logic of meaning originating in our earliest urge to secure, at least, some comprehension. The recondite image remains image, and purely image, even as it is looked upon as such.

Orbits traced by the spheres of life follow so many sundry trajectories that it would be naive to believe that language alone could deliver to man the substance of those ideas which contain essence. With language, as Malevich demonstrated, we are able to furnish, at best, one dimension of philosophical imperatives. For a more fulfilling account, other modes of attainment are required to meet the conjunction of life's hidden and obvious essences, regardless of for how brief an instant one is able to clutch the ephemeral instinct of epiphany.

It is to painting, to *Peasant Woman* of around 1930 (illus. 135), that we return for respite after our extensive, detailed journey through the work and life of an artist. In a simplistic, semaphoric pattern of delivering to the spectator those wholes of earth, sky, and man, Malevich identifies the focal narrative that allows for painting to recognize itself. 'I am centrally located', reads the echo or whisper, 'between the man-made sky and the man-cultured earth. My feet stand on the earth, support my body below the skull of my head, looking, perceiving, and comprehending this universe. All is centred in me, distilled through my body. Dressed simply but carefully, I feel my body inside these clothes as I move or remain still. Rest is my state of motion, as thought becomes my movement.'

Beginning on an earth, in green that recedes to the distant pastel yearning of faraway emotions, we are taken up into the diagonal beams of cloud, ridges of blue white. The boldly confirmed human of this earth looks skyward into day, into the coming future, exemplifying a confidence that engages the unknown, a conviction that dispels any attitude predicted by doubt. Hands poised to clasp the perennial machinery of production, this figure presumes the role of maker, of shaper of potential. With its black face, simplicity of dress, and immobile pose, the figure makes an assertive and gestural stand on earth. The earth is defined by a clearly articulated sky, and this sky threatens to oppress with its weight, yet registers no felt force; amidst these juxtaposed environments, the peasant woman prevails. The casual confidence in the radiant brushwork corresponds with optimism and pride; it conveys the assurance of a vast country, and a new idea of unity. The optimism exuded by the figure manifests itself in the painterly culture which produced the picture; the refined and typically restricted Suprematist brushstroke used in the dress has been offset by the conduct of the artist's hand in the upper green band of earth, which anticipates the sky in the manner of its brush-strokes. The prominent feet, turned outward, firmly assert position; and the figure seems to afford mankind the luxury of self-representation in a pure idiom that escapes even the classification of gender. It is this painting, at its last installation in 1935 (illus. 146), that hangs adjacent to Malevich's death-bed, close to the artist's head, where it exudes ultimate essence – life and what life is for. Communicating only with the *Black Square* and his final *Self Portrait*, it cohesively summarizes the body placed on earth, situated in a

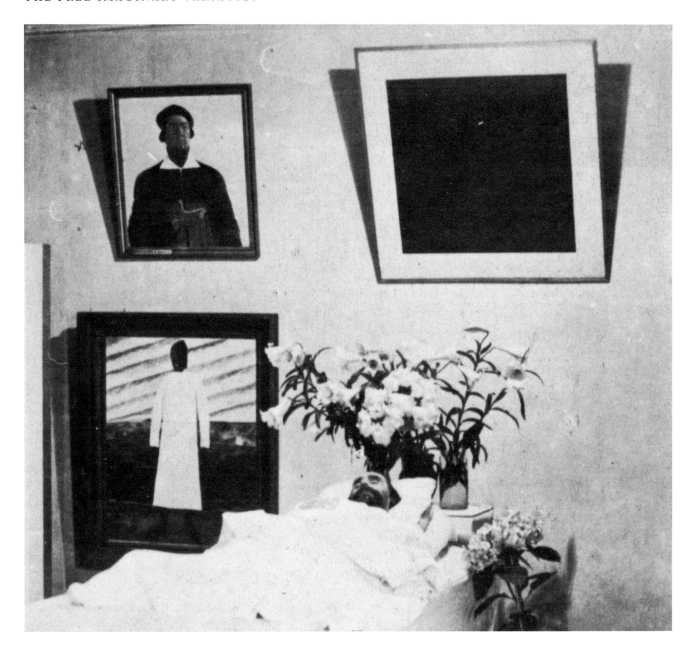

terrestrially and celestially determined environment that accords with the rhythm of the figure, tracing upright the body through its own rhythm.

This painting alone bodies forth, in all its infinite complexity, the musing observations of one mind that pierced beyond perception, beyond the farthest bounds of philosophical reach, touching the very surface we all inhabit. Through Malevich's work we are helped to recognize ourselves standing on this planet, to appreciate the urgency of the delicacy we must bring to this place, and to uncover the reasons for our being here.

# Exhibitions

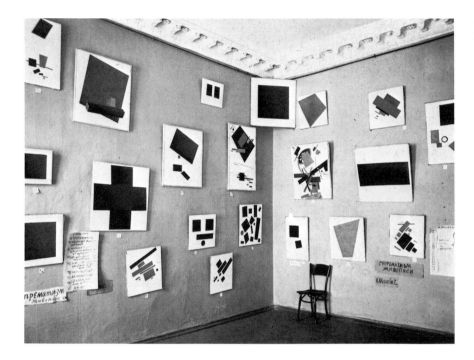

147 Installation photograph of *'o.10'. Last Futurist Exhibition*, Petrograd, 17 December 1915–17 January 1916.

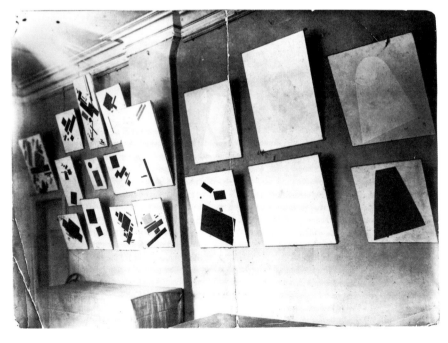

148 Malevich's Suprematist work in the solo exhibition 'Kazimir Malevich: His way from Impressionism to Suprematism'. 16th State Exhibition, Moscow, 1919–20.

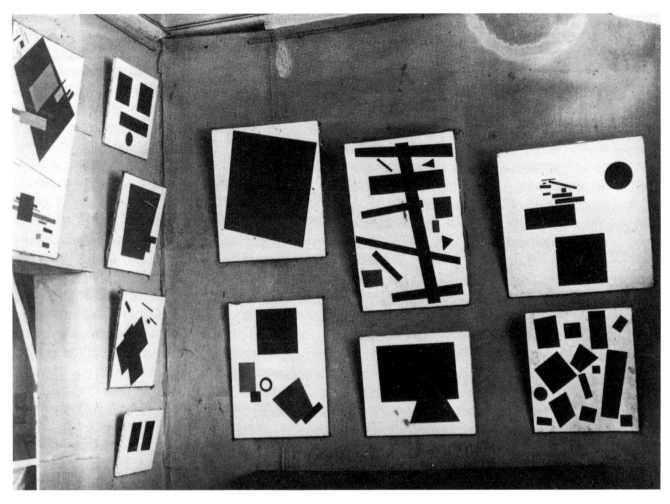

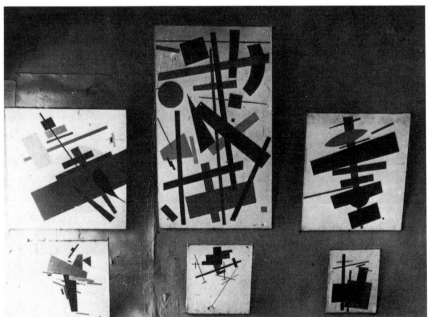

149, 150 Malevich's Suprematist work in the solo exhibition 'Kazimir Malevich: His way from Impressionism to Suprematism'. 16th State Exhibition, Moscow, 1919–20.

151 'Kazimir Malevich', solo exhibition in the Hotel Polonia, Warsaw, 8–28 March 1927.

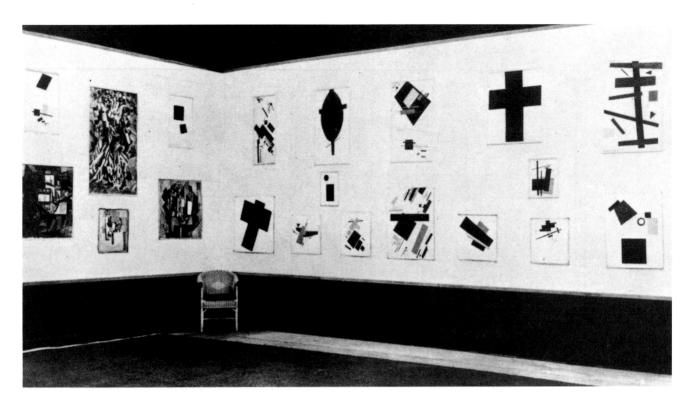

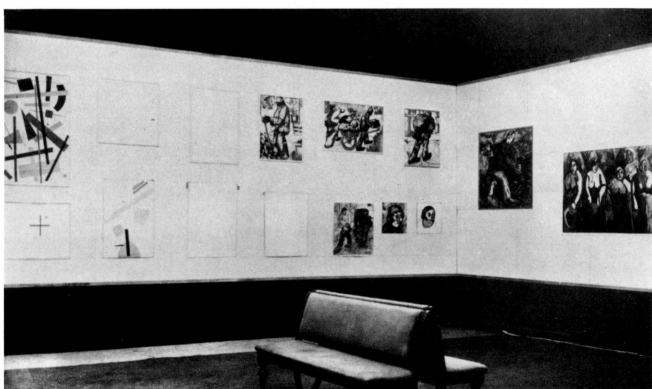

152, 153  Malevich's solo exhibition in the
'Grosse Berliner Kunstausstellung', Lehrter
Bahnhof, Berlin, 7 May–30 September 1927.

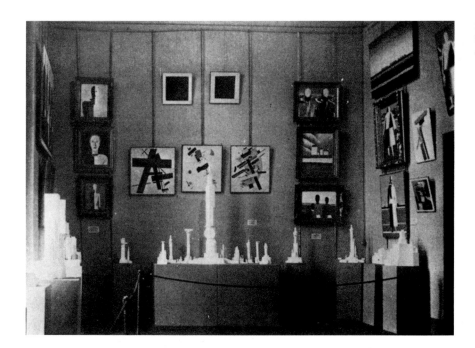

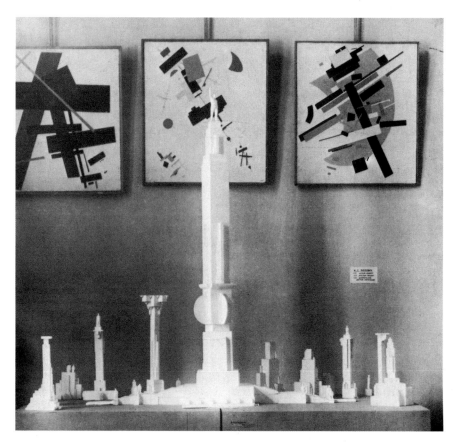

205

# Notes

Introduction
1 Roman Jakobson, 'Über die heutigen Voraussetzungen der russischen Slavistik', in *Slavische Rundschau*, 1, p. 633.
2 In conversation with Rainer Crone at Yale University, New Haven, in March 1978.

Chapter Notes
1 K. S. Malevich, *Essays on Art, 1915–1933*, ed. Troels Andersen, London, 1969, II, p. 108. Although the English translation offered by Andersen is capable and can always be verified against Jean-Claude Marcadé's refined and accurate French translations, it should by no means be presumed by the reader that quoted passages are exact transcriptions of Malevich's complex thinking processes and dense ways of expressing himself. The inadequacies of translation are ever-present concerns, and cannot be overemphasized. As authors, we are interested in accessing the core of Malevich's ideas, and conveying their meaning to the reader. We could never hope to deliver more than this to non-native speakers of Russian. The fantastic intricacies of Malevich's wording, and the unique, even opaque, poetry of Khlebnikov exacerbate the inevitable deficiencies of translation. This became apparent to us after numerous consultations with native speakers and Slavists at Yale University and at the Harriman Institute, Columbia University. In our opinion, with regard to poetry, one will never be able to ascertain the subtle levels of a language that one does not know, and that one has not experienced within its cultural context. These thoughts about how language actually operates are central to the discourse in this book (cf. Chapter 6).
2 F. M. Burnet, 'Men or Molecules? A Tilt at Molecular Biology', *The Lancet* (1 January 1966), p. 37.
3 This idea is taken over from Dr. Robert Strecker, a trained pathologist who also holds a PhD. in pharmacology, and a recognized expert in virology. See his 'The Strecker Memorandum', *Ontario's Common Ground Magazine* (Spring 1990), pp. 25, 50.
4 'Virus-associated Immunopathology: Animal Models and Implications for Human Disease', *Bulletin of The World Health Organization* (Geneva), XLVII, no. 2 (1972), p. 259. In the preceding paragraph to the above quoted passage the World Health Organization – a research centre based in London that oversees global progress in medicine – makes a recommendation regarding the necessity of establishing uniform syntax: 'since differences in terminology make it difficult to assess reports of pathological changes in lymphoid tissue, all modifications of the lymphoid organs should be described according to standardized criterion. Efforts at standardization are currently being supported by the World Health Organization.'
5 See Koshi Maruyama and Leon Dmochowsky, 'Cross-species Transmission of Mammalian RNA Tumor Viruses', *Texas Medicine*, LXIX (1973), pp. 65–75. In a controversial, even questionable, experiment conducted by Imanishi-Kari at MIT in 1985, genetic engineering yielded results that seemed to have a far-ranging impact on immunology, and the following description of the experiment details how advanced complex research is conducted in laboratories today: '... studying the immune system of transgenic mice, animals altered at embryonic stage by the injection of a foreign gene – called a transgene – which in this case was an antibody gene ... the transgene had the surprising effect of causing the native genes to produce antibody proteins closely related to those produced by the transgene. This discovery had the potential to help explain how the body comes up with its astonishingly wide variety of antibodies ... the native antibodies were 'mimicking' the transgenes' idiotype – the portion of the structure that determines what disease the antibody fights.' See Philip Weiss, 'Conduct Unbecoming?', *New York Times Magazine* (29 October 1989), p. 68.
6 Countries in Central Africa which the immunization campaign focused on, today show the highest incidence of Aids infection (where roughly 100 million Africans were inoculated, one recent statistic places the number of Aids-infected people there at approximately 75 million; see Strecker above, note 5). 'Brazil, the only South American country covered in the eradication campaign, has the highest incidence of Aids in that region. About 14,000 Haitians, on United Nations secondment to Central Africa, were covered in the campaign. They began to return home at a time when Haiti had become a popular playground for San Francisco homosexuals.' See Pearce Wright, 'Smallpox Vaccine "Triggered Aids Virus"', *The Times* (11 May 1987), pp. 1, 18. The wider dissemination of viral infections within specific population groups is further linked to vaccination programmes. In 1977 an inoculation programme took place in New York City, focusing on homosexual males roughly between the ages of 20 and 40 who were believed to be acutely susceptible to Hepatitis B. The following year in San Francisco a similar programme was set up.
7 The article continues, 'Dr Robert Gallo, who first identified the AIDS virus in the US, told *The Times*: "The link between the WHO programme and the epidemic in Africa is an interesting and important hypothesis. I cannot say that it actually happened, but I have been saying for some years that the use of live vaccines such as that used for smallpox can activate a dormant infection such as HIV. No blame can be attached to WHO, but if the hypothesis is correct it is a tragic situation and a warning that we cannot ignore."' Ibid., p. 18.
8 Hans-Georg Gadamer, *Truth and Method*, New York, 1988, p. xiv.
9 William Lovitt, in his introduction to Martin Heidegger's *The Question Concerning Technology and Other Essays* [translated by William Lovitt], New York, 1977, pp. xxvi–xxvii.
10 Ibid. p. 155–56.
11 Maurice Merleau-Ponty, 'Cézanne's Doubt', *Sense and Non-Sense*, Chicago, 1964, p. 13.
12 Handwritten MS (7 pp.) in the von Riesen Collection, Stedelijk Museum, Amsterdam.
13 *Malévitch Écrits*, ed. André B. Nakov, Paris, 1975, p. 413. English translation by Michel Moos.
14 'Kor re rezh ...', handwritten MS (2 pp.), 1915, in the von Riesen Collection, Stedelijk Museum, Amsterdam.
15 'In Nature There Exists ...', *Essays on Art 1915–1933*, 2 vols., ed. Troels Andersen, New York, 1971, p. 32–33.
16 Jacques Derrida, *Positions: Entretiens avec Henri Ronse, Julia Kristeva, Jean-Louis Houdebine, Guy Scarpetta*, Paris, 1972, pp. 23–25.
17 For a more involved semiotic analysis, discussing theological implications directed towards Malevich's supposed affinity to the function of the icon in the Russian Orthodox Catholic tradition, see 'The Revolution of a Poetics' in Jo Anna Isaak, *The Ruin of Representation in Modernist Art and Texts*, Ann Arbor, 1986, especially pp. 63–73.
18 K. S. Malevich, 'On New Systems in Art' (1919) in *Essays on Art 1915–1933*, 2 vols., ed. Troels Andersen, New York, 1971, pp. 90–91.
19 'An Attempt to Determine the Relation Between Colour and Form in Painting', in K. S. Malevich, *Essays on Art 1915–1933*, ed. Troels Andersen, London, 1969, II, p. 131.
20 Because of a certain thematic circularity in Malevich's painterly oeuvre (works from initial phases before 1910 and from later phases after 1927 share likenesses both in

subject matter and painterly treatment), confusion between the dates of early and late work abounds. Although Malevich did not date all of his work, in some cases, as is popularly known, he backdated late paintings, prominently indicating that he wished them to be considered as (or integrated into?) early work prior to 1910. The pedantic project of erecting a rigid scheme is complicated because primary source material (installation photographs, exhibition lists, etc.) is by no means comprehensive and inclusive of all works. One painting can serve to elucidate the full range of possibility that scholarship has recently generated. *Bathing Women* is dated to 1908 in the Stedelijk Museum exhibition catalogue (Moscow, Leningrad, Amsterdam, 1988), but is put into question and given the double date of 1908 or 1928(?) in the Armand Hammer Museum exhibition catalogue (Los Angeles, 1990), and finally assigned to *c.* 1930 by Jean-Claude Marcadé in his most recent major monograph (Paris, 1990). Although on the reverse of the canvas Malevich signed and dated the work, 'Moscow 1908 Malevich', the validity of this inscription is thrust into question because of Malevich's tendency to backdate certain paintings produced later in life, after 1927. Arguments for dating attributions commonly follow psychological and political lines of interpretation. Systems of analysis premised on such speculative and interpretative spheres as psychology and politics are tenuous, often leading to interpretative schemes that are distanced from the paintings themselves. Malevich's personal situation following Stalin's rise to power in 1922, is often too easily viewed as a prime factor in determining the type of subject matter and treatment possible under the circumstances. In conversation, Jean-Claude Marcadé (Paris, November 1990) raised the prospect that nearly all of the works of dubious designation commonly assumed to be executed before 1910, should perhaps be considered as late. Our present concern with date assignments of questionable paintings like *Bathing Women* is governed by stylistic factors. And because there is not – contrary to Marcadé's intimations – massive disagreement over numerous paintings, it is not necessary to become embroiled in the academic controversy. Our main interest is to isolate prominent works from each period in Malevich's development, to retrieve their salient properties and regard them in terms that conform to an encompassing understanding of his contribution as an artist. The *Flower Girl* presents a similar case to the *Bathing Women*. Until recently it was thought to be an early work, from 1903. In the Armand Hammer catalogue and Marcadé book, however, it too is assigned to the late 1920s. Marcadé has suggested that the red of the woman's skirt is of a colouristic complexity associated with late work, and that the sophistication of the integrated brushwork is too precocious for the

early Malevich. We believe, however, that the entire composition possesses too many tentative and imprecise passages to be worthy of Malevich's advanced mastery of both the physical and conceptual properties of paint. The treatment of the sky immediately above the roofs of buildings is governed by the awkward necessity of filling in blue for the sky rather than by the kind of evolved painterly concept so evident in his mature work. It is interesting to raise a possibility that has, to our knowledge, not been touched upon in existing scholarship. From even a cursory glance at the lists of works included in Malevich's major exhibitions (Moscow 1919, Warsaw/Berlin 1927, and Leningrad/Moscow 1932/33) one can ascertain that the repetitiveness of selection is indicative of the fact that major paintings remained in his personal possession since the time of their creation (especially remarkable with major Suprematist works). If this is so, it is not inconceivable that Malevich might have reflected upon early works later in life and taken the liberty to alter them (in a fashion completely dissimilar to an artist like Giorgio De Chirico). The startling white figures in *Bathing Women* might thus be explained through the proposition that Malevich reworked the figures in the late 1920s when he was embarking upon his integrative last phase. The curious, striking, red skirt in *Flower Girl* may also be explained with this proposition – requiring further research – that circumvents the rigid suggestion of Marcadé. If Malevich did return to reconsider previous paintings in the context of new philosophical insight, then the whole question of ascribing accurate dates to paintings is undermined, and, indeed, ingeniously circumvented by an artist assuming a position which aspired to transmogrify and transcend the boundaries of reality. It is not irrational to consider Malevich's relationship to the supposedly secure positions of reality that we – even as people in the last decade of the twentieth century – still take for granted. The impact and reactionary dreaming of the implications of relativity theory (cf. pp. 140–60) may have had circuitous ramifications in attuned minds of the calibre of Malevich's. The entire pedantic and positivistic notion of ascribing fixed dates to specific paintings may be a task that simply does not apply to the work of Malevich. Perhaps we must consider his contribution as one that stands outside the constraints of normally perceived and construed 'reality' and as a project that addresses itself to pure possibility. Dating – i.e. the search for a retrospective exactitude – might have been construed in the mind of Malevich as an antiquated and old fashioned concept that needed regeneration through disruption. And although it would be over-zealous to prescribe this possibility to many of his works, perhaps in certain obvious circumstances it does make sense to consider alternative modes of thinking about the discipline of history. Generally, we have

accommodated questionable paintings as they are suited for our overall thinking regarding Malevich's stylistic shifts. The dating dilemma, which should not be considered grave, is in our opinion insufficiently researched. The very recent emergence of works not previously seen by Western scholars will alter certain assumptions about works we are familiar with (see, for example, *Malevitch: Artiste et théoricien*, Moscow and Paris, 1990; introduction by Euguenia Petrova). And finally, concerning this conflict, we do not believe that it can be resolved without close examination of the physical aspects of the canvases: the reverse of the canvases, the stretcher frames, materials used to stretch the canvases, etc. The information yielded by such an investigation would surely provide valuable data, and offer insight not defensible by mere stylistic, painterly or psychological supposition.

21 'An Analysis of New and Imitative Art (Paul Cézanne)' (1928), in K. S. Malevich, *Essays on Art*, op. cit., II, p. 24.
22 'On New Systems in Art' (1919), in K. S. Malevich, *Essays on Art*, op. cit., I, p. 94.
23 Ibid., p. 94. Malevich's isolation of Cézanne's dictum (which by now has become a cliché in the syntax of twentieth century art) anticipates the importance future artists would ascribe to it. Barnett Newman has written, in perhaps the most pensive and profound interpretation of Cézanne's words since Malevich: 'Cézanne was the first artist to comprehend that in Nature there are no lines. Herein lies the significance of his remark that Nature is a collection of cubes, cones and spheres. He saw the world as it is, mass instead of contours. Line could not count; not one exists in Nature. It was what was between the lines that mattered. The artist's function is to use, not to draw, what is between the lines. The secret lay in the discovery and use of distortion as a principle.' Barnett Newman, *Barnett Newman: Selected Writings and Interviews*, New York, 1990, pp. 82–83.
24 'Impressionism' (1929), MS (69 pp.), in K. S. Malevich, *The Artist, Infinity, Suprematism: Unpublished Writings 1913–33*, ed. Troels Andersen, Copenhagen, 1978, IV, p. 189.
25 See Joseph Leo Koerner, *The Moment of Self-Portraiture in German Renaissance Art: Albrecht Dürer, Hans Baldung Grien, and Lucas Cranach*, forthcoming, MS pp. 55–62.
26 For the first major public showing of his Suprematist paintings ('0.10' exhibition, Dobychina Gallery, Petrograd, Dec. 17, 1915 – Jan 19, 1916), Malevich wrote a manifesto expressing his theoretical viewpoints and explaining his aspirations concerning Suprematist art. This important text appeared in three different forms: first, as written by Malevich in June 1915; the second version was edited by Matiushin for a pamphlet distributed at the opening of the '0.10' exhibition; and the third edition was re-edited

and published at the occasion of a public conference on the '0.10' exhibition (Jan. 12, 1916).

27 K. S. Malevich, 'Du Cubisme au Suprématisme en Art, au Nouveau Réalsolue de la Peinture en tant que Création Absolue', in *De Cézanne au Suprématisme*, ed. J. C. Marcadé, Lausanne, 1974, pp. 37, 43. The quoted passage has been translated into English by the authors.

28 Published in *October* (Boston), xxxiv (Fall, 1985), p. 26.

29 The trajectory to revolution was not a swift process in the control of equipped and capable political and ideological formulators. As circumstance determined, a party like the prominent Russian Social-Democratic Workers Party (RSDRP) found itself reacting unevenly. For example, at such a critical moment as that of late 1904 the Social-Democratic leaders suddenly 'had to decide what the role of their party and that of the working class should be in the imminent "bourgeois" revolution.' See Solomon M. Schwarz, *The Russian Revolution of 1905. The Workers' Movement and the Formation of Bolshevism and Menshevism*, Chicago, 1967, p. 7. For the foundations of the Liberation Movement and political party activism in pre-1906 Russia, see Shmuel Galai, *The Liberation Movement in Russia: 1900–1905*, Cambridge, 1973; of particular interest is the chapter concerning the intelligentsia and their uneasy relationship to the peasants, pp. 157–76.

30 These struggling and consciously ambitious classes did not include the 50 million *muzhik* (rural peasants), who were primarily and referentially unaware of their plight, and equally ignorant of politics per se. As Pipes noted of the *muzhik* mind: 'He thought rather in the archaic terms of Homeric epics in which the whims of gods decide human destiny', Richard Pipes, *The Russian Revolution*, New York, 1990, p. 114. For an in-depth characterization of rural Russia, see Pipes pp. 92–100.

31 Jacques Ellul, *Autopsie de la Révolution*, Paris, 1969, p. 56.

32 Richard Pipes offers a concise characterization of the Russian peasant, 'the culture of the Russian peasant, as that of the peasantry of other countries, was not a lower, less developed stage of civilization, but a civilization in its own right . . . the world of the Russian peasant was largely self-contained and self-sufficient. It is no accident that in the Russian language the same word (*mir*) is used for the peasant commune, the world, and peace. The peasant's experiences and concerns did not extend beyond his own and neighbouring villages'. Richard Pipes, *The Russian Revolution*, New York, 1990, p. 109.

33 The incompetence prevalent in Tsarist Russia is thoughtfully assessed by George F. Kennan in 'The Breakdown of the Tsarist Autocracy', in *Revolutionary Russia*, ed.

Richard Pipes, Cambridge: Harvard University Press, 1968, pp. 1–25.

34 For a chronicle of formative events occurring within the labouring populations in 1905, see Richard Pipes, *The Russian Revolution*, op. cit., pp. 38–51. See also Richard Charques, *The Twilight of Imperial Russia*, Oxford, 1958, pp. 111–39.

35 For an excellent detailed outline of these events, using biographical information, see Solomon M. Schwarz, *The Russian Revolution of 1905*, Chicago, 1967. For a more general introduction see Joel Carmichael, *A Short History of the Russian Revolution*, New York, 1964 (Chapter 1). See also, Tania V. York, *Russia's Road to Revolution: A Social, Cultural and Intellectual History of the Russian Revolution of 1917*, Boston, 1963.

36 This painting, as well as the preceding *Flower Girl*, are both revisionistically postdated to the late 1920s by Jean-Claude Marcadé, *Malévitch*, Paris, 1990, pp. 222, 228.

37 Larissa Zhadova, *Malevich*, London, 1982, p. 13.

38 The addition of this linear element seemingly derives from Braque's *Nude* (1908), which Malevich would have known from the second Moscow 'Golden Fleece' exhibition of January/February 1909.

39 In K. S. Malevich, *Essays on Art*, op. cit., New York, 1971, p. 190.

40 Velimir Khlebnikov, *Werke 2. Prosa. Schriften. Briefe*, ed. Peter Urban, Hamburg, 1972, pp. 464–65.

41 Translated by Paul Schmidt in *The King of Time: Velimir Khlebnikov*, ed. Charlotte Douglas, Cambridge: Harvard University Press, 1985, p. 20.

42 Transliterated by Gary Kern in *Velimir Khlebnikov: Snake Train: Poetry and Prose*, ed. Gary Kern, Ann Arbor, 1976, p. 61.

43 Edward J. Brown, 'Khlebnikov and Language', in *Velimir Khlebnikov: Snake Train: Poetry and Prose*, op. cit., p. 12.

44 Roman Jakobson, 'Newest Russian Poetry. First Version. Victor Khlebnikov', in *Texte der Russischen Formalisten*, II, ed. Wolf-Dieter Stempel, Munich, 1972, p. 31.

45 Vladimir Mayakovsky, 'V. V. Khlebnikov', in *Krasnaya nov'*, no. 4 (July–Aug. 1922); English translation, E. J. Brown, ed., *Major Soviet Writers: Essays in Criticism*, New York, 1973, p. 84.

46 For a concise yet in-depth account of Marinetti's 1914 tour of Russia, see Vladimir Markov, *Russian Futurism: A History*, Berkeley and Los Angeles, 1968, pp. 147–63. For a linguistic analysis, distinguishing the radical and advanced achievements of the Russian Futurists from the more traditional Italians, see Vahan D. Barooshian, *Russian Cubo-Futurism 1910 – 1930: Study in Avant-Gardism*, The Hague, 1974. For the comprehensive meaning of Russian Futurism and its more sophisticated position compared to other trends in Europe, a careful study of the difference between Russian and

Italian Futurism would be necessary – an endeavour not required in the present more hermeneutically inclined analysis. If, however, further information is desired, see Lionel Richard, 'Futurists Russes Contre Marinetti', *Europe* (Paris), April 1975, pp. 28–30; Benedict Livchits, *The One and a Half-Eyed Archer*, Newtonville, 1977, pp. 181–210; Jean-Claude Marcadé, 'Les Futurismes Russes et les Arts Plastiques: A Propos des Rapports du Futurisme Russe et du Futurisme Italien', *Europe*, op.cit., pp. 150–56; C. De Michelis, *Il Futurismo-Italiano in Russia 1909–1929*, Bari, 1973, pp. 43 ff.

47 As demonstrated by Roman Jakobson, 'Newest Russian Poetry. First Version. Victor Khlebnikov', in *Texte der Russischen Formalisten*, II, ed. Wolf-Dieter Stempel, Munich, 1972, pp. 25–31.

48 Markov, *Russian Futurism*, op.cit., p. 35.

49 Markov, ibid., p. 43.

50 Markov, ibid., pp. 42, 43.

51 Markov, ibid., p. 36.

52 For abridged translations of these and other major writings, see John E. Bowlt, ed., *Russian Art of the Avant-Garde: Theory and Criticism: 1902–34*, translated by John E. Bowlt, revised and enlarged edition, New York, 1988.

53 For an accurate and involved account of these various developments, see Vladimir Markov, *Russian Futurism*, op. cit., pp. 37–39. For a collective bibliographical account of the emerging sundry Futurists' undertakings, collaborations and disagreements, see Susan P. Compton, *The World Backwards: Russian Futurist Books 1912–16*, London, 1978, pp. 24ff. Her reporting of rapid and complex shifts in allegiance, a frequent occurrence in Futurist circles, is comprehensive.

54 See Françoise Monod, 'L'Exposition Centennale de L'Art Français à St Pétersbourg', *Gazette des Beaux Arts*, no. 657 (March 1912), pp. 191–98, and no. 658 (April 1912), pp. 301–26; and 'Vystavka sto lem frantsizskoi zhivopisi 1812–1912', *Apollon*, no. 5 (1912), p. 6.

55 Markov, *Russian Futurism*, op. cit., p. 39.

56 Quoted from Hershell B. Chipp, *Theories of Modern Art: A Source Book by Artists and Critics*, Berkeley, 1968, pp. 294–95. This manifesto, which functioned as an introduction to an exhibition of Italian Futurist painting in London in 1912, was signed by Boccioni, Carrà, Russolo, Balla and Severini.

57 Markov, *Russian Futurism*, op. cit., p. 56.

58 John E. Bowlt, ed., *Russian Art of the Avant-Garde: Theory and Criticism 1902–34*, revised and enlarged edition, New York, 1988, p. 75.

59 Quoted after Linda D. Henderson, *The Fourth Dimension and Non-Euclidean Geometry in Art*, Princeton, 1983, pp. 372–73.

60 Besides the fact that Cubism was a French invention, having grown directly out of Cézanne, it also revealed itself as culturally specific by making use of local subject matter

such as the café, Paris newspapers and the French countryside. Beyond these superficial aspects Cubism arrived as the culmination of a discourse that was reactionary, aimed against recently preceding movements in French painting such as Impressionism and Post-Impressionism. The degree to which the Russians were seeking their own nationally valid interpretation of Italian Futurism and French Cubism is revealed by the debate that flared between Malevich and Larionov in the spring of 1913. In Moscow, where Malevich was aligned with the Donkey's Tail group showing in an exhibition Larionov organized called 'Target' (March 24 – April 7, 1913), the cultural atmosphere was fraught with nationalistic concerns, tainting the artistic dialogue which continued on a somewhat less theoretically advanced level than comparable discourse in St Petersburg. Malevich, who was attuned to differences between the cities, delivered a speech at a Union of Youth sponsored event in St Petersburg one day before the opening of the 'Target' exhibition in Moscow (23 March 1913). Boldly, Malevich attacked not only the Knave of Diamond for being too dependent upon Western trends, which was incidently Larionov's original criticism, but also Larionov's 'Target' exhbition for pursuing narrow nationalistic concerns. (See Troels Andersen, *Moderne Russisk Kunst 1910–30*, Copenhagen, 1967, p. 49; p. 181, n. 67, 71, 72; and John Bowlt, 'The Union of Youth' in *Russian Modernism: Culture and the Avant-garde 1900–1930*, ed. George Gibian and H. V. W. Trjalsma, Ithaca, Cornell University Press, 1976, pp. 165–87.) This double rebuff of existing Moscow groups reveals Malevich's precocious embrace of Khlebnikov's vanguard methods, and the generally more autonomous theoretically disposed Union of Youth programme. This decisive move prepared Malevich for his final rejection of existing discourse, creating the early foundation for Suprematism.

61 The argument against metaphysical approaches the artist may be tempted to follow continues: 'From then on, by the study of all the manifestations of physical and mental life, he will learn to apply them. But if all the same he ventures into metaphysics, cosmogony, or mathematics, let him be content with obtaining their favour, and abstain from demanding of them certitudes which they do not possess.' In Robert L. Herbert, *Modern Artists on Art*, Englewood Cliffs, 1964, p. 18.
62 Henderson, *The Fourth Dimension*, op. cit., p. 375. These final two paragraphs are, indeed, potentially misleading because there are no indicators – as throughout the rest of the essay – distinguishing whether Matiushin is making his own comments or quoting 'Du Cubisme'.
63 See Linda Henderson, *The Fourth Dimension*, op. cit., Robert P. Welsh, 'Sacred Geometry: French Symbolism and Early Abstraction', in *The Spiritual in Abstract Painting, 1890–1985*, Los Angeles, 1986, pp. 63–87; Jean Clair, 'Malévitch, Ouspensky et l'espace Neo-platonicien', in *Malévitch*, Lausanne, 1979, pp. 15–30.
64 See for a translation of the complete text, Urban, *Chlebnikov*, op. cit., II, pp. 67–81.
65 Urban, *Chlebnikov*, op. cit., II, p. 580.
66 Khlebnikov's precise understanding of what language consists of has far reaching implications. For example, from his intuitive grasp and individual enumeration of language components and their workings, the foundations of Russian and French Structuralist theory are evident. One analysis begins with a breakdown of language's operative elements in preparation for transposition into close reading of paintings: 'The various structural strata of language – the minimal sound unit (phoneme), the minimal semantic unit (morpheme), the rules for their combination (syntax), reference (semantics), and the relation of the sign to the participants in its communication (pragmatics) – may all be examined for their applicability to painting.' (See Wendy Steiner, *The Colors of Rhetoric*, Chicago, 1982, p. 51.) This five tiered breakdown of structural theory into constituent parts has an application in painting of limited yet significant importance. Regarding theoretical insights between communicatory systems, one of the purest applications is Khlebnikov's proto-Structuralist/pure linguistic theory (the 'five columns') related to the painting of Malevich.
67 Urban, *Chlebnikov*, op. cit., II, p. 580.
68 Velimir Khlebnikov, *The King of Time*, Cambridge: Harvard University Press, 1985, p. 21.
69 Urban, *Chlebnikov*, op. cit., II, p. 70. For the original Russian text see Stempel, ed., *Texte der Russischen Formalisten*, op. cit., II, pp. 96–97. Translated by Rainer Crone/David Moos.
70 See Victor Erlich, *Russian Formalism: History Doctrine*, third edition, New Haven, 1981, pp. 23–26. See also Viktor Zirmunskij, 'Die Aufgaben der Poetik', in Stempel, *Texte der Russischen Formalisten*, op. cit., II, pp. 137–61.
71 Zirmunskij, op. cit., p. 139.
72 Erlich, *Russian Formalism*, op. cit., pp. 33–41.
73 Roman Jakobson, 'Modern Russian Poetry: Velimir Khlebnikov [excerpts]', in *Major Soviet Writers: Essays in Criticism*, ed. Edward J. Brown, Oxford, 1973, p. 82.
74 For a comprehensive analytic discussion of Malevich's working technique applied to this painting in particular, see Milda Vikturina and Alla Lukanova, 'A Study of Technique: Ten by Malevich in the Tretiakov Gallery', in *Malevich*, Armand Hammer Museum, Los Angeles, 1990, pp. 192–93.
75 Roman Jakobson, 'The Development of Semiotics', in *Language in Literature*, ed. Krystina Pomarska and Stephen Rudy, Cambridge: Harvard University Press, 1987, p. 453.
76 In Bowlt, *Russian Art of the Avant-Garde*, op. cit., pp. 71, 73, 77.
77 It is significant to note that Saussure's *Cours de linguistique générale* (1916) was introduced to Russia in the year of publication by Jakobson, who was at this time a young student of linguistics.
78 Within the present study it would be unwieldy to go into great depth about the most exciting developments in phonology and early structural linguistics. In late nineteenth century Russia, developments in the *Sprachwissenschaft* were more advanced and analytically sophisticated than dominant Western European trends in linguistics (for example, the neo-grammarians at the University of Leipzig). Centred at the University of Kazan, Baudouin de Courtenay, with his most gifted pupil Kruszewski (the Kazan School), laid the foundations of what would become a vital discipline in linguistics – phonology, or the study of the role of the phoneme in language (both spoken and written). They maintained that the phoneme, the smallest indivisible unit of the word, was a phonetic unit with a specified function within the communicative process: 'Baudouin de Courtenay clearly stated that sound features were used to differentiate meanings.' (Milka Ivic, *Trends in Linguistics*, the Hague, 1965, p. 133). It is more than noteworthy to realize that Khlebnikov was an enthusiastic and ardent student of linguistics and mathematics at the University of Kazan. He would surely have been exposed to (if not immersed in) the teachings of Baudouin de Courtenay, who took a post in the renowned faculty of linguistics at the University of St Petersburg about the time when Khlebnikov moved there to pursue his study of languages in 1908. It is this clear thread which leads us to the recently published June 1916 letter that Malevich wrote to his friend Mikhail Matiushin, several months after the opening of the '0.10' exhibition. Malevich, speaking about the 'new poets', clearly distinguishes the linguistic 'sound' (known to today as the phoneme) from the musical sound. In this letter Malevich makes the following observations in astonishing detail: 'Au début, il n'y avait pas de lettres, il n'y avait que le son. D'après le son, on déterminait telle ou telle chose. Après, on a divisé le son en différents son, et ces division ont été représentées par des signes. Aprés quoi on a pu exprimer, pour les autres, ces propres pensées et descriptions. Le nouveau poète semble être un retour au son (mais non au paganisme). Du son a résulté le mot. Maintenant, du mot a résulté le son. Ce retour n'est pas aller en arrière. Le poète a abandonné ici tous les mots et leur destination. Mais on a soustrait le son comme élément de poésie. Et la lettre n'est déjà plus un signe pour l'expression des choses, mais une note sonore (non musicale). Et cette note-lettre, peut-être, est plus subtile, plus claire et plus expressive que les notes musicales.' (See Jean-Claude Marcadé, ed., *Malévitch: 1878–1978; Actes du Col-

*loque International Tenu au Centre Pompidou*, Lausanne, 1979, p. 184–85.)

79 In his chapter entitled 'Logical Symbolism in Linguistics' Milka Ivic makes two observations about the function and development of logic in language. They are significant to note here, in so far as they not only impact upon verbal systems but also pertain to mathematics and methods of scientific notation. And in these terms, Ivic's thinking reflects upon Malevich's urge to turn painting into a transcendent language, simultaneously embodying and transgressing existing definitions for the attainment of a totalizing 'image': 'A "symbol" is a conventional sign by means of which actual phenomena are identified in order to facilitate the process of logical analysis . . . The introduction of the abstract methods (i.e. the use of symbols) into scientific analysis has been of revolutionary importance for the development of twentieth century scholarship . . . The cooperation between mathematics and logic has been primarily directed to the discovery of a 'metalanguage', an abstract, maximally logical language for the purposes of . . . definition.' (Milka Ivic, *Trends in Linguistics*, The Hague, 1965, p. 186.)

80 See Saul R. Kripke, 'Naming and Necessity', in David Davidson and George Harman, eds., *Semantics of Natural Language*, Dordrecht, 1972, pp. 253–355.

81 Markov praises Khlebnikov's contribution as the most interesting; see Markov, *Russian Futurism*, op. cit., p. 144.

82 We would like to thank Chris Sharples, Kent Hikida and, in particular, Brooke Daley who enlivened this discussion with their valuable comments and observations in the graduate seminar on Kazimir Malevich at Columbia University, Spring 1990.

83 Evgenii Kovtun, 'The Beginning of Suprematism', in From Surface to Space: Russia 1916–24, exhibition catalogue, Galerie Gmurzynska, Cologne, 1974, p. 40.

84 Velimir Khlebnikov and A. Kruchenykh, 'The Letter as Such', *The King of Time*, Cambridge: Harvard University Press, 1985, p. 121.

85 By the spring of 1911 Braque and Picasso had recognized the limitations of their formal fracturing and faceting of objects, fearing that their technique might overwhelm recognition and destroy attachments to the subject matter. With the inception of analytic Cubism they incorporated written letters into paintings, like Braque's *Still Life with Harp and Violin* (1912), which utilized the letters 'EMPS' to cunningly or punningly refer to a newspaper as well as a musical beat. In no Cubist paintings do letters fracture into unrecognizable entities, but always retain a direct relationship to parts of the perceived world. The Russian philosopher Nikolai Berdiaev published an article entitled 'Picasso' which discussed the philosophical importance of the works in the Shchukin Collection, finding:

'in Picasso's analysis of forms an expression of the collapse and ruin of a tradition in art that was only an echo of a more general change that was beginning in all areas of experience.' Berdiaev, however, connected Picasso not with the new values that were to emerge from this change, but with the old. His last sentence reads, 'Picasso – is not the new creation. He is – the end of the old.' Nikolai Berdiaev, 'Picasso', *Sofiia*, no. 3 (March 1914), p. 62; as cited by W. Sherwin Simmons, *Kazimir Malevich's Black Square and the Genesis of Suprematism 1907 – 1915*, New York and London, 1989, pp. 151–52.

86 A. I. Bachinskii, 'Pis'ma po filosfii estestvoznaniia, Pis'mo I: Chto takoe naturalisticheskii idealizm?', in *Voprosy filosofii i psikhologii*, no. 70 (1903), p. 820. Also see, Alexandre Vucinich, *Science in Russian Culture: 1861 – 1917*, Stanford, 1970, p. 372.

87 Ernst Cassirer, *The Philosophy of Symbolic Forms*, I, New Haven, 1955, p. 85.

88 K. S. Malevich, 'From Cubism and Futurism and Suprematism: The New Realism in Painting', in *Essays on Art*, op. cit., p. 19.

89 One of Chebyshev's numerous gifted disciples, Vasiljev was fully conversant with his master's probability theory of the 1880s. Vasiljev: 'was as keenly aware of the philosophical problems of modern science in general as he was of the deeper meanings of the expanded frontiers of modern mathematics . . . the first Russian scholar to resurrect the mathematical legacy of Nikolai Lobachevskii [the father of non-Euclidean geometry].' (Vucinich, *Science* . . ., op. cit., p. 348.) In 1913 Vasiljev published a two-volume anthology on new ideas in mathematics. In the introduction he writes: 'however one reacts to the futuro-scientific theories of Einstein and Minkowski it is clear that it is no longer possible to ignore it in an examination of the question of time and to be satisfied with old modes of thought.' See Aleksander V. Vasiljev, ed., *novye idei v matematike*, 2 vols., St Petersburg, 1913, II, pp. iii–iv, as quoted in Linda D. Henderson, *The Fourth Dimension*, op. cit., p. 243.

90 This letter is dated 3 December 1903. Urban, *Chlebnikov*, op. cit., II, p. 433.

91 See Urban, *Chlebnikov* op. cit., II, p. 541.

92 See *Snake Train*, ed. Gary Kern, op. cit., Appendix 1, pp. 267–72.

93 Khlebnikov, *The King of Time*, op. cit., pp. 86–7, 102–03.

94 Khlebnikov, *The King of Time*, op. cit., p. 98.

95 Urban, *Chlebnikov*, op. cit., II, p. 450.

96 In narrative painting since the Renaissance, and including Cubism, every installation and exhibition of work – regardless of site-specific details and the inclusion of thematically different paintings – maintained internal narrative. The contained narratives (even in examples of cyclical multi-format painting)

are generally unrelated to any other paintings.

97 For a discussion of the *Black Square* and its implications, some of which can be interpreted as holding a religious significance through their relationship to traditional Russian icon painting, see 'The Icon Unmasked: 1915' in W. Shermon Simmons, *Kazimir Malevich's 'Black Square' and the Genesis of Suprematism 1907–1915*, New York, 1981, pp. 224–62. For the theoretical implications of how icons functioned in a genre in the late nineteenth century and early years of the twentieth century, see Hans Belting, *Bild und Kult: Eine Geschichte des Bildes vor dem Zeitalter der Kunst*, Munich, 1990.

98 N. R. Umov, 'Evoliutsiia atoma', NS, no. 1 (1905), p. 5; as quoted in Alexander Vucinich, *Science* . . ., op. cit., p. 371.

99 Haftmann, *Suprematismus*, op. cit., p. 174. It is, of course, irrelevant that the quoted statement dates from 1922, because all of these subtly refined ideas were set forth seven years earlier in the paintings that Malevich refers to. Any argument against his full comprehension of his major painterly proposition must be refuted precisely because of this and other impressively succinct writings. Recourse to rigid positivism places an undue amount of attention upon the artist's responsibility to explain himself and his creations. Precisely because of Malevich's complete individuality, it could only have been years after the reception of his painting that he realized the necessity of interpretation. Consequently, this text, which aims to characterize Malevich's creative contribution in its entirety, treats each segment of his painterly development and theory first individually, and then, most significantly, as a unified self-contained whole. It would be naive to treat the sequence of creation as a temporally linear unreflective process. With individual cases history must define its own chronology.

100 The central figure among twentieth-century German physicists working on quantum mechanics, Werner Heisenberg, stated in sufficiently philosophical terms the profound complexity of redefined reality. A 1956 treatise 'Nature in Physics Today' is analogous to what Malevich struggled to articulate, both in his painting and writing: 'This new situation . . . appears most striking in modern science, where it occurs that we can in general no longer regard the building blocks of matter 'in themselves', originally thought of as the ultimate objective reality. They retreat from any objective determination in space and time and we can in the end always make only our knowledge of these particles the object of science . . . In natural science the object of research is no longer Nature in itself, but Nature that is subject to human questioning.' Werner Heisenberg, *Naturbild der Heutigen Physik*, Hamburg, 1956, pp. 17–18.

101 Vucinich discusses the impact of such

ideas in Russian culture. See Vucinich, *Science . . .*, op. cit., pp. 366–75. With the advent of quantum mechanics, at the beginning of this century, descriptive language was revealed as another convention that had been invented by the human mind. An example of this deficiency of language can be observed in Niels Bohr's 1913 discovery of an equation that explained how electrons orbit an atomic nucleus at precise successive stages. Bohr was unable to describe exactly how an electron jumped from one orbit to another and why it did not radiate light when circulating in one orbit. He noted that his orbit rule was probably not the 'real' rule, but was just an expression in the language of the old physics for a rule whose meaning would only become clear when the true language of quantum mechanics was discovered. (See Robert H. March, *Physics for Poets*, New York, 1978, pp. 180–97.) What Bohr expressed is reflexive of how intellectual and conceptual inquiry preceded man's ability to articulate radically new notions.

102 See Werner Heisenberg, 'Sprache und Wirklichkeit in der modernen Physik', *Physik und Philosophie*, Frankfurt, 1959, pp. 139–56.

103 Niels Bohr, quoted in Ilya Prigidone and Isabell Stengers, *Dialog mit der Natur*, Munich, 1989, pp. 237–38; translated by Rainer Crone.

104 Benjamin Lee Whorf, *Language, Thought and Reality*, Cambridge: MIT Press, 1963, p. 220.

105 K. S. Malevich, 'An Attempt to Determine the Relation between Color and Form in Painting' (1930), in *Essays on Art*, op. cit., II, p. 127.

106 Victor Schlovsky, 'O fakture i kontr-rel'efach', as quoted in Aage Hansen-Löve, *Der Russische Formalismus: Methodologische Rekonstruktion seiner Entwicklung aus dem Prinzip der Verfremdung*, Vienna, 1978, p. 95.

107 Kazimir Malevich, 'Suprematism as Pure Cognition', as quoted in W. Haftman, *Suprematismus*, op. cit., p. 160.

108 Ibid., p. 160.

109 Urban, *Chlebnikov*, op. cit., II, pp. 311, 312, 314. Translated by Rainer Crone/David Moos.

110 Nikolai Lobachevsky, a key predecessor mathematician to Planck, Einstein and Bohr, demonstrated how 'classical' space – in this case to be equated with illusionism in painting – was no longer sufficient as a characteristic constant in a non-Euclidean universe. In *New Principles of Geometry* (1835), which introduces into science abstract arithmetic or axiomatic mathematics, Lobachevsky proposes a system called 'imaginary geometry' to supplant Euclidean geometry. He declares that we cognize directly in Nature only motion, without which all the impressions our senses receive become impossible: 'All other ideas, for example geometric, though tied up implicitly in the properties of motion, are artificial products of our minds; and consequently space, by its

own self, abstractly, for us does not exist . . . Surfaces, lines, points, as geometry defines them, exist only in our imagination . . . From another side, lines straight or curved, plains and curved surfaces do not exist in Nature; we encounter only bodies, so that all the rest, created by our imagination, exist only in theory.' Nikolai Lobachevsky, *New Principles of Geometry, with a Complete Theory of Parallels*, Kazan, 1835; English translation by G. B. Halsted, *New Principles of Geometry*, Austin, 1897, p. 13.

111 Kazimir Malevich, 'On the Subjective and Objective in Art or On Art in General' (1922), in *Kazimir Malewitsch zum 100. Geburtstag*, exhibition catalogue, Galerie Gmurzynska, Cologne, 1978, p. 47.

112 Ibid., p. 41.

113 Ibid., p. 40.

114 Malevich's recognition of man's cosmic location is reflected in his thinking: 'In the distant past there existed an objective concept whereby the earth was flat and did not revolve, whereas everything in its vicinity or around it did revolve. Now we have a different concept whereby the earth revolves and everything with it. Consequently, the very same object – which existed objectively for all people, proved to be quite unobjective, because a new viewpoint revealed that the earth's globe was in a state of movement, and what had been objective evidence for everyone turned out to be unobjective. Now, in our time of culture, in our time of science and scientific analysis, it is impossible to guarantee that the broad mass of people will retain their objective understanding that the earth's globe does not revolve as soon as the sun encircles the earth, or that our scientists will retain their subjective notion that the earth revolves.' Ibid., p. 29.

115 Albert Einstein, *Relativity: The Special and General Theory*, translated by Robert W. Lawson, New York, 1947 (reprint edition), p. 28. This volume is a translation of the original German edition published in 1916–17.

116 Albert Einstein, *The Meaning of Relativity*, Princeton, 1955, pp. 30–31. Einstein was indebted to Minkowski, who linked space with time in the formulation of this co-relative significance. Equating three-dimensional coordinates, $x_1$, $x_2$, $x_3$ with $t$, the fourth co-ordinate, destroyed the classical conception of space and time as separate.

117 Lincoln Barnett, *The Universe and Dr Einstein*, with a foreword by Albert Einstein, New York, 1948, p. 53.

118 A similar experiment involving measuring rods was performed. If a stationary rod measuring one metre in length relative to a co-ordinate system K is accelerated through another system K1, then the length of this rod will change. 'The rigid rod is thus shorter when in motion than when at rest, and the faster it is moving then the shorter is the length.' Einstein, *Relativity*, 1916, op. cit., p. 43.

119 Einstein, *Relativity*, op. cit., pp. 128–34.

120 Roman Jakobson, *Phonological Studies: Selected Writings*, The Hague and Paris, 1971, I, p. 632.

121 See Linda Henderson's comprehensive description and analysis of the impact of scientific thought on Cubism in *The Fourth Dimension . . .*, op. cit., pp. 44–116.

122 Einstein, *Relativity*, op. cit., p. 32.

123 In Newtonian physics, objects move mechanically and continuously, according to laws allowing no deviation: events occur at fixed points in time, and any observer, from any position, will be able to determine their sequence, which becomes a question of objective fact. Any two events maintained an absolute relation in time. Einstein, however, demonstrated that the fundamental laws of Newtonian mechanics, and the concomitant notion of simultaneity, were inadequate for modern purposes. For Einstein, temporality is relative and unique for every observer.

124 J. C. Marcadé, 'What is Suprematism?' in *Kazimir Malewitsch*, exhibition catalogue, op. cit., p. 189.

125 Kazimir Malevich, 'On the Subjective and Objective . . .', in *Kazimir Malewitsch*, exhibition catalogue, op. cit., p. 41.

126 Werner Heisenberg, 'The Teachings of Goethe and Newton on Color in the Light of Modern Physics', in *Philosophic Problems of Nuclear Science*, New York, 1958, p. 67.

127 For further information about the inscription on the reverse of this canvas, which gives fragmentary insight into the title, see *Malevich*, exhibition catalogue, The Armand Hammer Museum of Art and Cultural Centre, Los Angeles, 1990, p. 208, cat. no. 45. For a complete account of the descriptive titles used at the '0.10' exhibition, see Troels Andersen, *Kazimir Malevich*, exhibition catalogue, Stedelijk Museum, Amsterdam, 1970

128 Kasimir Malewitsche, *Suprematismus – Die Gegenstandlose Welt*, translated by Hans von Rieson, Cologne, 1962, p. 160.

129 See Nicolai I. Lobachevski, *New Principles of Geometry with a Complete Theory of Parallels*, translated by George B. Halsted, Austin, 1897, p. 21. For more detailed analysis of the relationship between Malevich's thinking and abstract mathematics practised by Lobachevsky, Poincaré, et. al., see Rainer Crone, 'Apropos de la signification de la Gegenstandlosigkeit chez Malévitch et son rapport à la théorie poétique de Khlebnikov', in Jean-Claude Marcadé, *Cahier Malévitch No. 1. Recueil d'Essais sur l'œuvre et la pensée de K. S. Malévitch*, Lausanne, 1983, pp. 45–75. For a translated and abridged version, see Rainer Crone, 'Malevich and Khlebnikov: Suprematism Reinterpreted', *Artforum* (December 1978), pp. 40–47.

130 See Kasimir Malewitsch, *Suprematismus – Die Gegenstandlose Welt*, Cologne, 1962, p. 200. Translated by Rainer Crone/David Moos. Our translation, from the German into

English, aims to capture the spirit and essential thoughts of this passage, circumnavigating certain problems in the German translation from the Russian.

**131** J. L. Koerner, *The Moment of Self-Portraiture in German Renaissance Art: Albrecht Durer, Hans Baldung Grien, and Lucas Cranach*, forthcoming, MS pp. 8–9.

**132** Koerner, ibid., MS pp. 130–31.

**133** K. S. Malevich, *The Artist, Infinity, Suprematism: Unpublished Writings, 1913–33*, ed. Troels Andersen, Copenhagen, 1978, IV, p. 146.

**134** Hans Belting's reference, in this context, to Joyce's *Ulysses* anticipates the acute dislocation Beckmann began to experience in Germany, ultimately driving him to exile in 1937. See Belting's brilliant account, *Max Beckmann: Tradition as a Problem in Modern Art*, New York, 1989, pp. 82–95.

**135** F. W. J. Schelling, 'Concerning the Relation of the Plastic Arts to Nature' (inaugural speech given in 1807), in *The True Voice of Feeling: Studies in English Romantic Poetry*, ed. Herbert Read, London, 1968, pp. 324–25.

**136** K. S. Malevich, *The Artist, Infinity, Suprematism . . .*, op. cit., p. 203.

**137** Our use of the terms narrative, novel, epic and allegory do not necessarily reflect the rigid definitions these terms have in their literary contexts. As is often the case with linguistic definition, certain terminology that does not exist in one field, may be taken over from a related discipline. The act of transcription may alter the original meanings of those terms.

**138** K. S. Malevich, 'God is Not Cast Down', in *Essays on Art*, op. cit., New York, 1971, I, p. 192.

**139** Ibid., p. 192.

**140** Dr Peter Duesberg quoted in conversation, *Ideas*, 12 January 1988, The Canadian Broadcasting Corporation, transcript, p. 8. Dr Duesberg, one of the world's foremost retrovirologists, is a member of the department of molecular biology at the University of California, Berkeley.

**141** K. S. Malevich, 'Non-Objective Creation and Suprematism', in *Essays on Art*, op. cit., New York, 1971, I, p. 122.

**142** K. S. Malevich, 'Painting and the Problem of Architecture', in *Essays on Art*, op. cit., New York, 1971, II, p. 8.

**143** Leszek Kolakowski, *Husserl and the Search for Certitude*, New Haven, 1975; quoted here from Chicago, 1987, p. 42.

**144** Ibid., p. 45.

**145** K. S. Malevich, 'Painting and the Problem of Architecture', in *Essays on Art*, op. cit., New York, 1971, II, p. 9.

**146** The *Logical Investigations* were first translated into Russian in 1909.

**147** Leszek Kolakowski, op. cit., p. 50.

**148** Edmund Husserl, *Ideen zu einer reinen Phanomenologie und phanomenologische Philosophie*, *Husserliana III*, The Hague, 1913; here quoted after the English translation by W. R. Boyce Gibson, *Ideas: General Introduction to Pure Phenomenology*, New York, 1931, p. 167.

**149** Elmar Holenstein, *Roman Jakobsons phänomenologischer Strukturalismus*, Frankfurt, 1975, p. 12.

**150** Roman Jakobson, 'Um den russischen Wortschatz', *Slavische Rundschau*, VIII (1936), p. 81, translated by Rainer Crone and David Moos.

**151** Edmund Husserl, *Cartesianische Meditationen und Pariser Vortrage*, *Husserliana I*, The Hague, 1950; here quoted after English translation by Dorion Cairns, *Cartesian Meditations*, The Hague, 1960, p. 139.

**152** For more profound and detailed commentary on this topic, on the transcendental reduction that dissolved the ego of the individual, progressing one step beyond Descartes' recognition of doubt, see Leszek Kolakowski, op. cit., sections on 'The Way Toward Unmediated Insight' and 'Doubts About Transcendental Reduction', pp. 37–44.

**153** K. S. Malevich, 'The Suprematist Mirror', in *Essays on Art*, op. cit., New York, 1971, I, p. 224.

**154** Ibid., pp. 224–5.

# Bibliography

The aim of the following bibliography is to provide the reader with a usable guide to source material primarily focused on Malevich. The most comprehensive (but by now somewhat dated) bibliography can be found in Troels Andersen's 1970 *Kasimir Malevich* catalogue of the Stedelijk Museum, Amsterdam. The next best reference source is to be found in the 1978 *Malévitch* catalogue of the Musée National d'Art Moderne, Paris. For a thorough overview, the reader should consult John Bowlt's extensive bibliography in *Russian Art of the Avant-Garde: Theory and Criticism 1902–1934*, New York, 1980. For general references to literature and art the extensive bibliography in Vladimir Markov's *Russian Futurism: A History*, Berkeley and Los Angeles, 1968, still remains the most satisfactory source.

I Writings by Malevich
    English translations
    French translations
    German translations
    Italian translations
    Russian and original sources
II Books (alphabetically ordered)
III Catalogues (chronologically ordered)
IV Essays (chronologically ordered)

## I  WRITINGS BY MALEVICH

Note: The most thorough and accurate translations of Malevich's writings are those in French by Jean-Claude Marcadé. Whenever possible all other translations should be compared to, and checked against, Marcadé.

### English translations

*The Non-Objective World*, trans. Howard Dearstyne, Chicago, 1959

'Autobiographical Fragment', *Studio International*, CLXXVI, no. 905 (October 1968), pp. 129–33

*Essays on Art, 1915–1933*, 2 vols., ed. Troels Andersen, trans. Xenia Glowacki-Prus and Arnold McMillin, 2nd edition, Copenhagen, 1971

*The World as Non-Objectivity (Unpublished Writings 1922–1925)*, vol. III of *Essays on Art*, ed. Troels Andersen, trans. Xenia Glowacki-Prus and Edmund T. Little, Copenhagen, 1976

*The Artist, Infinity, Suprematism (Unpublished Writings 1913–1933)*, vol. IV of *Essays on Art*, ed. Troels Andersen, trans. Xenia Hoffmann, Copenhagen, 1978

'Autobiography', from manuscript I/42, in exhibition catalogue, *Kasimir Malewitsch zum 100: Geburtstag*, Galerie Gmurgzynska, Cologne, June–July 1978, pp. 11–19

'Malevich the Organizer', ed. and trans. Charlotte Douglas, in *Soviet Union/Union Sovietique*, vol. 5, part 2, Arizona State University, 1978

*From Cubism to Suprematism: The New Realism in Painting*, Petrograd (1915); translation in Charlotte Douglas, *Swans of Other Worlds: Kasimir Malevich and the Origins of Abstraction in Russia*, Ann Arbor, 1980, pp. 107–110

### French translations

*Écrits I: De Cézanne au Suprématisme: Tous les traites parus de 1915 à 1922*, ed. and trans. Jean-Claude and Valentine Marcadé, Lausanne, 1974

*Écrits*, ed. Andrei B. Nakov, trans. A. Roebel-Chicurel, Paris, 1975 (reprinted in 1988)

*Écrits II: Le Miroir Suprématiste*, ed. and trans. Jean-Claude and Valentine Marcadé, Lausanne, 1977

*Écrits III: Izologia*, ed. and trans. Jean-Claude and Valentine Marcadé, Lausanne, forthcoming

'Lettres de Malévitch à Matiouchine (1913–1916)', in *Malévitch 1878–1978: Actes du Colloque International 4 et 5 Mai 1978, Centre Georges Pompidou, Musée National d'Art Moderne*, ed. Jean-Claude Marcadé, Lausanne, 1979, pp. 171–89

'Autobiographie', in *Malévitch 1878–1978: Actes du Colloque International 4 et 5 Mai 1978, Centre Georges Pompidou, Musée National d'Art Moderne*, ed. Jean-Claude Marcadé, Lausanne, 1979, pp. 153–70

*Écrits IV: La Lumière et la Couleur*, ed. and trans. Jean-Claude and Valentine Marcadé, Lausanne, 1981

'Dans mon expérience de peintre' (1924), trans. Galina Demostenova, in *Malévitch: artiste et theoricien*, introduction by Evguenia Petrova, Moscow and Paris, 1990, pp. 199–209

### German translations

'Lenin: Aus dem Buch "Uber das Ungegenstandlische"', trans. El Lissitsky, in *Das Kunstblatt*, no. 10, 1924, pp. 289–93

Statement in Arp and Lissitsky, *Die Kunstismen*, Erlenbach-Zurich, 1925, p. ix

*Die gegenstandlose Welt*, trans. Anton von Riesen, Munich, 1927

'Suprematistische Architektur', *Wasmuths Monatshefte fur Baukunst*, no. 10, 1927, p. 412

'Zuschrift von K. Malewitsch, Leningrad', *Wasmuths Monatshefte fur Baukunst*, no. 3, 1928, 169–70

*Suprematismus – Die gegenstandlose Welt*, trans. Hans von Riesen, Cologne, 1962

'Unsere Aufgaben' [Nashi zasachi] [Our tasks] in *Izobrazitel'noye iskusstvo*, no. 1, 1919, p. 29; trans. in *El Lissitsky*, Dresden, 1967

'Autobiographie', from manuscript I/42, in exhibition catalogue, *Kasimir Malewitsch zum 100: Geburtstag*, Galerie Gmurgzynska, Cologne, June–July 1978, pp. 11–19

### Italian translations

Kazimir S. Malevič: *Scritti*, ed. Andrei B. Nakov, trans. Erica Klein Betti and Sergio Leone, Milan, 1977

### Russian
A. *archive material*

Letters to Matiushin, 1913. In the archive of the GAIS, Leningrad

'Ot kubizma do supremat izma' [From Cubism to Suprematism], Petrograd, 1916

'O suchestve' [On the essence], 1919. Private archive, Leningrad

'Novatory i obshchestvo' [Innovators and Society], September 1920. Private archive, Leningrad

'Futurizm', March 1921. Archive of Hans von Riesen, Bremen

'Novoye dokazatel'stvo v iskusstve' [A new proof in art], June 1922. Lecture held in the Museum of Artistic Culture, Petrograd

'Zadachi muzeyev zhivopisnoy kul'tury' [The tasks of the museums of painterly culture], November 1922. Lecture held in the Museum of Artistic Culture, Petrograd

Vaedenie v teoriyu o pribavochnom elemente v zhivopisi [Introduction to the theory concerning the additional element in painting], Typescript, p. 1, 1923–4. Private archive, Moscow

Art and artists (Monet, Cézanne, Van Gogh, Gaugin aphorisms). Before 1924. Mentioned by El Lissitsky in a letter to his wife, March, 1924

Notebook. Before 1924. Mentioned by El Lissitsky in March 1924

Letters to El Lissitsky, October 1924 and 8 December 1924. Private archive, Leningrad

'Doklad o novoy arkhitekture' [Lecture on a new architecture], 1924. Held in Leningrad's architectural society

Notebook. 1924. Archive of Hans von Riesen, Bremen

Dokladnaya zapiska na imya nachalnika Glaviskusstva NKP [Report addressed to the Head of the Chief Administration for Art,

People's Commissariat for Education], April 1927. Central State Archive for Literature and Art

Letters to the critic Radlov, 1928–9. Archive of the Russian Museum, Leningrad

Letter to the director of the Russian Museum, 1933. Archive of the Russian Museum, Leningrad

Letters to Matiushin, the composer, and Shkolnik, the painter. The Tretyakov Gallery, Moscow

'My, kak utilitar'noye sovershenstvo' [Us, as utilitarian perfection]. Mentioned by Malevich in *Suprematism: 34 Drawings*

'On the Institute of Artistic Culture', no date. Private archive, Leningrad

Fragment of manuscript on 'The Academy of Art'. Archive of the Russian Museum, Leningrad

Letter to the director of the Russian Museum. Archives of the Russian Museum, Leningrad

Draft for a letter to Wasmuths Monatshefte fur Baukunst. Private archive, Leningrad

Untitled MS [Volume and colour exist in nature, sound is born . . .']. Archive of Hans von Riesen, Bremen

'Khudozhestvenno-nauchny film: Zhivopis' i problemy arkhitektury' [An artistic-scientific film: Painting and the problems of architecture]. Archive of Hans von Riesen, Bremen

'Suprematizm, kak gosudarstvo . . .' Archive of Hans von Riesen, Bremen

'Mir kak bespredmetnost. 1/41' [The world as non-objectivity. 1/41]. Private archive, Leningrad (several versions); Archive of Hans von Riesen, Bremen (one version)

'Mir kak bespredmetnost. 1/42. Bespredmetnost' [The world as non-objectivity. 1/42. Non-objectivity]. Private archive, Leningrad (several versions); Archive of Hans Von Riesen, Bremen (one version)

'Iz 1/42. Zametki', Archive of N. I. Khardzhiyev, Moscow

'Impressionizm, svet, tsvet. Iz. 1/42' [From 1/42. Impressionism, light and colour]. Private archive, Leningrad (several versions)

'1/45. V vedenii v teoriyu o pribavochnom elemente v zhivopisi' [1/45. Introduction to the theory of the additional element in painting]. Private archive, Leningrad (several versions)

'1/45a. Teoriya pribavochnogo elementa v zhivopisi' [1/45a. The theory of the additional element in painting]. Private archive, Leningrad (several versions)

'1/46. Eklektika' [1/46. Eclectics] Private archive, Leningrad

'Mir kak bespredmetnost. 1/47' [The world as non-objectivity. 1/47]. Archive of Hans von Riesen, Bremen

'Mir kak bespredmetnost. 1/48–49' [The world as non-objectivity. 1/48–49]. Private archive, Leningrad (several versions); Archive of Hans von Riesen, Bremen (one version)

'Pyat'punktov' [Five points], no date. Private archive, Leningrad

'Khudozhestvennoye i utilitarnoye nachalo' [Artistic and utilitarian principles], no date. Private archive, Leningrad

B. *published material*

'Pervy vserossiyskiy s'ezd Bayachey Budushchego (poetov-futuristov) Zasedanie 18-i-19-ogo yulya 1913 g.v Usikirko (Finlandiya)' [The first all-Russian congress of Futurist-poets, July 18, 1913], *Za 7 dney*, no. 20, Aug. 15, 1913, p. 605

Contribution to the journal *Supremus*, no 1, 1916

'K novoy grani' [To the new limit], *Anarkhiya*, no. 31, 30 March 1918

'K priyezdu Vol'tero-terroristov iz Peterburga' [On the arrival of Voltarian terrorists from Petersburg], *Anarkhiya*, no. 41, 11 April 1918

Advertisement in *Iskusstvo*, Jan. 1, no. 1, 1919

'Os 'tveta i formy' [The axis of colour and form], *Izobrazitel'noye iskusstvo*, no. 1, 1919, pp. 29–30

'Utverditeli novykh iskusstv', *Iskusstvo*, no. 1, 1921, p. 9

'Unovis', *Iskusstvo*, no. 1, 1921, pp. 9–10

'Russkiy Muzey. K obmenu khudozhestvennykh proizvedeniy mezhdu Moskvoy i Leningradom' [The Russian Museum. The exchange of works between Moscow and Leningrad], *Zhizn' iskusstva*, no. 16, April 24, 1923, pp. 13–14

'Extra Dry (Denaturat)' [Extra dry (Denatured)], *Zhizn' iskusstva*, no. 18, May 8, 1923, pp. 17–18

'Van'ka-vstan'ka' [The Tumbler], *Zhizn' iskusstva*, no. 21, May 29, 1923, pp. 15–16

'Swiat jako bezpreamiotowsc' [The world as non-objectivity], *Praesens*, no. 1, 1923, pp. 34–40

'I likuyut liki na ekranakh' [And images triumph on the screen], *A. R. K. Kino*, no. 10, 1925, pp. 7–9

'Zhivopis v probleme arkhitektury' [Painting in the problem of architecture], *Nova generatsiya*, no. 2, 1928, p. 123

'Teoriya suchasnoi zapadnoi arkhitekturi' [The theory of contemporary Western architecture], *Nova Generatsiya*, no. 4, 1928, p. 306

'Analiz novogo izobrazitelnogo iskusstva (Pol Sezann)' [Analysis of the new figurative art (Paul Cezanne)], *Nova generatsiya*, no. 6, 1928, p. 439

Letter to the editors of *Sovremennaya arkhitektura*, no. 5, 1928, p. 156

'Popytka opredeleniya zavisimosti mezhdu tsvetom i formoi v zhivopisi' [An attempt to define the relation between colour and form in painting], *Nova Generatsiya*, nos. 8–9, Krackow, 1930

'Nashi zadachi' [Our tasks], *Izobrazitel'noye iskusstvo*, no. 1, 1919, p. 29. Trans. in *El Lissitzky*, Dresden, 1967

Pisma k M. V. Matyushinu [Letters to M. V. Matiushin], in *Ezhegodnik rukopisnogo otdela Pushkinskogo Doma* [Yearbook of the Manuscript Section of Pushkin House], Leningrad, 1976

Address to the artists in the West, *Vytvarne umeni*, no. 8–9, 1967, p. 453 (Prague)

'Lenine', *Macula*, no. 3–4, 1978, pp. 186–90

II BOOKS (alphabetically ordered)

A. *Primarily on Malevich*

Bowlt, John E. and Douglas, Charlotte, eds., *Kasimir Malevich 1878–1935–1978*, special issue, *Soviet Union: Union Sovietique*, vol. 5, part 2, Arizona State University, 1978

Douglas, Charlotte, *Swans of Other Worlds: Kasimir Malevich and the Origins of Abstraction in Russia*, Ann Arbor, 1980

Kruchenykh, A., *Nash vykhod* [Our exit], unpublished memoirs, The Mayakovsky Museum, Moscow, the archive

*Malevitch: artiste et théoricien*, introduction by Evgenia Petrova, with essays by Joop M. Joosten, Irina Vakar, Charlotte Douglas, Evgueni Kovtun, Dimitri Sarabianov, Irina Karassik. Moscow and Paris, 1990

Marcadé, Jean-Claude, ed., *Malévitch 1878–1978: Actes du Colloque International 4 et 5 Mai 1978, Centre Georges Pompidou, Musee National d'Art Moderne*, Lausanne, 1979

– *Cahier Malévitch No. 1*, Lausanne, 1983

– *Malévitch*, Paris, 1990

Martineau, Emmanuel, *Malévitch et la Philosophie*, Lausanne, 1977

Sandberg, Will, ed., *Werken van de russiche schilder en voortrekker der suprematisten Kasimir Malevitch 1878–1935* (album collected by Will Sandberg; contains photographs of the collection of the museum, photocopies of posters, exhibition catalogues, etc.), Stedelijk Museum, Amsterdam

Shadowa, Larissa A., *Suche und Experiment: Russische und Sowjetische Kunst 1910 bis 1930*, Dresden, 1978; English translation: *Malevich: Suprematism and Revolution in Russian Art 1910–1930*, London, 1982

Simmons, W. Sherwin, *Kasimir Malevich's 'Black Square' and the Genesis of Suprematism 1907–1915*, New York, 1981

Strzeminski, W., *Kazimierz Malevica 1876–1935* (sic). (Album collected about 1935–36. Contains 25 lithographs, some in half-finished state or re-made, one colour lithograph and 10 original photographs of architectural models.) Museum Sztuki, Lodz

B. *Directly Related to Malevich*

Andersen, Troels, *Moderne Russisk Kunst*, Copenhagen, 1967

Andersen, Troels and Grigorieva, Kesnia, eds., *Art et Poésie russes: 1900–1930*, Paris, 1979

Andreeva, L., *Sovetsky Farfar 1920–1930 gody* [Soviet Porcelain of the 1920s and 1930s], Moscow, 1975, pp. 116–26

Apollonio, Umbro, ed., *Futurist Manifestos, Documents of Modern Art*, New York, 1973

Arkin, D. and Khvoynik, I., *Samtida Konsti Ryssland*, Malmo, 1930, pp. 16, 18, 123 (ill.)

Arp, Hans and Lissitsky, El, *Die Kunstismen*, Zurich, 1925, pp. 22–23 (ill.). From *On New Systems in Art* and a short, otherwise unpublished, statement

Bablet, Dennis, *Les Revolutions scéniques au XX siècle*, Paris, 1975, pp. 92, 107–109, 175

Bann, Stephen, *The Tradition of Constructivism*, New York, 1974

Barooshian, Vahan D., *Russian Cubo-Futurism 1910–1930: A Study in Avant-Gardism*, The Hague, 1974

Barr, Alfred, *Cubism and Abstract Art*, New York, 1936, pp. 2, 120, 122–26, 215–16, 241, 246 (ill.)

Bauermeister, Christiane, ed., *Sieg über die Sonne: Aspekte russische Kunst zu Beginn des 20 Jahrhunderts*, Berlin, 1983

Belenson, Aleksandr, ed., *Strelets, Sbornik pervy*, Petrograd, 1915; reprint edition, Ann Arbor, 1978

Belloli, Carlo, *Russky vklad v plasticheskie avangardy*, Milan, 1964

Benevolo, L.: *Geschichte der Architektur des 19 und 20 Jahrhunderts*, vol. II, Munich 1964, pp. 18, 32, 33, 34 (ill.)

Beringer, Herman, and Cartier, Jean-Albert, *Jean Pougny (Iwan Puni) 1892–1956: Catalogue de l'oeuvre*, vol. I: *Les années d'avant-garde: Russie-Berlin, 1910–1923*, Tübingen, 1972

Billington, James H., *The Icon and the Ax: An Interpretive History of Russian Culture*, New York, 1970

Bojko, Szyman., *New Graphic Design in Revolutionary Russia*, New York, Washington, 1972

Bowlt, John E., *Russian Art 1875–1975: A Collection of Essays*, New York, 1976, pp. 102–106, 188–23, 130–51 et passim

Bowlt, John E., ed. and trans., *Russian Art of the Avant-Garde: Theory and Criticism 1902–1934*, The Documents of 20th-Century Art, New York, 1976

Brion-Guéry, Liliane, ed., *L'année 1913*, 3 vols., Paris, 1973

Brion, Marcel, *Art Abstrait*, Paris, 1956, pp. 135–44 (ill.). Reprinted in Brion, *Geschichte der abstrakten Kunst*, Cologne, 1961 (2nd edition), pp. 99–105 (ill.)

Bush, M. and Zamoshkin, A., *Put' sovetskoy zhivopisi 1917–1932*, Moscow/Leningrad, 1933, pp. 13, 15, 16, 17, 21, 23, 27, 28

Carrieri, Raffaele, *Futurism*, Milan, 1960, pp. 134, 137 (ill.)

Chagall, Marc, *Ma vie*, Paris, 1931, pp. 209–12

Cladders, Johannes, *Rationale Spekulationen: Konstruktivistische Tendenzen in der europäi-schem Kunst zwischen 1915 und 1930, ausge-wählt aus deutschen Privatsammlungen*, Monchengladbach, Städtisches Museum, 1972

Compton, Susan P., *The World Backwards: Russian Futurist Books 1912–1916*, London, 1978

– ed., *Russian Futurism 1910–1916: Poetry and Manifestoes*, Cambridge, England, 1977

– 'Kasimir Malevich: A Study of the Paintings, 1910–1935', PhD thesis, London, 1983

Conio, Gérard, ed., *L'Avant-Garde russe et la synthèse des arts*, Lausanne, 1990

Cork, Richard, *Vorticism and Abstract Art in the First Machine Age*, vol. I, Berkeley, 1976

Diakonitsyn, L. *Ideynye protivorechiya v estetike russkoy zhivopisi kontsa 19-nachalo*, 20 vols., Perm, 1966, pp. 162–3, 184–5, 197–8, 162–3, 210–16

Douglas, Charlotte, *Swans of Other Worlds: Kasimir Malevich and the Origins of Suprematism 1908–1915*, Ann Arbor, 1980

Efros, A., *Profily*, Moscow, 1930, pp. 200–201

Eisenstein, S., *Sobranie sochinenie*, Moscow, 1964, vol. I, pp. 314, 420; vol. II, p. 57; vol. III, pp. 68, 522, 620

Ehrenburg, Ilya, *Lyudy, gody, zhizn'*. First published in Novy Mir, Jan. 1961, no. 1, p. 116

Etkind, E., Nivat, G., Serman, I., and Strada, V., eds., *Histoire de la littérature russe: Le XXe siècle*, vol. I and II, Paris, 1987–88

Fauchereau, Serge, *L'avant-garde russe*, Paris, 1979

Gibian, George and Tjalsma, H. W., eds., *Russian Modernism: Culture and the Avant-garde, 1900–1930*, Ithaca, 1976

Gray, Camilla, *The Great Experiment: Russian Art 1863–1922*, London, 1962, pp. 65, 86, 92, 96, 98, 106–7, 122, 128–40, 156–68, 184, 190, 192–93, 195–96, 215, 226–27, 243, 248, 282–84, 291–92, 308 (ill.)

Grohmann, Will, *Die Sammlung Idda Biennert*, Dresden/Potsdam, 1933, pp. 16, 23

Guerman, Mikhail, *La flamme d'octobre, art et révolution*, Paris, 1977

Gushchin, A., *Iso-iskusstvo v massovykh prazdnestvakh i demonstratsiyakh*, Moscow, 1930, p. 3 (ill.)

Haftmann, Werner, *Malerei im 20. Jahr-hundert*, Munich, 1954, vol. I, pp. 266–67; vol. II, p. 189 (ill.)

Henderson, Linda Dalrymple, *The Fourth Dimension and Non-Euclidean Geometry in Modern Art*, Princeton, 1983

Hiberseimer, L., *Contemporary architecture: Its Roots and Trends*, Chicago, 1964 (ill.)

Hildebrandt, Hans, *Die Kunst des XIX and XX Jahrhunderts*, Potsdam, 1931, pp. 317, 400–401 (ill.)

Ioffe, I, *Krizis sovremennogo iskusstva*, Leningrad, 1925, pp. 31–32 (ill.)

– *Sinteticheskaya istoriya isskustv*, Leningrad, 1933, pp. 432–38 (ill.)

Jakobson, Roman, *Language in Literature*, Cambridge, Massachusetts, 1987

Janecek, Gerald, *The Look of Russian Literature*, Princeton, 1984

Kassak, Lajos, and Moholy Nagy, L., *Buch neuer Künstler*, Vienna, 1922 (ill.)

Khan-Magomedov, S, *Teoreticheskie kontseptsii tvorcheskikh techenii sovetskoi arkhivektury – Obzor* [Theoretical concepts in the creative trends of Soviet architecture – a survey], Moscow, 1974

Khardzhiyev, N. I., *El'Lisitsky-konstruktor knigi in Iskusstvo knigi*, Moscow, 1962, pp. 147–48, 154

– *Mayakovsky zhivopis'. Mayakovsky. Issledov-aniya materialy*, Moscow, 1940, pp. 337, 349, 352, 354, 358–59, 361, 364, 371, 386, 380, 397

Khardjiev, N. and Trénine, V., *La culture poétique de Maiakovski*, Lausanne, 1982

Kovtun, Evgenii, *Kniznye Oblozhki russkikh Khudozhnikov nachala XX veka* [The Book Covers of Early Twentieth Century Russian Painters], Leningrad, 1977

– *Die Wiedergeburt der künstlerischen Druck-grapkik*, Dresden, 1984

Kroutchonykh, Khlebnikov, Matiouchine, Malévitch, *La Victoire sur le Soleil*, trans. Jean-Claude Marcadé, Lausanne, 1976

Kurtz, Rudolf, *Expressionismus und Film*, Berlin, 1926, p. 88 (ill.)

Lanne, Jean-Claude, *Velimir Khlebnikov, poète futurien*, 2 vols., Paris, 1983

Lapshin, V. P., *Soiuz russkikh khudozhnikov*, Leningrad, 1974

Lebedev, P. ed., *Bor'ba za realizm*, Moscow, 1962, pp. 117, 212–14 (ill.)

Lisitsky, El, *Russland, Neues Bauen in der Welt*, vol. I, Vienna, 1930, pp. 10–11, 43 (ill.)

– *Maler, Architekt, Typograf, Fotograf*, Erin-nerunge Briefe, Schriften. Übergeben von Sophie Lissitsky-Küppers, Dresden, 1967; English trans., Greenwich, 1968, pp. 6, 14, 16, 21, 35, 47, 50, 52, 53, 60–62, 65, 88, 330, 332, 334, 335, 337, 338, 349, 368

Livshits, Benedikt, *Polutoraglazy strelets*, Leningrad, 1933, pp. 432–38 (ill.)

– *L'Archer à un oeil et demi*, trans. Jean-Claude Marcadé, Lausanne, 1971; English trans., *The One and a Half-Eyed Archer*, trans. and ed. John E. Bowlt, Newtonville, Massachusetts, 1977

Lobanov, V., *Khudozhestvennye gruppirovki za poslednye 25 let*, Moscow, 1930, pp. 59–90

Lozowick, L., *Modern Russian Art*, New York, 1925, pp. 9, 18, 23–24, 28 (ill.)

Lunacharsky, A., 'Preface', in G. Kaiser, *Dramy*, Moscow/Prague, 1923; reprinted in Lunacharsky, *Sobr. sochinenie*, vol. v, Moscow, 1965, p. 424

Marcadé, Jean-Claude, *Le Futurisme russe 1907–1917*, Paris, 1989

– ed., *Michel Larionov: Une Avant-Garde Explosive*, Lausanne, 1978

Marcadé, Valentine, *Le Renouveau de l'art pic-tural russe 1863–1914*, Lausanne, 1971

Makarov, *Sovietskoye dekorativnoye iskusstvo* [Soviet decorative art], Leningrad, 1970

Markov, Vladimir, *The Longer Poems of Velimir Khlebnikov*, Berkeley, 1962

– ed., *Manifesty i programmy russkikh futuristov*, Munich, 1967

– *Russian Futurism: A History*, Berkeley, 1968

Marinetti, F. T., 'The Birth of Russian Futurism: Milan, Paris, Moscow, St Petersburg', *Marinetti's Writings*, ed. R. W. Flint, New York, 1971

Martin, Marianne W., *Futurist Art and Theory*, Oxford, 1968

Mayakovsky, V. V., *Polnoye sobraniye sochineniy (v 12 tomakh)*, ed. N. I. Khardzhiyev, Moscow, 1939, vol. I, pp. 432, 449, 471, 486, 497

Meyer, Franz and Chagall, Marc, *Leben und Werk*, Cologne, 1961, pp. 32, 266, 271, 277, 303, 608

Nakov, Andrei, *Abstrait/Concret: art non-objectif, russe et polonais*, Paris, 1981

– *L'Avant–Garde russe*, Paris, 1984

Pertsov, N., *Reviziya LEF-a* [The Inspection of LEF], Moscow, 1925, pp. 17–18

Pleynet, Marcelin, *L'Enseignement de la peinture*, Paris, 1971, pp. 145–58

Pospelov, Gleb, *Moderne russische Malerei: Die Künstlergruppe Karo-Bube*, Berlin, 1985

Pozharskaia, M. N., *Russkow teatral'no-dekoratsionnoe iskusstvo kontsa XIX nachala XX veka*, Moscow, 1970

Puni, Ivan, *Sovremennaya Zhivopis'*, Berlin, 1923, pp. 10–25 (ill.)

Read, Herbert and Martin, Leslie, *Gabo: Constructions, sculpture, paintings, drawings, engravings*, London, 1957, pp. 156, 157, 159

Richardson, John, and Zafran, Eric, eds., *Master Paintings from The Hermitage and The State Russian Museum, Leningrad*, New York, 1975

Rickey, George, *Constructivism, Origins and Evolution*, London, 1967, pp. 17–21, 41–42, 49, 66, 67, 84–85, 94 (ill.)

Richter, Jans, *Köpfe und Hinterköpfe*, Zurich, 1967, pp. 81, 101–109

Ripellino, Angelo, *Majakovskii e il teatro russo d'avantguardia*, Turin, 1959

Robel, Leon, ed., *Manifestes futuristes russes*, Paris, 1971

Rost, Nico, *Kunst en Cultuur in Sowjet-Rusland*, Amsterdam, 1924, pp. 71–73, 76

Rotzler, Willy, *Constructive Concepts: A History of Constructive Art from Cubism to the Present*, Zurich, 1977, pp. 29–59

Sarabyanov, D., *Russkaya zhivopis kontsa 1900-kh – nachala 1910-kh godov* [Russian painting of the end of the 1900s and beginning of the 1910s], Moscow, 1971, p. 94

– *Russkie zhivopistsy nachala XX veka – Novye napravleniya* [Russian painters of the beginning of the 20th century – New trends], Leningrad, 1973, p. 173

Schmied, Wieland, *Wegbereiter zur modernen Kunst*, Hannover, 1966, p. 249

Seckel, Kurt, *Masstäbe der Kunst im 20.Jahrhundert*, Vienna, 1967, pp. 118–99

Seuphor, Michel, *L'art abstrait, ses origines, ses premier maitres*, Paris, 1949, pp. 49–52, 220–25, 303–304 (ill.)

– *Le style et le cri: Quartorze essais sur l'art de ce siècle*, Paris, 1965, pp. 36–44, 51, 54–58

Shklovsky, Viktor, *Mayakovsky and his Circle*, trans. and ed. by Lily Feller, New York, 1972

– *La marche du cheval*, Paris, 1973 [French translation of original Russian edition of 1923]

Solovyov, V., 'Odno iz vospominaniy o Mayakovskom', in the anthology *Mayakovskomu*, Moscow, 1940, p. 150 (cf. also pp. 25–28 and p. 155 of the same volume)

Steneberg, Eberhard, *Russische Kunst: Berlin 1919–1932*, Berlin, 1969

Stoykov, A., *Kritika abstraktnogo ishusstva i ego teorii*, Moscow, 1964, pp. 113–18, 163 (ill.)

Strzeminski, Wladyslaw and Kobro, Katarzyna, *L'Espace Uniste*, Lausanne, 1977

Taraboukine, Nikolai, *Le Dernier Tableau: 1. Du chevalet à la machine; 2. Pour une théorie de la peinture* (Moscow, 1923), trans. Andrei B. Nakov and Michel Pétris, Paris, 1972

Tschizewskij, Dmitrij, *Anfänge des russischen Futurismus*, Wiesbaden, 1963

Tugendhold, Ya., *Iskusstvo Oktyabrskoi epokhi* [The art of the October Era], Moscow, 1930, p. 14

Umanskij, Konstantin, *Neue Kunst in Russland*, Potsdam, 1920, pp. 20, 22, 44, 57, 59, 64

Vallier, Dora, *L'art abstrait*, Paris, 1967, pp. 35, 140–70 (ill.)

Walkemier, Elizabeth, *Russian Realist Art*, Ann Arbor, 1977

Weicker, Carola Giedion, *Plastik des 20. Jahrhunderts*, Stuttgart, 1955, p. 149 (ill.)

– *Moderne Plastik*, Zurich, 1937, p. 199 (ill.)

Weisgerber, Jean, ed, *Les Avant-Gardes littéraires au XXe siècle*, 2 vols., Budapest, no date

Westheim, Paul, ed., *Künstlerbekenntnisse. Briefe. Tagebuchblätter. Betrachtungen heutiger Künstler*, Berlin, 1925 (contains statements by Altman, Lissitsky, Malevich, Puni, et al)

Williams, Robert C.: *Artists in Revolution: Portraits of the Russian Avant-garde, 1905–1925*, Bloomington, Indiana, 1977

Zander-Rudenstine, Angelika, *Russian Avant-Garde Art: The George Costakis Collection*, New York, 1981

Zelinsky, Bodo, ed., *Russische Avantgarde 1907–1921: Vom Primitivismus zum Konstruktivismus*, Bonn, 1983

Zhuravlev, A. and S. Khan Magomedov, *Polveka sovetskoi arkhitektury* [A half century of Soviet architecture], Moscow, 1967

## III EXHIBITION CATALOGUES (chronologically ordered)

*Kasimir Malewitsch*, Braunschweig, Kunstverein, 1958

*Kasimir Malevich, 1878–1935*, introduction by Camilla Gray, London, Whitechapel Gallery, 1959

*Kasimir Malewitsch*, introduction by Franz Meyer, Bern, Kunsthalle Bern, 1959

*Casimir Malevic*, Rome, Galleria Nazionale d'Arte Moderna, 1959

*Kasimir Malevich*, Stockholm, Moderna Museet, 1965–66

*Kasimir Malevich: Catalogue Raisonné of the Berlin Exhibition of 1927, including the Collection of the Stedelijk Museum, Amsterdam*, Amsterdam, Stedelijk Museum, 1970

*Malévitch: Dessins*, Paris, Galerie Jean Chauvelin, 1970

*Kasimir Malevic*, Galeria Breton, Milan, 1971

*Kunstler-Theorie-Werk: Zur Zweiten Biennale*, Nuremberg, 1971

*The Non-Objective World, 1914–1924*, London, Annely Juda Fine Art; Paris, Galerie Jean Chauvelin; Milan, Galleria Milano, 1971 (editions in English, French and Italian)

*The Non-Objective World, 1924–1939*, London, Annely Juda Fine Art; Paris, Galerie Jean Chauvelin; Milan, Galleria Milano, 1971 (editions in English, French and Italian)

*Kasimir Malevic*, Milan, Galleria Breton, 1971

*Russian Art of the Revolution*, Ithaca, NY, The Andrew Dickson White Museum of Art at Cornell University; Brooklyn, Brooklyn Museum of Art, 1971

*Rationale Spekulationen: Konstruktivistische Tendenzen in der europäischen Kunst zwischen 1915 und 1930*, Mönchengladbach, Städtisches Museum, 1972

*Tatlin's Dream: Russian Suprematism and Constructivist Art 1910–1923*, London, Fischer Fine Art, 1973

*Iwan Puni (Jean Pougny) 1892–1956*, Berlin, Haus am Waldsee, 1975

*Kasimir Malevich. The Graphic Work: 1913–1930. A Print Catalogue Raisonné*, ed. Donald Karshan, Jerusalem, The Israel Museum, 1975

*Kasimir Malevich*, London, The Tate Gallery, 1976

*Russian Pioneers at the Origins of Non-Objective Art*, London, Annely Juda Fine Art, 1976

*Malewitsch – Mondrian und ihre Kreise*, Cologne, Kunstverein, 1976

*Tendenzen der zwanziger Jahre. Europäische Kunstausstellung*, Berlin, Nationalgalerie, 1977

*Suprématisme*, Paris, Galerie Jean Chauvelin, 1977

*The Suprematist Straight Line: Malevich, Suetin, Chashnik, Lissitsky*, Annely Juda Fine Art, 1977

*Malewitsch-Mondrian: Konstruktion als Konzept*, Kunstvereine Hannover, 1977

*Kasimir Malewitsch. Zum 100. Geburtstag*, Cologne, Galerie Gmurzynska, 1978

*Malevich and his Circle*, New York, Rosa Esman Gallery, 1978

*Revolution: Russian Avant-Garde 1912–1930*, New York, The Museum of Modern Art, 1978

Andersen, Troels et al., eds., *Art et poésie russes 1910–1930*, Paris, Centre Georges Pompidou, 1979

*Russkoe iskusstvo pervoi treti XX veka* [Russian Art of the First Third of the Twentieth Century], ed. V. I. Rakitin, Yaroslavl', USSR, Museum of Fine Art, 1979

*Abstraction: Towards a New Art: Painting 1910–1920*, London, Tate Gallery, 1980

*The Avant-Garde in Russia, 1910–1930: New Perspectives*, Los Angeles, Los Angeles County Museum of Art, 1980

*Journey into Non-Objectivity: The Graphic Work of Kasimir Malevich and Other Members of the Russian Avant-Garde*, ed. John E. Bowlt, Dallas, Museum of Fine Arts, 1980

*Kasimir Malewitsch (1878–1935): Werke aus sowjetischen Sammlungen*, Düsseldorf, Kunsthalle, 1980

*Malévitch: Oeuvres de Casimir Severinovitch Malévitch (1878–1935)*, ed. Jean Hubert Martin, Paris, Musée National d'Art Moderne, 1980

*Constructivisme et avant-garde russe*, Montréal, Musée d'Art Contemporain, 1982

*Plastyka radziecka: Sztuka okresu pazdziernika 1917–1930*, Warsaw, Zacheta, 1982

*Von Malevitsch bis Mondrian: Graphik und Zeichnungen des Konstruktivismus aus den Jahren 1913–1930*, Dresden, Staatliche Kunstsammlungen Dresden, 1982–83

*Masterpieces of the Avantgarde*, London, Annely Juda Fine Art/Juda Rowan Gallery, 1985

*Futurismo e futurismi*, Venice, Palazzo Grassi, 1986

*Kasimir Malevich*, Leningrad, State Russian Museum; Moscow, Tretiakov Gallery; Amsterdam, Stedelijk Museum, 1988–89

*Kazimir Malevich 1878–1935*, Washington, D.C., National Gallery of Art; Los Angeles, Armand Hammer Museum and Cultural Center; New York, The Metropolitan Museum of Art, 1990–91

IV ESSAYS (Chronologically ordered)

**1908**

Tasteven, Genrikh, 'Impressionizm i novye iskaniia', *Zolotoe Runo*, XVII–XIX, nos. 7/9 (1908)

**1910**

Kandinskii, Vasilii, 'Soderzhanie i forma', *Salon*, no. 2 (1910), pp. 14–16

**1912**

Markov, Vladimir, 'Printsipy novogo iskusstva', *Soyuz molodezhi*, no. 1 (April, 1912), pp. 5–14; no. 2 (June, 1912), pp. 5–18

**1913**

Aksenov, I, 'K voprosu o sovremennom sostoyanii russkoi zhivopisi, *Sbornik statei po iskusstvu*, Moscow, 1913, p. 13

Rostislavov, A., 'Report of discussion in the Troitsky Theatre', *Rech'* (March 26, 1913), pp. 3–4

Timofeyev, S., 'Report of discussion in the Troitsky Theatre', *Den'* (24 March, 1913), pp. 3–4

**1914**

Kandinskii, Vasilii, 'O dukhovnom v iskusstve (zhivopis)', *Trudy vserossiiskogo s'ezda khudozhnikov v Petrograde, Dekabr', 1911-Janvar', 1912*, vol. I, St Petersburg, 1914, pp. 47–76

Matiushin, M., 'Futurizm v Peterburge', *Spektakli*, nos. 2, 3, 4, 5 (1913); reprinted in *Purby zhurnal' russkikh futuristov* (St Petersburg), nos. 1–2 (1914) pp. 153–57

Tasteven, Genrikh, 'Futurizma puti k novomy simvolizmu', Moscow, 1914

**1915**

Tasteven, Genrikh, 'Paskha Futuristov', *Siny Zhurnal* (St Petersburg), no. 12 (March 21, 1915), pp. 6–7

**1916**

Benaii, Aleksandr, 'Posledniaia futuristskaia vystavka', *Rech'* (January 9, 1916)

Matiushin, M., 'O vystavke poslednykh futuristov', *Otsharovanity Strannik: Almanakh veseni* (St Petersburg) (1916), pp. 16–18

Rostislavov, A., 'A Propos de l'exposition des futuriste', *K. S. Malévitch. Écrits II. Le Miroir Suprématist*, Lausanne, 1977, pp. 155–56; French translation of an article which originally appeared in *Rech'* [Speech], Petrograd (January, 1916)

– 'Le crachoir des novateurs', *K. S. Malévitch, Écrits II. Le Miroir Suprématiste*, Lausanne, 1977, pp. 158–60; French translation of an article which originally appeared in *Rech'* [Speech], Petrograd (January, 1916)

Shterenberg, D., 'Report of lecture in the Tenishev Hall', *Apollon*, no. 1 (1916), p. 37

Tugendhold, Iakov, 'Futuristitcheskaya vystavka "Magazin"', *Apollon*, no. 3 (1916), pp. 61–62

**1918**

Kamenskii, Vasilii, 'Ego-moia biografiia velikogo futurista', Moscow, 1918

Levinzon, A., 'Misteriya-Buff Mayakovskogo', *Zhizn 'iskusstva* (Nov. 11, 1918)

Punin, Nicolai, 'O misterii-Buff, *Iskusstvo kommuny* (Prague), no. 2 (Dec. 15, 1918), p. 2

**1919**

Jakobson, Roman, 'Futurizm', *Iskusstvo*, no. 7 (Aug. 2, 1919)

Pugny, Ivan, 'Les groupes contemporains dans l'art russe de gauche', *K. S. Malévitch, Écrits II. Le Miroir Suprématiste*, Lausanne, 1977, pp. 168–69; excerpt from an article that originally appeared in *Iskusstvo kommuny*, no. 19 (April 13, 1919)

Punin, Nikolai, 'About New Art Groupings',

*Iskusstvo kommuny*, no. 10 (Feb. 9, 1919)

Punin, Nicolai, 'V Moskve (Pis'mo)', *Iskusstvo kommuny*, no. 10 (Feb. 9, 1919), p. 2

Shklovsky, Victor, 'Space in Painting and Suprematism', *Iskusstvo*, no. 8 (Sept. 3, 1919)

**1920**

Efros, A., 'K. Malevich (Retrospektivnaya vystavka)', *Khudozhestvennaya zhizn*, no. 3 (1920), pp. 39–40

Sidorov, A., 'Review of the Tenth National State Exhibition', *Tvorchestvo* (Prague), nos. 2–4 (1920), p. 34

– 'Review of From Cézanne to Suprematism', *Tvorchestvo* (Moscow), nos. 7–10 (1920), p. 54

Umanskij, K., 'Kandinskijs Rolle im Russischen Kunstleben', *Der Ararat* (2. Sonderheft), Munich, 1920, p. 29

**1921**

Einstein, Carl, 'Absolute Kunst und absolute Politik: Aus der Eineleitung für den russischen Maler' (1921); reprinted in the exhibition catalogue, *Malewitsch-Mondrian: Konstruktion als Konzept*, Kunstverein Hannover, 1977, pp. 24–27

Kunin, M., 'Ob Unoviso', *Iskusstvo* (Vitebsk), nos. 2–3 (1921), pp. 15–16

Romm, A., 'Vystavka v Vitebske 1921 g.', *Iskusstvo*, nos. 4–6 (1921), pp. 41–42

**1922**

Romm, A., 'Beeldend Rusland', *de Stijl* (The Hague) (Sept. 1922), columns 12, 133, 134 (ill.)

– 'Beeldend Rusland', *de Stijl* (The Hague), Sept. 1922, columns 12, 133, 134 (ill.)

Editorial, in *Zhizn' iskusstva* (April 6, 1922), p. 20

– in *Zhizn' iskusstva* (June 20, 1922), p. 4

– in *Zhizn' iskusstva* (July 11, 1922)

– in *Zhizn' iskusstva* (Nov. 5, 1922), p. 8

Lozowick, L., 'A Note on New Russian Poetry', *Broom* (Rome/London/New York), I, no. 4 (Feb. 1922), p. 310

Shterenberg, D., 'Die künstlerische Situation in Russland', *Das Kunstblatt* (Potsdam), no. 11 (Nov. 1922), p. 487

Westheim, Paul, 'Die Ausstellung der Russen', *Das Kunstblatt* (Potsdam), no. 11 (Nov. 1922), pp. 494, 497

**1923**

Bakushinsky, A., 'Lineinayaperspektiva v iskusstve i zritelnom vospriyatii realnogo prostranstva', *Iskusstvo* (Moscow) (1923), p. 214

– in *Zhizn' iskusstva*, (Feb. 27, 1923) p. 19

Lissitsky, El, 'Die plastische Gestaltung der elektromagnetischen Schau Sieg *über die Sonne*. Lithographs with preface, Kunstmuseum, Hannover, 1923 (preface reprinted in *Maler, Architekt, Typograf, Fotograf. Erinnerungen Briefe, Schriften*. Übergeben von Sophie Lissitsky-Küppers, Dresden, 1967; English trans. Greenwich, 1968

Punin, Nikolai, 'Komu oni meshayut?', *Zhizn' iskusstva*, no. 19 (1923), pp. 15–16

– 'Gosudarstvennaya vystavka (prodolzhenie)', *Zhizn' iskusstva*, no. 22 (1923), pp. 5–6

– 'Obzor novykh techenii v iskusstve Peterburga', *Russkoye iskusstvo* (Moscow and Prague), no. 1 (1923), pp. 17–23

Radlov, N., 'Novoye iskusstvo i ego teorii', *Dom iskusstv* (Prague), no. 1 (1921), pp. 47–49; reprinted in N. Radlow, *O Futurizme*, Prague, 1923

– 'Vers les sources de l'art', *K. S. Malévitch, Écrits II. Le Miroir Suprématiste*, Lausanne, 1977, pp. 181–84; French translation of an article which originally appeared in *Zhizn' Iskusstva* [The Life of Art], no. 1 (1923)

Tugenkhol'd, Y., 'Russkaya khudozhestvennaya vystayka a Berline', *Russkoe iskusstvo*, no. 1 (1923)

**1924**

Tugenkhol'd, Y.,'Khudozhniki ob AKHRR', *Zhizn'iskusstva*, no. 6 (Feb. 2, 1924), p. 24

Kallai, Ernst, 'Konstruktivismus', *Jahrbuch der Jungen Kunst* (Leipzig) (1924), pp. 375, 377–78 (ill.)

Kemeny, Alfred, 'Die abstrakte Gestaltung vom Suprematismus', *Das Kunstblatt*, VIII (1924), pp. 245–48 (ill.)

Lissitsky, El and Schwitters, Kurt, 'Merz 8–9', *Nasci* (April–July, 1924), p. 74 (ill.)

**1925**

Arp, Hans and Lissitsky, El, *The Isms of Art*, Zurich, 1925, pp. 22–23

Lissitsky, El, 'A. and Pangeometry', *Europa-Almanach*, ed. Carl Einstein and Paul Westheim, Hannover, 1925, pp. 103–13

Ioffe, I., *Krizis Sovremennogo Iskusstva*, Leningrad, 1925, pp. 31–43

**1926**

Anonymous, 'Bazar', *de Stijl* (Leiden), nos. 75–76 (1926), columns 157–58 (ill.). Four reproductions are wrongly ascribed to Malevich

Anonymous, 'Editorial', *Sovetskoye iskusstvo*, no. 5 (1926), p. 25 (ill.)

Tschichold, Iwan, 'Die Neue Gestaltung', *Tyographische Mitteilungen* (October 1925); reprinted in *ABC: Beiträge zum Bauen* (Basel), series 2, no. 2 (1926) (ill.)

**1927**

Gan, Aleksey, 'Spravka o Kazimire Maleviche', *SA*, no. 3 (1927), pp. 104–106 (ill.). Reprinted in *Nova Generatsiya*, no. 2 (1928), pp. 124–27 (Khar'kov)

Kallai, Ernst, 'K. Malewitsch', *Das Kunstblatt* (Potsdam), XI (1927), pp. 264–66 (ill.)

Kamenskii, Vasilii, 'Kak ia zhil i zhivu,' Tiflis, 1927

Lunacharsky, A, 'Russian Artists in Berlin' (extract), *Bgorek*, no. 30 (1927)

Syrcus, H., 'L'architecture ouvrant le volume', *i10* (Amsterdam), no. 1–5 (1927), pp. 164, 165 (ill.)

**1928**

Stazewslo. Jemrul, [without title], *Nova Generatsiya*, no. 10 (1928)

**1929**

Fedorov-Davydov, A., 'The Art of K. S. Malevich', *Exhibiting Works by K. S. Malevich*, State Tretyakov Gallery, Moscow, 1929

**1930**

Lissitsky, El, *Russland: Neues Bauen in der Welt*, vol. I, Vienna, 1930, pp. 10–11

Lobanow, W., *Khudozhestvennye gruppirovki sa poslednye 25 let*, Moscow, 1930, pp. 59–90

**1931**

Kamenskii, Vasilii, 'Put' entuziasta', Moscow, 1931

Sidorov, A., 'Vospominaniya', *Stroyka* (Leningrad), no. 11, 1931

Solovyov, V., 'Vospominaniya', *Stroyka* (Leningrad), no. 11, 1931

**1933**

Bush, M. and Zamoshkin, A., 'Put' sovetskoy zhivopisi 1917–1932', *Iskusstvo*, nos. 1, 2 (1933), pp. 64, 69

Efros, A., 'Vchera, segodnya, zavtra', *Iskusstvo*, no. 6 (1933), p. 41

Grabar, Igor, 'Fünfzehn Jahre Sowjetkunst: Die Jubiläumsausstellungen', *Leningrad und Moskau in Osteuropa*, no. 9 (1933–34), pp. 3–4, 166, 167

Ioffe, I., *Sintetitcheskaya istoriya iskusstv*, Leningrad, 1933, pp. 432–38

**1934**

Sobolevsky, N., 'Put' sovetskogo farfora', *Iskusstvo* (Moscow/Leningrad), no. 5 (1934), pp. 166–67

**1935**

Sobolevsky, N., 'Obituary', *Slavische Rundschau*, no. 7 (1935), p. 281

**1937**

Wescher, Herta, 'Hommage à Malévitch', *Plastique* (Paris/New York), no. 1 (1937), pp. 3–10 (ill.)

**1939**

Khardzhiyev, N., 'Iz materialov o Mayakovskom', *30 Dnei* (Moscow), no. 7 (1939), pp. 83–84

**1940**

Kamenskii, Vasilii, 'Zhizn' s Matykovskim', Moscow, 1940

**1950**

Seuphor, Michel, 'Suprématisme et Neoplasticisme', *Art d'Aujourd'hui* (Paris), nos. 7–8 (1950), pp. 22–24

**1953**

Alvard, Julien, 'Les idées de Malévitch', *Art d'Aujourd'hui*, no. 3 (1953), pp. 16–21 (ill.)

**1955**

Chamot, Mary, 'The Early Work of Goncharova and Larionov', *The Burlington Magazine*, XCVII (1955), pp. 170–74

Habasque, Guy, 'Documents inédits sur les débuts du suprématisme', *Art d'Aujourd'hui*, IV (September 4, 1955), pp. 14–16

Seuphor, Michel, 'Au temps de l'avant-garde', *L'oeil*, no. 11 (1955), pp. 30–34, 36, 37, 38 (ill.)

**1957**

Aschenbrenner, Margo, 'Farben und Formen im Werk von Kasimir Malewitsch 1878–1935', *Quadrum IV* (Brussels) (1957), pp. 99–110 (ill.)

– 'Kasimir Malewitsch (1987–1935)', *Die Kunst und das schöne Heim*, no. 7 (1957), pp. 254–57 (ill.)

Pevsner, Antoine: 'Recontre avec Malévitch dans la Russie d'après 1917', *Art d'Aujourd'hui*, no. 15 (1957), pp. 4–5

**1958**

Penkula, Eduard, 'Malewitsch Oeuvre geborgen', *Das Kunstwerk*, XI, no. 10 (April 1958), pp. 3–16

Riesen, Hans von, 'Berichtigungen und Ergänzungen', *Das Kunstwerk*, no. 10 (1958), p. 42

**1959**

Bucarelli, Palma, *Casimir Malevic*, exhibition catalogue, Galleria Nazionale d'Arte Moderna, Rome, 5 May–2 June, 1959

Gray, Camilla, 'Introduction', exhibition catalogue, Whitechapel Gallery, London, Oct.–Nov., 1959

Meyer, Franz, *Kasimir Malewitsch*, exhibition catalogue, Kunsthalle Bern, Feb.–March 1959

Steneberg, E., 'Die Ungeduldigen: Zum Verständnis der *Ecole Russe*', *Das Kunstwerk* (August 1959), pp. 20, 24

**1960**

Gray, Camilla, 'The Russian Contribution to Modern Painting', *The Burlington Magazine*, CII (1960), pp. 207, 209–10 (ill.)

Habasque, Guy, 'Malévitch', *L'oeil*, LXXI (1960), pp. 40–47, 88–90 (ill.)

Vallier, Dora, 'L'art abstrait en Russie; ses origines, ses premiers manifestations: 1910–1917', *Cahiers d'Art*, nos. 33–35 (1960), pp. 272–85 (ill.)

**1961**

Andersen, Troels, 'Malevitj-rysk revolutionskonstnar', *Dagens Nyheter* (Nov. 14, 1961) (ill.)

Gasser, Helmi, 'Kasimir Malewitsch', *Werk*, no. 4 (1961), pp. 140–45 (ill.)

Sandberg, W., 'The Turning Point, 1917–1907: Abstract Art', *Pioneers of Modern Art*, New York, 1961

**1962**

Riesen, Hans von, 'Introduction', *Kasimir Malewitsch: Suprematismus – Die gegenstandslose Welt*, ed. Werner Haftmann, Cologne, 1962, pp. 31–35

**1963**

Eisenstein, S., 'Zametki o V. V. Mayakovskom', *Iskusstvo Kino*, no. 1 (1958). Reprinted in *V. Mayakovsky v vospominaniyakh sovremennikov*, Moscow, 1963, p. 279

– 'Notes about V. V. Mayakovsky', *Mayakovsky: The Recollections of his Contemporaries*, Moscow, 1963, pp. 279–80

Grohmann, Will, 'Review of *Malewitsch: Die gegenstandslose Welt*', *Neue Deutsche Hefte*, no. 95 (1963), pp. 114–17

**1964**

Abramsky, I, 'Eto bylo v Vitebske', *Iskusstvo*, no. 10 (1964), pp. 69–71. Falsified memoirs of so-called pupils of Malevich

**1965**

Andersen, Troels, 'Introduction', exhibition catalogue, *Inner and Outer Space*, Moderna Museet, Stockholm, 1965–66

Baljieu, Joost, 'Den hegelianske romantiske negationen i den moderna bildkonsten', exhibition catalogue, *Inner and Outer Space*, Moderna Museet, Stockholm, 1965–66
– 'Der neue Raum in der Malerei El Lissitskys', exhibition catalogue, *El Lissitsky*, Eindhoven/Basel/Hannover, 1965–66, pp. 17–18
– 'The problem of reality: Suprematism, Constructivism, Proun, Neoplasticism, and Elementarism', *The Lugano Review*, no. 1 (1965), pp. 105–33 (ill.)
Khardzhiyev, N., [Letter to the editor], *Paragone*, no. 183 (1965), pp. 71–78
Seuphor, Michel, *Le style et le cri: Quatorze essais sur l'art de ce siècle*, Paris, 1965, pp. 36–44, 54–58
1966
Moholy-Nagy, Sibyl, 'Constructivism from Kasimir Malevich to Laslo Moholy-Nagy', *Arts and Architecture* (June 1966), pp. 24–27; also published in *Paletten*, no. 2 (1967), pp. 24–29
Raffa, Piero, 'La rivoluzione costruttiva e la poetica teatrale de Majakovskij – Meyerhold', exhibition catalogue, *La Biennale di Venezia*, no. 59 (1966), pp. 46–47
1967
Bojko, Szymon, 'Malevich-Stage Designer', *Projekt*, no. 61 (1967), pp. 20–23
Calvesi, Maurizio, 'Il futurismo russo', *Arte Moderna*, XLIV (1967), pp. 281–316
Harmsen, Ger, 'Nederlandse en russische kunstenaars tijdens de revolutiejaren' [contains a letter by Kasimir Malevich], *De nieuwe Stem*, no. 6 (1967), pp. 309–21
Kovtun, E., 'Malevicova myslenka plastick e beztize', *Vytvanne prace* (Prague), no. 2 (1967)
Lamac, Miroslav, 'Der unbekannte Malewitsch: Beobachtungen zu seinem Werk von 1920 bis 1935', *Neue Züricher Zeitung* (July 2, 1967) (ill.)
– 'Gegenstände sind ausgekühlte Gedanken: Ein Beitrag zur Geschichte des Suprematismus', *Disks* (Frankfurt), no. 5 (July 1967) (ill.)
– 'Interview', *Bonner Generalanzeiger*, June 1, 1967 (ill.)
– 'Malevic a jeho okruh', *Vytvarne Umeni*, nos. 8–9 (1967), pp. 365–67, 372–83, 392–93
Lippard, Lucy L., 'The Silent Art', *Art in America* (Jan.–Feb. 1967), pp. 58–59 (ill.)
Molok, Yu, 'Nachalo moskovskoi knigi', *Iskusstvo knigi* (1967; 7th installment, 1971)
Padrta, Jiri, 'Suprematismus a dnesek', *Vytvarne Umeni* (Prague), nos. 8–9 (1967), pp. 446–50 (ill.)
Veronesi, Giulia, 'Suprematisti e construttivisti in Russia', *L'arte moderna* (Milan), no. 48, VI (1967)
1968
Alloway, Lawrence: 'Systemic Painting', *Minimal Art: A Critical Anthology*, ed.

Gregory Battcock, New York, 1968, pp. 37–60
– 'Malevich on "New Art",' *Malevich: Essays on Art*, vol. 1, Copenhagen, 1968, pp. 9–16
Cepan, Oskar, 'Malevicov Suprematizmus', in *Kazimir S. Malevic O nepredmetnom svete, State 1915–1922*, Bratislava, Tatran, 1968, pp. 179–203
Lamac, Miroslav, 'Malévitch le Méconnu' [Malevich The Misunderstood], *Climaise*, nos. 85–86 (Feb./Mar./April, 1968), pp. 38–45
Lufft, Peter, 'Kasimir Malewitsch inszeniert *Sieg über die Sonne*, Petersburg 1913', in Henning Rieschbieter, *Bühne und Bildende Kunst im XX. Jahrhundert*, Velber bei Hannover, 1968, p. 137
Rose, Barbara, 'ABC Art', *Minimal Art: A Critical Anthology*, ed. Gregory Battcock, New York, 1968, pp. 274–97
1969
Jensen, Kjeld Bornager, 'Marinetti in Russia 1910, 1912, 1914?', *Scando-Slavica*, XV (1969), pp. 21–26
Nakov, Andreii, 'Destination l'infini: la théorie du suprématisme', *XX Siècle* (Paris), no. 33 (December 1969), pp. 171–72
Padtra, Jiri, 'Russischer Konstruktivismus', exhibition catalogue, *Konstrukive Kunst: Elemente und Prinzipien*, Biennale Nuremberg, 1969
Sharp, Willoughby, 'Luminism and Kineticism', *Minimal Art: A Critical Anthology*, ed. Gregory Battcock, New York, 1968, pp. 317–58
1970
Andersen, Troels, 'The History of the Berlin exhibition', *Malevich: Catalogue Raisonné of the Berlin Exhibition of 1927, including the Collection of the Stedelijk Museum, Amsterdam*, exhibition catalogue, Amsterdam, 1970, pp. 57–58
Elderfield, John, 'Constructivism and the Objective World', *Studio International*, no. 180 (Sept. 1970), pp. 73–81
Gammelbo, Paul, 'Kunstinformation', *Information* (Sweden) (June 15, 1970)
Goncharova, Natalia, 'Introduction to the Exhibition Catalogue', reprinted in *Mastera iskusstva ob iskusstve* (Moscow), VII (1970), p. 489
Hahn, Otto, 'Malévitch', *L'Express*, (Dec. 7–13, 1970)
Kovtun, E., 'Litografowane Ksiazki Rosykich Futuristow', *Projekt* (Warsaw), no. 79 (Nov.–Dec. 1970), pp. 40–46
Leveque, Jean-Jacques: 'Le Point de non-retour', *Le Nouveau Journal* (November 21, 1970)
– 'Malevitch: La quête de l'absolu', *La Galerie*, no. 99 (December 1970), p. 6
Marcadé, Jean-Claude and Marcadé, Valentine, 'Préface', exhibition catalogue, *Malevitch: Dessins*, Galerie Jean Chauvelin, Paris, 1970

Moulin, Raoul-Jean, 'Dessins de Malévitch', *Lettres Française* (December 9, 1970)
Pluchart, Françoise, 'Le Malevitch du siècle', *Combat* (November 23, 1970)
Rakitin, V., 'Unovis', *Architectural Design*, no. 2 (1970), pp. 78–79
– 'Ot zhivopisi k arkhitekture', Moscow, 1970, pp. 184–85
Roche, Denis-Pierre, 'Les dessins de Malévitch', *Le Provençal* (December 1970)
Zhazanova, V., 'Sovetskaya arkhitektura pervykh let Oktyabrya', *History of Soviet Architecture*, Moscow, 1970, pp. 126–30
1971
Bouillon, Jean-Paul, 'Le cubisme et l'avant-garde russe', *Le Cubisme: Actes du premier colloque d'Histoire de l'Art. Contemporain tenu au Musée d'Art et d'Industrie, Saint-Etienne, les 19, 20, 21, novembre 1971*, Saint-Etienne, 1971
Lamac, Miroslav, 'L'avanguardia dell' est Europeo', exhibition catalogue, *Kasimir Malevic*, Galeria Breton, Milan, 1971, pp. 13–14
– 'Kazimir Malewitsch', in *Kunstler-Theorie-Werk: Zur Zweiten Biennale*, Nuremberg, 1971
Welsh, M., 'The Spiritual Modernisme of Malevich', *Arts Magazine*, XLVI (November 1971), pp. 45–48
1972
Pugh, Simon, 'Suprematism: an unpublished manuscript by Malevich', *Studio International*, vol. 183, no. 942, (March 1972), pp. 100–105
– 'Towards a Minimal Art: Part II', *Studio International*, vol. 183, no. 942 (March 1972), pp. 102–105
Traeger, Jörg, 'Duchamp, Malewitsch und die Tradition des Bildes', *Zeitschrift für Aesthetik und Allgemeine Kunstwissenschaft*, XVII (1972), pp. 131–38
1973
Birnholz, Alan, 'Notes on the Chronology of El Lissitsky's Proun Compositions', *The Art Bulletin* (Sept. 1973), pp. 437–39
Birnholz, Alan, 'Review of Troels Andersen, *Malevich* (Amsterdam, 1970) and *Moderne Ruusisk Kunst 1910–1930*', *The Art Quarterly*, XXXVI, nos. 1–2 (1973), pp. 109–11
Bowlt, John E., 'Nikolai Ryabushinky: Playboy of the Eastern World', *Apollo*, no. 98 (December 1973), pp. 486–93
Bowlt, John E., 'Russian Symbolism and the "Blue Rose" Movement', *The Slavonic and East European Review*, LI (April 1973), pp. 161–81
Bowlt, John E., 'The Semaphor of Suprematism: Malevich's Journey into the Non-Objective World', *Art News*, X (Dec. 1973), pp. 16–22
Chalupecky, Jindrich, 'Moscow Diary', *Studio International*, CLXXXV (Feb. 1973), pp. 81–96
Davis, Ivor, 'Primitivism in the First Wave of the Twentieth Century Avant-Garde in

Russia', *Studio International*, no. 186 (September 1973), pp. 80–84

Devade, Marc, 'Dates, Repères, Références et Commentairs', *Peinture, Cahiers Theoriques*, no. 6–7 (April 1973), pp. 76–100

Douglas, Charlotte, 'Colors Without Objects: Russian Color Theories 1908–1932', *The Structuralist*, no. 13–14 (1973–74), pp. 30–41

Nakov, Andreii, 'Suprématisme', *Encyclopedia Universalis*, XV (1973), pp. 561–63

Richter, Hans, *Begegnungen von Dada bis Heute*, Cologne, 1973, pp. 43–49

Staber, Margit, 'Methods, Meanings and Reactions', exhibition catalogue, *The Non-Objective World, 1914–1924*, Annely Juda Fine Art, London, 1973, pp. 3–5

Zhadova, Larissa, 'Teatr Maiakovskogo', *Dekorativnoe iskusstvo SSSR*, VI, no. 187 (1973), pp. 39–43

**1974**

Zhadova, Larissa, 'Voraussetzungen des Suprematismus in der russischen Kunsttheorie' and 'Zu den Tafeln von Malewitsch: Analyse einer Kunstauffassung', *Kunst – Über Kunstwerke und Theorien: Eine Austellung in drei Teilen*, exhibition catalogue, Cologne, 1974

– 'Introduction to Malevich's letters', exhibition catalogue, *From Surface to Space, Russia 1916–1924*, Galerie Gmurzynska, Cologne, 1974, p. 53

Bowlt, John E., 'From Cézanne to Suprematism', *Art in America*, LXII (Nov.–Dec. 1974), p. 49

Bowlt, John E., 'The Construction of Space', exhibition catalogue, *From Surface to Space, Russia 1916–1924*, Galerie Gmurzynska, Cologne, 1974, p. 4–15

Bowlt, John E., 'Neo-primitivism and Russian Painting', *The Burlington Magazine*, CXVI (March 1974), pp. 133–40

Bouyeure, Claude, 'L'imagination de Malévitch sur la révolution due XXe siecle', *Connaissance des arts*, CCLXIX (July 1974), p. 95

Cachin, Françoise, 'Futurism in Paris 1909–1913', *Art in America*, LXII (March–April 1974), pp. 39–44

Catoir, Barbara, 'Kunst-Über Kunst', *Das Kunstwerk*, XXVII, no. 4 (July 1974), pp. 42–43

Compton, Susan P., 'Malevich and the Fourth Dimension', *Studio International*, CLXXXVII (April 1974), pp. 190–94

Coplans, John, 'Mel Bochner on Malevich: An Interview', *Artforum*, XII (June 1974), pp. 59–63

Derfner, Phyllis, 'The Malevich collection of the Stedelijk Museum in Amsterdam', *Art International*, XVIII (January 1974), p. 18

Douglas, Charlotte, 'Birth of a "Royal Infant": Malevich and "Victory over the Sun"', *Art in America*, LXII (March–April 1974) pp. 45–51

Friedrichs, Yvonne, 'Unerschwinglicher Malewitsch', *Das Kunstwerk*, XXVII, no. 4 (July 1974), p. 29

Judd, Donald, 'Malevich: Independent Form, Color, Surface', *Art in America*, LXII (March – April 1974), pp. 52–58

Kovtun, Evgenii, 'The Beginning of Suprematism', exhibition catalogue, *From Surface to Space: Russia 1916–1924* (German/English), Galerie Gmurzynska, Cologne, 1974, pp. 32–47

Kozloff, Max, 'Malevich as a Counter-revolutionary (East and West)', *Artforum*, XII (January 1974), pp. 30–39

Kuspit, Donald, 'Malevich's Quest for Unconditioned Creativity, part I', *Artforum*, XII (June 1974), pp. 53–58

Lamac, Miroslav, 'The Beginning of Suprematism', exhibition catalogue, *From Surface to Space: Russia 1916–1924*, Galerie Gmurzynska, Cologne, 1974, pp. 50–54

Marcadé, Jean-Claude, 'Préface: Une Ésthetique de l'Abime', *Écrits I, De Cézanne au Suprématisme: Tous les Traites parus de 1915 à 1922*, ed. and trans. Jean-Claude and Valentine Marcadé, Lausanne, 1974, pp. 9–32

– 'Présentation', *Malévitch: Suprematisme 34 Dessins*, Paris, 1974

Nakov, Andreii, 'The Iconoclast Fury', *Studio International*, vol. 187, no. 967 (June 1974), pp. 281–88

– 'The show must go on: Some remarks on the Malevich exhibition of the Guggenheim Museum', *Studio International*, vol. 187, no. 963 (February 1974), pp. 86–87

– 'Présentation', *Tatlin's Dream: Russian and Constructivist Art 1910–23*, Fischer Fine Art, London, 1974

Rakitin, V., 'Od maliarstvi K architekture', *Architektanica Kompozice* (Prague) (1974), pp. 26–31

Vallier, Dora, 'Aux sources de l'art abstrait', *La Quinzaine Littéraire* (September 16–30, 1974), p. 18

Young, M. S., 'Malevich and the happy Futurists', *Apollo* (London), XCIX, no. 147 (May 1974), p. 374

Zhadova, Larissa, 'Tsvetovaia sistema M. Matiushina', *Iskusstvo*, VIII (1974), pp. 33–42

**1975**

Andreeva, L., *Sovetsky Farfor 1920–1930 Gody* [Soviet Porcelain of the 1920s and 1930s], Moscow, 1975, pp. 116–26

Bablet, Denis, 'Les Revolutions scéniques ou XXe siècle', *Société Internationale d'art du XXe siècle*, Paris, 1975, pp. 92, 107–109, 175

Beret, Chantal, 'Suprématisme', *Art Press*, no. 15 (Dec.–Jan. 1975), pp. 9–10

Berlewi, Henri: 'Reflexions sur Malévitch', *Malévitch Écrits*, Paris, 1975, pp. 133–35

Betz, Margaret, 'Time and Space in the Art and Thought of El Lissitzky', *The Structuralist*, no. 15–16 (1975–1976), pp. 89–96

Bowlt, John E., 'From Surface to Space: The Art of Liubov Popova', *The Structuralist*, no. 15–16 (1975–76), pp. 80–88

– 'Western European Art Forms Influenced by Nietzsche and Bergson before 1914. Particularly Italian Futurism and French Orphism', *Art International*, XIX (March 20, 1975), pp. 170–74

Douglas, Charlotte, 'Suprematism, The Sensible Dimension', *The Russian Review*, XXXIV (July 1975), pp. 266–81

– 'The New Russian Art and Italian Futurism', *Art Journal* XXXIV (Spring 1975), pp. 229–39

– 'Views for the New World. A. Kruchenykh and K. Malevich: Theory and Painting', *Russian Literature Triquarterly*, XII (Spring 1975), pp. 352–70

Franzke, Irmela, 'Zum Dekorationsstil russischer Porzellane im ersten Jahrzehnt nach der Oktober-Revolution', *Jahrbuch des Staatlichen Kunstsammlungen in Baden-Württemberg*, XII, Karlsruhe, 1975, pp. 195–204

Golding, John, 'The Black Square', *Studio International*, vol. 189, no. 974 (March–April 1975), pp. 86–106

Henderson, Linda, 'The Merging of Time and Space: *The Fourth Dimension* in Russia, Ouspensky to Malevich', *The Structuralist*, no. 15–16 (1975–1976), pp. 97–108

Jakobson, Roman, 'De la Poésie à la Linguistique', *L'Arc*, no. 60 (1975), pp. 18–19

Lamac, Miroslav, 'Kasimir Malévitch', exhibition catalogue, *Kasimir Malévitch: Dessins*, Musée Royeax des Beaux-Arts de Belgique, Brussels, 1975, pp. 7–9

Nakov, Andreii, 'Malévitch: Écrits', *Chroniques de l'art vivant*, no. 57 (May–June 1975), pp. 27–29

– 'Malévitch: Écrits: 2 Manifestes', *Chroniques de l'art vivante*', no. 57 (May–June 1975), pp. 86–87

– 'Prologue: Le nouveau Läocoon' [pp. 9–26]; 'La fureur iconoclaste' [pp. 29–73]; 'Le Carré Noir: affirmation de la surface-plan au niveau du concept instrumental [pp. 75–113]; 'L'impossible voyage parisien [pp. 115–31]', in *Malévitch: Écrits*, trans. Andrée Robel-Chicurel, Paris, 1975

– 'Russian Art Again', *Studio International*, vol. 189, no. 975 (May–June 1975), pp. 231–33

Robert-Jones, P., 'Préface', exhibition catalogue, *Kasimir Malévitch: Dessins*, Musée Royeaux de Beaux-Arts de Belgique, Brussels, 1975, p. 3

Rosen, Nathan, 'The Magic Cards and the Queen of Spades', *Soviet and East European Journal*, XIX (Fall, 1975), pp. 255–75

Sandberg, W., 'Preface', in Karshan, Donald, *Malevich: The Graphic Work: 1913–1930. A Print Catalogue Raisonné*, The Israel Museum, Jerusalem, 1975

Simonov, K., 'In View of Services to Soviet Figurative Art', *Nauka i Zizn* [Scientific Life], no. 12 (1975), pp. 126–27

Strzeminski, Wladyslaw 'Editorial', in *Pisma* (Warsaw), Zaklas Narodowy Imiena Osso-

linskich Wydwnictwo Polskiej Akademii Nauk (1975), pp. 7–9 et passim

Vallier, Dora, 'Dans le vif de l'avant-garde', *L'Arc*, no. 60 (1975), pp. 9–12

– 'Malévitch et le modèle linguistique en peinture', *Critique* no. 334 (March 1975), pp. 284–96

Zadrodzki, Janusz, 'Malewicz w Polsce' [Malevich in Poland], *Project*, no. 3 (1975), pp. 38–43

Zhadova, Larissa, 'Iz istorii sovetskoi polikhromii', *Tekhnicheskaia estetika* (Moscow), no. 7 (1975), pp. 3–5

**1976**

Andersen, Troels, 'Preface', in *K. S. Malevich: The World as Non-Objectivity. Unpublished Writings 1922–1925*, Copenhagen, 1976

Bois, Yve-Alain, 'Malévitch, le carré, le degré zero', *Macula*, no. 1 (1976), pp. 35–36

Bowlt, John E., 'Malevich's Artistic and Political Testament', *Art News*, LXXV, (May 1976), pp. 20–26

Chasnik, Ilja, 'Programmentwurf fur die Schule, UNOWIS', *Ilja G. Tschaschnik*, Dusseldorf, 1978, pp. 39–41

Cohen, Arthur A., 'Futurism and Constructivism: Russian and Other', *The Print Collector's Newsletter*, VII (March–April 1976), pp. 1–3

– 'Malevich's Suprematism – The Higher Intuition', *The Burlington Magazine*, no. 118 (August 1976), pp. 576–84

Dauriac, J. P., 'L'oeuvre gravé 1913–1930: Musée d'art moderne de la ville de Paris', *Pantheon*, XXXIV, no. 3 (July/Aug./Sept. 1976), p. 255

– 'Message sur Malévitch', *Change*, no. 26–27 (Feb. 1976), pp. 293–94

Herzogenrath, Wulf, 'Die holländische und russische Avantgarde in Deutschland', exhibition catalogue, *Malewitsch-Mondrian und ihre Kreise aus der Sammlung Wilhelm Hack*, 1976, pp. 40–50

Joosten, Joop, 'Drawings, Graphics and Documents of K. S. Malevich', exhibition catalogue, Stedelijk Museum, Amsterdam (February, 1976)

Khardzhiyev, N., 'Presentation of the Autobiography of Malevich', *The Russian Avant-Garde*, Stockholm, 1976 [in Russian], pp. 87–102

Kovtun, E., 'K. S. Malevic. Pis'ma k M. V. Matjusinu' [letters of Malevich to Matiushin], *Ezhegodnik Rukopis'nogo Otdela Puskinskogo Doma*, 1974 [annual publication of the manuscript/archive department of the Pushkin House], Leningrad, 1976, pp. 177–95

Lamac, Miroslav, 'Kasimir Malewitsch', exhibition catalogue, *Malewitsch-Mondrian und ihre Kreise aus der Sammlung Wilhelm Hack*, 1976, pp. 12–13

Marcadé, Jean-Claude, 'La *Victoire sur le Soleil* ou le Merveilleux futuriste comme nouvelle sensibilité', in M. Matiouchine, A. Kroutchonykh, V. Khlebnikov, K. Mal-

évitch, *La Victoire sur le Soleil*, Lausanne, 1976, pp. 65–97

Nakov, Andreii, 'Malevich as Printmaker', *The Print Collector's Newsletter*, no. 7 (March–April 1976), pp. 4–10

– 'Russian Precursors: Sources of Non-Objective Art', Annely Juda Fine Art, London, 1976

– 'Preface', exhibition catalogue, *Russian Suprematist and Constructivist Art, 1910–1930*, Fischer Fine Art, London, 1976

– 'Malevich's Transrational Trip to the *Tenth Land*', exhibition catalogue, *Kasimir Malevich*, The Tate Gallery, London, 1976

Rudenstine, Angelika, 'Morning in the Village after Snowstorm', *The Guggenheim Museum Collection: Paintings 1880–1945*, New York, 1976, vol. II, pp. 480–83

Simmons, W. Sherwin, 'Kasimir Malevich's *Black Square*. The Transformed Self. Part One: Cubism and the Illusionistic Portrait', *Arts Magazine*, LIII (Oct. 1976), pp. 116–25

Zagrodski, J., 'Malewitch reis naar Polem in 1927', *Museumjournaal* (Amsterdam), XXI, no. 1 (1976), pp. 7–11

**1977**

Benois, Alexandre, 'La dernière exposition futuriste', in *K. S. Malévitch, Écrits II*, Lausanne, 1977, pp. 156–57

Betz, Margaret, 'The Icon and Russian Modernism', *Artforum*, XV (Summer 1977), pp. 38–45

Birnholz, Alan, 'Forms, Angles, and Corners: On Meaning in Russian Avant-Garde Art', *Arts Magazine*, LI (Feb. 1977), pp. 101–109

Birnholz, Alan, 'On the Meaning of Kazimir Malevich's "White on White"', *Art International*, XXI (Jan. 1977), pp. 9–16, 55

Bois, Yve-Alain, 'Lissitsky, Malévitch et la question de l'éspace' [with English translation], exhibition catalogue, *Suprématisme*, Galerie Jean Chauvelin, Paris, 1977, pp. 29–46

Bouisset, Maiten, 'L'avant-garde russe à l'heure de la révolution', *Le Matin* (November 17, 1977), p. 26

Bowlt, John E, 'Russian Moderns', *Art in America*, CXV (Jan.–Feb. 1977), pp. 73–74

– 'Une conscience éclatée' [with English translation], exhibition catalogue, *Suprématisme*, Galerie Jean Chauvelin, Paris, 1977, pp. 70–81

Breerette, Geneviève, 'Le Suprématisme à la Galerie Jean Chauvelin, Histoire de carrés', *Le Monde* (November 24, 1977)

Deligeorges, Stephanie, 'Suprématisme', *Semainier*, no. 8, XII (1977)

Draeger, Wallace, review of *Suprématisme* (Paris, 1977), *The Structuralist* (Saskatoon, Saskatchewan), no. 17–18 (1977–78), pp. 118–24

Fischer, Friedrich W., 'Geheimlehre und moderne Kunst', *Fin de siècle: Zur Literatur und Kunst der Jahrhundertwende*, Frankfurt, 1977, passim

Giroud, Michel, 'Malévitch et le Suprémat-

isme', *Art Press*, no. 13, (Dec. 1977), p. 16

Grabar, Igor, 'A propos de quelque chose d'ennuyeux (La conférence des futuristes)', *K. S. Malévitch, Le Miroir Suprématiste: Écrits II*, Lausanne, 1977, p. 158

Hahn, Otto, 'Les Suprématistes à Paris', *L'Express* (Nov. 7, 1977)

Issakov, S., 'L'Église et l'artiste', *K. S. Malévitch, Le Miroir Suprématiste: Écrits II*, Lausanne, 1977, pp. 184–87

Karshan, Donald, 'L'art graphique de Kasimir Malévitch: Information et Observations nouvelles' [with English translation], exhibition catalogue, *Suprématisme*, Galerie Jean Chauvelin, Paris, 1977, pp. 48–68

– 'Innen/Außen – Das Verhältnis von Raum und Betrachter in den Bildern von Mondrian und Malewitsch', exhibition catalogue, *Malewitsch-Mondrian: Konstruktion als Konzept*, Kunstverein Hannover, 1977, pp. xiv–xv

Klium, Ivan, 'L'art de la couleur', *K. S. Malévitch, Le Miroir Suprématiste: Écrits II*, Lausanne, 1977, pp. 163–64

Kovtun, E., 'Le Suprématisme comme irruption de l'espace du monde' [with English translation], exhibition catalogue, *Suprématisme*, Galerie Jean Chauvelin, Paris, 1977, pp. 23–27 (excerpt of the preface by the same author for the publication of the letters of Malevich to Matiushin, 1976)

– 'A propos de l'OUNOVIS', *K. S. Malévitch, Le Miroir Suprématiste: Écrits II*, Lausanne, 1977, pp. 180–81

Lamac, Miroslav, 'Die weiBe Flamme der Erregung und das rote Quadrat der Revolution', exhibition catalogue, *Malewitsch-Mondrian: Konstruktion als Konzept*, Kunstverein Hannover, 1977, pp. 30–38

Lamac, Miroslav and Padrta, Jiri, 'Malévitch et le Suprématisme' [with English translation], exhibition catalogue, *Suprématisme*, Galerie Jean Chauvelin, Paris, 1977, pp. 7–21

Larionov, Michel, 'Malévitch: Souvenirs', exhibition catalogue, *Suprématisme*, Galerie Jean Chauvelin, Paris, 1977, pp. 6–8

Lecombre, Sylvain: 'Le geste suprématiste', *Canal* (December 1977), p. 8

Mansouroff, P., 'Les debuts de l'art abstrait en Russie', exhibition catalogue, *Suprématisme*, Galerie Jean Chauvelin, Paris, 1977, p. 8

Marcadé, Jean-Claude, 'A propos de la nonfiguration', *K. S. Malévitch, Le Miroir Suprématiste: Écrits II*, Lausanne, 1977, pp 35–38

Marcadé, Jean-Claude, 'Quelques réflexions sur le Suprématisme' [with English translation], exhibition catalogue, *Suprématisme*, Galerie Jean Chauvelin, Paris, 1977, pp. 97–107

– 'What is Suprematism?' [with German translation], *Die Kunstismen in Russland 1907–1930*, exhibition catalogue, Galerie Gmurzynska, Cologne, 1977, pp. 182–95

Martineau, Emmanuel: 'Preface', *K. S. Malévitch, Le Miroir Suprématiste: Écrits II*, Lausanne, 1977, pp. 7–33

– 'Une philosophie de "suprema"' [with English translation], exhibition catalogue, *Suprematisme*, Galerie Jean Chauvelin, 1977, Paris, pp. 82–96

Masheck, Joseph, 'Cruciformality', *Artforum*, XV (Summer 1977), pp. 56–63

MaNamee, Donald, 'Review of John Bowlt's *Russian Art of the Avant-Garde*' (New York, 1977), *The Structuralist* (Saskatoon, Saskatchewan), no. 17–18 (1977–78), pp. 118–24

Moulin, Raoul-Jean, 'Autour de Malévitch et du Suprématisme', *L'Humanité* (November 15, 1977)

Nakov, Andreii, 'Existieren oder Handelin: Einige Bemerkungen zur Frage des Inhalts in der gegenstandslosen Kunst', exhibition catalogue, *Tendenzen der zwanziger Jahre: Europäische Kunstausstellung*, Nationalgalerie, Berlin, 1977, pp. 1/13–1/19

– 'Also habe ich die Welt von der Sünde gereinigt', exhibition catalogue, *Malewitsch-Mondrian und ihre Kreise Aus der Sammlung Wilhelm Hack*, Ludwigshafen, 1976, pp. 25–34; and exhibition catalogue, *Malewitsch-Mondrian: Konstruktion als Konzept*, Kunstvereine Hannover, 1977, pp. 50–59

– 'L'enseignement de Malévitch', *Art Press*, no. 13 (December 1977), p. 17

– 'Preface', in *Kazimir S. Malevic: Scritti*, Milan, 1977

– 'Preface', in exhibition catalogue, *The Suprematist Line*, Annely Juda Fine Art Gallery, London, 1977

Padtra, Jiri and Lamac, Miroslav, 'Malévitch et le Suprematisme', exhibition catalogue, *Suprématisme*, Galerie Jean Chauvelin, Paris, 1977, pp. 7–21

Padtra, Jiri, 'Kasimir Malewitsche – Einige Fragen und Bemerkungen zur Interpetation', exhibition catalogue, *Malewitsch-Mondrian: Konstruktion als Konzept*, Kunstvereine Hannover, 1977, pp. 39–49

Parone, Sandro, 'Che c'edi Malevic', *Panorama* (December 13, 1977), pp. 122–29

Pely, Annick, 'Les deux versants de l'abstraction géométrique', *Le Quotidien de Paris* (November 8, 1977)

Punin, Nicolai, 'Présentation des salles du Musée Russe à Leningrad montrant, à partir de 1927, les courants les plus récents de l'art russe en 1927', *K. S. Malévitch, Le Miroir Suprématiste: Écrits II*, Lausanne, 1977, p. 188

– 'A Moscou (Lettre)', *K. S. Malévitch, Le Miroir Suprématiste: Écrits II*, Lausanne, 1977, pp. 167, 168; excerpt from an article that originally appeared in *Iskusstvo Kommuny* (Art of the Commune), no. 10 (February 1919)

Rubercy, Erick de, 'Malévitch et la Philosophie', *Info-Attitudes*, no. 19 (June 1977), p. 11

Vallier, Dora, 'La genèse théorique du suprématisme', *Malévitch, Cahier I: Recueil d'Essais sur L'oeuvre et la Pensée de K. S. Malévitch*, ed. Jean-Claude Marcadé, Lausanne, 1977, pp. 77–83

Warnod, Jeanine, 'Malévitch et le Suprématisme', *Le Figaro* (December 13, 1977)

Wiese, Stephan von, 'Die Architektur des Suprematismus', exhibition catalogue, *Werke aus der Sammlung Costakis: Russische Avantgarde, 1910–1930*, Kunstmuseum Düsseldorf, 1977, pp. 56–57

Woimant, François, 'Nouveau transvaux sur l'avant-garde russe – Malévitch', *Nouvelles de l'Estampe*, no. 31, Paris (January–February 1977), pp. 44–45

**1978**

Andersen, Troels, 'Preface', *K. S. Malevich: Essays on Art*, vol. IV, Copenhagen, 1978

Betz, Margaret, 'From Cézanne to Picasso to Suprematism: The Russian Criticism', *Artforum*, XVI (April 1978), pp. 32–37

– 'Malevich and His Circle', *Art in America* (May–June 1978), pp. 113–14

– 'Malevich's Nymphs: Erotica or Emblem?', *Soviet/Sovietique*, vol. 5, part 2 (1978), pp. 204–14

Bliznakov, Milka, 'Suprematism in Architecture', *Soviet/Sovietique*, vol. 5, part 2 (1978), p. 241–55

Bojko, Szymon, 'Commentary', exhibition catalogue, *Kasimir Malewitsch*, Galerie Gmurzynska, Cologne, 1978, pp. 20, 71

Bojko, Szymon, 'Materials for Study of the History of Ginkhuk', exhibition catalogue, *Kasimir Malewitsch*, Galerie Gmurzynska, Cologne, 1978, pp. 280–83

Bowlt, John E., 'From Suprematism to Constructivism', exhibition catalogue, *Malevich and his Circle*, Rosa Esman Gallery, New York, 1978

– 'Beyond the Horizon', exhibition catalogue, *Kasimir Malewitsch*, Galerie Gmurzynska, Cologne, 1978, pp. 232–51

– 'Malevich and His Students', in *Soviet/Sovietique*, vol. 5, part 2 (1978), p. 256

Chasnik, Ilja, 'Die Architektur-technische Fakultät', exhibition catalogue, *Ilja G. Tschaschnik*, Kunstmuseum, Düsseldorf, 1978, pp. 41–42

Crone, Rainer, 'Malevich and Khlebnikov: Suprematism Reinterpreted', *Artforum*, XVII (Dec. 1978), pp. 38–47

– 'Zum Suprematismus – Kasimir Malevic, Velimir Chlebnikov, und Nicolai Lobacevskij', *Wallraf-Richartz-Jahrbuch*, XL (1978), pp. 129–62

Dabrowski, Magdelena, 'Revolution: The Russian Avant-Garde 1912–1930', in *Revolution: Russian Avant-Garde 1912–1930*, exhibition catalogue, The Museum of Modern Art, New York, 1978

Douglas, Charlotte, 'Malevich and His Circle', *Art in America* (May–June 1978), pp. 113–14

– 'Malevich's Painting: Some Problems of Chronology', *Soviet/Sovietique*, vol. 5, part 2 (1978), p. 301

Henderson, Linda D., 'The Merging of Time and Space: The 'Fourth Dimension', *Soviet/Sovietique*, vol. 5, part 2 (1978), pp. 171

Hulten, Pontus, 'L'idée d'avant-garde et Malévitch, homme de ce siècle,' *Malévitch*, Musée National d'Art Moderne, Centre Georges Pompidou, Paris, 1978, pp. 5–8

Karshan, Donald, 'Behind the Square: Malevich and the Cube', exhibition catalogue, *Kasimir Malewitsch*, Galerie Gmurzynska, Cologne, 1978, pp. 253–62

Kovtun, E., 'The Beginning of Suprematism', exhibition catalogue, *Kasimir Malewitsch*, Galerie Gmurzynska, Cologne, 1978, pp. 196–231

Ladurner, H., 'David D. Burljuks Leben und Schaffen 1908–1920', *Wiener Slawistisches Almanac*, vol. 1 (1978), pp. 27–55

Lamac, Miroslav, and Padrta, Jiri, 'The Idea of Suprematism', exhibition catalogue, *Kasimir Malewitsch*, Galerie Gmurzynska, Cologne, 1978, pp. 134–80

Leporskaia, Anna, 'The Beginnings and the Ends of Figurative Painting – Suprematism', exhibition catalogue, *Kasimir Malewitsch*, Galerie Gmurzynska, Cologne, 1978, pp. 65–70

Levin, Ilya, 'The Fifth Meaning of the Motor Car: Malevich and the *Oberiuty*', *Soviet/Sovietique*, vol. 5, part 2 (1978), pp. 287–300

Marcadé, Jean-Claude: 'An Approach to the Writings of Malevich', *Soviet/Sovietique*, vol. 5, part 2 (1978), pp. 225–40

Marcadé, Valentine, 'The Peasant Theme in the Work of Kazimir Severinovich Malevich' [with German translation], exhibition catalogue, *Malewitsch*, Galerie Gmurzynska, Cologne, 1978, pp. 94–119

Nakov, Andreii, 'Eine neue Philosophie der Form', exhibition catalogue, *Ilja G. Tschaschnik*, Kunstmuseum, Düsseldorf, 1978, pp. 26–36

– 'Introduction', in exhibition catalogue, *Liberated Colour and Form*, Scottish National Gallery of Modern Art, Edinburgh, 1978, pp. 5–21

Simmons, W. Sherwin, 'Kasimir Malevich's *Black Square*: The Transformed Self. Part Two: The New Laws of Transrationalism', *Arts Magazine*, LIII (Nov. 1978), pp. 130–41

– 'Kasimir Malevich's *Black Square*: The Transformed Self, Part Three: The Icon Unmasked', *Arts Magazine*, LIII (Nov. 1978), pp. 126–33

– 'The Step Beyond: Malevich and the Ka', *Soviet/Sovietique*, vol. 5, part 2 (1978), p. 149

Szewcyk, Andrei, 'Malevich and the Polish Avant-Garde', exhibition catalogue, *Kasimir Malewitsch*, Galerie Gmurzynska, Cologne, 1978, pp. 264–68

Vachitova, Ludmila, 'Ilja Tschaschnik und die Gruppe *UNOWIS*', *Neue Zürcher Zeitung* (May 27, 1978), p. 37

**1979**

Andersen, Troels, 'Malévitch: polemiques et inspirations dans les années 20' [Malevich: Polemics and Influences in the 1920s], *Malévitch, 1878–1935: Actes du colloque international tenu au Centre Pompidou, Musée National d'Art Moderne, les 4 et 5 mai 1978*, Lausanne, 1979, pp. 85–90

Broos, Kees, 'Het beeld van de taal' [The Picture of Language], *Openbaar Kunstbezit*, XXIII, no. 5 (October 1979), pp. 149–59 (15 ill.)

Compton, Susan, 'Malévitch et l'avant-garde', *Malévitch, 1878–1935: Actes du colloque international tenu au Centre Pompidou, Musée National d'Art Moderne, les 4 et 5 mai 1978*, Lausanne, 1979, pp. 51–58

Clair, Jean, 'Malévitch, Ouspensky et l'espace neo-platonicien' [Malevich, Uspenskij and Neo-Platonic Space], *Malévitch, 1878–1935: Actes du colloque international tenu au Centre Pompidou, Musée National d'Art Moderne, les 4 et 5 mai 1978*, Lausanne, 1979, pp. 15–30 (8 ill.)

Deryng, Xavier, 'Malévitch et la Pologne' [Malevich and Poland], *Malévitch, 1878–1935: Actes du colloque international tenu au Centre Pompidou, Musée National d'Art Moderne, les 4 et 5 mai 1978*, Lausanne, 1979, pp. 91–95

Douglas, Charlotte, 'Cubisme français/ Cubo-futurisme russe', *Cahiers du Musée National d'Art Moderne*, 79/2 (Oct.–Dec. 1979), pp. 184–93

Marcadé, Jean-Claude, 'L'Avant-Garde russe et Paris: Quelques Faits méconnus ou inédits sur les rapports artistiques franco-russes avant 1914', *Cahiers du Musée National d'Art Moderne*, 79/2 (Oct./Dec. 1979), pp. 174–83

– 'Malévitch et Khlebnikov', *Malévitch, 1878–1935: Actes du colloque international tenu au Centre Pompidou, Musée National d'Art Moderne, les 4 et 5 mai 1978*, Lausanne, 1979, pp. 31–46

Martin, Jean-Hubert, 'Kasimir Malévitch: Fonder une ère nouvelle', *Cahiers du Musée National d'Art Moderne*, 79/2 (Oct./Dec. 1979), pp. 9–20

Martineau, Emmanuel, 'Malévitch et l'enigme 'cubiste': 36 propositions en marge de Des nouveaux systemes en art' [Malevich and the Cubist Enigma: 36 Propositions in the Margin of On New Systems in Art], *Malévitch, 1878–1935: Actes du colloque international tenu au Centre Pompidou, Musée National d'Art Moderne, les 4 et 5 mai 1978*, Lausanne, 1979, pp. 59–72

Vallier, Dora, 'L'avant-garde russe et le livre éclaté', *Revue de l'art* (Paris), no. 44 (1979), pp. 57–67

Zhadova, Larissa, 'Naissance des principes de la polychromie contemporaine' [Birth of the Principles of Contemporary Polychromy], *Malévitch, 1878–1935: Actes du colloque international tenu au Centre Pompidou, Musée National d'Art Moderne, les 4 et 5 mai 1978*, Lausanne, 1979, pp. 79–84

**1980**

Betz, Margaret, 'Review of *Journey into Non-Objectivity: the Graphic work of Kasimir Malevich and other Members of the Russian Avant-Garde*' (catalogue of exhibition at Museum of Fine Arts, Dallas, Texas), *Art Journal*, XL, no. 1–2 (Fall–Winter 1980), pp. 417–21

Bilardello, Enzo, 'L'astrattismo; percorso a genesi' [The Origin and Course of Abstraction], *Storia dell'arte*, 38–40 (Jan.–Dec. 1980), pp. 393–402 (13 ill.)

Bowlt, John E., 'Report on two Constructivism exhibitions and two Symposia on Constructivist Art and Design, Dallas, Texas', *Leonardo*, XIII, no. 4 (Autumn 1980), pp. 303–306 (5 ill.)

Douglas, Charlotte, 'Review of *Journey into Non-Objectivity: the Graphic work of Kasimir Malevich and other Members of the Russian Avant-Garde*' (catalogue of exhibition at Museum of Fine Arts, Dallas, Texas), *Artscanada*, XXXVII, no. 1 (April–May 1980), pp. 47–48

Marcadé, Jean-Claude, 'From Black Quadrilateral (1913) to White on White (1917): From the Eclipse of Objects to the Liberation of Space', exhibition catalogue, *The Avant-Garde in Russia, 1910–1930: New Perspectives*, eds. Stephanie Barron and Maurice Tuchman, Los Angeles County Museum of Art, 1980, pp. 20–24

Schaefer, Scott, 'Review of *The Avant-Garde in Russia, 1910–1930: New Perspectives*' (catalogue of exhibition at Los Angeles County Museum of Art, Los Angeles), *The Burlington Magazine*, CXXII, no. 933 (December 1980), pp. 871–72

Shone, Richard, 'Review of *Abstraction: Towards a New Art; Painting 1910–1920* (catalogue of exhibition at Tate Gallery, London )', *The Burlington Magazine*, CXXII, no. 924 (March 1980), pp. 210–13

Various authors, 'Dossier: Kasimir Malevic', *Cahiers du Musée National d'Art Moderne*, no. 3 (Jan.–Mar. 1980), pp. 122–59 (46 ill.)

**1981**

Barooshian, Vahan D., 'Review of *Swans of Other Worlds: Kasimir Malevich and the Origins of Suprematism, 1908–1915*' (dissertation by Charlotte Douglas), *Russian Review*, XL, no. 2 (April 1981), pp. 227–28

Bless, Frits, '"Malewitch" late werk: eigen keus of politieke dwang' [Malevich's late work: Personal Choice or Political Constraint], *Openbaar Kunstbezit* (Amsterdam), XXV, no. 4 (Aug.–Sept. 1981), pp. 130–35 (10 ill.)

Henderson, Linda D., 'Italian Futurism and the *Fourth Dimension*', *Art Journal*, XLI, no. 4 (Winter 1981), pp. 317–23 (12 ill.)

Kerber, Bernhard, 'Bild und Raum – zur Auflsung einer Gattung' [Painting into Space – On the Dissolution of a Genre], *Stadel-Jahrbuch*, VIII (1981), pp. 324–45 (7 ill.)

Kovtun, Evgenii, 'Kasimir Malevich', *Art Journal*, XLI, no. 3 (Fall 1981), pp. 234–41 (6 ill.)

**1982**

Compton, Susan P., 'Review of *Malevich: Suprematism and Revolution in Russian Art, 1910–1930* by Larissa Zhadova', *Art Monthly*, no. 60 (October 1982), pp. 23–24

Dabrowski, Magdalena, 'Malevich-Mondrian: Geometric Form as the Expression of the Absolute', *Art Bulletin of the Nelson-Atkins Museum*, V, no. 7 (October 1982), pp. 19–34 (ill.)

Marcadé, Jean-Claude, 'Marinetti et Malévitch', *Présence de Marinetti*, Lausanne, 1982, pp. 260–65

Mormone, Raffaele, 'L'educazione spaziovisiva negli scritti di Malevic' [Spatiovisual education in the Writings of Malevich], *Scritti in onore di Ottavio Morisani*, Universita' degli studi di Catania, 1982, pp. 475–500 (10 ill.)

Pedersen, Paul, 'Malévitch: un problème de sculpture', *Cahiers du Musée National d'Art Moderne*, no. 10 (1982), pp. 260–63 (9 ill. and diagrams)

Zelinsky, Bodo, 'Die Befreiung von Gegenstand: Russland und die *grosse Abstraktion* [The Liberation from the Object: Russia and *Great Abstraction*], *Zeitschrift für Aesthetik und Allgemeine Kunstwissenschaft*, XXVII, no. 2 (1982), pp. 198–224

– 'Der Primitivismus und die Anfänge der avantgardistischen Malerei und Literatur in Russland' [Primitivism and the beginnings of Avant-Garde Painting and Literature in Russia], *Zeitschrift für Aesthetik und Allgemeine Kunstwissenschaft*, XXVII, no. 2 (1982), pp. 121–41

**1983**

Birringer, Johannes H., 'Constructions of the Spirit: The Struggle for Transfiguration in Modern Art', *Journal of Aesthetics and Art Criticism*, XLII, no. 2, (Winter 1983), pp. 137–50

Bowlt, John E., 'Review of *Malevich: Suprematism and Revolution in Russian Art, 1910–1930* by Larissa Zhadova', *Times Literary Supplement* (April 8, 1983), p. 361

Crone, Rainer, 'A propos de la signification de la Gegenstandslosigkeit xhez Malévitch et son rapport à la théorie poétique de Klebnikov', trans. Jean-Claude Marcadé, in *Malévitch, Cahier I: Recueil d'essais sur l'oeuvre et la pensée de K. S. Malévitch*, Lausanne, 1978, pp. 45–75

Lynton, Norbert, 'Review of *Malevich: Suprematism and Revolution in Russian Art, 1910–1930* by Larissa Zhadova', *Art International*, XXVII, no. 5 (Nov.–Dec. 1983), pp. 93–94

Overy, Paul, 'Review of *Malevich: Suprematism and Revolution in Russian Art, 1910–1930*', by Larissa Zhadova, *Studio International*, CXCVI, no. 998 (Jan.–Feb. 1983), pp. 61–62

Vaizey, Marina, 'Review of *Malevich: Suprematism and Revolution in Russian Art, 1910–1930* by Larissa Zhadova', *Art Book Review*, II, no. 5 (1983), pp. 39–42

Waldman, Diane, 'Kasimir Malevich: The Supremacy of Pure Feeling', *Arts Magazine*, XLVIII (December 1983), pp. 24–29

**1984**

Fischer, Friedhelm, 'Zur Symbolik des Geistigen in der Modernen Malerei' [On the Symbolism of Spirits in Modern Painting], *Zeitschrift für Aesthetik und allgemeine Kunstwissenschaft*, XXIX, no. 1 (1984), pp. 5–18

Langer, Michael, *Kunst am Nullpunkt: eine Analyse der Avantgarde im 20. Jahrhundert* [Art at zero level: an analysis of the avantgarde in the 20th century], Worms, 1984

Marcadé, Jean-Claude, 'Le Suprématisme de K. S. Malevic ou l'art comme réalisation de la vie', *Revue des Études Slaves*, LVI, no. 1 (1984), pp. 61–77

Smith, Terry, 'Review of *Malevich: Suprematism and Revolution in Russian Art, 1910–1930* by Larissa Zhadova', *Art Monthly*, no. 73 (February 1984), pp. 33–36

**1985**

Beckett, Jane, 'Review of *Malevich: Suprematism and Revolution in Russian Art, 1910–1930* by Larissa Zhadova', *The Burlington Magazine*, CXXVII, no. 983 (February 1985), pp. 106–107

Olbrich, Harald, 'Lebendiges Interesse an der Zukunft: zum Schaffen von Kasimir Malewitsch' [Active interest in the future: On the Art of Kasimir Malevich], *Bildende Kunst*, V (May 1985), pp. 228–30 (8 ill.)

Pedersen, Poul, 'Gips som materiale' [Plaster as material], *Louisiana Revy*, XXVI, no. 1 (September 1985), pp. 49–52 (5 ill.)

**1986**

Douglas, Charlotte, 'Evolution and the Biological Metaphor in Modern Russian Art', *Art Journal*, XLIV, no. 2 (Summer 1984), pp. 153–61

Madoff, Steven H., 'Vestiges and Ruins: Ethics and Geometric Art in the Twentieth Century', *Arts Magazine*, LXI (December 1986), pp. 32–40

Strauss, Thomas, 'Malewitschs Spätwerk', *Kunstwerk*, XXXIX, no. 2 (April 1986), pp. 22–28

**1987**

Kuspit, Donald, 'Imi Knoebel's Triangle', *Artforum*, XXV (January 1987), pp. 72–79

Marcadé, Jean-Claude, 'Kazimir Malévitch (1878–1935)', *Histoire de la littérature russe: Le XXe siècle*, vol. I, Paris, 1987, pp. 454–63

Turowski, Andrzej, 'Theories de la sculpture en Europe de l'Est, 1910–1920', *Revue de l'Art*, no. 76 (1987), pp. 85–87

– 'Modernité à la russe', *Cahiers du Musée National d'Art Moderne*, vol. 19–20 (June 1987), pp. 110–29

**1989**

Bowlt, John E., 'Rehabilitating the Russian Avant-Garde', *Art News*, LXXXVIII (February 1989), pp. 116–19

Crone, Rainer and Moos, David, 'Subjectivity in Temporality: Kasimir Malevich', *Artforum*, XXVII (April 1989), pp. 119–25

Douglas, Charlotte, 'Behind the Suprematist Mirror', *Art in America*, LXXVII (September 1989), pp. 164–77

Lodder, Christina, 'Supreme Suprematist', *Art International*, VIII (Autumn 1989), pp. 77–78

Mercillon, Henri, 'Malévitch à Amsterdam: du Suprématisme à la figuration', *Connaissance des Arts*, no. 447 (May 1989), pp. 68–77

Stallabrass, Julian, 'Kasimir Malevich', *The Burlington Magazine*, CXXXI (March 1989), pp. 240–41

**1990**

Kramer, Hilton, 'Art, Revolution, and Kasimir Malevich', *The New Criterion*, IX (November 1990), pp. 7–9

**1991**

Handy, Ellen, 'A Mind of Winter: Malevich in America', *Artsmagazine*, LXV (March 1991), pp. 54–58

# Index